# HOW TO SELECT AND USE

# Canon
# EOS

## SLR CAMERAS

**Published by HPBooks**
**A Division of Price Stern Sloan, Inc.**
360 North La Cienega Boulevard
Los Angeles, California 90048

**Library of Congress Cataloging-in Publication Data**

Shipman, Carl.
    How to select and use Canon EOS SLR cameras.

    Includes index.
    1. Canon camera.    2. Single-lens reflex cameras.
3. Photography—Handbooks, manuals, etc.    I. Title.
TR263.C3S53   1988           771.3'1           88-25284
    ISBN 0-89586-677-3

# HOW TO SELECT AND USE

# Canon EOS

## SLR CAMERAS

### By Carl Shipman

# Contents

# Preview

This book is about Canon EOS cameras, the companion EF lenses, Canon EZ-type electronic flash and other accessories—how they work and how to use them. It begins with fundamentals of photography and cameras. Building on fundamentals, this book helps you understand and use all features of the most advanced cameras.

The cameras and accessory items discussed are listed in the adjoining table.

## A NEW CAMERA SERIES

The name EOS identifies a new series of cameras, announced by Canon in 1987. These cameras take advantage of recent developments in electronics, optics and automatic focusing methods. The name EOS stands for Electro-Optical System, which implies that control of the lens is entirely electronic.

EOS cameras offer automatic or manual exposure control, automatic or manual focus, and many other automatic features. They have advanced capabilities, but are easy to use, even by a beginning photographer.

EOS cameras and lenses are distinctly different from earlier Canon cameras and from contemporary cameras of other brands. In Greek mythology, Eos is the goddess of dawn. It may well be that the EOS cameras herald the dawn of a new era in camera design.

## A NEW LENS SERIES

EOS cameras use a new series of Canon lenses, labeled EF for Electro-Focus. These lenses are designed to be focused automatically by the camera, using a tiny electric motor built into each lens. Many are advanced zoom lenses offering the capabilities of several conventional lenses, plus a macro range that allows you to make

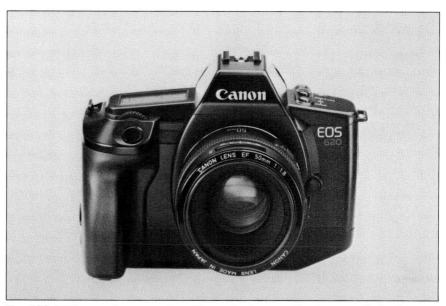

The EOS 620 is one of a new series of Canon "auto everything" cameras that offer you a variety of sophisticated features, some not used before in SLR cameras. You can allow the camera to focus the scene automatically or you can choose to do it manually. You can choose between automatic or manual exposure control. You can take control if you wish, or relax and let the camera do the job automatically.

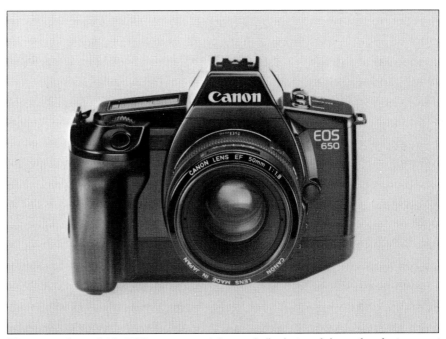

The currently available EOS camera models are similar but each has a few features not found on the others. For example, the EOS 650 has a Depth-of-Field mode that allows you to choose which parts of a scene are in good focus.

## EQUIPMENT DISCUSSED IN THIS BOOK

**Cameras**
EOS 620
EOS 650
EOS 750 QD
EOS 750
EOS 850

**Lenses**
EF lenses
EF Macro Lens
EF Lens type A

**Flash**
Speedlite 420EZ
Speedlite 300EZ
Speedlite 160E

Lens Accessories
Focusing Screens
Interchangeable Grips
Quartz Date Back E
Technical Back E
Filters
Remote Control

A new series of EF lenses was introduced with EOS cameras. The lenses have tiny built-in motors and computers that work with the camera to focus the lens automatically and provide automatic exposure control. The lenses also have a control to allow manual focus, when desired. Lenses are packaged with front and rear lens caps. Here, the front lens cap has been removed.

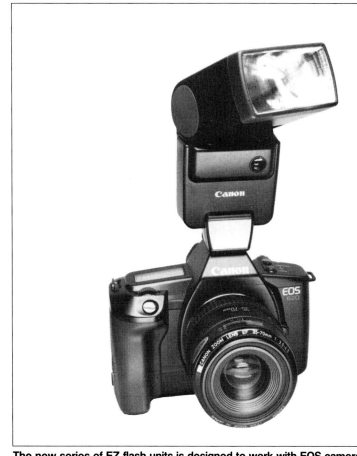

The new series of EZ flash units is designed to work with EOS cameras to provide fully automatic flash—or manual control, when desired. The flash head on this 420EZ can be tilted vertically and rotated, to make photos not possible with ordinary "straight-ahead" flash units.

large images of small objects.

Canon EF lenses communicate electronically with EOS cameras to provide new and helpful operating features that were not possible a few years ago.

### A NEW FLASH SERIES

Canon electronic flash units are called Speedlites. New Speedlites are available to work with EOS cameras. These are identified by the letters EZ or E in the label, such as the Canon Speedlite 420EZ and 160E. They provide all features of modern electronic flash units, including full automation. In addition, these flash units have a built-in AF (AutoFocus) auxiliary light source that automatically illuminates a subject in dim light so EOS cameras can focus automatically in the dark—even in total darkness.

### INTERCHANGEABLE CAMERA BACKS

Interchangeable camera back covers are available with a range of capabilities. The Quartz Date Back E imprints data on the film, such as the date and time the picture was made. Technical Back E, with its accessories, imprints data on the film, records exposure settings for future reference, and has other advanced features.

## A CAMERA SYSTEM

One or more camera models, together with interchangeable lenses and back covers, a variety of flash units and a wide range of accessories is called a camera *system*. The system approach allows you to choose equipment for virtually any kind of photography. This book is about the Canon EOS system.

## ORGANIZATION OF THIS BOOK

This book explains how EOS cameras and accessories work and how to use them. Some chapters are tutorial—the chapter on exposure metering is an example. Some chapters are specific—for example, Chapter 10 provides descriptions of EOS cameras, with specifications.

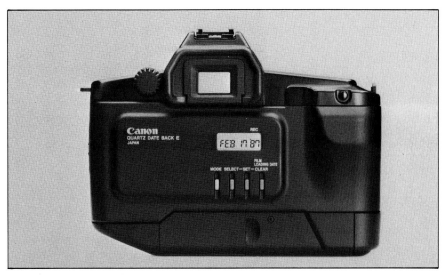

**Quartz Date Back E replaces the standard back cover of the camera. It can imprint the date or other information in the lower right corner of the picture. It remembers and displays the date that the film in the camera was loaded. When set to imprint data on film, the data is shown in the display on the Date Back. This unit is set to imprint a date: Feb 17 '87.**

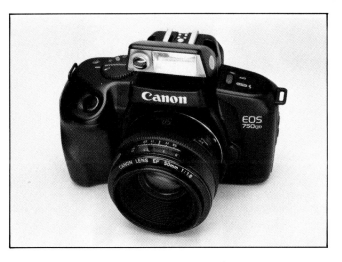

**These two pictures represent three camera models. They are basically the same and are easy to operate. Each has EOS features that include fast autofocus, even in dim light, programmed automatic exposure control, evaluative metering that does the "thinking" for you, and automatic depth-of-field control.**
* **The EOS 750 QD has has a permanently-attached Quartz Date back cover that can be used to imprint the date or time on pictures. It also has a built-in pop-up flash. The camera can use the built-in flash or accessory EOS flash units, such as Speedlite 160E.**
* **The EOS 750 has the built-in flash but not the Quartz Date back cover. It can use the built-in flash or accessory EOS flash units such as Speedlite 160E.**
* **The EOS 850 is the "basic" and simplest camera of the group. It doesn't have a built-in flash or the Quartz Date back cover. It can use an accessory flash, such as Speedlite 160E, which is more powerful than the built-in flash in the other two models.**

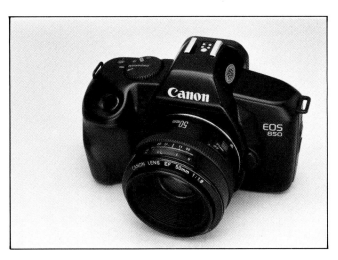

# How an EOS Camera Works

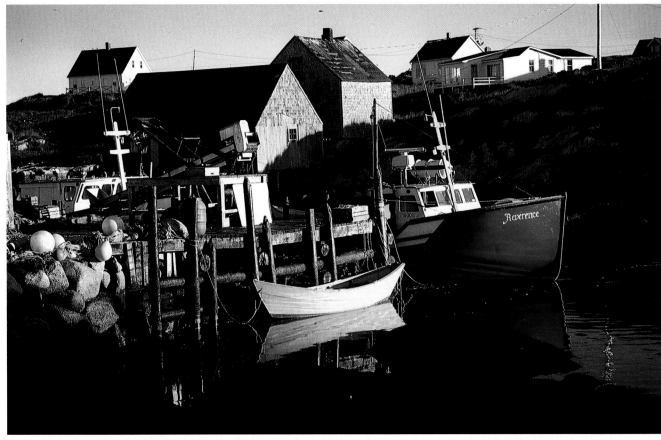

A pleasing photo brings back a vivid memory of the time and place where it was taken, plus the satisfaction of having made the image. This is Peggy's Cove, probably the most photographed place in Nova Scotia.

This chapter discusses camera fundamentals—the main controls and features. Following chapters provide more information on each of these topics.

Some camera designs use two lenses or optical systems, one to view the scene and another to actually take the picture. What you see in the viewing system may not be exactly the same as the resulting photo.

EOS cameras are a type known as *single-lens reflex*, abbreviated *SLR*. You view and shoot through the same lens. You see exactly what will appear on the film, which helps you make an effective composition. Another major advantage of SLR cameras is that they use interchangeable lenses, such as wide-angle or telephoto. This gives you artistic control when composing a photograph.

## VIEWING THE SCENE

As shown in the accompanying drawing, light from the scene enters the camera through the lens. The camera allows you to view and compose the scene before taking the picture. To do that, the image from the lens is intercepted and reflected upward by a movable mirror. The cavity in the camera body that contains the mirror is called the *mirror box*.

To view the scene, the mirror is in the "down" position. The image formed by a lens is upside down and reversed left-to-right. This image is reflected upward to a *focusing screen*, which has a frosted or *matte* surface like ground glass. From the focusing screen, the light rays pass through a *pentaprism* and emerge at the viewfinder eyepiece.

The purpose of the pentaprism is to show you a correctly oriented view, with the top of the scene at the top of the image and with left and right not

reversed. With your eye at the viewing eyepiece, you see a correctly oriented image of the scene that is formed at the focusing screen.

The focusing-screen image is used to compose the scene and to check its focus. You may improve the focus by turning the focusing control on the lens—or an EOS camera can focus the lens automatically, usually faster than you can do it manually.

**The SLR Principle**—With an SLR, viewing and taking the picture are done with a *single lens* and the *reflex* method is used for viewing. For the image to reach the viewfinder, it is *reflected* by a mirror in the camera.

## TAKING THE PICTURE

While you are viewing the scene, the film is protected from light by a shutter directly in front of the film. When you press the Shutter Button to take the picture, the mirror swings up so it is out of the way. It moves up against the bottom of the focusing screen. This closes the light path through the viewfinder so you can no longer view the scene.

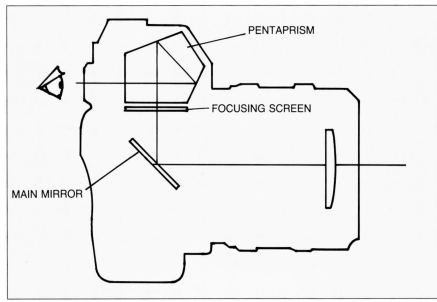

By looking into the viewfinder eyepiece, you can view the scene and compose the image before making the picture. Light from the scene enters the lens and is reflected upward by the main mirror. An image of the scene is formed on the focusing screen. The purpose of the pentaprism is to present that image to your eye with correct left-right orientation.

After the mirror has moved up, the shutter opens a rectangular window in front of the film. The image from the lens falls on the sensitive front surface of the film—the photographic emulsion. The dimensions of the window in front of the film determine the size and shape of the image frame on film—in this case 24 x 36mm.

At the end of the exposure, the shut-

The focal-plane shutter appears in a rectangular window inside the camera body, just in front of the film. When the shutter is closed, as shown here, no light can reach the film. The shutter is made of thin metal blades. It is a delicate, precision mechanism and you should avoid touching it.

When the focal-plane shutter opens, an image of the subject falls on the film.

9

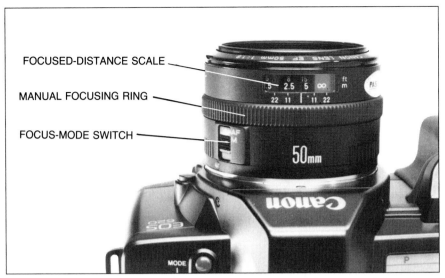

Most EF lenses have a Focus-Mode Switch to select automatic or manual focusing, a Manual Focusing Ring and a Focused-Distance Scale. A few EF lenses—the type A lenses—can be used only with automatic focus and have no distance scale. Type A lenses are shown later.

ter closes and the mirror moves down again so you can view and compose the image for the next frame. The film is advanced so an unexposed frame is in place behind the lens.

## FOCUSING THE LENS

EOS cameras use Canon EF (Electro-Focus) lenses that are designed to focus the lens automatically. This is the usual way of operating the camera. However, there are some scenes that cannot be focused automatically, such as a "blank" surface.

You may wish to focus the lens manually, because the subject is unsuitable for automatic focus, or to achieve a special effect.

Most EF lenses have a Focus-Mode Switch on the lens body. If set to M, the lens must be focused manually by turning the Manual Focusing Ring on the lens body.

If the Focus-Mode switch is set to AF, for Auto Focus, the camera focuses the lens automatically. The Manual Focusing Ring on the lens is disabled. You can turn it, but nothing happens.

## ON-OFF CONTROL

EOS cameras have a Main Switch. When it is turned off, the camera can-

not be operated. Turning the switch on allows the camera to be used.

## EOS 620 AND EOS 650

The following discussion applies primarily to the EOS 620 and 650 cameras.

This book uses the term EOS 620/650 when referring to both models. The newer EOS 750 and 850 models are similar but greatly simplified and are discussed separately, later in this chapter.

## MAIN SWITCH SETTINGS

The Main Switch on the EOS 620/650 is to the left of the viewfinder eyepiece. It has four settings that you select by rotating the control.

**The L Setting**—The off setting is labeled L, which means Lock. At this setting, the camera is turned off and cannot be operated. When you are not using the camera, set the Main Switch to the L position to save battery power and avoid the chance of accidental exposures.

**The Green Rectangle**—Rotating the Main Switch counterclockwise, from L to the green rectangle, turns the camera on and simultaneously makes all other camera settings for you.

With the Focus-Mode Switch on the lens at AF, the camera is set to function as follows: It focuses automatically and sets exposure automatically. It makes a single exposure each time the shutter button is pressed, but only if the subject is in good focus. A built-in beeper confirms good focus with a *beep-beep* and also provides a "camera shake" warning, discussed in Chapter 2.

This is the simplest way to use the camera. It requires no decisions by the user. Anyone can use an EOS camera set to the green rectangle—even if he knows nothing about photography and has never seen an EOS camera before.

In this mode, you can choose to focus the lens manually by setting the Focus-Mode Switch to M. Other than that, you can't change *any* of the camera settings listed in the preceding paragraph. The only camera-body control that does anything is the battery-check button, which allows you to test the battery. All other camera-body controls are disabled and don't do anything. This prevents a novice or casual user of the camera from making incorrect settings accidentally.

Canon refers to the green rectangle setting of the Main Switch as the "full auto" mode. A better name might be "no-decision auto." As you will see, there are other ways to use the camera that are also fully automatic but allow decisions and control settings by the user.

**The A Setting**—Turning the Main Switch clockwise from L to A turns on the camera—except for the beeper—but leaves the rest up to you. All camera-body controls work and you can make any settings that you wish.

Historically, Canon has used the letter A to indicate that the camera is turned on and ready to operate. It stands for Advance, meaning "go ahead" or proceed to use the camera.

**The Beeper**—When the Main Switch is set to A, the camera is on but the beeper is turned off. If you want to hear it, turn the Main Switch past A to the "sound wave" symbol. That turns on both camera and beeper.

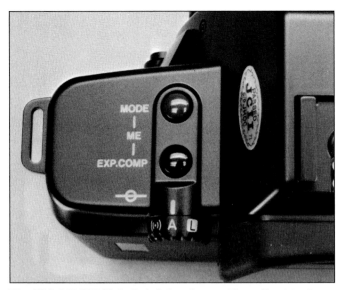

The EOS 620/650 **Main Switch** has four settings. If set to A as shown here, the camera is ready to use but the built-in beeper is off. If set past A, to the sound-wave symbol, the camera is ready and the beeper is on. At L, the camera is off and the shutter is locked. The fourth setting is on the bottom of the Main Switch, not visible in this photo. It's a green rectangle that sets the camera for "full auto"—the camera makes all decisions for you.

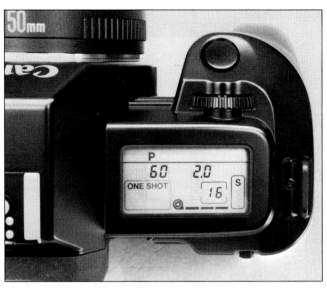

The EOS 620/650 **Shutter Button** and **Electronic Input Dial** are at the top right on the camera body, just in front of the LCD Display Panel. The Shutter Button is angled so it is convenient to press with your right forefinger. The Input Dial is serrated to make it easy to turn. The LCD Display Panel shows everything you need to know about camera status, as discussed later.

## SHUTTER BUTTON

With the Main Switch turned on, the Shutter Button has two stages of operation. When depressed halfway, to the point where you feel a slight resistance, all camera electronic systems are turned on and operate. For example, the autofocus system will focus on the subject. This is the first stage.

The second stage of operation is to depress the button fully, which causes the camera to make an exposure on film.

If you release the Shutter Button, before making an exposure, most of the camera electronic systems automatically turn off in eight seconds. This saves battery power because the camera electronics are turned on only when you need them.

The camera has a built-in exposure meter that measures light from the scene. This function is also controlled by the Shutter Button, as discussed in Chapter 5.

## ELECTRONIC INPUT DIAL

The EOS 620/650 Input Dial is a grooved "wheel" that you rotate with the index finger of your right hand. It is used to make virtually all control settings on the camera.

Because the Input Dial has several functions, pushbuttons on the camera are used to select the function to be performed. Pushbuttons that are used frequently are on top of the camera body. Those that are used less often are behind a hinged Switch Cover on the back of the camera, at the bottom.

Two operations are required: press the appropriate pushbutton to choose the function and then rotate the Input Dial to make a setting or adjustment of that function. Here is an example:

**To Select Shooting Mode**—One function of the Input Dial is to choose among several *shooting modes*. This can be done with the Main Switch set to A and the beeper on or off, but not at the green rectangle setting. The basic

choice of shooting mode is between manual or automatic exposure control.

To make that choice, press the MODE button on top of the camera while rotating the Input Dial. The LCD Display on top of the camera shows which shooting mode is being selected. Choose M if you want to control exposure manually.

There are several types of automatic exposure, discussed in Chapter 5, each with its own symbol in the display. To choose an automatic-exposure mode, rotate the Input Dial until the desired symbol appears in the display.

**Other Functions**—The Input Dial has other purposes that will be described later, when the individual functions that can be controlled by the Input Dial are discussed.

## FILM TRANSPORT

Film for EOS cameras is of the conventional 35mm format. It is 35mm

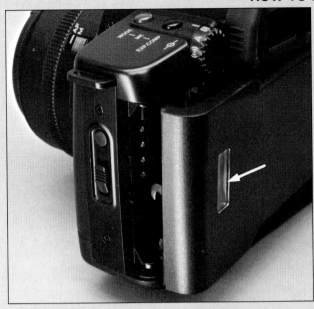

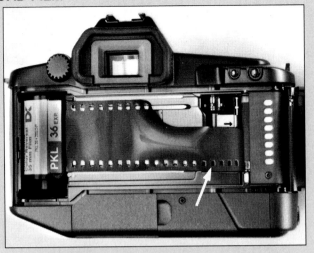

### Opening Back Cover to Load Film:

1. Before opening the back cover, check to see if there is film in the camera. The Film-Load Check Window (arrow) in the back cover lets you see if a film cartridge is in place. If so, the LCD Display Panel shows you if the film has been rewound so it is safe to open the camera.

2. The Back Cover Lock Button and Latch are on the left end of the camera. To open the back cover, press the round Lock Button while sliding the Latch downward. The back cover will spring open as shown here.

### Inserting Film and Drawing End Across:

3. Insert the film cartridge, top end first. Don't allow the film end to touch the focal-plane shutter.

4. Pull the film end across the camera body. The end should align with a red rectangle at the lower right corner of the opening. The lip on the film cartridge should lie flat against the camera body. The film should be flat and not bow upward. If you pull out too much film, push some back into the cartridge.

5. Place a sprocket hole of the film over a sprocket tooth in the camera (arrow). Hold the film in that position with your finger, as long as possible, while closing the camera back.

6. If the camera Main Switch is at L, turn it to A or the green rectangle. The automatic takeup mechanism will grasp the film end and advance film to frame 1, ready to make the first exposure.

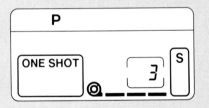

### LCD Display for Film Loading:

7. Symbols in the LCD Display Panel on top of the camera show the status of the camera. If a film cartridge is in the camera, the cartridge symbol appears.

The three dashes extending from the cartridge represent film. When film is being wound onto the takeup mechanism at the right side of the camera, the dashes blink sequentially, left to right.

When film is being rewound back into the cartridge, the dashes blink sequentially, right to left. When film has been fully rewound into the cartridge, the dashes disappear and it is safe to open the camera back. If there is no film cartridge in the camera, the cartridge symbol disappears.

The number of the next frame to be exposed appears in the rectangle just above the film dashes. This display shows that film is in the camera and has been advanced to frame 3. The film-status indicators operate even when the camera is turned off.

wide. When purchased, it is rolled up on a spool inside a light-tight cartridge. One end of the film sticks out of the cartridge through a slot. The other end is attached to the spool inside the cartridge with adhesive tape.

The film cartridge is loaded into the camera as shown in the accompanying photos. As exposures are made, the EOS 620/650 winds film onto the take-up spool inside the camera. This is called *advancing* the film.

When all exposures have been made, the exposed film has been wound onto the take-up spool. If you were to open the camera back at that time, light would strike the unprotected film on the take-up spool and the film would be ruined.

Before opening the camera back, it is necessary to *rewind* the film back into the original light-tight cartridge. This is done automatically by a motor in the camera body, as discussed later

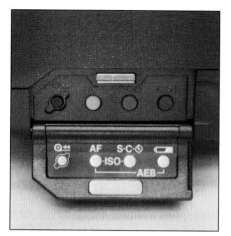

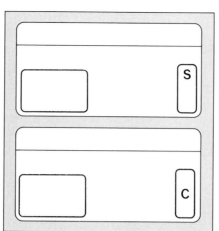

To set the EOS 620/650 Self-Timer, press the blue button behind the Switch Cover while turning the Input Dial to display the clock-face symbol in the LCD Display Panel, as shown here. When set, the Self-Timer delays shutter operation for 10 seconds after you press the Shutter Button.

A Switch Cover on the back of EOS 620/650 cameras is held closed by a magnetic latch. The cover conceals pushbuttons that are not frequently used. The recessed button at left causes the camera to rewind film immediately, without waiting to expose all frames on the roll.

Pressing the button labeled AF allows you to select an autofocus mode, discussed later. The third button from the left is used with the Input Dial to select the film-winding mode: Single-frame, Continuous, or Self-Timer—indicated by the symbols S, C and a clock face. The fourth button tests the battery in the camera and shows the result in the LCD Display Panel.

Pressing buttons 2 and 3 simultaneously allows you to set ISO film speed, discussed later. With an EOS 620 camera, pressing buttons 2 and 4 simultaneously selects Automatic Exposure Bracketing (AEB), also discussed later.

The selected EOS 620/650 film-winding mode is shown by a symbol in the LCD Display Panel: S for Single-frame or C for Continuous. The Self-Timer mode is indicated by a clock-face symbol, shown at right

beeper on or off, three film-winding modes can be selected, using the Input Dial and the blue pushbutton inside the Switch Cover. The pushbutton is labeled with three symbols, S, C, and a clock face. One of these symbols appears in the LCD Display on top of the camera, to show which mode has been selected.

**To Select a Mode**—Open the Switch Cover and press the blue pushbutton while rotating the Input Dial. You can remove your finger from the pushbutton if you wish and still have eight

seconds to make the selection.

● Single Exposures: Rotate the Input Dial so the symbol S appears in the LCD Display. The camera will expose and then advance one frame of film each time you press and release the Shutter Button.

● Continuous Exposures: Rotate the Input Dial so the symbol C appears in the LCD Display. The camera will expose frames continuously as long as you hold the Shutter Button depressed. The viewing mirror moves down between exposures so you can see what is

in this chapter. Then, you can open the camera back and remove the cartridge of exposed film to have it developed.

## FRAME COUNTER

The EOS 620/650 counts exposures as they are made. The LCD Display on top of the camera shows the number of the *next frame* to be exposed in a "framed" area near the lower right corner of the display. This value is displayed even with the Main Switch off.

## FILM-WINDING MODES

EOS 620/650 cameras use built-in electric motors to advance the next frame after each exposure and wind the exposed frames onto the take-up spool. With the Main Switch set to A, and the

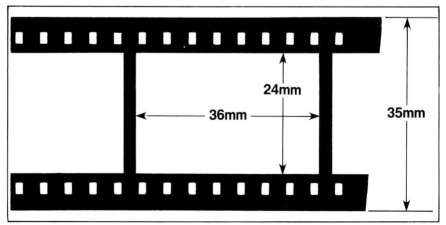

A 35mm SLR camera uses film that is 35mm wide, with sprocket holes along the edges. The film frame, where the image is formed, is approximately 24mm by 36mm. The film frame is defined by the rectangular opening in the focal-plane shutter.

Dimensions in photography are often stated in metric units. An exception is the focused-distance scale on lenses, which shows both meters and feet.

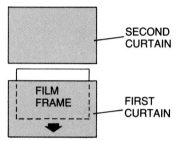

An Eyepiece Cover snaps into the rubber shoulder pad on the camera shoulder strap. If you are using the self-timer with the camera set for automatic exposure and your eye will not be at the eyepiece when you press the shutter button, use the Eyepiece Cover to cover the eyepiece. Otherwise, stray light entering the eyepiece may cause incorrect exposure.

in the frame—to follow a moving subject, for example.

Maximum speed is 3 frames per second. Operation is slower at long exposure times, such as 1 second, because the camera must wait until the shutter closes before advancing film to the next frame. Operation may be slowed down by autofocus operation between frames.

### SELF-TIMER

This setting combines the single-exposure film-winding mode with a built-in delay timer. Press the blue pushbutton behind the Switch Cover and rotate the Input Dial to display the "clock face" symbol.

When you press the Shutter Button, the camera will wait for 10 seconds and then make a single exposure. This allows time for you to move around to the front of the camera, so you can take your own picture.

To use the timer for that purpose, put the camera on a tripod or other firm support. Compose the scene and prepare the camera to take the picture. Then, press the shutter button to start the timer.

The numerals in the LCD Display that normally show frame count are used to show time remaining, counting down from 10 seconds. During the countdown, a red lamp on the front of the camera blinks—more rapidly during the last two seconds.

You can cancel the Self-Timer during countdown by turning the Main Switch to L or by pressing the Battery-Check button behind the Switch Cover.

**Eyepiece Cover**—If the camera sets exposure automatically, and your eye is not at the viewfinder eyepiece, light entering the eyepiece may cause incorrect exposure. To prevent that, a rubber eyepiece cover is clipped into the shoulder pad on the camera strap. Remove the cover and snap it over the camera eyepiece.

### EOS 620/650 FILM REWIND

When the last frame has been exposed, the film is automatically rewound. The film end is drawn all the way into the cartridge.

**Mid-Roll Rewind**—To rewind before reaching the end of the roll, fold down the Switch Cover and press the recessed Rewind Button at left. It is labeled

## HOW A FOCAL-PLANE SHUTTER WORKS

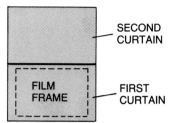

Ready to make an exposure, the first shutter curtain covers the film-frame opening.

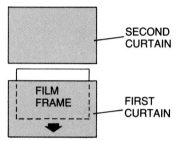

When you press the Operating Button, the mirror moves up. Then, the first curtain travels down across the frame, progressively opening the film area to light.

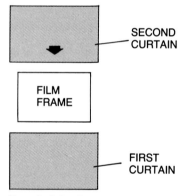

Travel of the first curtain is completed. The film frame is fully open to light.

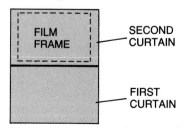

To end the exposure, the second curtain moves downward across the frame, closing it to light.

with a symbol showing film moving back into the cartridge.

**Optional Modifications**—A Canon service center can modify an EOS 650 or EOS 620 camera so it doesn't automatically rewind after the last frame has been exposed. It rewinds when you press the Rewind Button.

The EOS 620 can be altered so it stops rewinding with a short length of film extending from the cartridge.

## EOS 750, 750 QD AND 850

These three models are designed for simplicity of operation and for people who are more interested in getting the picture than in operating the camera. This book uses the term EOS 750/850 to refer to all three models. To designate a specific model, specific nomenclature is used, such as EOS 750.

Although simplified on the outside, these cameras are similar internally to the EOS 620/650 models. They have

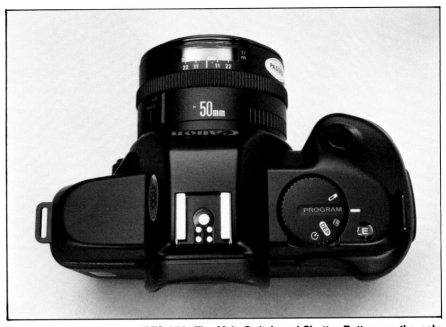

This is the top view of an EOS 850. The Main Switch and Shutter Button are the only controls on the camera. The Frame Counter shows E (Empty) because film is not loaded. EOS 750 models have additional controls. The EOS 750 has a Flash Switch to turn on the built-in flash. The EOS 750 QD has a Flash Switch plus controls for the Quartz Date back cover.

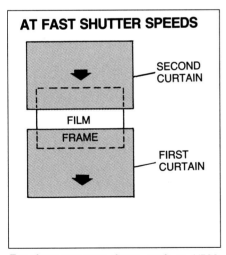

For short exposure times, such as 1/500 second, the second curtain must start closing the frame before the first curtain has fully opened it. The film is exposed by a moving slit of light between the two curtains.

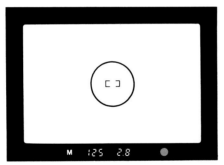

When looking in the viewfinder eyepiece, you see an image of the scene within a black border. At the center of the image, the AF Frame shows the area that is viewed by the electronic focus detector in the camera. The surrounding circle is a partial-metering indicator, discussed later.

Below the image is an information display. The numerals show the shutter speed and aperture size that will be used to photograph the scene visible in the viewfinder.

The green dot is controlled by the electronic focus detector. If it glows steadily, the image in the AF Frame is in good focus. If the dot blinks, the electronic focus detector cannot determine if the image is in focus or not. You can always check focus visually by looking at the image in the viewfinder.

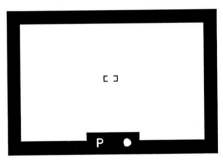

The EOS 750/850 cameras have a simplified viewfinder. There is an AF Frame at the center of the image, to show the area used to check focus electronically. There are only two symbols. The Green Dot glows steadily if the image is in focus. The P symbol glows steadily if exposure will be OK.

A row of electrical contacts in the film chamber reads the DX-code on a cartridge of DX-coded film. The encoded data includes film speed and the number of exposures on the roll.

A DX-coded film cartridge has a "checkerboard" pattern of silver and black rectangles. The silver areas are electrically conductive; black is an insulator. Electrical "feeler" contacts in the camera read the pattern. The encoded film-speed value is automatically set in the camera.

the same sophisticated autofocus, exposure and depth-of-field control systems. The differences are discussed in the following paragraphs.

### EOS 750/850 MAIN SWITCH

The camera instruction booklet refers to this control as the Selector Dial. This book uses the term Main Switch. The control has five settings:

At L, the camera is turned off and cannot be operated.

At PROGRAM, the camera is turned on. It sets exposure automatically, choosing both shutter speed and aperture, and will focus an EF lens automatically if the lens Focus-Mode Switch is set to AF.

At the Battery-Symbol setting, the built-in beeper beeps rapidly if the battery is OK; slowly or not at all if the battery is discharged.

The DEP setting is discussed later. It allows you to "tell" the camera which parts of the scene you want to be in sharp focus.

At the Clock-Face symbol, the camera Self-Timer is set.

### EOS 750/850 FILM TRANSPORT

The Frame Counter shows an E symbol when film is not loaded. Film is inserted as shown earlier. Place the cartridge in the film chamber, draw the film end across to the red mark, engage a sprocket tooth, and close the back cover. If the Main switch is at L, turn it to PROGRAM.

**Film Pre-Wind**—When a new film is inserted, these cameras immediately wind *all of the film* onto the takeup spool. With 36-exposure cartridges, the Frame Counter advances to 36 before you can shoot any pictures.

As you use the camera, the exposed film is drawn back into the light-tight cartridge. The purpose is to protect the exposed film if the camera back cover is opened inadvertently, before the roll is finished.

The Frame Counter counts "backward," always showing the number of *unexposed* frames remaining in the camera. When the last available frame has been exposed, the film leader is drawn back into the cartridge and the Frame Counter shows E.

### EOS 750/850 FILM-WINDING MODES

With the Main Switch at PROGRAM, the camera is in the Continuous film-drive mode. It will normally make exposures continuously as long as you hold down the Shutter Button. With the lens Focus-Mode Switch at AF, continuous exposures will be made only if the image is in focus. With Manual focus, continuous exposures will be made whether or not the image is in focus.

At the DEP setting, the camera exposes a single frame and stops.

When the Self-Timer is set, the camera exposes a single frame. If you hold down the Shutter Button, it will reset the timer and start over to expose another frame.

### FOCAL-PLANE SHUTTER

All EOS cameras use a focal-plane shutter. It is very close to the film, or focal plane, where the image is brought to focus by the lens. A focal-plane shutter has two shutter curtains, shown in the accompanying drawings.

The aperture in this EF lens is closed one step so you can see the edges of the diaphragm blades that form the opening. At maximum aperture, the opening is circular.

The aperture is made smaller to reduce the amount of light reaching the film.

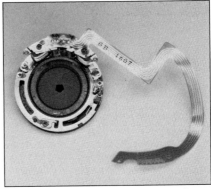

The aperture in EF lenses is formed by an Electro-Magnetic Diaphragm (EMD) assembly. It has five metal blades that pivot to change the size of the opening. The EMD is controlled electrically, through the flat "computer type" cable.

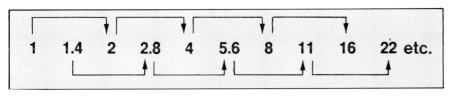

1   1.4   2   2.8   4   5.6   8   11   16   22 etc.

It's easy to remember the series of standard f-numbers. Start with the values 1 and 1.4, then double them alternately, as shown by the arrows.

| Standard f-numbers | 1.4 | 2 | 2.8 | 4 | 5.6 | 8 | 11 | 16 | 22 |
|---|---|---|---|---|---|---|---|---|---|
| Half steps | | 1.7 | 2.4 | 3.5 | 4.5 | 6.7 | 9.5 | 13 | 19 |

Standard aperture sizes, in full steps, are shown at the top. Intermediate half steps are below.

When you press the Shutter Button, the first curtain moves across the opening, exposing the film frame to light from the lens. To end the exposure, the second curtain moves across the opening to close the shutter. When film is advanced, the shutter mechanism is reset so it can expose the next frame.

### THE VIEWFINDER

The viewing system includes the mirror, which reflects the image upward into the viewfinder, the focusing screen, the pentaprism, and the viewfinder eyepiece. The eyepiece lens helps your eye focus on the image at the focusing screen.

**Viewfinder Image Area**—In most SLR cameras, the image in the viewfinder is a little smaller than the image on film.

Slides are placed in cardboard or plastic mounts that cover a small part of the image at each edge of the frame. The viewfinder image is approximately what you see when you project a slide. It is less than you see on a print made from the full frame.

**Information Displays**—In the viewfinder, information displays are in the area below the image. Numbers are used to show the exposure-control settings for the shot you are preparing to make. A green circle glows if the image is in good focus. The viewfinder information displays are turned on when you depress the Shutter Button halfway. Additional information is in an LCD Display Panel on top of an EOS 620/650 camera.

**Focusing Aids**—The EOS focusing screens have a small rectangle at the

center of the screen to show you which part of the scene the autofocus system is focusing on. This is called the AF (Auto Focus) Frame. You can judge focus visually by looking at the image on the screen.

Interchangeable focusing screens, with other optical focusing aids, are available. They are discussed in Chapter 3.

### EXPOSURE CONTROLS

When you have composed and focused the image, the next step is to set exposure so the image will be correctly exposed on the film. This is usually done automatically by the camera. EOS 620/650 cameras also allow manual control of exposure. Exposure is determined by three factors:
- The film's speed or sensitivity.

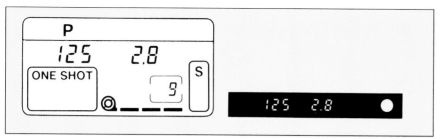

In the Program mode, the camera sets both shutter speed and aperture. With EOS 620/650 cameras, a P symbol appears in the LCD Panel, but not in the viewfinder information display, shown at the right in this illustration. Both displays show the camera-selected shutter-speed and aperture values—in this example, 1/125 second and *f*-2.8.

## SHUTTER-SPEED RANGE

| | |
|---|---|
| **EOS 620** | 1/4000 to 30 sec. plus BULB |
| **EOS 650** | 1/2000 to 30 sec. plus BULB |
| **EOS 750** | 1/2000 to 2 sec. |
| **EOS 750 QD** | 1/2000 to 2 sec. |
| **EOS 850** | 1/2000 to 2 sec. |

● The brightness of the light on the film.
● The length of time the light falls on the film.

## SENSITIVITY OF THE FILM

Some types of film require more or less exposure than others. This is determined by the *film speed*, which is expressed by a number called the ISO film-speed rating. ISO stands for International Standards Organization.

**Fast** films, having *high* ISO speed numbers, such as 400 or 1000, form an image relatively quickly, with only a small amount of exposure.

**Slow** films require more exposure, having *lower* speed numbers, such as 32 or 25.

The film-speed number is a *message* from the film manufacturer to the exposure-control system in your camera. It tells the camera how much exposure that type of film requires.

For the camera to receive that message, the film-speed number must be set on a camera control. This can be done manually or, with certain film cartridges, it can be done automatically by the camera.

**Automatic Film-Speed Setting—**Film cartridges that are DX-coded have a "checkerboard" code pattern that conveys the film speed and other data. The film-speed code is read automatically by EOS 620/650 cameras and the film-speed setting is made automatically. The setting is displayed during the film loading procedure.

**EOS 620/650—**If you prefer to use a different film-speed number, you can change the setting by a manual procedure shown in Chapter 5.

If you are using a film cartridge without the DX code, the camera will retain the setting used previously. If that is not correct, you can change it, using the manual procedure.

**EOS 750/850—**With DX film, these models set film speed automatically. With non-DX film, film speed is automatically set to ISO 25 and cannot be changed. There is no manual procedure to set or change film speed.

## LENS APERTURE

The brightness of the light reaching the film is controlled by an adjustable opening in the lens called the *aperture*. Aperture size is an exposure control. A larger aperture allows more light from the scene to reach the film and thereby produces more exposure.

**Electro-Magnetic Diaphragm—**Mechanically, an aperture is formed by a set of thin, overlapping metal leaves. The leaves are pivoted. Moving the leaves on their pivots makes the opening larger or smaller.

The leaves are called a *diaphragm* and the opening at the center is called an *aperture*. In Canon EF lenses, aperture size is controlled by an Electro-Magnetic Diaphragm (EMD), which is operated by a small electric motor.

**Aperture Size—**The size of the opening is represented by a number, such as 2 or 8, called the *f*-number. Smaller *f*-numbers represent *larger* aperture openings. For example, *f*-2 represents a larger opening than *f*-8.

**The f-number Scale—**In the accompanying table of *standard* f-numbers, each larger number on the *f*-number scale is approximately 1.4 times the preceding value. On this scale, the largest aperture is *f*-1. The smallest shown is *f*-22. The next smaller standard value would be *f*-32.

The *standard* values on the aperture scale change the light by a factor of 2. For example, a setting of *f*-4 transmits twice as much light as *f*-5.6 but half as much as *f*-2.8.

The *f*-number settings of a lens are usually called *f*-stops. The interval between *standard* f-numbers is one *step*. Changing aperture from *f*-4 to *f*-5.6 is one step.

In this book, the term *maximum* aperture means the *f*-number setting that transmits the *most* light, such as *f*-1.4. The *minimum* aperture if the *f*-

## SHUTTER SPEED IN STEPS AND HALF STEPS

| Full Steps | Approx. Half Steps |
|---|---|
| 30 | |
| | 20 |
| 15 | |
| | 10 |
| 8 | |
| | 6 |
| 4 | |
| | 3 |
| 2 | |
| | 1.5 |
| 1 | |
| | 0.7 |
| 1/2 | |
| | 1/3 |
| 1/4 | |
| | 1/6 |
| 1/8 | |
| | 1/10 |
| 1/15 | |
| | 1/20 |
| 1/30 | |
| | 1/45 |
| 1/60 | |
| | 1/90 |
| 1/125 | |
| | 1/180 |
| 1/250 | |
| | 1/350 |
| 1/500 | |
| | 1/750 |
| 1/1000 | |
| | 1/1500 |
| 1/2000 | |
| | 1/3000 |
| 1/4000 | |

**This table shows shutter speeds in full and approximate half steps. Values are in seconds. For example, 1/90 is halfway between 1/60 and 1/125. Shutter speed in full or half steps can be set *manually* using controls on the camera. The manually set value is displayed. When the camera sets shutter-speed *automatically,* it can use any value, such as 1/453 second. However, the nearest half-step is displayed.**

number that transmits the least light, such as *f*-22.

**Setting Aperture**—EF lenses do not have an aperture control on the lens. Aperture size is changed by a motor in the lens, which is controlled by an electrical signal from the camera.

Aperture size may be set automatically by the automatic-exposure system in the camera. With the EOS 620/650, you can select aperture size manually, using a control on the camera, as discussed in Chapter 5. The setting is shown by an *f*-number in the viewfinder display and on the LCD Display Panel on top of the camera.

**Intermediate Settings**—Aperture size in full steps and half steps is shown in the accompanying table. When you select aperture size manually, by a control on the camera, you can choose full or half steps.

When the camera selects aperture size automatically, it is not restricted to full steps or half steps but the nearest half step is displayed.

**Aperture Range**—The range of aperture sizes that can be used is determined by the lens that is installed on the camera. The lens table in Chapter 2 shows maximum and minimum aperture for current EF lenses.

## SHUTTER SPEED

Shutter speed is an exposure control. The shutter-speed setting determines how long the focal-plane shutter remains open so light from the scene strikes the film. Shutter speed may be set automatically by the automatic-exposure system in the camera or manually with EOS 620/650, as discussed in Chapter 5.

**Shutter-Speed Scale**—Shutter speeds in *standard* full steps and intermediate half steps are shown in the accompanying table. The numbers on the scale are time intervals, measured in seconds. Each *standard* time interval is double the next shorter standard time.

Shutter speeds that provide short exposure times, such as 1/1000 second, are called *fast* speeds. *Slow* shutter

speeds hold the shutter open for a relatively long time, such as 1 second.

**EOS 620/650 Display**—The shutter-speed setting is shown in the viewfinder and in the LCD Display Panel on top of the camera. The numerators of fractions are omitted. The value 1/500 is shown as 500. A shutter speed of 1/2 second is represented by the number 2.

Shutter speeds slower than 1/2 second are displayed with a "seconds" symbol. The symbol doesn't always appear where you might expect. For example, a speed of 0.7 second is represented by 0"7. A speed of 1.5 seconds is represented by 1"5. Slower speeds are shown conventionally, such as 2", which is 2 seconds.

**Intermediate Settings**—When you set shutter speed manually, you may select either full steps or half steps.

When the camera sets shutter speed automatically, any value may be used, such as 1/323 second. Because it is not necessary to use standard steps or half steps, this is called *stepless* shutter operation. The nearest half-step will be displayed in the viewfinder and LCD Display Panel.

**Shutter-Speed Range**—The range of available shutter speeds depends on the camera model. The accompanying table shows shutter-speed ranges for current EOS cameras.

**The Bulb Setting**—The EOS 620/650 also has a setting labeled bulb. At that setting, the shutter remains open as long as the Shutter Button is depressed. This is used to make "time" exposures longer than the slowest available shutter-speed provided by the camera.

## EXPOSURE STEPS

Changing aperture or shutter speed in steps causes exposure to change in steps. Each larger exposure step is double the exposure of the preceding step.

Doubling exposure makes a perceptible difference in the appearance of a photograph, but not a large difference. If exposure is doubled repeatedly, to make a series of exposure steps, *human vision* perceives the steps to be *equal* in

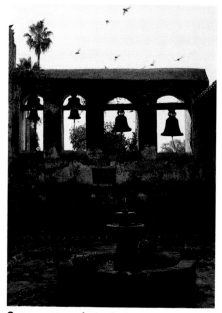
Scene exposed at −1 step.

Same scene exposed at metered value.

Same scene exposed at +1 step.

These three photos of the same scene show the visual effect of changing exposure by one step. The photo in the center was shot using metered exposure. The darker photo received one step less exposure. The lighter photo received one step more.

visual effect.

The formula for exposure is:

$$\text{Exposure} = \text{Intensity} \times \text{Time}$$

Intensity is the brightness of the light striking the film. Time is how long the shutter is held open.

Because Exposure is the *product* of Intensity and Time, doubling either will double the exposure—one more step. Dividing either factor by two will cut the exposure in half—one less step.

That's the reason for the values on the aperture and shutter-speed scales. Changing aperture to the next larger or smaller standard value on the scale doubles or halves the amount of light and thereby changes exposure by one step.

Changing shutter speed to the next larger or smaller standard value also changes exposure by one step. Changing either factor by one-half step changes exposure by one-half step.

These two controls can be used to counterbalance each other. Changing aperture to the next *larger* size and

shutter speed to the next *faster* setting will maintain the same amount of exposure, but with different values of shutter speed and aperture.

**Steps and Stops**—Most photographic literature uses the word *stop* instead of *step* to describe the standard incremental changes in aperture size, shutter speed and exposure. This book uses *step*.

## OTHER EFFECTS OF EXPOSURE CONTROLS

In addition to setting exposure, these controls may have visible effects on a photo. They are *technical* controls that affect exposure and also *artistic* controls that affect the image on film.

**Depth of Field**—In some photos, you don't want everything in sharp focus. The background behind the subject may be blurred, or the foreground may be blurred, or both. The zone of good focus is called *depth of field*. Depth of field is controlled by aperture size— and by other factors. All other conditions being similar, a smaller aperture provides more depth of field.

You can control depth of field by using an aperture that gives the desired visual effect and then set shutter speed to give correct exposure. More information on depth of field is in Chapter 2.

**Subject Motion**—With a moving subject, you may want to stop the apparent motion, which is sometimes called "freezing" the action. Or, you may wish to allow the image to blur to give the impression of movement.

Using a slow shutter speed, such as 1/8 second, allows a moving subject to travel a greater distance while the shutter is open and thereby make a blurred image on film. Using a fast shutter speed, such as 1/1000 second, reduces the amount of subject movement that occurs while the shutter is open and the image is less blurred.

**Camera Shake**—When handholding a camera without other support, you cannot hold the camera perfectly still. It will move or shake during the exposure, which can blur the image. Using faster shutter speeds reduces image blur when handholding the camera.

More information on this topic is in Chapter 2.

## VIEWING WITH OPEN APERTURE

Most exposures are not made with the lens aperture wide open. Correct exposure is obtained with a smaller aperture setting, called the *shooting* aperture size.

While you are viewing the scene, an EOS camera holds the aperture wide open so you see the brightest image. This is called *full-aperture viewing*.

When you press the Shutter Button to make the shot, the lens is closed down to the shooting aperture size be-fore the exposure is made.

Changing the aperture from its max-imum size to a smaller size is called *stopping down* the lens.

## THE EXPOSURE SEQUENCE

To do the things described in this chapter requires a rather complicated series of events. When you press the Shutter Button to make an exposure, this is what happens:
- The mirror moves up so light from the lens can reach the film.
- The lens aperture closes to the shoot-ing aperture size.
- The first curtain of the focal-plane shutter opens the frame.

- An electronic timer in the camera holds the shutter open for the desired exposure time.
- The second curtain of the focal-plane shutter closes the frame.
- The mirror moves down so you can view through the lens again.
- The lens opens up to maximum aper-ture so you view the brightest image.

At fast shutter speeds, all of that happens in a small fraction of a second. Before making the next exposure, the film is automatically advanced to place an unexposed frame in position behind the lens. The camera mechanically re-sets the focal-plane shutter so it can operate again.

# Canon EF Lenses

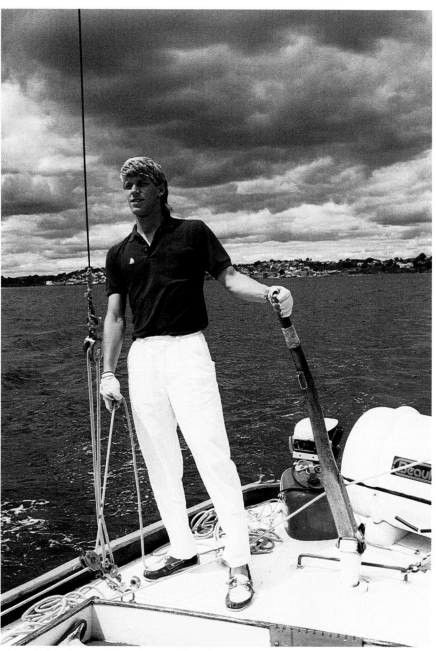

**Your choice of lens affects the resulting photo. Here, a wide-angle lens, used up close, emphasizes the dominance of the helmsman.**

A major advantage of SLR cameras is the interchangeability of lenses. You can select from a variety of lenses with different capabilities and pictorial effects.

Three classes of EF (Electro-Focus) lenses are available. Most are of the regular type. They are of excellent quality and satisfy most requirements. These have no special markings or nomenclature.

A group of high-performance EF lenses is identified by a red ring around the lens body, near the front, and the symbol L in the nomenclature.

A-type lenses are primarily for EOS 750/850 cameras. They are modestly priced, *autofocus only,* and without Focus-Mode Switch, Manual Focusing Ring and Focused-Distance Scale. Optically, they are of the same high quality as other Canon lenses.

Each EF lens contains a small computer that cooperates with a computer in the camera. Each lens also has a ROM (Read-Only Memory) chip that stores data about the lens.

The camera reads the data stored in the lens and other information, such as the focused distance setting of the lens. The information is used by the camera to provide autofocus and automatic exposure.

## LENS MOUNT

The lens attaches to the camera body as shown in the accompanying photos. The lens is held in place by three lugs on the lens that fit behind three lugs on the camera body. This is referred to as a *bayonet* mount.

Half of the mount is on the camera and the other half on the lens. In this book, the part on the camera is called the lens mount because it receives the lens. The other part is called the back of the lens.

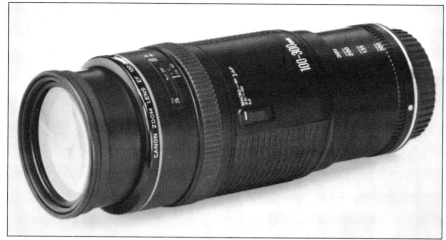

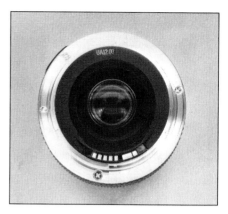

This EF 100—300mm *f*-5.6 zoom lens is an L type, which is indicated by a red ring around the lens body. The ring is adjacent to the words CANON ZOOM LENS.

The EOS lens mount is referred to as the New EF (Electro-Focus) mount. It is larger in diameter than the mount on earlier Canon cameras. Earlier Canon lenses, such as FD and FL lens types, are incompatible with EOS cameras and cannot be mounted.

## COUPLINGS

In addition to holding the lens securely, the mount also provides electrical connections between camera and lens. This is done by a row of eight gold-plated electrical contacts inside the lens mount on the camera and a similar set of contacts on the back of the lens. This allows transfer of data and control signals between camera and lens.

For example, when installed, an EF lens "tells" the camera which lens it is and provides technical data, such as its maximum and minimum aperture size.

Historically, SLR cameras have used mechanical coupling devices between camera and lens, such as levers and rotating shafts, to control aperture size and to focus the lens. In designing the EOS system, Canon eliminated mechanical couplings to provide the greater capability and versatility of totally electronic operation.

## APERTURE CONTROL

The aperture size of EF lenses is controlled by the camera's electronic system, which issues a control signal to the Electro-Magnetic Diaphragm in the lens.

While you view the scene, before making an exposure, the aperture is held wide open to provide the brightest possible image in the viewfinder. When you press the Shutter Button to make an exposure, aperture size is set by the camera to provide correct exposure. After the exposure, the camera opens the aperture to its maximum size again.

# HOW A LENS FORMS AN IMAGE

Under most normal conditions, light travels in a straight line, in the form of *rays*. The rays do not change direction unless they encounter optical devices, such as a lens or mirror.

Light rays that come to a focal point from a distant source, such as the sun, appear to be parallel, as shown in Figure 2-1.

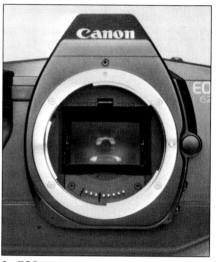

An EOS camera mounts the lens mechanically, but controls it electrically through electrical contacts on camera and lens.

A row of electrical contacts on the back of an EF lens mates with a similar row of contacts on the camera to transfer control signals and information back and forth. Using these contacts, the camera controls the focus motor and the Electro-Mechanical Diaphragm in the lens.

## CONVERGING LENS

Light rays from a single point on a distant scene are *effectively* parallel when they enter the lens. Rays from each point of the scene are scattered all over the surface of the lens. Those rays that come from the *same* point converge and are brought to focus at a single point on the film, as shown in Figure 2-2.

In this drawing, all light rays entering the lens are from the same point of

## HOW TO ATTACH AND DETACH A LENS

To mount a lens, place the lens on the lens mount with the red dot on the lens opposite the red dot on the camera. Rotate the lens clockwise until it locks in place.

To remove a lens, press the Lens-Release Button (arrow) while turning the lens counterclockwise until it can be lifted off the camera.

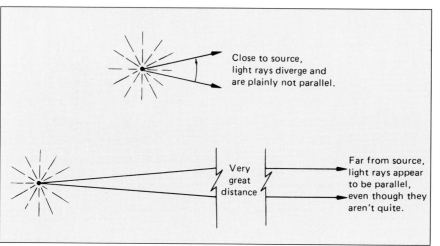

Figure 2-1/Light rays from a point diverge. If viewed from a location that is close to the source, rays reaching the eye, or camera lens, are obviously not parallel. At a great distance from the source, the light rays still diverge, but the divergence is so small that the rays appear to be parallel.

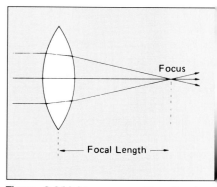

Figure 2-2/Light rays reaching the lens from a distant point appear to be parallel and are treated by the lens as though they were parallel. A converging lens focuses parallel or near-parallel rays at a distance behind the lens that is equal to the lens focal length.

the scene. Light rays from a different point on the scene will be brought to focus at a different location on the film. Thus, all points of the scene are imaged at their correct locations on the film.

A lens that brings rays to a point is called a *converging* lens because light rays converge and meet at a point behind the lens.

**Image Orientation**—The image formed by a lens is upside down and reversed left-to-right. The pentaprism in the camera's viewfinder provides a correct view of the scene.

**Compound Lens**—A lens made of a single piece of glass is called a *singlet*. This type of lens, as shown in these drawings, is useful to explain optical principles in the simplest way. However, such lenses have optical defects—called aberrations—and produce poor images.

To correct the aberrations, photographic lenses are manufactured with several pieces of carefully formed glass, called *elements*. The result is called a *compound* lens. A compound lens forms an image by converging the light rays, just like a single-element lens, but with reduced aberrations.

## DIVERGING LENS ELEMENTS

Diverging lens elements have con-

## HOW TO CLEAN A LENS

Assemble a lens-cleaning kit. You need some way to direct a stream of air against glass surfaces to blow away the dust. A blower brush, shown here, has a squeeze-bulb to make a puff of air and a brush that is used to sweep dust off glass surfaces.

Use a second brush, such as a small paint brush, to clean lens bodies and camera bodies. Never use this brush to clean glass surfaces.

You need lens-cleaning fluid and lens-cleaning tissues—not eyeglass tissues or facial tissues. A soft cloth is handy to clean lens bodies and camera bodies. Don't use the same cloth on glass surfaces.

Don't clean a glass surface unless you can see dirt or smudges. Every cleaning has the potential for producing tiny scratches that accumulate and can eventually impair optical quality.

Begin by blowing away loose dirt using a squeeze-bulb or "canned air," available from camera stores. If that removes it, stop. Some types of "canned air" will chill the glass surface and may damage the lens if used too close or for too long. Hold the can six inches or more away from the glass surface and use short bursts.

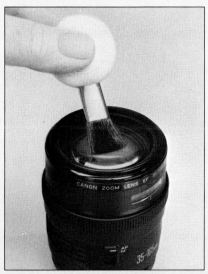

If the blower doesn't remove the dirt, try lifting it off gently, using a lens brush. If that removes it, stop.

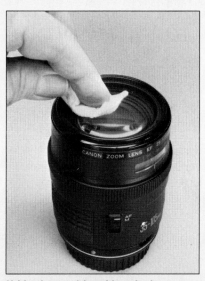

If blowing and brushing don't remove smears and smudges, put one drop of lens-cleaning fluid on a piece of lens-cleaning tissue. Never apply fluid directly to the glass surface.

Use the moistened tissue to gently clean the surface, starting at the center and spiraling outward. At the outer edge, lift the dirt away. If the cleaning fluid leaves a visible film, use clean, dry lens-cleaning tissue to wipe it away.

---

cave surfaces, as shown in the accompanying drawing, and cause light rays to diverge as they pass through the lens. Diverging lens elements are sometimes used in a compound lens, along with converging elements.

## FOCAL LENGTH

The distance behind a converging lens at which *parallel* light rays are brought to focus is called the *focal length* of the lens. With a single-element lens, focal length is determined by the curvature of the lens surface. Greater curvature brings light rays to focus at a shorter distance and reduces the focal length. With a compound lens, focal length is determined by the net effect of all elements in the lens.

A common focal length for a 35mm

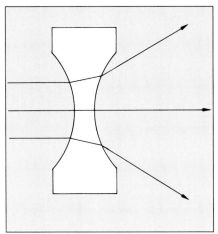

A diverging lens causes rays to diverge. This type of lens is used together with converging lens elements in a compound lens having several glass elements. When the converging elements are more "powerful," rays are brought to focus by the lens. The diverging element or elements are used to help correct lens aberrations.

If light rays are parallel, from a distant source, lens brings them to focus at a distance equal to the focal length.

If light rays are diverging, from a nearby source, lens brings them to focus at a distance longer than the focal length.

Figure 2-3/Light rays reaching a lens from a nearby point diverge noticeably. Greater distance is needed behind the lens to bring those rays to focus.

SLR lens is 50mm. Parallel light rays entering the lens are brought to focus at a point that is 50mm behind the lens.

**Subjects at Infinity**—An unlimited distance is called *infinity*, ∞. Light rays entering a lens traveling from infinity will be parallel. Rays arriving from distant subjects, such as 100 yards away, are *effectively* parallel.

Photographically, any distant subject is considered to be at infinity. The image of a subject at infinity is behind the lens at a distance equal to the focal length of the lens—such as 50mm.

**Nearby Subjects**—As shown in Figure 2-3, light rays from a point that is not distant will not be parallel when they enter the lens. They will diverge.

The lens will still bring them to focus. Because they were diverging rather than parallel when they came into the lens, it takes a greater distance behind the lens to bring them to focus.

To focus the image of a nearby subject, the lens must be moved *farther* from the film so the focused image falls on the surface of the film. For example, if the lens focal length is 50mm, a nearby subject might require a lens-to-film spacing of 56mm.

**Summary**—To focus a lens at infinity, it is placed at a distance from the film that is equal its focal length. To focus on a *nearer* object, the lens is moved *farther* from the film.

# FOCUSING

To focus a lens, the glass elements in the lens body are moved using a screw-thread, called a *helicoid*, or some other mechanism. In the simplest case, all

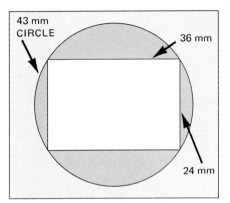

43 mm CIRCLE

36 mm

24 mm

The lens makes a circular image at the film plane. The rectangular film frame fits snugly inside the image circle.

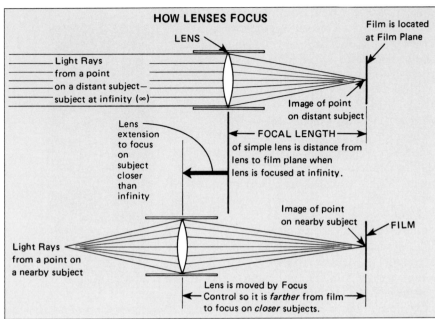

**HOW LENSES FOCUS**

Film is located at Film Plane

LENS

Light Rays from a point on a distant subject— subject at infinity (∞)

Image of point on distant subject

FOCAL LENGTH of simple lens is distance from lens to film plane when lens is focused at infinity.

Lens extension to focus on subject closer than infinity

Image of point on nearby subject

FILM

Light Rays from a point on a nearby subject

Lens is moved by Focus Control so it is *farther* from film to focus on *closer* subjects.

When a lens is focused on a distant subject, the distance from lens to film is the focal length of the lens. To focus on a subject that is closer, lens-to-film distance must be increased.

lens elements move together. In complex, modern lenses, the individual elements may not move in unison, and some may even move in opposite directions, but the end result is to focus the image.

Most lenses have a telescoping barrel that becomes longer or shorter as the lens is focused.

**Internal Focusing**—Some lenses are designed so the lens body does not change length as it is focused. The lens elements move inside the lens.

**Rear Focusing**—This is a type of internal focusing in which only the rear elements in the lens move. With the lens removed from the camera, you can focus it manually and see the rear element move in or out.

**Floating Element**—To improve image quality when the subject is very close to the lens, some lenses cause one element to move independently of the others. This is called a floating element.

**Focused-Distance Scale**—Most EF lenses have a scale that shows the distance at which the lens is focused, in feet and meters. The distance scale rotates as the lens is focused and is viewed through a window in the lens body.

**Focus Mode**—Most EF lenses have a Focus-Mode Switch on the body of the lens that can be set to AF for automatic focus or M for manual focus, using a focusing ring on the lens body.

With the switch set to AF for autofocus, the Manual Focusing Ring on the lens is mechanically disconnected from the focus mechanism and is not rotated by the focus motor. It rotates freely and has no effect on focus.

**AUTOMATIC FOCUS**

EF lenses use the letters EF (Electro-Focus) in their nomenclature because they can be focused automatically by a motor in the lens that is controlled by the electronic autofocus system in the

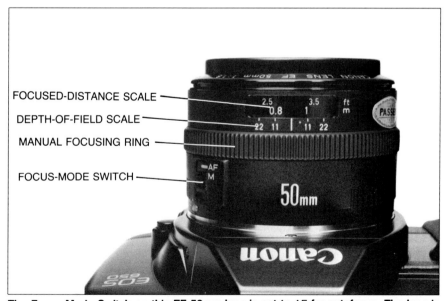

FOCUSED-DISTANCE SCALE

DEPTH-OF-FIELD SCALE

MANUAL FOCUSING RING

FOCUS-MODE SWITCH

The Focus-Mode Switch on this EF 50mm lens is set to AF for autofocus. The lens is focused at about 0.9 meters or 3 feet, depending on which focused-distance scale you read. The Depth-of-Field Scale is discussed later in this chapter.

camera, as discussed in Chapter 3. The focus motors are so small that they fit inside the cylindrical lens body without adding noticeable size or weight. Two types of focus motors are used.

Most EF lenses use an Arc Form Drive (AFD) motor. The term *Arc Form* means that the motor is curved to fit inside the cylindrical lens body. Except for its small size and curved shape, this is a conventional type of electric motor, using a magnet and coils of wire.

Most L-type lenses use an Ultra-Sonic Motor (USM) to drive the focusing mechanism. This is an unconventional motor specially developed by Canon for this purpose. Lenses with the USM focus motor are identified by the word Ultrasonic engraved on the lens body. They are identified in the same way in the lens table at the end of this chapter.

Both motors bring the lens to focus quickly. You can hear the Arc Form Drive motor operate, although it is quiet and not obtrusive. The Ultrasonic Motor is silent.

**Focus-Motor Location**—Other current autofocus SLR cameras focus the lens using a motor built into the camera body rather than into the lens. This is called *body-integral*, meaning that the focus motor is integrated into the camera body.

Canon refers to the EOS system as *lens-integral*, meaning that each lens has its own focus motor. There are several advantages of this design.

Lens-integral motor characteristics are optimized for each lens. Large lenses with many elements require more turning effort to focus than small lenses. Because the motor is designed to match the requirements of the lens, focusing is fast and smooth, without overshoot or hunting.

With EOS cameras and EF lenses, a device that is inserted between lens and camera need only relay electrical signals between camera and lens, which is simple and straightforward.

**Moving Parts**—Most people use the

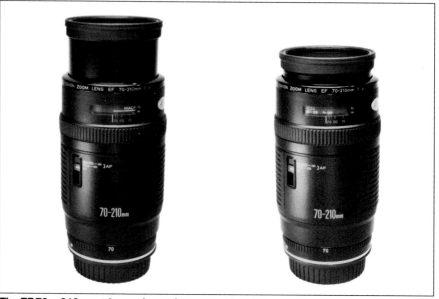

The EF 70—210mm *f*-4 zoom lens telescopes when focused. It becomes physically longer when focused at the closest possible distance, shown at left. At right, the lens is focused at infinity. Not all lenses change their physical length when focused—some focus internally.

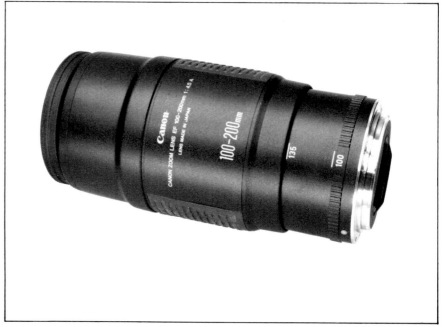

This A-type lens is the EF Zoom 100—200mm *f*-4.5A, zoomed to a focal length of 135mm. It has no Focus-Mode Switch, Manual Focusing Ring or Focused-Distance scale.

The Arc Form Drive assembly built into an EF lens includes a small electric motor and gears. To provide quick and efficient focus operation, the motor and gear design is "customized" for each type of lens.

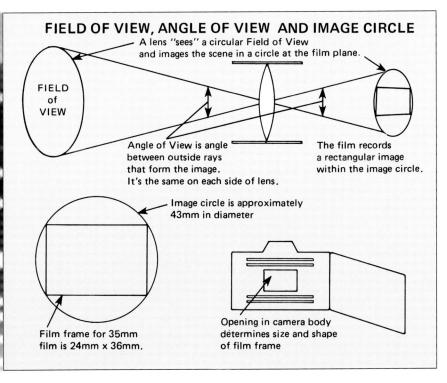

## FIELD OF VIEW, ANGLE OF VIEW AND IMAGE CIRCLE

A lens "sees" a circular Field of View and images the scene in a circle at the film plane.

FIELD of VIEW

Angle of View is angle between outside rays that form the image. It's the same on each side of lens.

The film records a rectangular image within the image circle.

Image circle is approximately 43mm in diameter

Film frame for 35mm film is 24mm x 36mm.

Opening in camera body determines size and shape of film frame

## MANUAL FOCUS

Most EF lenses offer the option of manual focus. Each has a Focus-Mode Switch and a Manual Focusing Ring.

With the lens set for manual focus, the Manual Focusing Ring is engaged and controls focus. The autofocus system in the camera does not attempt to focus the lens.

**Manual Focusing Method**—If the lens uses an AFD focus motor, the Manual Focusing Ring simply replaces the motor. When you turn the focusing ring, it rotates gears that focus the lens.

If the lens uses an ultrasonic USM motor, turning the Manual Focusing Ring produces a series of electrical pulses that are processed by the computer in the lens. The computer controls the USM motor, which focuses the lens. The USM motor is controlled either by the autofocus system in the camera or by turning the Manual Focusing Ring on the lens. For this reason, Canon sometimes refers to the focusing ring on USM Ultrasonic lenses as an electronic focusing ring.

### BATTERY POWER

An EF lens has a built-in AFD or USM focusing motor, an Electro-Magnetic Diaphragm and a computer chip. Electrical power to operate these devices is furnished by a battery in the camera, through electrical contacts on the lens mount. The camera battery is a long-life lithium type.

# FIELD AND ANGLE OF VIEW

A lens "sees" a circular part of the scene. The *field of view* is the circular part of the scene that the lens sees. The lens makes a circular image in the back of the camera. A rectangular portion of that circular image is exposed on the film.

If a lens has a wide field of view, then it also has a *wide angle* of view, which is the angle between the outside rays that form the image. The angle of view is the same on both sides of the lens—for rays coming in at the front and going out the back.

left hand to support the lens and to turn the focusing ring when focusing manually.

The Manual Focusing Ring on Canon EF lenses is disconnected during autofocus, so it doesn't matter if you touch it with your hand. To make it easy to focus the lens manually, the focusing ring is wide, with a serrated surface, and it is placed where your thumb and forefinger fall naturally when supporting the lens.

Most EF lenses telescope when focused. When set at infinity, the telescoping portion is withdrawn into the lens body. As the lens is focused closer, the telescoping portion moves forward and also rotates. On autofocus, be sure not to place your left hand so far forward that it impedes the focusing action. When focusing manually, you are not likely to touch the front of the lens because your hand is operating the Manual Focusing Ring.

## EFFECTS OF FOCAL LENGTH

In the accompanying drawing, the angle of view is shown by an arrow drawn between the outside rays that form the image circle. When you use a lens with a different focal length, the diameter of the image circle in the camera doesn't change. It is always slightly larger than the film frame.

When focused on the same subject, a long-focal-length lens requires greater distance between lens and film than a short-focal-length lens. With a long-focal-length lens, the distance between the back of the lens and the image plane must be longer, but the diameter of the image circle does not change. Therefore the *angle* between the rays that form the image circle *must* become smaller. For that reason, long-focal-length lenses have narrow angles of view.

If the lens is closer to the film because it is a short-focal-length lens, the rays must "expand" faster to fill the image circle. Short-focal-length lenses have wide angles of view. The angles of view of EF lenses are included in the lens table at the end of this chapter.

**Zoom Lenses**—Zoom lenses have a control to change the angle of view. When set for a wide angle of view, the image includes a lot of the scene, such as an entire village. If the angle of view is made narrower, less is included in the image. You can "zoom in" to a single building in the village, such as a church or castle.

## MAGNIFICATION

Image magnification is a ratio or fraction: the size of the image divided by the size of the subject.

You may compare image height and subject height, or their widths. The result will be the same. For example, if the image on film is 5mm (millimeters) tall and the subject is 100mm tall, magnification is 5/100. I complete the indicated division and state magnification as a decimal—in this example, 0.05. The value can be stated as a percentage—the image is 5 percent as

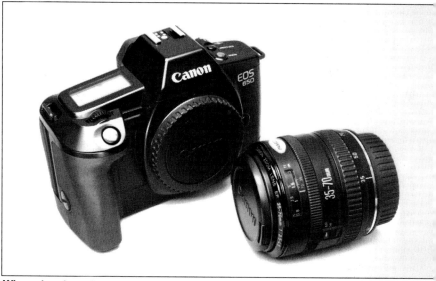

When a lens is not installed on the camera, both front and rear lens caps should be used. A body cap should be placed on the camera body to protect the mirror and keep dirt out of the camera.

tall as the subject.

In ordinary photography, the size of the image is smaller than the size of the subject, and magnification is less than 1. If image and subject are the same size, magnification is 1, which is sometimes referred to as *life-size*. Macro photography deals with magnifications of 1 or more.

## WORKING DISTANCE

The distance between the front of a lens and the subject being photographed is called *working distance*. For the same subject and image size, working distance increases with longer focal lengths.

There are shooting situations that benefit from large working distances. Subjects are easier to illuminate. People being photographed are usually more comfortable and relaxed if the camera is at a distance, rather than up close. Sometimes, the photographer is more relaxed with a large working distance. For example, if the subject is a snake it would be natural to prefer a long working distance.

## APERTURE

Physically, a lens aperture is an approximately circular opening formed by the diaphragm. The diameter of the opening is changed to admit more or less light.

Optically, aperture is specified by an *f*-number:

$$f\text{-number} = \frac{\text{Focal Length}}{\text{Aperture Diameter}}$$

The *f*-number is an indication of the amount of light that will reach the film. If one lens set at *f*-4 gives correct exposure of a scene, then another lens set at *f*-4 will also give correct exposure, even if the second lens has a different focal length.

In print, *f*-numbers are written in a variety of ways, such as *f*/4, F4, and *f*-4. This book uses *f*-4.

### MAXIMUM APERTURE

Lenses are identified by two principal characteristics, focal length and maximum aperture. For example, the

**Essential lens data is engraved near the front of the lens. This lens has a focal length of 50mm. The label 1:1.8 is a way of stating maximum aperture. Disregard the 1: part. The lens has a maximum aperture of f-1.8.**

## LENS ABERRATIONS

| Aberration | Effect | User Correction |
|---|---|---|
| Spherical Aberration | Image not sharp with any film or subject. | Use smallest possible aperture. |
| Chromatic Aberration | Image not sharp with any film. Color fringes around edges of objects on color film. | Use smallest possible aperture. |
| Astigmatism | All parts of image cannot be brought to focus at same time. | Use smallest possible aperture. |
| Coma | Off-axis points have tails like comets when viewed under magnification. To unaided eye, edges of photo are fuzzy. | Use smallest possible aperture. |
| Curvature of Field | Image of flat object perpendicular to lens axis can be focused at center or edges, but not both at same time. | Use smallest possible aperture. |
| Distortion | Straight lines appear curved. | None. |

**Good image quality depends mainly on the lens manufacturer's standards. As you can see, when there are aberrations, most can be reduced by using a smaller lens aperture.**

EF 50mm f-1.8 lens has a focal length of 50mm and a maximum aperture of f-1.8. Also available is the EF 50mm f-1.0 L, which is significantly more expensive and has about 1.5 steps larger maximum aperture.

In the earlier series of FD lenses, Canon offered more than one lens with the same focal length. The lenses had different maximum apertures and different prices. This allowed the buyer to balance cost and other considerations when choosing lenses.

### LENS SPEED

Lenses with large maximum apertures, such as f-1 or f-1.4, are said to be "fast" lenses because they admit a lot of light at maximum aperture and can make an exposure at a fast shutter speed. Lenses with small maximum aperture, such as f-5.6 or f-8 are called "slow" lenses.

## IMAGE DEFECTS

No lens is perfect. Even if designed and manufactured perfectly, there are optical characteristics such as diffrac-tion that cause image defects. They are normally not visible if the lens is from a reputable manufacturer. The accompanying table lists some image problems and what you can do about them.

### ABERRATIONS

Following are two of the more common lens defects or aberrations:

**Spherical Aberration**—Produces unsharp images. The cause is the fact that conventional lens surfaces are segments of a sphere. A correction is to use lens elements that are not spherical—called *aspheric*. Canon has been a leader in developing manufacturing techniques to reduce the inherently higher cost of aspheric lens elements. Aspheric elements are used in many of the EF lenses.

Spherical aberration is reduced by use of a smaller lens aperture.

**Chromatic Aberration**—Causes color fringes around bright lights or objects because light of different colors is not brought to focus at the same plane. Canon uses special low-dispersion glass to reduce this effect.

In the current series of EF lenses, the only example of duplicate focal lengths with different maximum apertures is the 50mm lenses mentioned earlier. As new lens types are added to the EF series, other focal lengths may be duplicated.

Because viewing is done at maximum aperture, lenses with larger aperture produce brighter images on the focusing screen, which is especially helpful in dim light.

An advantage of shooting at large

aperture is when you must handhold the camera in dim light. By choosing a larger aperture, you can use a faster shutter speed and thereby avoid image blur due to camera motion.

However, depth of field is also affected by aperture. If you shoot at maximum aperture, you should be aware that the photo will have minimum depth of field. Usually, a better solution is a tripod or other firm camera support that allows you to use a smaller aperture with a correspondingly slower shutter speed.

Films with higher film speeds are intended to help solve the problem of shooting in dim light, although high-speed films usually have slightly poorer image quality than slower films. For example, at the same aperture setting, ISO 400 film allows you to use two steps faster shutter speed than ISO 100 film, which may make handholding the camera possible.

If maximum depth of field is needed, ISO 400 allows two steps smaller aperture than ISO 100. Another solution that is sometimes possible is to put more light on the scene, such as with flash or floodlights.

**Lens Correction**—There are more aberrations than the two mentioned here, but an extensive discussion is beyond the scope of this book. Lens designers seek to reduce or *correct* aberrations. This is done by using several elements of different shapes and materials. Some of the elements may be joined together in a group.

As mentioned a little earlier, a superior method of correction is the use of aspheric lens elements, one of which can replace several conventional spherical elements in a lens, resulting in simpler lens construction but improved optical performance.

**Effect of Aperture**—The effect of many aberrations is reduced by shooting at small aperture.

## DIFFRACTION

When light rays skim past the edge of an opaque object, their direction is changed. This is called *diffraction*.

It's a good idea to use a lens hood. It protects the front of the lens from stray light that may degrade the image as well as from possible physical damage. Lens hoods for each lens type are indicated in the lens table at the end of this chapter.

Diffraction is produced by the edges of the lens aperture. At a small aperture, when a relatively large proportion of the light skims the edges of the diaphragm, diffraction can cause an overall lack of sharpness in the image because the diffracted rays don't land on the film at the right places.

Diffraction cannot be prevented, but its effect can be reduced by using a large aperture. The larger the lens aperture, the more light rays can pass through the center of the opening, without getting near the edge.

### OPTIMUM APERTURE

Because some aberrations are reduced by smaller aperture and diffraction is reduced by larger aperture, lenses generally make the sharpest image when set about midway between the largest and smallest aperture. Of course, when depth of field is a major consideration, you must set the lens aperture with that in mind.

### FLARE AND GHOST IMAGES

These are caused by stray light entering the lens and reflecting off internal glass and metal surfaces. Flare is an overall haze or a diffused spot of light. Sometimes one or more ghost images of the aperture are formed, especially if you shoot into the sun.

The best prevention is to use a lens hood or otherwise shade the lens so unwanted light doesn't enter the lens.

### LENS HOOD

Lens hoods are available for most EF lenses. They clip onto a groove at the front of the lens body. They can be installed backwards on the lens for storage.

A hood should closely fit the lens's angle of view, so it blocks all light from outside the angle of view but does not intrude into the angle of view. For that reason, the correct hood should be used with each lens, as shown in the lens table at the end of this chapter.

### FILTER MOUNT

Optical filters can be mounted on the front of a lens to change the image in some way, as discussed in Chapter 6. A

Depth of field is the zone of good focus, measured from the near limit to the far limit. It is increased by using a smaller aperture.

color filter, for example, changes the color of light reaching the film.

Most EF lenses have a threaded ring just in front of the front lens element, called a filter ring or accessory ring. A filter or filter holder can be screwed into the filter ring.

## LENS COATINGS

Flare and ghost images are greatly reduced by a procedure called lens coating, applied during the manufacture of the lens.

A very thin, transparent coating on the front surface of a lens reduces reflection from that surface and admits more light into the lens. Coating the interior glass surfaces reduces internal reflections and thereby reduces flare and ghost images.

A single-layer coating reduces reflections at one color of light. An improvement is to use multiple layers of different thicknesses to reduce reflections at all colors of the spectrum.

Canon refers to multiple-layer coating as Super Spectra coating. All current EF lenses have Super Spectra coating.

## FLATNESS OF FIELD

When photographing a flat surface, such as a newspaper page or a postage stamp, all parts of the subject should be in focus on the film. If they are not, the lens has poor flatness of field. You can improve it by using a smaller aperture.

## DEPTH OF FIELD

In some photographs, the scene is not in sharp focus at all distances from the camera. The main subject may be in good focus but objects closer to the camera and distant scenes are blurred. The zone of good or acceptable focus is called *depth of field*. It has a near limit and a far limit.

Suppose the near limit of good focus is 10 feet from the camera and the far limit is 15 feet. The zone of good focus extends from a distance of 10 feet to a distance of 15 feet. The depth of field (DOF) is therefore 5 feet—the far limit minus the near limit.

The point of *best* focus is the distance at which the lens is actually focused. In ordinary photography, the point of best focus is closer to the near limit. For example, if good focus extends from 10 feet to 15 feet, the lens is focused at a distance of about 12 feet.

Changing the focused distance of the lens moves the entire zone of good focus farther from or closer to the camera. It will also change the depth of field—the zone will become deeper or more shallow.

For technical photography, such as the photos of equipment in this book, it is usually best to have everything in sharp focus. For artistic photography, it is usually desirable to control depth of field. For example, a portrait against a busy background usually looks better if the background is out of focus.

**Depth-of-Field Mode**—EOS 650/750/850 cameras have a novel way of setting depth of field automatically. You "show" the camera the nearest and farthest objects that you want to be in good focus. The camera does the rest. This mode is discussed in Chapter 5.

## FACTORS AFFECTING DEPTH OF FIELD

Three factors affect depth of field: aperture size, lens focal length and subject distance. The following rules apply.

**Depth of Field is Increased By—**
- Smaller aperture.
- Shorter focal length.
- Greater subject distance.

**Depth of Field is Decreased By—**
- Larger aperture.
- Longer focal length.
- Shorter subject distance.

When you have prepared an EOS 620/650 to photograph a scene and pressed the Shutter Button halfway to turn on the exposure meter, the shooting aperture to be used is displayed in the LCD Panel and the viewfinder. To see depth of field at shooting aperture, press the Depth-of-Field Check Button (arrow) with your left thumb.

## HOW TO READ THE DEPTH-OF-FIELD SCALE

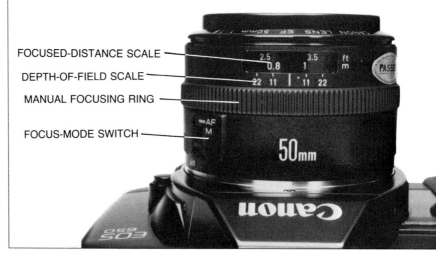

FOCUSED-DISTANCE SCALE

DEPTH-OF-FIELD SCALE

MANUAL FOCUSING RING

FOCUS-MODE SWITCH

The Depth-of-Field Scale shows *f*-numbers on each side of the center Index Mark. To read depth of field, find the shooting *f*-number on the left side of the center Index Mark. Suppose it is *f*-11. The near limit of good focus is directly opposite on the Focused Distance Scale. With this lens focused as shown, the near limit of focus at *f*-11 is 0.8 meters or about 2.6 feet. The far limit is opposite *f*-11 on the other side of the Index Mark. In this example, is 1 meter. Depth of field extends from 0.8 meters in front of the camera to 1 meter away. The depth is 0.2 meter.

As you can see, depth of field at *f*-22 is considerably greater. For aperture values no marked, estimate their locations on the Depth-of-Field Scale. EF Zoom lenses and A-type lenses don't have a Depth-of-Field Scale.

The EF 28mm *f*-2.8 lens has a moderately wide 75-degree angle of view. The lens is physically small and focuses to a minimum distance of 1 foot or about 0.3 meter.

## VIEWING DEPTH OF FIELD

Viewing the scene in the viewfinder to compose the image is done at maximum aperture, so you see *minimum* depth of field. If the lens stops down to a smaller aperture to take the picture, there will be more depth of field on the film than you saw in the viewfinder.

EOS 620/650 cameras have a Depth-of-Field Check Button that allows you to view the scene with the lens stopped down to shooting aperture, so you can see the depth of field that will be recorded on film. With the Main Switch at A, or turned beyond A to use the beeper, prepare the camera to make the shot and compose the scene. The aperture size to be used will be displayed in the viewfinder.

While viewing the scene, depress the Depth-of-Field Check Button with your left thumb. The lens will stop down to the displayed aperture size. If you listen closely, you can hear the Electro-Magnetic Diaphragm motor in the lens whir to change aperture size. If the exposure is to be made at maximum aperture, then of course nothing happens when you press the button.

You see the same depth of field in the viewfinder that will be recorded on film. The viewfinder image may become noticeably darker because of smaller aperture but you can usually judge depth of field.

If the depth of field is not satisfactory, change aperture size until it is. In extreme cases, you may decide to change focal length or subject distance.

**Green Rectangle**—With the Main Switch set at the green rectangle, all camera controls are set automatically to allow "no decision" photography. The Depth-of-Field Check Button is inoperative.

## READING DEPTH OF FIELD ON THE LENS SCALE

EF fixed-focal-length lenses have a depth-of-field scale adjacent to the focused-distance scale. For each focused distance, it shows depth of field for several aperture sizes. The accompanying photo shows how to read it.

EF zoom lenses don't have a depth-of-field scale because depth of field varies with the focal-length setting.

# LENS CATEGORIES

The lens table at the end of this chapter shows currently available lenses. The EF series of lenses is still being developed, therefore additional lenses may become available.

## WIDE-ANGLE LENSES

These have focal lengths of 35mm and shorter, with wider angles of view at shorter focal lengths. A 35mm lens has an angle of view of 63 degrees.

Wide-angle lenses are useful to photograph interiors, where you want to get a lot of a room in a single photo and have limited working space. They are useful with any subject when you can't stand far enough back to use a lens with longer focal length.

Wide-angle lenses make pleasing outdoor and scenic shots when you want to include an expanse of landscape. Such photos are usually improved and given dimension by including something interesting in the foreground, such as a fence or a flower.

## STANDARD LENSES

The standard lens for EOS cameras is the 50mm $f$-1.8. *Standard* indicates that it is the lens that is usually sold with the camera.

A 50mm lens is a good general-purpose lens. I suggest using a 50mm lens unless there is a photographic reason to prefer some other focal length.

The angle of view of 50mm lenses is 46 degrees—about the angle of view of the human eye. When planning a shot, look at the scene with one eye. If you want a wider view, use a focal length shorter than 50mm. For a narrower view, use a longer lens.

Introduced with the EOS cameras was an L-type lens, the EF 50mm $f$-1.0 L, which has the largest maximum aperture currently available among lenses for SLR cameras. For superior image quality, it uses two aspheric elements and a floating element.

## MEDIUM TELEPHOTO LENSES

Focal lengths from about 70mm to 210mm are useful when you can't get a standard lens close enough so the subject fills the frame.

These focal lengths are practical for most photographers and useful for sports, travel and nature photography. Because they have narrow angles of view, they can isolate an interesting part of a scene, leaving out the uninteresting parts. The angle of view at 135mm is 18 degrees. Focal lengths from about 80mm to 150mm are often used to make portraits, as discussed later in this chapter.

## LONG TELEPHOTO LENSES

These are specialist's lenses with focal lengths of 300mm and longer. They usually require a tripod or other steady mount to avoid image blur due to camera movement. The angle of view at 300mm is 8 degrees. At 600mm, the angle is 4 degrees.

These lenses will reach out a long way to fill the frame with a distant subject, for example sailboats or surfers photographed from the beach. Image quality sometimes suffers due to air turbulence, mist, haze, or atmospheric pollution in the long air space between lens and subject.

Most photographers rarely need focal lengths longer than 300mm. However, when you do need a very long lens, there is usually no other way to make the photo.

**Filters for Long Telephotos**—Long telephotos, such as the EF 300mm $f$-2.8L, don't use front-mounted filters because the front diameters of these lenses are very large. Large-diameter filters are not readily available, and if they are, they are expensive.

Instead, the filter is screwed into a holder and the holder is inserted in a slot near the back of the lens. These are usually called "drop in" filters.

The lens is designed on the assumption that a thickness of glass will always be in the filter holder. The lens is delivered with a clear glass filter, which should be used unless another filter is installed.

## MACRO LENSES

The *macro* range of photography is defined as a magnification of 1 and larger. Lenses designed to provide magnification in this range are called *macro* lenses.

Special macro lenses are designed and optically corrected to provide higher magnification than ordinary lenses without noticeable degradation of image quality. A typical 50mm macro lens provides magnification of 0.5 at closest focus. The image is 50% as tall as the subject.

To reach a magnification of 1.0, an accessory called Life-Size Converter EF is inserted between lens and camera. What the converter does in the technical sense is discussed in Chapter 7. What it does practically is to change the magnification range so it begins at 0.25 and continues to 1, which makes an image that is the same size as the subject.

Macro lenses are used to fill the frame with small objects such as coins and postage stamps. They have good image quality, even when shooting at life-size, and have excellent flatness of field. Because they focus all the way to infinity, they can be used for ordinary photography, too.

## ZOOM LENSES

Zoom lenses have a control that changes the focal length without changing focused distance. The subject grows larger or smaller in the frame as

# USING DIFFERENT FOCAL LENGTHS AT
# THE SAME CAMERA LOCATION

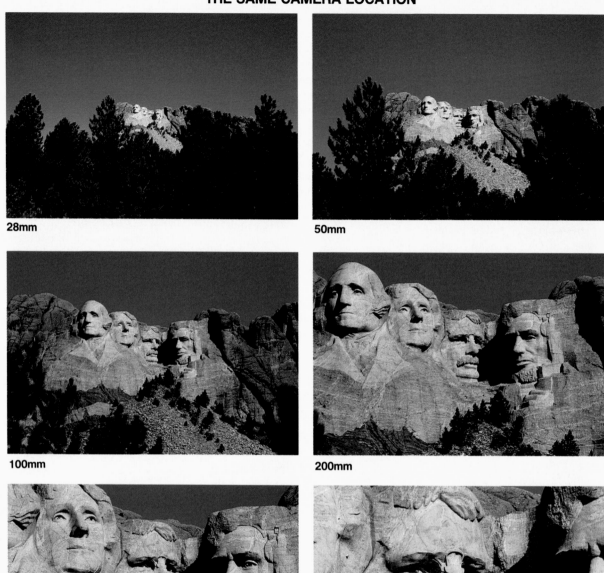

28mm

50mm

100mm

200mm

300mm

600mm

Changing focal length without changing camera location merely includes more or less of the scene in the frame. Perspective is the same. For example, if the 100mm shot were enlarged by a factor of 2, the faces would appear identical to those in the 200mm shot.

The EF 35—105mm *f*-3.5—4.5 Zoom lens has a zoom range of 35mm to 105mm. The entire forward section of the lens is a push-pull zoom control that incorporates the Manual Focusing Ring, so both move together. The IR (Infrared) Focusing Marks are above the Focused-Distance Scale. There is no Depth-of-Field Scale. Maximum aperture changes from *f*-3.5 to *f*-4.5 as the lens is zoomed from 35mm focal length to 105mm.

The EF 35—70mm *f*-3.5—4.5 Zoom lens uses a rotating Zoom Ring to change focal length. The IR (Infrared) Focusing Marks are below the Focused-Distance Scale. There is no Depth-of-Field Scale. Maximum aperture changes from *f*-3.5 to *f*-4.5 as the lens is zoomed from 35mm focal length to 70mm.

you zoom. For example, the EF 70—210mm *f*-4.0 lens changes focal length from 70mm to 210mm.

A zoom is useful in composing a photo because it gives very precise control of what appears within the frame. This is especially handy in situations where it is not convenient to change the camera location. Zoom lenses are sometimes essential when shooting action and sports, when you don't have time to change lenses to get a different focal length.

Zoom lenses have become very popular, and deservedly so. There is normally no perceptible difference in image quality of zoom and non-zoom lenses. Among the first 13 EF lenses announced by Canon, 7 were zooms.

**Zoom Ratio**—The longest focal length divided by the shortest focal length is the zoom ratio. A 70—210mm lens has a zoom ratio of 3. The change in magnification and image size

while zooming is approximately the same as the zoom ratio.

The technical challenge is to provide a zoom ratio large enough to be useful but not so large as to produce image degradation. Current EF zoom lenses have zoom ratios from 2 to 3.

**Zoom Control**—EF lenses use one of two types of zoom control, as shown in the accompanying photos. One is a Zoom Ring that you rotate to change focal length. These lenses also have a Manual Focusing Ring. If you are using autofocus, the only lens control that you operate is the Zoom Ring.

If you are focusing manually, then there are two separate rings to turn and you must move your hand from one to the other. The usual procedure is to focus first, then zoom.

The other type is a push-pull zoom control. A wide segment of the lens body moves forward or back to change focal length. The Manual Focusing

Ring is included in the push-pull section. If you are using autofocus, the only lens control that you operate is the push-pull zoom control. If you are focusing manually, it is convenient to grip the push-pull zoom control with your left hand so that your thumb and forefinger fall on the Manual Focusing Ring. Thus, you can focus and zoom simultaneously without moving your hand.

**Maximum Aperture**—Zoom lenses typically have smaller maximum apertures than single-focal-length lenses in the same range of focal lengths.

**Aperture Change**—Some EF zoom lenses change *f*-number as the lens is zoomed, if the lens is set at maximum or minimum aperture. This changes the amount of light reaching the film.

For example, the EF 35—70mm *f*-3.5—4.5 at maximum aperture changes from *f*-3.5 to *f*-4.5 as the lens is zoomed from a focal length of 35mm

Zoom lenses with a macro range don't have as much magnification as a conventional macro lens. They are nevertheless useful when photographing objects in nature. This photo was made with the EF 70-210mm zoom lens set at 210mm and focused in the macro range. Magnification is about 0.2, not enough for the flower to fill the entire frame.

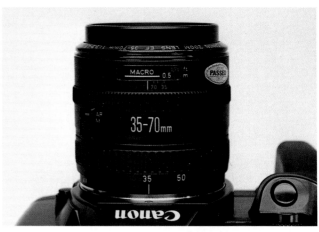

Most EF zoom lenses have a macro focusing range, which is closer than the nearest marked distance on the Focused-Distance Scale. The macro range is indicated by the word MACRO and the yellow line. Maximum magnification is about 0.2, available at the longest focal-length setting of the lens.

to 70mm. At minimum aperture it changes from *f*-22 to *f*-29 over the zoom range. Incidentally, the camera displays the *f*-29 setting as *f*-27 because it displays the nearest half-step. If the lens is set at an intermediate value, such as *f*-8, the *f*-number will not change as the lens is zoomed.

With automatic exposure, the aperture change due to zooming—if it happens—is compensated automatically by the camera. It will occur only at maximum or minimum aperture. If you set exposure manually, zoom first so the aperture size is established, then set exposure.

## ZOOM LENS WITH "MACRO" RANGE

The word *macro* usually refers to equipment that can produce a life-size image, or larger. Macro-zoom lenses don't provide that much magnification, but they are nevertheless useful.

When macro-zooms were first offered, by various makers, there were two ranges of operation, usually selected by a control on the lens. One was the normal range of focused distance and magnifications. The other allowed closer focusing and higher magnification, but with reduced image quality.

The close-focusing range typically has a maximum magnification of around 0.2. Lens manufacturers chose to call this the "macro" range, even though it isn't if the definition of *macro* is strictly applied.

In the "macro" range of a zoom lens, flatness of field may not be good enough to photograph flat subjects such as postage stamps. Also, straight lines near the edges of the frame may curve slightly. Such defects are normally not noticeable if you use a macro-zoom lens to photograph non-flat objects that don't have straight

lines or edges, such as rocks and flowers.

EF zoom lenses have a close focusing "macro" range with slightly reduced image quality. Image quality at ordinary shooting distances is excellent.

EF macro-zoom lenses, except A-type, have a focused-distance scale—in feet and meters—from infinity to closest focusing distance. Over this range, there is no compromise in image quality.

The closest focusing distance is the lowest number on the scale and in the lens table at the end of this chapter. It should be called the closest *marked* focusing distance because closer focusing is possible in the macro range. The macro range is shown by a yellow line on the scale that is not marked with distance numbers. The word MACRO appears above the yellow line.

For example, the EF 35—70mm *f*-

## SPECIAL FOCUSING FEATURES OF EF LENSES

| Lens | Variable-Rate Manual | Preset Focused Dist. | Focus Zones |
|------|------|------|------|
| EF 50—200mm *f*-3.5—4.5 | No | No | Yes |
| EF 50—200mm *f*-3.5—4.5L | No | No | Yes |
| EF 70—210mm *f*-4 | No | No | Yes |
| EF 100-300mm *f*-5.6 | No | No | Yes |
| EF 100-300mm *f*-5.6L | No | No | Yes |
| EF 200mm *f*-1.8L | Yes | Yes | Yes |
| EF 300mm *f*-2.8L | Yes | Yes | Yes |
| EF 600mm *f*-4.0L | Yes | Yes | Yes |

The EF 300mm *f*-2.8 L-type lens uses an ultrasonic USM focusing motor. With an unusually large maximum aperture for this focal length, the lens is very useful in dim light. Because of the large aperture, dramatic photos can be made with very narrow depth of field. It has preset focused-distance capability, a choice of three manual-focusing rates and a choice of three autofocus zones.

Because this lens is large and relatively heavy, it has a tripod mount at the balance point of the combination of lens and camera. Use the tripod mount on the lens instead of the tripod socket on the camera body.

With the Focus-Mode Switch at AF for autofocus, three autofocus zones can be selected—3 meters to infinity, 3 meters to 65 meters, or 65 meters to infinity—using the control above the Focus-Mode Switch. The Focus Preset control is below the Focus-Mode Switch. The Manual Focus Speed selector is near the tripod mount, barely visible in this photo.

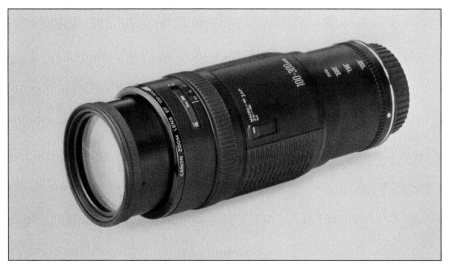

The Focus-Mode switch on this EF 100-300mm ƒ-5.6 Zoom lens has two autofocus zones: MACRO to infinity and 2 meters to infinity.

The EF 15mm ƒ-2.8 Fish-Eye lens makes a rectangular image with an angle of view of 180 degrees, corner to corner. The lens has a permanently attached hood that is cut away at the corners and sides so it doesn't intrude into the angle of view.

3.5—4.5 lens has a closest focusing distance of 0.5 meter or 1.75 feet. At a focal length setting of 70mm, magnification at that distance is 0.15. If you focus still closer, in the MACRO range, the shortest distance is 0.39 meter or 15 inches, with a magnification of 0.2.

EF macro-zoom lenses have no special control to allow use of the macro range. If you focus close enough, you are in it. You can use the macro range at any focal-length setting of the zoom control. Magnification is greater at longer focal lengths. The autofocus system will focus the lens automatically in macro, or you can do it manually.

A-type zoom lenses also have a macro range, even though there is no distance scale with a MACRO indication. These lenses will focus closer than the minimum distance shown in the lens table and, when focused closer, they are in the macro range.

## VARIABLE-RATE MANUAL FOCUSING

On lenses that use the USM motor for focusing, rotating the Manual Focusing Ring produces a series of electrical pulses that are processed by the computer in the lens, which then controls the USM motor electronically. This allows variable-speed manual focusing. Turning the Manual Focusing Ring causes the lens to change focus rapidly or slowly, depending on the selected focusing speed.

The EF 300mm ƒ-2.8L lens is an example. By a switch on the lens body, you can select among three focusing speeds: normal, half speed, or double speed. With fast-moving subjects, you may prefer double-speed focusing. For the greatest precision in focusing, you may prefer half-speed.

## PRESET FOCUSED DISTANCE

The EF 300mm ƒ-2.8L lens has another feature that is useful for sports photography. If you are photographing a race, for example, and want to prepare in advance for a shot of the finish, use autofocus to focus on the finish line. Then operate the Focus Preset control on the lens to store that focused distance in memory in the autofocus system.

With that distance memorized, you can use the camera on autofocus to photograph subjects near and far. As

Extender EF 2X is designed for use with the EF 300mm ƒ-2.8 L lens. It doubles both focal length and aperture value. With the extender installed, the focal length becomes 600mm and the maximum aperture becomes ƒ-5.6. The closest focusing distance does not change.

the racers near the finish, slight rotation of a control ring on the lens causes it to set focus at the preset distance in less than a half second.

Point the camera at the finish line. When the racers arrive, press the Shutter Button. The autofocus system doesn't focus on the racers. The preset focused distance is used.

A beeper in the lens can be switched on to beep when the preset distance has been memorized, and beep again when the lens has returned to the preset distance.

## FOCUS ZONES

Some EF long-focal-length lenses, both zoom and single-focal-length, can be set to work on autofocus over a limited range of subject distances. This can reduce the time needed to auto-focus by preventing the system from searching at distances where the subject cannot be, and also conserve battery power.

An example is the EF 70-210mm *f*-4 lens. The normal focusing range for this lens is from infinity to 1.5 meters. There is a MACRO range at shorter distances.

The Focus-Mode Switch on this lens has two autofocus AF settings. One setting allows focusing only from 1.5 meters to infinity. The MACRO range cannot be used. The other setting allows all distances to be used.

If you know that the subject will always be more distant than 1.5 meters, or you want to prevent use of the MACRO range, the first setting is appropriate.

The EF 300mm *f*-2.8L single-focal-length lens has a closest focusing distance of 3 meters. You can select among three autofocus zones: 3 meters to infinity, 3 meters to 6.5 meters, or 6.5 meters to infinity.

## FISH-EYE LENSES

A special lens design called *fish-eye* has a very wide angle of view—typically 180 degrees. These lenses create fish-eye distortion. Any straight line that is off center in the picture is

Fish-eye distortion, causing straight lines to be curved, is obvious in this view of Honolulu. It is less obvious in the scene from nature because there are no straight lines.

bowed away from center.

Fish-eye lenses have very short focal lengths, such as 15mm. Because of the wide angle of view, accessory filters cannot be attached to the front of the lens—the filter frame would extend into the field of view and darken, or *vignette,* the edges of the picture.

**Circular Fish-Eye Lens**—This lens makes a circular image within the film frame. The remainder of the frame is

black. Because the image is circular, the photos look like trick shots. Circular fish-eyes are mainly useful in science and astronomy. When this book was prepared, there were no EF circular fish-eye lenses.

**Full-Frame Fish-Eye Lens**—This lens makes a rectangular image that fills the frame. Even though there is fish-eye distortion, the photo is more acceptable to viewers because the im-

age is full-frame.

The EF 15mm *f*-2.8 full-frame fish-eye lens has a filter holder on the back of the lens that accepts gelatin filters. Filters are discussed in Chapter 6.

## TELE-EXTENDER

Accessories called *tele-extenders,* or just *extenders,* fit between the lens and the camera body. They multiply both focal length and *f*-number by a factor such as 1.4 or 2. The factor is written with an X to signify multiplication, such as 2X, and is stated in the nomenclature of the extender. The closest focusing distance of the lens is not changed when an extender is used.

An extender provides a handy and relatively inexpensive way to get two focal lengths from the same lens. Degration of image quality is not noticeable if the extender is used as specified by the manufacturer.

Two extenders are available: Extender EF 1.4X and EF 2X. Lenses with which they can be used are indicated in the lens table at the end of this chapter.

When the extender is installed, the camera and lens computers "know" it is there and make adjustments so the autofocus and automatic-exposure systems work as usual.

## PERSPECTIVE

The word *perspective* is derived from Latin words meaning *to see through.* With perfect perspective, a photo or painting of a scene is indistinguishable from the scene itself. It's as though you are *seeing through* the picture frame to view the actual scene.

In a picture on a flat surface, perspective is produced by the relative sizes of objects in the scene. Distant objects are smaller than objects nearby. The width of a highway becomes smaller as it recedes into the distance.

With lenses of varying focal lengths, you can create perspective effects as shown in the accompanying photos.

**Short Focal Lengths**—The closest focusing distances of lenses are usually

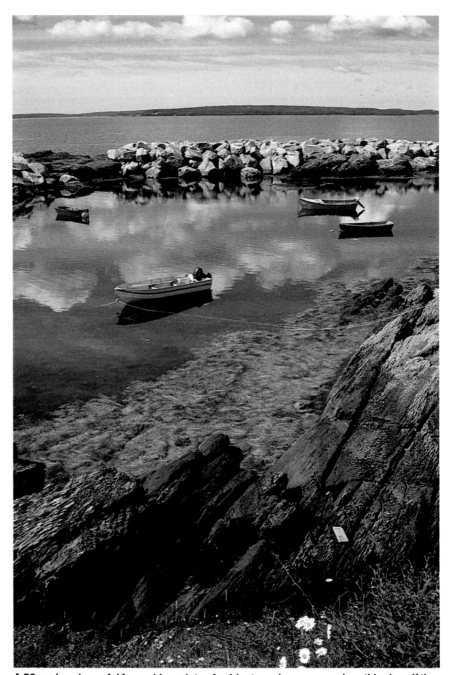

A 50mm lens is useful for a wide variety of subjects and scenes, such as this view. If there is no specific reason to shoot with a different focal length, use a standard 50mm lens.

proportional to their focal lengths. The EF 28mm *f*-2.8 lens, for example, focuses down to 0.3 meter or 1 foot. This allows you to place the lens very close to a subject and get a photo that shows a person with an apparently big nose or big foot.

When people see such a photo, they usually think it is funny and has incorrect perspective. In fact, perspective is correct for that point of view. If you substitute your eye for the lens, you will see exactly the same thing.

**Long Focal Lengths**—Lenses with long focal lengths are usually used to photograph distant scenes, with closer objects not in the frame. When we view such a photo, objects at different dis-

# WHEN LOCATION CHANGES, PERSPECTIVE CHANGES

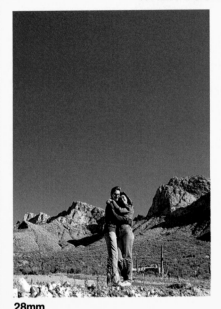 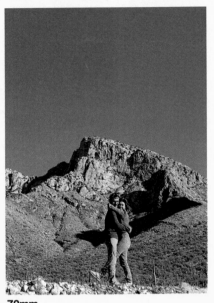 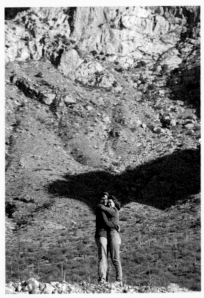

**28mm**      **70mm**      **210mm**

These photos were made with three focal lengths, at three different camera locations. As focal length increased, the camera was moved back so the models were about the same height in the viewfinder. In the 28mm view, the background appears small and distant. In the 70mm view, it appears larger and closer and in the 210mm view it appears still larger and closer. Perspective changes when camera location changes. The apparent distance between models and background is different in each view.

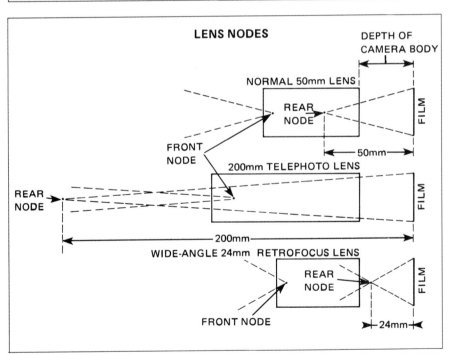

### LENS NODES

All lenses have the same *mechanical* distance between lens mount and film—the thickness of the camera body. However, lenses with different focal lengths require different *optical* lens-to-film distances. The lens-to-film distance is measured from an optical location, in or near the lens, called the rear node.

To use lenses of various focal lengths on the same camera body, each lens is designed optically to place the rear node where it must be to provide the correct distance for that focal length. This makes possible the interchangeability of lenses on SLR cameras.

tances seem unusually close together in the picture. We say that long-focal-length lenses *compress* distance in a scene.

If you place your eye at the same location, and look through a frame so you don't see nearby objects, the view will be identical.

## PORTRAIT LENS

Focal lengths of around 80mm to 150mm are commonly used to make portraits that include the head and shoulders of a subject. Such relatively long focal lengths give more working distance and less extreme perspective.

Although the usual goal of photography is to produce an image with optimum sharpness, that is sometimes a disadvantage in portraiture. Subjects with skin blemishes or wrinkles often prefer a photo that isn't totally sharp, so the blemishes are less apparent. Some landscape scenes, too, are best in "soft focus" so they have a dreamy or surreal effect.

The Softfocus EF 135mm *f*-2.8 lens

A telephoto lens is useful for photographing distant subjects and scenes, especially when there is no handy way to get closer.

is designed to meet these requirements. The focal length provides a perspective that is good for portraits. A control on the lens changes focus from sharp to softly blurred in three steps, labeled 0, 1 and 2.

This lens, like others in the EF series, uses an aspheric element to reduce spherical aberration. However, the lens has a Softness Control that moves the aspheric element in the lens so that spherical aberration increases. The increased spherical aberration provides the required soft-focus effect.

At the 0 setting of the Softness Control, spherical aberration is fully corrected and the image is sharp. At that setting, the lens can be used for ordinary photography. At the 1 setting, there is visible softness and at the 2 setting even more pronounced softness.

If a point is sharply focused and spherical aberration is then increased, the point remains sharp but is surrounded by a halo. Thus, the basic structure of the image is still there, but it is overlaid by a veil of softness.

As mentioned earlier, spherical aberration is reduced by using a smaller aperture. The softness effect of this lens is controlled both by the setting of the Softness Control and the aperture size used to make the photo. At larger aperture, softness is greater.

## NODAL POINTS

A subject at infinity is imaged at a distance behind the lens that is equal to the lens focal length. With a simple single-element lens, the image distance is measured from the center of the lens to the image plane. With a real-world compound lens, image distance and subject distance are measured from *optical* locations in the lens—the rear and front *nodes*.

The image plane must coincide with the film plane in the camera, because you want the focused image to fall on the film. EOS cameras show the location of the film plane by the symbol on top of the camera.

The distance between the front surface of the lens mount on the camera body and the film plane at the back of the camera is a fixed distance of 44mm. Nevertheless, interchangeable lenses with a variety of focal lengths make a focused image at the film plane. This section discusses how that is possible.

**Normal Design**—With a 50mm lens focused at infinity, the image distance is 50mm. Therefore, the optical rear node must be 6mm in front of the lens mount—6mm inside the lens body—so there is a total of 50mm between the optical node and the film. This is called a *normal* lens design because the rear node is at or near the rear element of the lens.

**Telephoto Design**—A 300mm lens focused at infinity requires 300mm between the rear node and the film. The lens designer places the optical rear node 256mm forward of rear element of the lens. That distance, plus the 44mm inside the camera, provides the required image distance of 300mm.

This design is called *telephoto*. The optical *rear* node is inside the lens or sometimes in the air *in front of* the lens. The advantage is a more compact lens because much of the required image distance is contained inside the lens body or even in front of it.

To make a 300mm lens for an EOS camera using the normal lens design would require an empty tube, 256mm long, behind the rear element.

**Retrofocus Design**—Wide-angle lenses have short focal lengths. A 28mm lens focused at infinity has an image distance of 28mm. The distance inside the camera body from mount flange to film is 44mm. Therefore, wide-angle lenses are designed to place the rear optical node in the air behind the lens, inside the camera body. Compared to the telephoto design, the node is moved in the opposite direction.

This design is called *retrofocus*, sometimes *reversed telephoto*. It provides a simple way of mounting a wide-angle lens on an SLR body.

In the old days, camera makers used the normal design for short-focal-length lenses, which caused some com-

## CANON EF LENSES

| Lens | Focus Motor | Angle of View (deg.) | Minimum Aperture (f-no.) | Closest Focused Distance (m) | (ft) | Filter Size (mm) | Length (mm) | (in) | Weight (g) | (oz) | Case | Hood |
|---|---|---|---|---|---|---|---|---|---|---|---|---|
| Fisheye EF 15mm f-2.8 | AFD | 180 | 22 | 0.2 | 0.7 | Holder | 62 | 2.4 | 360 | 12.7 | ES-C9 | None |
| EF 24mm f-2.8 | AFD | 84 | 22 | 0.25 | 0.8 | 58 | 49 | 1.9 | 270 | 9.5 | ES-C9 | EW-60 |
| EF 28mm f-2.8 | AFD | 75 | 22 | 0.3 | 1.0 | 52 | 43 | 1.6 | 185 | 6.5 | ES-C9 | EW-65 |
| EF 50mm f-1.0L | USM | 46 | 16 | 0.6 | 2.0 | 72 | 80 | 3.1 | 960 | 33.9 | LH-D12 | ES-79 |
| EF 50mm f-1.8 | AFD | 46 | 22 | 0.5 | 1.5 | 52 | 43 | 1.6 | 190 | 6.7 | ES-C9 | ES-65 |
| EF 50mm f-2.5 Macro | AFD | 46 | 32 | 0.23 | 0.75 | 52 | 63 | 2.5 | 285 | 9.9 | ES-C9 | None |
| Softfocus EF 135mm f-2.8 | AFD | 18 | 32 | 1.3 | 4.5 | 52 | 99 | 3.9 | 410 | 14.4 | ES-C13 | ET-65 |
| EF 200mm f-1.8L* | USM | 12 | 22 | 2.5 | 8.2 | 48** | 208 | 8.2 | 3000 | 106 | *** | ET-123 |
| EF 300mm f-2.8L* | USM | 8.25 | 32 | 3.0 | 9.8 | 48** | 243 | 9.6 | 2850 | 101 | *** | ET-118 |
| EF 600mm f-4.0L* | USM | 4.17 | 32 | 6.0 | 19.6 | 48** | 456 | 17.9 | 6000 | 212 | *** | ET-161 |
| EF 28—70mm f-3.5—4.5 | AFD | 75-34 | 22-29 | 0.5 | 1.8 | 52 | 75 | 2.9 | 300 | 10.6 | ES-C13 | EW-68A |
| EF 28—80mm f-2.8—4.0L | USM | 75-30 | 22-32 | 0.8 | 2.5 | 72 | 122 | 4.8 | 940 | 33.2 | LH-D16 | EW-79 |
| EF 35—70mm f-3.5—4.5 | AFD | 63-34 | 22-29 | 0.5 | 1.8 | 52 | 63 | 2.5 | 245 | 8.6 | ES-C9 | EW-68B |
| EF 35—70mm f-3.5—4.5A | AFD | 63-34 | 22-29 | 0.5 | 1.8 | 52 | 63 | 2.5 | 230 | 8.1 | ES-C9 | EW-68B |
| EF 35—105mm f-3.5—4.5 | AFD | 63-23.5 | 22-29 | 1.2 | 4.0 | 58 | 82 | 3.3 | 400 | 14.1 | ES-C13 | EW-68B |
| EF 35—135mm f-3.5—4.5 | AFD | 63-18 | 22-29 | 1.5 | 5.0 | 58 | 95 | 3.7 | 475 | 16.8 | ES-C13 | EW-68B |
| EF 50—200mm f-3.5—4.5 | AFD | 46-12 | 32 | 1.5 | 4.9 | 58 | 146 | 5.8 | 690 | 24.1 | LH-C19 | ET-62 |
| EF 50—200mm f-3.5—4.5L | AFD | 46-12 | 32 | 1.5 | 4.9 | 58 | 146 | 5.8 | 695 | 24.3 | LH-C19 | ET-62 |
| EF 70—210mm f-4.0 | AFD | 34-11.8 | 32 | 1.5 | 5.0 | 58 | 138 | 5.4 | 650 | 23.0 | ES-C17 | ET-62 |
| EF 100—200mm f-4.5A | AFD | 24-12 | 32 | 1.9 | 7.0 | 58 | 131 | 5.1 | 540 | 18.9 | ES-C17 | ET-62 |
| EF 100—300mm f-5.6 | AFD | 24-8.25 | 32 | 2.0 | 7.0 | 58 | 167 | 6.6 | 720 | 25.4 | ES-C20 | ET-62 |
| EF 100—300mm f-5.6L | AFD | 24-8.25 | 32 | 2.0 | 7.0 | 58 | 167 | 6.6 | 720 | 25.4 | ES-C20 | ET-62 |

AFD = Arc Form Drive; USM = Ultrasonic Motor.
*Uses Extender EF 1.4X and Extender EF 2X. Autofocus not possible when EF 2X is used with EF 600mm f-4.0L because of small effective aperture (f-8).
**48mm drop-in filter fits in lens body.
***Case is furnished with lens.

plications. To get the rear element close enough to the film, the back of the lens extended inside the camera body. That prevented the mirror from moving up and down, so it was locked in the up position. That prevented viewing through the viewfinder, so an accessory viewing lens was attached to the top of the camera. Obviously, retrofocus is much better.

**Front Node**—Lens-to-subject distance is measured from the front optical node. Locations of the rear and front nodes for three lens designs are shown in the accompanying drawing.

## ASSORTED DISTANCES

In optical terms, image distance and subject distance are measured from the nodal points, as just discussed. In ordinary photography, however, we don't know where the nodes are and don't care. We are just grateful because they make interchangeable lenses practical on SLR cameras.

Focused distance is shown on the Focused-Distance Scale on the lens. Focused distance is measured from the focal-plane symbol on top of the camera. Part of the focused distance is "used up" by the length of the lens and the depth of the camera body. Usually, that doesn't matter but occasionally it's handy to know that.

Working distance is between the front of the lens and the subject plane. It is actual air space. It's the focused distance minus the distance from the front of the lens to the film plane.

Closest focusing distance is the smallest *marked* distance on the Focused-Distance Scale of the lens. This distance is shown for each lens in the accompanying lens table.

If the lens is a zoom with a MACRO range, the closest normal focusing distance is the dividing point between the normal focusing range and the MACRO range. You can focus closer by entering the MACRO range, but macro-range distances are not shown on the Focused-Distance Scale. Instead, there is a yellow line.

## CAMERA SUPPORT

Virtually every photo is improved if the camera is firmly supported during

exposure. If the camera moves slightly during exposure, the image may be blurred.

A tripod is a very good way to support camera and lens, but there are other ways. Rest the camera against a solid surface, such as a fence or a window ledge. Press it sideways against a tree trunk or the wall of a building.

## RULE FOR HANDHOLDING A CAMERA

If it is necessary to handhold the camera, use a shutter speed that's fast enough to prevent image blur. Use a shutter speed equal to or faster than the *reciprocal* of the lens focal length. Reciprocal means "one divided by focal length."

For example with a 50mm lens, use a shutter speed of 1/50 second or faster. The nearest faster shutter speed is 1/60 second. That value, or any faster shutter speed, will usually produce an acceptable image. With a 200mm lens, don't use a slower shutter speed than 1/250 second.

When handholding the camera, look for ways to brace your body, such as leaning against a wall. Look for ways to brace your elbows, such as placing them on a fence railing or a chair back. Anything you can to to make the camera more steady will improve the resulting photo.

## CAMERA-SHAKE WARNING

When an EOS 620/650 camera sets exposure automatically, it may choose a shutter speed that is slower than the reciprocal of the lens focal length. If the beeper is turned on, it sounds a warning when that happens. The beeper makes long beeps continuously until you correct the problem or turn the beeper off.

There are modes in which you choose shutter speed manually. The beeper does not warn of slow speeds in that case, because you know what speed you are using.

With EOS 750/850, the beeper does not warn of slow shutter speed. Instead, the P symbol in the viewfinder blinks slowly.

## CHOOSING A SET OF LENSES

The main advantage of an SLR camera is that you can use interchangeable lenses, having various angles of view. If you intend to make photos that are more artistic or creative than "snapshots," you will make a series of decisions about each exposure: the scene or subject, the lighting, where to position the camera, depth of field, and the lens angle of view. Angle of view is an essential ingredient.

In choosing lenses, the best advice is to acquire a range of focal lengths that includes 50mm. Then, learn to use various focal lengths by observing what you see in the viewfinder and what appears in the resulting print or slide. The results will often surprise and instruct you.

A good way to begin is with zoom lenses. For travel or general photography, two zoom lenses can satisfy most requirements. The EF 35—70mm with the EF 70-210mm provide every focal length from 35mm to 210mm.

# Viewing & Focusing

**EOS cameras can focus and set exposure automatically, leaving you free to concentrate on the pictorial opportunity at hand.**

EOS cameras have two ways to focus the lens—manual or automatic. There are also two ways to check or confirm focus—visually by looking at the image on the focusing screen or electronically by the camera autofocus system.

The autofocus system operates a green In-Focus Indicator light in the viewfinder that glows if the image is in focus, whether the lens was focused manually or automatically. If the camera beeper is turned on, it makes a *beep-beep* sound when the image is in focus.

## ELECTRONIC FOCUS DETECTION

Visual observation of focus is done by examining the focusing screen in the viewfinder. Electronic focus detection is done by an electronic focus sensor in the bottom of the mirror box. Both are done at the same time, with the mirror down, before making the exposure.

**The Light Path**—EOS cameras use a special main mirror that reflects most of the light from the scene upward into the viewfinder but allows some light to pass through. Because it lets part of the light pass through, it is called a *half-mirror*, even though more than half of the light is reflected upward into the viewfinder.

A sub-mirror, behind the main mirror, reflects light that passes through the main mirror downward to the autofocus optical system in the bottom of the camera—as shown in the accompanying drawing.

When the main mirror moves up to make an exposure, the sub-mirror folds flat against the bottom of the main mirror.

**The Principle**—The focus-detection

47

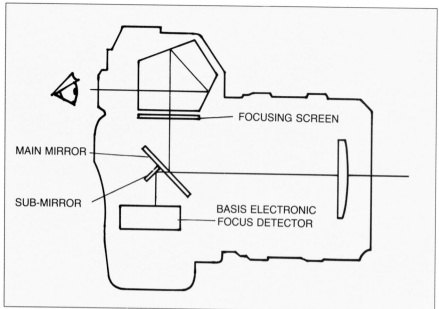

An EOS camera checks focus electronically, with the main mirror down, while you are viewing the scene. Part of the light reaching the main mirror is reflected upward to the focusing screen. Part of the light passes through the main mirror and is reflected downward by a sub-mirror to the BASIS electronic focus detector in the bottom of the mirror box.

apart or closer together.

**The Focus Detector**—In the bottom of the mirror box are two rows of tiny light sensors, with 48 sensors in each row. Optically, one row views the image from the left of center and the other row views it from the right.

The light pattern on each row is converted to an electronic signal and the two patterns are examined electronically, as shown in Figure 3-1. By observing the distance between the two patterns, the focus detector can determine whether the image is in focus or not. If the image is not in focus, the detector can determine which way it is out of focus, and how much. Canon refers to the electronic focus detector as a ranging sensor. It determines the range, or camera-to-subject distance, and tells the lens which way to change focus, if necessary.

**Basis**—Canon designed the ranging sensor to have greater sensitivity than other contemporary focus detectors and refers to it as *BASIS,* an acronym for *Base Stored Image Sensor.* Greater sensitivity means that it can detect focus in light that is more dim. The fundamental improvement is that each light sensor has a built-in electronic amplifier to make the signal stronger

method is referred to as phase detection. It is based on observation of the image from two off-center locations, left and right of center.

Assume that a camera is focused on a nearby vertical line and then the camera position is moved so the image becomes unsharp. If you could see two unsharp off-center views of the line simultaneously, you would notice that, when you move the camera position, the two blurred images move farther

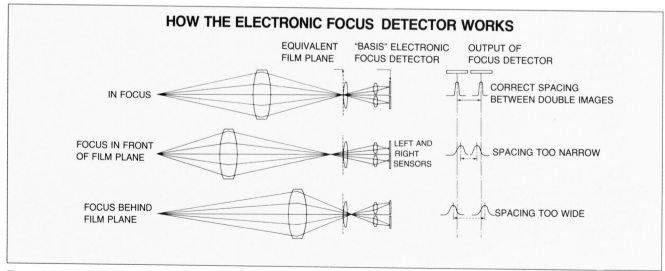

Figure 3-1/The BASIS electronic focus detector checks focus at a location that is equivalent to the film plane. It determines if the image is in focus or not. If it is not, the detector determines which way the image is out of focus and how much focus adjustment is needed.

before it is processed by the autofocus system.

**Working Range**—The autofocus system works over a range of scene brightnesses that is specified by EV numbers. If you are not familiar with EV numbers, they are discussed in Chapter 5.

The autofocus systems of the EOS cameras work from EV 1 to EV 18, with a film speed of ISO 100. EV 1 is dim, such as at twilight. EV 18 is brighter than a sunlit outdoor scene.

## AUTOFOCUS FRAME

The focus detector checks focus along a narrow *horizontal* area at the center of the image. The standard focusing screen for EOS cameras has two square brackets that designate a small rectangle at the center of the image area, called the AF (Auto Focus) Frame.

The electronic focus detector checks focus only in the area that is inside the AF Frame. Hold the camera so the AF Frame overlays the subject to be focused.

## FOCUS DISPLAY

The focus detector operates an In-Focus Indicator in the viewfinder. It's a green dot that glows when the image is in focus. If the beeper is turned on, it also confirms good focus.

**On Automatic Focus**—When the camera brings the image to focus automatacally, the green In-Focus light glows steadily. There are some subjects that cannot be focused automatically. When focus is impossible, the In-Focus light blinks.

**On Manual Focus**—When focusing manually, the green In-Focus Indicator in the viewfinder glows steadily when the image in the AF Frame is focused. This is usually called *focus confirmation*. There is never an indication that focus is impossible when focusing manually.

## GOOD SUBJECTS
## FOR AUTOFOCUS

Because the row of light sensors in the electronic focus detector is horizon-

This enlarged photo of the BASIS electronic focus detector shows the two rows of sensors that view the scene at the center of the image, inside the AF Focus Frame.

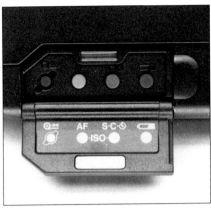

Pushbuttons behind the EOS 650 Switch Cover are identified by symbols molded into the camera body and also shown on the inside of the cover.

tal, it works best on vertical lines or edges. The best subject is a vertical line or border between two areas of visibly different brightness or contrast, in a brightly lit setting.

Good subjects are most things that we shoot, such as people and buildings, in light that isn't dim.

You can help the focus detector by placing the AF frame so it includes a vertical line on the subject. For example, the line can be a corner of a building or the edge of a door or window. It can be a facial feature, such as an eye or the shadow cast by a nose.

With a little experience, you will learn to place the AF Frame on an area of the subject so autofocus is quick and easy.

## BAD SUBJECTS
## FOR AUTOFOCUS

The worst subject is anything in the dark. The focus detector must be able to "see" the subject. Equally bad is a blank surface in good light. The focus detector must have some detail to examine.

A border between two areas that have nearly the same brightness is a poor target for autofocus. If possible, find a subject area with more contrast.

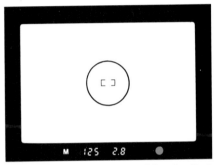

The AF Frame at the center of the viewfinder image shows the area that is examined by the electronic focus detector. The green dot glows steadily when the image is in focus.

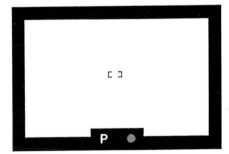

EOS 750/850 cameras have an AF Frame at the center of the image to show the area being examined by the electronic focus detector. The Green Dot glows steadily if the image is in focus and blinks if it is not.

These photos of a variety of subjects were made with an EOS camera on autofocus.

A scene with only horizontal lines is bad. The focus detector needs vertical lines.

Scenes that offer the focus detector vertical lines at more than one distance may be bad. For example, shooting a scene through a grille. The camera may focus on the grille instead of the scene.

Subjects that are highly reflective or strongly backlit may be difficult to autofocus.

Moving subjects may move faster than the autofocus system can follow. It may be difficult to keep a moving subject in the AF Frame long enough for the autofocus system to work.

**What to Do**—If the problem is dim light, EOS flash units have built-in scene illuminators that allow autofocus in the dark. These are discussed in Chapter 8.

If the subject has only horizontal lines, rotate the camera ninety degrees while focusing. If you can't focus on one part of the subject, try another part. Find a different subject at the same distance and focus on it.

If autofocus can't work, you can always switch to manual and focus the lens yourself. Judge focus visually by looking at the image on the focusing screen.

## EOS 620/650 FOCUS MODES

Depending on the setting of the Focus-Mode Switch on the lens, you can focus the lens manually or let the camera do it automatically. Either way, the focus detector in the camera operates and the In-Focus Indicator in the viewfinder glows when the image is in focus.

Focus modes of EOS 620/650 cameras, using a lens that is not an A-type, are described in the following paragraphs. Focus modes of EOS 750/850 cameras are discussed later.

**Manual Focus**—Usable with any EF lens except an A-type, which doesn't have a Focus-Mode Switch.

Set the lens Focus-Mode Switch to M. With the camera turned on, the LCD Display on the camera will show M.FOCUS. Press the Shutter Button halfway to turn on the camera electronics. Focus manually. Press the Shutter Button fully to make an exposure.

In the One-Shot autofocus mode, I placed the subject at the center of the frame and depressed the Shutter Button halfway to focus. Keeping the Shutter Button depressed to lock focus, I recomposed to place the subject away from center and then pressed the Shutter Button fully to make this photo.

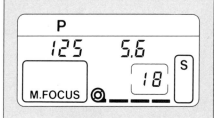

If the Focus-Mode Switch on the lens is set to *M* for manual focus, the LCD panel shows *M.FOCUS*. An autofocus mode cannot be selected with the lens Focus-Mode Switch at *M*.

The two autofocus modes are *ONE SHOT* and *SERVO*. The selected mode is shown in the LCD Panel on top of the camera.

**One Shot AF**—Usable with any EF lens. A-type lenses are always set for autofocus. With regular or L-type EF lenses, set the Focus-Mode Switch on the lens to AF. Set the Main Switch to A, with the beeper on or off. Then press the AF pushbutton behind the Switch Cover on the back of the EOS 620/650 camera and turn the Input Dial to display the word ONE SHOT in the LCD Display. After releasing the AF pushbutton, you have 8 seconds to make the selection using the Input Dial.

Place the AF Frame in the viewfinder on the subject to be autofocused. Press the Shutter Button halfway to turn on the electronics. The camera will autofocus on the subject, if possible. When focus is found, it is *locked* at that distance as long as you keep the Shutter Button depressed halfway.

With focus locked by pressure on the Shutter Button, you can recompose to place the subject off center in the frame, if you wish. Press the Shutter Button fully to make the exposure.

In this mode, you focus once and make the shot, which is why it is called *one shot*. If you have focused on a subject and then decide to focus on a different subject, you must release the Shutter Button and start over.

In the one-shot AF mode, the shutter will not operate unless the image is in focus and the green In-Focus Indicator in the viewfinder is glowing. This is sometimes called *focus priority*. You can't make an exposure that is out of focus.

**Servo AF**—The word *servo* implies continuous change. In the servo AF mode, focus is never locked and can change continuously. For example if you place the AF Frame in the viewfinder on a moving subject, such as a bicyclist or jogger, the autofocus system will track the subject—if possible—changing focus as it moves. If you point the camera at different objects in a scene, it will refocus on each object as it comes into the AF Frame.

The camera will make an exposure immediately, when you press the Shutter Button fully, *whether the image is in focus or not*.

This mode is usable with EOS 620/650 cameras and any EF lens. A-type lenses are always set for autofocus. With regular or L-type EF lenses, set the Focus-Mode Switch on the lens to AF. Set the Main Switch to A, with the beeper on or off. Then press the AF pushbutton behind the Switch Cover and turn the Input Dial to display the word SERVO in the LCD Display. After releasing the AF pushbutton, you have 8 seconds to make the selection using the Input Dial.

Press the Shutter Button halfway to turn on the camera electronics. The camera will autofocus continuously on whatever is in the viewfinder AF Frame. The green In-Focus Indicator will glow each time focus is found and

This photo demonstrates a technique that helps the autofocus system capture a fast-moving subject. Here, a truck traveling at highway speed is moving toward the camera. In the One-Shot autofocus mode, with the lens focused at infinity, I pointed the camera at the truck and pressed the Shutter Button fully. The camera searched for focus, starting at infinity and moving inward. When the search pattern overtook the moving truck, focus was found and the exposure made.

As the truck passed by, I depressed the Shutter Button halfway to focus on the ground at my feet. Then, I pointed the camera at the back of the departing truck and pressed the Shutter Button fully. The camera searched outward for focus. As the search pattern overtook the moving truck, focus was found and the exposure made.

turn off when focus is lost. Press the Shutter Button fully to make an exposure, whether or not the In-Focus Indicator is glowing.

If the camera is set for automatic exposure control, exposure is set at the instant you press the Shutter Button all the way down—just before the shutter opens.

**Main Switch at Green Rectangle—** With the Main Switch set to the green rectangle and the Focus-Mode Switch to AF, the one-shot AF mode is selected automatically. Servo AF cannot be used.

### SEARCHING FOR FOCUS

When you press the Shutter Button halfway to turn on the autofocus system, in either of the AF modes just discussed, the focus detector examines the image in the AF Frame. There are three possible results:

• The lens may already be focused at the correct distance. If so, the system will declare good focus immediately by turning on the green In-Focus Indicator and beeping—if the beeper is turned on.

• The image is not in focus, but the focus detector can determine which way the lens should be focused, and how much. The system will bring the image to focus.

• The image is not in focus and the focus detector cannot determine which way to focus the lens or how much. This can happen if the subject in the AF Frame is unsuitable, such as a blank wall or clear sky, or is in the dark.

In this case, the autofocus system will search for focus. The search begins at whatever distance the lens is focused. Focus is changed to shorter distances until the shortest possible distance is reached or an image is brought to focus.

If focus is not found, focus is changed to greater distances until infinity is reached or an image is brought to focus. If focus is not found, the search stops with the lens focused at infinity. The autofocus system declares that focus is impossible by blinking the In-Focus Indicator.

**Drive Speed—**When searching for focus, all current EF lenses focus from infinity to the shortest distance, or the reverse, in less than half a second.

**Using the Search Pattern—**You can sometimes use the search pattern to assist focusing on a moving subject, using the single-frame winding mode and the one-shot AF mode.

If the subject is moving toward you, start with the lens focused at infinity. Place the focus frame on the subject and depress the Shutter Button fully. The lens will change focus rapidly and "overtake" the subject.

Because focus distance and subject motion are in the same direction, there may be sufficient time to allow autofocus and an exposure. If the subject is moving away, start with the lens at the shortest focused distance.

### INTERACTION OF MODES USING EOS 620/650 CAMERAS

There are two film-winding modes: S for single-frame and C for continuous exposures. There are two AF modes: one-shot and servo. This section discusses using these modes in all possible combinations, assuming that the camera is set to automatically control exposure of the film.

**S Mode With One-Shot AF—**With the Shutter Button depressed halfway, focused distance is locked when focus

is found. Exposure of the film is set and locked at the same time. Press the Shutter Button fully to make the shot. The shutter will not operate if the image is not in focus.

**S Mode With Servo AF**—With the Shutter Button depressed halfway, the autofocus system will change focused distance continuously to follow a moving subject or switch from one subject to another. Pressing the Shutter Button all the way causes the shutter to operate whether or not the image is in focus. Exposure is set just before the shutter opens.

**C Mode With One-Shot AF**—Focused distance is locked when focus is found. Exposure is set and locked at the same time. When the Shutter Button is held down, a sequence of frames is shot, all with the same focused distance and exposure setting. Maximum frame rate is 3 frames per second. The shutter will not operate if the image is not in focus.

**C Mode With Servo AF**—When the Shutter Button is held down, a sequence of frames is shot. Focus is never locked. Focused distance changes as needed before the first frame and between frames during the brief time that the main mirror is down. Exposure is set for each frame, just before the shutter opens.

The viewfinder displays and the beeper are turned off as long as the Shutter Button is held down. Because focused distance and exposure may change for each frame, the frame rate decreases to about 2 frames per second. There is no guarantee of good focus—the shutter operates whether the image is in focus or not.

If the subject moves out of the AF Frame, focus is locked until the subject moves back into the AF Frame or the end of the sequence. That prevents the camera from searching for focus and making shots that may be far out of focus.

**EOS 750/850 FOCUS MODES**

Two focus modes are available—Manual and One-Shot—depending on

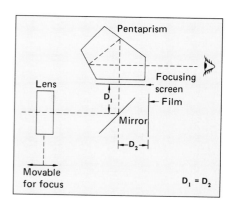

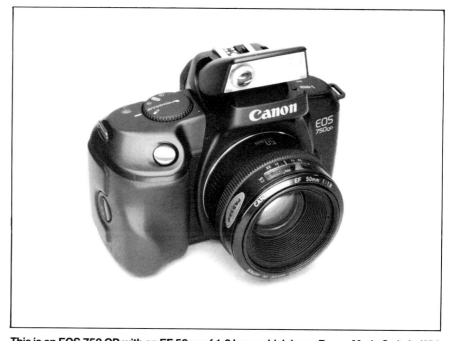

This is an EOS 750 QD with an EF 50mm f-1.8 lens, which has a Focus-Mode Switch. With lenses that have a Focus-Mode Switch, EOS 750/850 cameras can use either manual or automatic focus. With A-type lenses, which don't have a Focus-Mode Switch, only autofocus can be used.

the lens in use.

**With A-Type Lenses**—These lenses have no Focus-Mode Switch and are always set for autofocus. Manual focus cannot be used.

**With Regular and L-Type EF Lenses**—Both Manual and One-Shot focus modes are available, depending on the setting of the lens Focus-Mode Switch.

**Manual Focus Mode**—Set the lens Focus-Mode Switch to M. Set the EOS 750/850 Main Switch to PROGRAM or

Self-Timer. Press the Shutter Button halfway to turn on the camera electronics. Exposure is set and locked until you make the shot or release the Shutter Button. You can recompose before shooting, if you wish.

Focus manually until the green In-Focus Indicator dot glows or the image in the viewfinder looks OK to you. Press the Shutter Button fully to make the exposure. In this mode, you can make an exposure whether or not the green In-Focus Indicator glows. Fo-

## EOS 620 AND 650 INTERCHANGEABLE FOCUSING SCREENS TYPE E

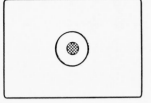

**Type E-A, Microprism.** Matte (frosted) surface with microprism optical focusing aid at center. Circle is partial-metering zone, discussed in Chapter 5. This screen is suitable for general photography. Microprism focusing aid may black out at apertures smaller than $f$-5.6.

**Type E-B, New Split.** Matte surface with new type biprism (split-image) optical focusing aid at center, surrounded by partial-metering circle. Suitable for all lenses. Optical focusing aid not useful at apertures smaller than $f$-5.6 but does not black out.

**Type E-C, Overall New Laser Matte/AF Frame.** Standard factory-installed screen for EOS cameras. Matte surface with AF frame and partial-metering circle at center. Useful with all lenses.

**Type E-D, Laser/Matte Section.** Matte surface with grid lines. Useful for architectural photography and to assist image placement within frame.

**Type E-H, Laser Matte/Scale.** Matte surface with vertical and horizontal scales marked in millimeters, plus partial-metering circle. Useful in high-magnification photography.

**Type E-I, Laser Matte/Double-Cross-Hair Reticle.** Matte Surface except clear within partial-metering circle. Reticle (cross) in center formed by double lines. Precise focus can be checked by moving your eye slightly while observing position of reticle on subject. If cross-hairs don't move in relation to subject, image is in focus. Useful in high-magnification and astrophotography.

**Type E-L, Cross Split-Image.** Matte surface with combined horizontal and vertical biprism inside partial-metering circle. Biprisms split image both vertically and horizontally when image is out of focus. Optical focusing aid not useful at apertures smaller than $f$-5.6.

---

cused distance will not change until you change it manually.

If you hold down the Shutter Button, a continuous series of exposures will be made. You can change focus manually during the series, if you wish. Exposure will be set automatically *for each shot,* just before the shutter opens.

**One-Shot AF**—In this mode, focus and exposure are set for one shot, then reset for the next shot.

With regular or L-type EF lenses, set the Focus-Mode Switch to AF. A-type lenses are always set for autofocus. Set the EOS 750/850 Main Switch to PROGRAM or Self-Timer.

Place the AF Frame over the subject to be focused. Press the Shutter Button halfway. The camera will autofocus on the subject, if possible. When focus is found, both focus and exposure are locked until you make the shot or release the Shutter Button. You can recompose before shooting, if you wish.

If you hold down the Shutter Button, a continuous series of exposures will be made. Both focus and exposure will be reset for each shot.

When using autofocus, the shutter will not operate unless the green In-Focus Indicator glows steadily.

## PREFOCUSING THE LENS

In Chapter 2, I described the prefocus capability of lenses such as the EF 300mm $f$-2.8L lens. You can prefocus it to a set distance, use it at other distances, and then quickly return to the prefocused distance.

You can prefocus any EF lens. An obvious way is to manually focus the lens at the desired distance and then wait for the intended subject to arrive at that point.

Another way is to use the camera in the servo AF mode. Press the Shutter Button halfway to autofocus on any object at the desired distance—such as

---

The Type designation E appears on the focusing-screen package along with a drawing of the screen and its identifying letter symbol, such as D. The focusing-screen name, such as Laser Matte/Section refers to the screen design.

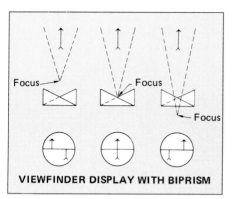

**VIEWFINDER DISPLAY WITH BIPRISM**

A biprism is two prisms, angled in opposite directions, in a circle at the center of the focusing screen. When an out-of-focus image of a straight line passes through the biprism, one part of the line is optically displaced in one direction and the other part is displaced in the opposite direction.

This is often called a split-image focusing aid because it "splits" the image in the biprism area. In this drawing, the biprism is oriented to split vertical lines. The division between the two prisms, where the image is split, is visible in the viewfinder as a horizontal line.

If a scene has no vertical lines, rotate the camera 90 degrees. The biprism will then split horizontal lines.

In some focusing screens, Canon uses a Cross Split-Image optical focusing aid, which is two biprisms at right angles to each other. It splits both horizontal and vertical lines, thus avoiding the necessity of rotating the camera.

A microprism consists of an array of small pyramids whose intersections work like tiny biprisms. A microprism works well on surfaces with texture or small details such as foliage but without definite vertical or horizontal lines.

the ground, a race official, or a fence post. Release the Shutter Button.

The lens will remain focused at the preset distance. When the subject arrives at that distance, there is no need to autofocus again. With the subject visible in the viewfinder, press the Shutter Button fully without pausing at the halfway point.

In the servo AF mode, the camera doesn't require the subject to be in focus. It will take the picture immediately. If you want only a single shot, use the single-exposure winding mode.

If you want several shots, use the continuous-exposure mode. The camera will refocus between exposures if possible, on whatever is in the AF

Frame. Be sure the subject is centered in the viewfinder.

## JUDGING FOCUS VISUALLY

EOS cameras use focusing screens made of precision-molded plastic. They have a *matte* surface resembling ground glass. With the main mirror down, the matte surface receives light rays from the lens and forms an image. If in focus, the image will be sharp.

The distance from lens to focusing screen, with the mirror down, is the same as the distance from lens to film with the mirror up. Therefore, if the image is in good focus on the focusing

screen, it will be in good focus on the film later, when the shutter opens.

When the autofocus system operates, you can see the image come to focus on the focusing screen. It's a good idea to check focus visually, by examining the image on the focusing screen, to be sure that the autofocus system worked as you expected it to.

### IMAGE CUTOFF

The mirror design in most SLRs is a compromise. The mirror is made shorter at the bottom so it will not collide with the front of the mirror box when it swings up to make an exposure. This enables the camera body to be made thinner.

With lenses of short and medium focal length, this has no effect on the viewfinder image.

With long-focal-length lenses, some of the light rays pass below the mirror and are not intercepted when viewing. Some of the image is missing in the viewfinder. However, the film receives the *complete* image when the mirror moves up to make the exposure.

The rays that are not intercepted by the mirror form the top of the image in the viewfinder, so that part of the image is missing or *cut off*, appearing as a dark band across the top of the focusing screen.

Part of the technical description of an SLR camera is the focal length at which viewfinder image cutoff begins. With EOS cameras, it begins at a focal length of 800mm, which is an improvement over earlier models.

### TYPES OF FOCUSING SCREENS

Interchangeable screens for EOS 620/650 cameras are shown in the accompanying drawing. The screen that is installed at the factory is a type C, which has an AF Frame at the center.

Other screens are available as accessories and can be interchanged using a special tool that is packaged with each screen.

None of the accessory screens has an AF Frame. The autofocus system

# HOW TO CHANGE FOCUSING SCREENS IN EOS 620/650 CAMERAS

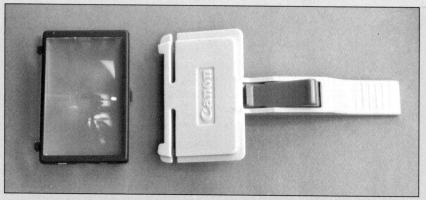

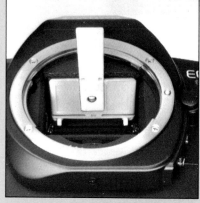

1. Accessory focusing screens are packaged with a special tool to interchange screens. Never touch the surface of a focusing screen with your fingers or any object. Never touch the mirror in the camera. When you know how the special tool works, the rest is easy.

This photo shows the bottom side of a focusing screen. The screen has a metal frame with two tabs at the back. When installed, the tabs fit into grooves in the camera body. The single tab at front is held by a latch in the camera. The dark Latch-Release Lever on the handle of the special tool is used to release the latch.

The focusing screen is recessed in its frame so there is space on the bottom side. The tool fits into the recessed space. The tool has two projections on the front, called Holding Arms, that bend and act as springs.

To grasp the focusing screen shown here, pick up the tool and turn it over. Place the front edge of the tool into the back of the focusing-screen frame, opposite the two tabs.

Press forward on the tool, so the Holding Arms bend, then lower the back part of the tool into the focusing-screen frame. Release pressure on the tool, so the Holding Arms spring forward. The tool is locked into the focusing-screen frame.

2. To change focusing screens, remove the camera lens. Without touching the mirror, carefully place the tool in position under the focusing-screen frame and grasp it as just described. This photo shows the tool locked into the bottom of the focusing-screen frame. Press the Latch-Release Lever on the tool to release the screen. Remove it carefully from the camera, without touching the mirror.

3. Accessory focusing screens are packaged in a case that has a storage area to hold the screen that you removed from the camera—the "old" screen. The "new" screen is visible, at the left end of the case. The old screen is attached to the tool, ready to be placed in the storage area. Press forward on the tool handle to flex the Holding Arms. Lift the tool out of the frame of the old focusing-screen. It may be necessary to touch the corner of the frame with your finger so you can withdraw the tool.

4. Use the tool to grasp the new screen. Look into the camera to locate the grooves that receive the two tabs on the back of the focusing-screen frame. Position tool and screen as shown here. Carefully place the screen in the camera, inserting the tabs into the grooves. Lift the handle of the tool until the screen is latched in place.

Press forward on the tool to flex the Holding Arms. Lower the handle of the tool to detach it from the focusing screen.

Use the tool to move the old screen forward to the area in the case that was occupied by the new screen. Place the tool in the area formerly occupied by the old screen. Close the lid. Replace the camera lens.

# HOW TO HOLD THE CAMERA

When holding the camera horizontally, support camera and lens with your left hand. If you are focusing the lens manually, use your thumb and forefinger to turn the Manual Focusing Ring on the lens. Operate the shutter button with your right forefinger.

To make a vertical shot, viewing with the right eye, just rotate the camera and operate it as described.

To view with the left eye, rotate the camera in the other direction and operate the Shutter Button with your right thumb.

No matter how you hold the camera, take a braced stance, tuck your elbow snugly against your body and don't breathe while making the shot. When possible, support your body or the camera by leaning against a wall or tree, putting your elbows on a fence rail or chair back, or using some other firm supporting surface.

works the same with or without an AF Frame in the viewfinder. Some of the accessory screens have an optical focusing aid at the center, to assist you in judging focus visually.

EOS 750/850 cameras use a non-interchangeable focusing screen with an AF Frame at the center.

## OPTICAL FOCUSING AIDS

Judging focus visually by observing the matte area of a focusing screen is usually satisfactory. However, there are more precise optical focusing aids that may be useful when focusing the lens manually, especially on subjects that cannot be autofocused.

Optical focusing aids are at the center of some accessory focusing screens, in the area normally occupied by the AF Frame. They have no effect on the camera autofocus system.

**Split Image**—This focusing aid appears as a circle with a horizontal line through the center. It will "split" a vertical line or edge if the image is not in focus. Part of the line moves in one direction part in the opposite direction.

To obtain correct focus manually, turn the lens focus control so the two parts of the vertical line move toward each other. When the line is continuous, not split, the image is in best focus. The technical name for this focusing aid is *biprism.*

**Microprism**—A *microprism* is useful to check focus on a textured surface, such as foliage, where there are no clearly visible vertical lines to split with a biprism.

A microprism consists of an array of tiny pyramids whose intersections work like small biprisms. When the image is in focus, you are unaware of the microprism. When the image is out of focus, it breaks up into a grid pattern

caused by the tiny pyramids. If the camera shakes, as it may do when handheld, the image seems to scintillate when out of focus.

**Focusing-Aid Blackout**—If you install an accessory focusing screen with an optical focusing aid at the center, you may notice that it "blacks out" when you press the Depth of Field Check Button to view the scene at small aperture.

A biprism focusing aid is two small prisms, angled in opposite directions. When looking at the scene through a biprism, one segment deviates your line of sight to the left, the other to the right.

With a small aperture, both lines of sight can't get through the aperture opening simultaneously. Depending on where your eye is at the viewfinder, one segment of the biprism is black and the other is bright. If you move your

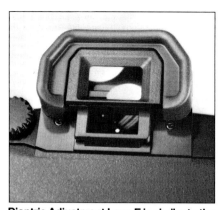

Dioptric Adjustment Lens E is similar to the standard rubber eyecup, except that it has a built-in lens to provide eyesight correction. To install, remove the standard eyecup and replace with Dioptric Adjustment Lens E. In this photo, you can see reflections in the viewfinder optics and in the Dioptric Adjustment Lens. Adjustment lenses are available in 10 diopter strengths, listed in the accompanying text.

An Angle Finder clips over the viewfinder eyepiece frame, replacing the standard rubber eyecup. It rotates so you can view from above, below, or any angle in between.

A magnifier helps you judge focus visually by magnifying the central part of the image. The magnifier can be flipped up, out of the way, so you can see the entire image.

eye to the left or right, the effect reverses and the opposite segment of the biprism blacks out. A microprism focusing aid blacks out at small aperture in a similar way.

Normally, viewing and focusing is done at maximum aperture and the focusing aid is not blacked out. A microprism blacks out at apertures of f-5.6 and smaller.

Canon uses an improved biprism design, called New Split. It also won't work as focusing aid at apertures smaller than f-5.6, but will not black out at the smaller apertures, thus eliminating a disturbing distraction to the viewer.

## VIEWING AIDS

Some viewfinders require you to place your eye very close to the viewfinder eyepiece to see the entire frame. The distance from eye to eyepiece is determined by the *eyepoint*. A relatively long eyepoint distance is more comfortable, especially if you are moving the camera around rapidly such as when photographing sports. It is also appreciated by those who wear eyeglasses, because it allows room for the glasses.

The eyepoint distance for EOS 620/650 models is 19.3mm (0.76 in.). For EOS 750/850 cameras, it is 16mm (0.63 in.).

## DIOPTRIC ADJUSTMENT LENSES

The viewfinder optics provide an image of the focusing screen that appears to be about one meter distant— about arm's length. If your vision is good at that distance, you can judge focus accurately by looking at the image in the viewfinder.

If you wear eyeglasses to correct your vision at a distance of 1 meter, you have two choices. You can wear your glasses while viewing. Or, you can change the viewfinder optics to match your eyeglass prescription so you can use the camera without wearing your glasses.

Changing the viewfinder optics to match your eyeglass prescription is done by attaching an accessory lens to the viewfinder eyepiece. Eyeglass prescriptions are written in diopters, which is a measure of optical "power." The accessory lenses are called Dioptric Adjustment Lenses.

EOS cameras use Dioptric Adjustment Lens E, which has a rubber frame similar to the standard rubber frame around the viewfinder eyepiece.

Ten strengths of adjustment lenses are available, each labeled with the *resulting* diopter power of the viewfinder system *after* the adjustment lens

is attached. The powers are: $+3$, $+2$, $+1.5$, $+1$, $+0.5$, $0$, $-0.5$, $-2$, $-3$, and $-4$. The power of the viewfinder optics without an accessory lens is $-1$ diopter, therefore there is no accessory lens with that power.

Theoretically, if your eyeglass prescription is $+1.5$ diopters for a subject at 1 meter, you should use a $+1.5$ Dioptric Adjustment Lens. If you wear bifocals or trifocals, your lenses have two or three diopter values.

The best way to select a Dioptric Adjustment Lens is by trial, testing lenses from your dealer's stock. One way is to let the camera focus a subject automatically. Then choose an adjustment lens so the focus looks best to your eye. Another method is to choose an adjustment lens so the AF frame or any of the lines on a focusing screen appear sharp with the lens pointed toward a blank surface such as a wall.

## ANGLE FINDER

You may occasionally put the camera at a location—such as on the floor—where it's difficult to place your eye at the viewfinder eyepiece. Angle Finder attachments, sometimes called Right-Angle Finders, are available to solve the problem.

As you can see in the accompanying photo, an angle finder attaches to the viewfinder eyepiece. It can be rotated so you can view from above the camera, below, or at any intermediate angle.

Two types are available for EOS cameras. Angle Finder A2 inverts the image. Angle Finder B shows a correct, upright image.

## MAGNIFIER

For precise manual focusing, it is sometimes desirable to magnify the viewfinder image. Magnifier S fits on the viewfinder eyepiece and enlarges the central area of the image by a factor of 2.5. You don't see the entire frame when viewing through the magnifier.

The magnifier can be flipped up out of the way, so you can see the entire frame.

# Films

Color film, when correctly exposed, provides a range of brightnesses and colors that we accept as realistic.

This chapter discusses color and black-and-white films. There are several types of film that you can use in a 35mm camera. Each is available in a range of film speeds.

## B&W NEGATIVE FILM

This produces a negative black-and-white (b&w) image. In a negative, brightnesses are reversed, white becoming black and black becoming white.

To make a positive image, the negative is exposed onto photographic printing paper. When developed, the brightnesses have reversed again, so the image looks normal. Usually, the printed image is also enlarged.

## COLOR NEGATIVE FILM

This film makes a negative image in color. Brightnesses are reversed in a way similar to b&w negative film. Also, the colors are "reversed." The reverse of a color is called its *complement,* discussed later in this chapter.

The reversed brightnesses and colors of the negative are exposed onto color

**A black-and-white negative has reversed brightnesses compared to the resulting print.**

printing paper and a normal-looking image results. Color negative film is usually labeled Color Print film because a color print is the end result.

## COLOR SLIDE FILM

When exposed in the camera, a *latent* negative image is placed on slide film. In subsequent chemical processing, the image is reversed to a visible positive image in color. The color slide that is returned to you is the same piece of film that you originally exposed in the camera.

## SPECIAL-PURPOSE FILMS

There are a lot of special-purpose films. Some are discussed briefly later in this chapter.

## EXPOSING FILM

Black-and-white film has a clear base on which is coated a light-sensitive photographic *emulsion* composed of silver-halide particles dispersed in gelatin. It is exposed by allowing light to reach the emulsion surface. Where light strikes the emulsion, silver-halide particles are sensitized. Brighter light sensitizes more of the particles. An invisible latent image is formed.

After exposure, the film is processed chemically, to *develop* the image. This changes the sensitized particles of silver halide into metallic silver particles, which are black and opaque to light.

This discussion is about b&w film

**In a color negative, both brightnesses and colors are reversed. The additional overall orange color, evident in this negative, serves to produce better color fidelity in the final print.**

**When you make a color print, colors and brightnesses are reversed again, to appear normal. The overall orange cast is removed during the printing procedure.**

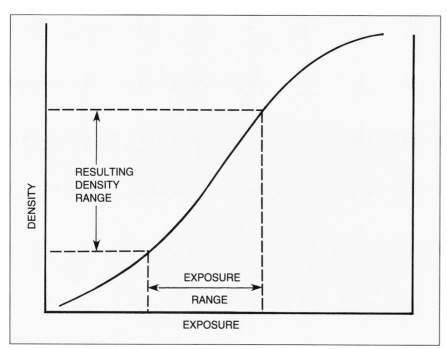

Figure 4-1/Each type of film has a characteristic curve similar to this. It shows how the exposure range is converted to a range of densities in the processed film. The central part of the curve is a straight line, or nearly so. When the exposure range falls mainly on the straight part of the curve, the result will be a satisfactory record of the scene brightnesses.

Notice that the toe of the curve flattens out toward horizontal. If exposure extends into the toe area, the resulting densities can not be distinguished from each other. This causes loss of shadow detail in the print.

If the shoulder of the film curve is used, highlight detail is lost. Brighter objects in the scene blend together and are lost in solid white.

**Fitting Scene Brightnesses onto the Curve**—To make a good exposure, there are two things to consider: the scene brightness range and where it is placed on the characteristic curve of the film.

By using exposure controls on the camera, as discussed in the next chapter, you can center the scene brightness range on the straight section of the curve. Then, if the brightness range is not too wide, neither the toe nor the shoulder will be used and an acceptable exposure results. That is the situation shown by Figure 4-1.

**Underexposure**—If you place the exposure too far to the left on the curve, the toe section will be used and the photo will lose shadow detail. That is underexposure.

**Overexposure**—If the scene brightness range is too far to the right, the shoulder is used and you lose highlight detail. That is overexposure.

An over- or underexposed negative can usually be improved during printing. However, shadow or highlight details that are lost on the negative cannot be restored.

**Brightness Range too Wide**—If the scene brightness range is wider than the straight part of the curve, the photo loses shadow or highlight detail or both, depending on how the exposure is placed on the curve.

**Calculating Brightness Range**—The exposure range on the film is determined by the range of brightnesses in the scene. Exposure is measured in steps. Each step is double the next smaller value.

A very dark object in the scene may reflect about 3% of the light that falls on it. A white object may reflect about

because it is simpler and easier to understand than color film. However, the basic concepts discussed here also apply to color film. The essential difference is that color film produces a color image.

**Brightness Range**—Each object in the scene reflects light toward the camera. The scene has a range of brightnesses.

**Density Range**—The darkness of an area on the film is called *density*. When b&w negative film is exposed and then developed, a white area of the scene causes the negative to be black. Black areas cause it to be clear. Intermediate brightnesses in the scene cause shades of gray. B&W film has a range of densities from clear to black with shades of gray in between.

**Exposure Range**—The goal of b&w photography is to record each part of

the scene by a shade of gray that is proportional to its brightness. Each brightness of the scene must have a corresponding density on the negative.

The scene must be exposed in such a way that the brightness range of the scene corresponds with the density range of the film.

**Characteristic Curve**—Figure 4-1 shows how b&w film responds to exposure. It shows a range of exposure along the bottom of the graph—caused by the scene brightness range.

The resulting range of film densities is shown vertically, on the left. Each different value within the exposure range causes a different density on the film. This graph shows the film's characteristic curve. The curve is relatively straight along the middle but it has a *toe* at the bottom and a *shoulder* at the top.

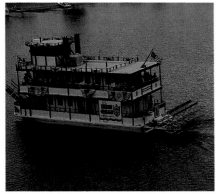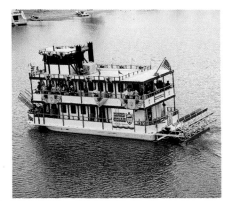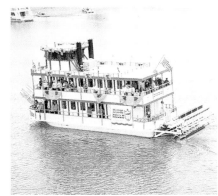

Underexposure causes loss of detail in the dark or shadowed areas of the scene. Overexposure causes loss of detail in the bright areas.

96%. It's easy to calculate the number of exposure steps between those extremes by doubling the numbers starting at 3:

3 - 6 - 12 - 24 - 48 - 96

The dashes represent exposure steps. The scene-brightness range is 5 steps.

A general-purpose b&w film can accept about seven steps of exposure without getting too far into the toe or shoulder and losing detail.

**Uneven Scene Illumination**—If 100 "units" of light fall everywhere on the scene, then the part that reflects 3% will reflect 3 units, the part that reflects 6% will reflect 6 units, and so forth.

However, if part of the scene receives 100 units of light but another part receives only 25 units because it is in shadow, the scene brightness range will almost certainly be increased.

Suppose the darkest object in the scene is in shadow. It reflects 3% of 25 light units, which is only 0.75 unit. Calculating again:

0.75 - 1.5 - 3 - 6 - 12 - 24 - 48 - 96

The scene-brightness range is seven exposure steps because part of the scene is in shadow. In order not to lose detail in shadows and highlight areas, exposure must be very accurate.

The brightness range of a scene is determined both by the reflectivity of objects in the scene and variations of illumination on the scene.

In bright sunlight with shadows, the usable exposure range of the film may be exceeded. You can set exposure to lose shadow detail, or highlight detail, or some of each. Setting exposure is discussed in Chapter 5.

### EXPOSURE LATITUDE

If the usable part of the film characteristic curve is seven steps wide and the brightness range of the scene is also seven steps, there is no latitude. The exposure must be exactly centered on the usable part of the curve.

If the film can accomodate seven steps, but the brightness range of the scene is only four steps, then there is some exposure latitude. You can vary exposure somewhat without losing picture detail. The overall tonality of the photo will be a little lighter or darker,

but you will not lose any detail.

Exposure latitude depends both on the number of exposure steps the film can accept and the brightness range of the scene.

## COLOR FILM

Reproduction of color on film is based on the fact that the human eye responds to only three colors: red, green and blue. These are called the *primary* colors.

All visible colors can be produced by combinations of red, green and blue light in various proportions. If your eye sees a mixture of equal amounts of red, green and blue, your brain "sees" white light. If the brightness of all three colors is reduced, you perceive a shade of gray. The absence of all light gives black.

There are three *complementary* colors that are formed by combining primary colors. The combination of red and green produces yellow. Red and blue combine to make a purple color called magenta. Green and blue make cyan.

Photos with strong, vivid colors are eye-catching and can be very attractive.

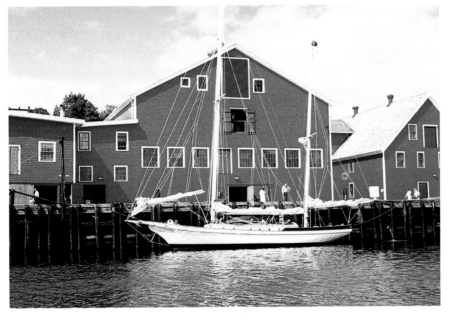

Each color has many shades. Lighter shades are made by adding white. If no white is present, a color is very strong and we say it is *saturated*.

## COLOR NEGATIVE FILM

In its simplest form, color negative film has three layers of emulsion, each similar to the emulsion of b&w film. The film is manufactured so that each layer responds to only one of the three primary colors.

When color negative film has been exposed, each layer has a latent image that records a single primary color. For example, the red-sensitive layer has a "map" showing the amount of red at each point on the scene.

In processing, the latent silver-halide image in each layer is developed and then replaced with a visible color image formed by a chemical dye. The colors are complementary—"reversed" compared to the actual colors of the scene. The layers of negative color film are cyan, magenta, or yellow. Each has reversed colors *and* reversed brightnesses of the scene.

To make a color print, white light projected through the color negative is used to expose color printing paper. Color printing paper also has three layers, similar to the three layers of the negative. The result is that the scene brightnesses and colors are reversed again to provide a positive image that resembles the original scene.

**Exposure Considerations**—What was said earlier about exposing b&w film applies also to color negative film. The film has a characteristic curve with a straight part, a toe and a shoulder.

The usable exposure range of color negative film is *narrower* than that of b&w film. Typically, it is about five exposure steps, which is enough to record most scenes under uniform illumination but not enough for outdoor scenes with bright sunlit and dark shaded areas.

If you can control the lighting, as in a studio, avoid large light variations on the scene. Outdoors, shooting on an overcast day will avoid loss of shadow detail. In sunlight, you can "fill" shadows to make them lighter by using flash or reflector cards.

Over- or underexposure of the negative can be compensated to some extent during printing. For this reason, color negative film is said to have a relatively wide exposure latitude.

## COLOR SLIDE FILM

Color slide film also has three silver-halide layers, each responding to a single primary color. In the developing procedure, each layer is converted to the *original* primary color and brightness. The result is a positive image on the same piece of film that was originally exposed in the camera.

**Exposure Considerations**—Slide film also has a characteristic curve with a toe and shoulder. The usable exposure range is about five or six steps.

Depending on the subject and composition, photos with muted, similar colors can also be very effective.

Because there is no subsequent printing stage, at which exposure errors could be compensated for, a correctly exposed slide must be correctly exposed in the camera at the time the photo is taken.

# FILM SPEED

Each film type is assigned a film-speed number, such as 25 or 400, by the manufacturer. The purpose is to tell the camera how much exposure the film needs to place the brightness range of an *average* scene at the correct location on the film's characteristic curve.

### THE STANDARDS

The system of ASA film-speed ratings shown in Figure 4-2 was developed by the American Standards Association (now called the American National Standards Institute).

In Germany, a system called DIN has been used. DIN film-speed numbers are followed by a degree symbol.

The now commonly used International Standards Organization (ISO) method of specifying film speed simply combines ASA and DIN numbers, as shown in Figure 4-3.

EOS 620/650 cameras use ISO to identify film-speed numbers. The numbers that are displayed are only the first part of the ISO designation. For example, ISO 100/21° is displayed as ISO 100.

### EFFECT ON EXPOSURE

Figure 4-2, the *standard* film speed series is shown by the large numbers, such as 25, 50, 100, 200 and so forth. These numbers double as the series progresses.

Higher film-speed numbers represent faster films that require less expo-

sure. Each *larger* number in the *standard* series demands an exposure that is *half* the preceding value.

The difference in exposure between one *standard* film-speed number and the next is one exposure step. ISO 400 film requires one step *less* exposure than ISO 200 film.

Not all films have speeds that can be stated by numbers in the standard series. Between the standard speeds are two intermediate speeds, representing one-third steps. The intermediate settings are shown by dots in the scale of Figure 4-2.

### CHOOSING FILM SPEED

Most types of film are available in a range of film speeds. To shoot in dim light, you may prefer a fast film, such as ISO 400 or faster. Fast film requires shorter exposure times, which may allow you to hand-hold the camera rather

## FILM-SPEED VALUES USED IN EOS CAMERAS

| Full Steps | Intermediate 1/3 steps |
|---|---|
| 6 | |
| | 8 |
| | 10 |
| 12 | |
| | 16 |
| | 20 |
| 25 | |
| | 32 |
| | 40 |
| 50 | |
| | 64 |
| | 80 |
| 100 | |
| | 125 |
| | 160 |
| 200 | |
| | 250 |
| | 320 |
| 400 | |
| | 500 |
| | 640 |
| 800 | |
| | 1000 |
| | 1250 |
| 1600 | |
| | 2000 |
| | 2500 |
| 3200 | |
| | 4000 |
| | 5000 |
| 6400 | |

Figure 4-2/Film speed in EOS cameras can be set in standard full steps or intermediate 1/3 steps.

## ISO FILM SPEED RATINGS

| Full Steps | Intermediate 1/3 steps |
|---|---|
| 6/9° | |
| | 8/10° |
| | 10/11° |
| 12/12° | |
| | 16/13° |
| | 20/14° |
| 25/15° | |
| | 32/16° |
| | 40/17° |
| 50/18° | |
| | 64/19° |
| | 80/20° |
| 100/21° | |
| | 125/22° |
| | 160/23° |
| 200/24° | |
| | 250/25° |
| | 320/26° |
| 400/27° | |
| | 500/28° |
| | 640/29° |
| 800/30° | |
| | 1000/31° |
| | 1250/32° |
| 1600/33° | |
| | 2000/34° |
| | 2500/35° |
| 3200/36° | |
| | 4000/37° |
| | 5000/38° |
| 6400/39° | |

Figure 4-3/The ISO method of stating film speed combines ASA and DIN values, using the form ASA/DIN such as 400/27°. Only the first part of the ISO film speed is used in EOS camera displays, such as 400.

than putting it on a tripod.

In bright sunlight, fast film may be a disadvantage because it forces you to use both small aperture and fast shutter speeds. To control depth of field, you may prefer larger aperture.

Usually, slower films produce sharper images, with less visible grain.

## COLOR BALANCE

If colors are believable and satisfactorily close to the original scene, the film has good color balance. Films of various types have slightly different color balance. Some show skin tones that are *warm,* or biased slightly toward red. Others reproduce skin tones as relatively *cold,* or bluish.

Photo magazines often publish surveys of color films with test photos, so you can judge color balance and other factors relating to image quality.

**Daylight and Tungsten Films**—Both color print and slide films are available with color balance suitable for use either with daylight illumination or incandescent lamps with tungsten filaments. The film carton is marked Daylight or Tungsten. More information on this topic is in Chapter 6.

## FILM STORAGE

After manufacture, film changes its color balance and other characteristics slowly until it is developed. The changes are accelerated by high temperature and high humidity. They are reduced by storage at low temperatures and virtually stopped by freezing.

Film cartons are imprinted with an "expiration" date, after which image quality *may* not be satisfactory.

Films are available as professional or general-purpose. The difference is mainly in storage requirements.

**Professional Films**—After manufacture, professional films are held at the factory until they have aged to the best color balance. They are refrigerated to stop further changes and shipped under refrigeration to retail suppliers of professional films. At the store, they should be held under refrigeration.

After purchase, they should be refrigerated until shortly before use. Film should be allowed to warm up to room temperature, before the seal on the package is broken. After exposure, if not processed immediately, film should be refrigerated again until processed.

**General-Purpose Films**—Films for the general public are held at room temperature until sold and usually held by the user at room temperature until exposed and processed. During this time, the color balance will slowly change. For general use, the change is so small that it is usually acceptable or not even noticed. The expiration date shows the approximate end of the usable life, when stored at room temperature.

If you store general-purpose film in a refrigerator, the change in characteristics will slow down greatly. It does not guarantee that the film is at its optimum color balance.

Store film as suggested on the carton. If you must store film for a very long time, you can freeze it. This may protect its quality even beyond the expiration date on the carton.

Film is packaged to protect it from humidity. Leave it in the original packaging until just before you use it.

If you refrigerate film, keep it in the original packaging while being re-

## IR FOCUSING MARKS

Lenses are designed to bring all visible colors of light to focus at the film plane. Special black-and-white infrared (IR) films are intended to form an image using only IR light rays, which are invisible to the human eye. Bringing IR light rays to focus requires a different distance between lens and film than focusing with visible light.

To use special black-and-white IR film, begin by focusing in the usual way with visible light. Notice the subject distance on the lens focused-distance scale. Place an IR (dark red) filter over the lens to exclude visible light. Set the Focus-Mode Switch on the lens to M for manual focus. Refocus the lens manually as shown.

There is color IR film, which makes the exposure partly with IR light and partly with visible light. Focus color IR film in the usual way, as though it were being exposed only with visible light.

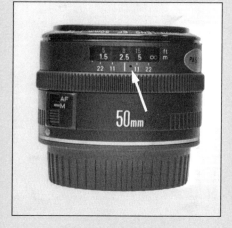

On this 50mm lens, focused distance is read opposite the white Index Mark below the Focused-Distance Scale. This lens is focused at a subject distance of 2.5 meters, approximately 8 feet. To the right of the Index Mark is a red dot (indicated by an arrow), called the IR Focusing Mark. The numbers 11 and 22 form a Depth-of-Field scale.

After focusing the lens with visible light, you can focus the lens for IR (infrared). Turn the Manual Focusing Ring to place the subject distance opposite the IR Focusing Mark instead of the white index mark. If the subject distance is 2.5 meters with visible light, place that scale value, 2.5 meters, opposite the IR mark.

Zoom lenses usually have a different IR Focusing Mark for each marked focal-length setting of the lens. For example, this 28—70mm zoom has four focal-length settings on the Zoom Ring—28mm, 35mm, 50mm and 70mm.

Below the Focused-Distance Scale and to the right of the Index Mark, are four IR marks, corresponding to the four focal length settings. The 28mm mark and the 70mm mark are labeled. If you use an in-between focal-length setting, such as 60mm, estimate the location of the IR mark for that focal length.

---

frigerated and for a sufficient time afterward to allow it to return to room temperature. If you open it while it is still colder than the surrounding air, moisture may condense on the emulsion, which will ruin it.

For 35mm film cartridges refrigerated in individual cartons, three hours is normally enough time for it to return to room temperature. If frozen, allow about 24 hours.

## RECIPROCITY FAILURE

The equation shown earlier:

$$\text{Exposure} = \text{Intensity} \times \text{Time}$$

is called the *reciprocity law*. It says that doubling the amount of light on the film will double the exposure of the film.

That is true over a wide range of exposure intervals. However, with very short and very long exposure times, it is not exactly true. Those deviations are referred to as failures of the reciprocity law, or *reciprocity failure*.

When reciprocity failure occurs, at either long or short exposures, the film does not receive as much exposure as it should. The basic adjustment is to give more exposure by using larger aperture or extending the exposure time.

With b&w and color films, ex-

posures longer than about 1 second may cause low-light reciprocity failure.

With b&w film, exposures shorter than about 1/1000 second may cause short-duration reciprocity failure. Very short exposures are produced by electronic flash. Because you can't make the flash last longer, the correction is to use a larger aperture.

Color films generally tolerate very short exposures and corrections are usually not needed.

There are two ways to compensate for reciprocity failure due to low light levels and, therefore, long exposure time: use larger aperture or even longer

exposure time. Larger aperture is better, because longer time adds to the reciprocity-failure effect.

**Effect on Color**—Color films suffer low-light reciprocity failure. The three emulsion layers go into reciprocity failure at different exposure times and to different degrees. This causes a change in color balance.

**Correction for B&W Films**—The correction is both increased exposure and a change in development time.

**Correction for Color Films**—The correction is increased exposure plus use of a color filter over the lens to correct the change in color balance. Filters are discussed in Chapter 6.

## SPECIAL-PURPOSE FILMS

There are a lot of special-purpose films. Here are a few types.

**B&W Infrared Film**—Infrared (IR) light is not visible to the human eye. This film is sensitive both to visible light and to infrared. It is normally exposed with a dark red filter over the lens, which blocks all or most of the visible light. The film then records mainly the IR radiation reflected by the scene. This can give a scene a surreal effect or make a daylight photo appear to have been taken by moonlight.

Focusing with IR light and b&w infrared film requires a special technique, shown in the accompanying illustration.

**Color Infrared Film**—This is color slide film. The three emulsion layers record red, green and IR images of the scene. This film has medical and scientific uses. It is also used, with color filters, to produce startling color slides whose colors are greatly altered from the original scene.

This film is focused in the usual way, the same as ordinary color films with visible light.

**Chromogenic B&W Film**—The word *chromogenic* means to produce color. This film produces b&w images in a way similar to color films. The latent silver image is replaced with a black or near-black dye image. The result is similar to a normal b&w negative except that the image is formed by dye rather than particles of metallic silver. Processing is the same as color negative film and most film labs can do it.

The advantages are less visible grain in the image and variable film speed. Chromogenic b&w film can be exposed over a range of film-speed settings without any change in processing.

**Instant Slide Film**—This film, made by Polaroid Corporation, is a self-developing color slide film, similar to instant print film. It can be used in any 35mm SLR camera. It is developed in a small accessory developing machine.

**FILM INFORMATION**

Manufacturers regularly introduce new films and often change the characteristics of existing film types. For up-to-date information, such as reciprocity-failure corrections, consult the film manufacturer or your photo dealer.

# Exposure Metering & Control

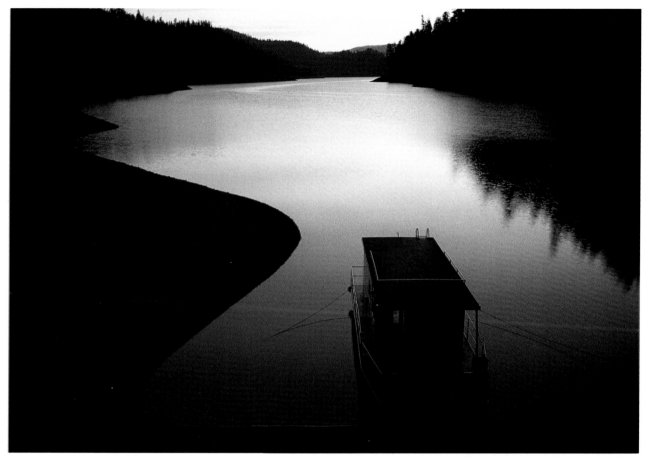

The evaluative metering system of an EOS camera set exposure automatically for this early-morning scene. With other types of metering, an adjustment by the camera operator would be necessary to compensate for the bright area near the center of the photo.

EOS cameras have a built-in exposure-control system that measures scene brightness and then calculates aperture size and shutter speed to correctly expose the film. The camera "knows" how much exposure the film needs because the film-speed number conveys that information.

## SETTING FILM SPEED

For good exposures, you should normally have the correct film-speed number set into the camera.

**EOS 620/650 DX Coding**—If you load a DX-coded film cartridge, film speed is set automatically. The range of possible automatic settings is ISO 25 to ISO 5000. While film is being advanced to frame 1, the LCD Display on top of the camera shows the film-speed number. If you prefer to use a different value, you can change the setting by a manual procedure.

**EOS 620/650 Manual Procedure**— With this procedure, you can set film speeds from ISO 6 to ISO 6400. Turn the Main Switch to A. This procedure will not work with the Main Switch at the green rectangle. Open the Switch Cover on the back of the camera. On the diagram inside the cover, the yellow and blue pushbuttons are shown connected by the symbol ISO. Press the two buttons simultaneously.

The LCD Display will change to show the existing ISO film-speed setting. You have 8 seconds to change it by rotating the Input Dial so the desired ISO value appears in the display.

During the film-loading procedure, while the camera is advancing film to frame 1, the film speed set into the camera is briefly displayed in the LCD Panel on top of the camera. This camera is set for ISO 200.

DX-coded film cartridges are imprinted with data that can be seen through the Film Window in standard camera backs. This camera is loaded with Professional Kodachrome, 36 exposures, ISO 200/24°.

If you finish sooner than 8 seconds, you can restore the display to its normal function by pressing the Shutter Button halfway or pressing the MODE button.
**EOS 620/650 with Non-DX Film**—If you load film without DX coding, the camera will use and display the film-speed setting for the preceding cartridge—which may not be correct. The camera will show the film-speed being used as a *blinking* number in the LCD Display as a way of "asking" you if it is OK. The camera will operate using the set film speed but the ISO value will blink between frames, each time you release the shutter button.

To stop the blinking, set film speed manually. If the blinking value is correct, go through the manual procedure, but don't change the displayed value. If you want to use the camera with the Main Switch at the green rectangle, you can set it now.
**Double-Checking**—A window in the

camera back cover allows you to see if a film cartridge is in the camera and read data imprinted on the cartridge, which normally includes film speed.

To see what speed is actually set in an EOS 620/650 camera, turn the Main Switch to A and press the yellow and blue pushbuttons, just as in the manual procedure. The LCD Display will show the set value for 8 seconds or until you restore the display to its normal function. You can make this check at any point along a roll of film.
**With EOS 750/850 Cameras**—These models are designed to use DX-coded film in the range of ISO 25 to ISO 3200. When DX film is loaded, film speed is set automatically to the nearest full step. For example, ISO 160 film will be set as ISO 200.

The film-speed setting is not displayed but you can look in the window on the back cover to see what is loaded. With non-DX film, ISO 25 is set.

# EXPOSURE METERING

The combination of a light-measuring sensor and an exposure calculator is called an *exposure meter*. The camera's exposure meter measures light coming through the lens. Such meters are called *Through-The-Lens (TTL)* exposure meters.

### LIGHT SENSORS

EOS cameras have two light sensors. Each is a silicon photo cell (SPC) that responds electrically to the amount of light reaching it.

One SPC is in the viewfinder housing, above the focusing screen. It "looks at" the image on the screen and measures its brightness. This sensor is used for ambient or continuous scene illumination, which is the subject of this chapter.

Another light sensor is in the bottom of the mirror box. It is used to measure light and control exposure with electronic flash, as discussed in Chapter 8.

### OPEN-APERTURE METERING

EOS cameras hold the aperture wide open until the moment of exposure, so you get the brightest view of the scene.

Exposure metering is done at that time, with the mirror down and the lens wide open, before the exposure is made. This is called *open-aperture metering*, sometimes *full-aperture metering*.

### AVERAGE SCENES

Exposure metering is based on the "average" scene. An average scene reflects 18 percent of the total light falling on the scene. Light areas of the scene reflect more than dark areas but, *on the average,* 18 percent of the light is reflected toward the camera. Average scenes are those without large areas that are unusually light or dark. Most of the scenes that we photograph, such as landscapes, are average.
**Gray Card**—Camera shops sell cards, called *18-percent gray cards,* that have the same reflectance as an

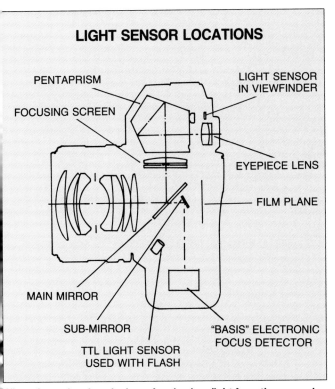

## LIGHT SENSOR LOCATIONS

PENTAPRISM

FOCUSING SCREEN

LIGHT SENSOR IN VIEWFINDER

EYEPIECE LENS

FILM PLANE

MAIN MIRROR

SUB-MIRROR

TTL LIGHT SENSOR USED WITH FLASH

"BASIS" ELECTRONIC FOCUS DETECTOR

When the main mirror is down for viewing, light from the scene is reflected upward to the focusing screen. A light sensor in the viewfinder housing views the focusing-screen image and measures its brightness so the camera's built-in exposure meter can calculate exposure settings.

Simultaneously, some light from the scene is enabled to pass through the main mirror and is reflected downward by the sub-mirror to the BASIS electronic focus detector, which checks focus electronically.

A second light sensor is in the bottom of the mirror box, adjacent to the focus detector. This sensor is used only with electronic flash, with the mirror up, as discussed in Chapter 8.

Camera shops sell 18-percent gray cards that are visually a medium gray. A way to set exposure for any scene in uniform light is to set exposure by metering on a gray card in the same light as the scene.

average scene. A gray card represents an average scene. It can be used as an aid when measuring and setting exposure. Visually, a gray card is a medium shade of gray—sometimes called "middle" gray.

## CALCULATING EXPOSURE

Exposure meters work on the assumption that *every* scene is average and reflects 18 percent of the light. If you photograph an 18-percent gray card, using slide film, the meter does exactly the right thing. In the resulting slide, the image of the gray card looks 18-percent gray.

I am specifying slide film here because the exposure of a slide is determined *entirely* by the exposure setting of the camera. With negative film, the appearance of the resulting print depends also on the printing procedure. With negative film, moderately inaccurate exposures can be saved. With slides, what you shoot is what you get. Because with slide film accurate exposure is most important, in the rest of this chapter I assume that slide film is being used.

**Light Subjects**—If you photograph a white card that fills the frame, the

camera doesn't know it's a white card. It "thinks" everything in the outside world is 18-percent gray, and will expose accordingly. The resulting photo of the card will be 18-percent gray, *which is not correct*. The film should have received more exposure, to make the white card appear white in the photo.

A principal topic of this chapter is how to prevent such mistakes. This mistake can be prevented by using more exposure than the meter calculated. This is called *exposure compensation*. Here's a basic rule: If the

From a metering standpoint, these are average scenes. Areas of light and dark balance each other so the overall scene reflectance is about 18 percent.

These are not average scenes. The light and dark areas don't balance to give an average scene reflectance of about 18 percent.

The exposure-compensation button is labeled EXP.COMP. The circle with horizontal line shows the location of the film plane inside the camera. On this EOS 650, the Main Switch is set to A.

Pressing the EXP.COMP button causes the LCD Panel to display a plus-minus symbol that signifies exposure compensation along with the amount of exposure compensation that has been set. This camera is using zero compensation.

While pressing the EXP.COMP button, you can turn the Input Dial to set exposure compensation from +5 to −5 in half steps. The value in the LCD Display Panel will change accordingly. When set, exposure compensation remains effective until reset to zero. When exposure compensation is any value other than zero, a plus-minus symbol also appears in the viewfinder display as a reminder that the camera is not using metered exposure.

subject is *lighter* than 18-percent gray, use *more* exposure than the meter suggests.

**Dark Subjects**—If you photograph a black card without exposure compensation it will appear 18-percent gray in the photo—because that's what exposure meters are designed to do. The black card will have received too much exposure. Here's the rule for exposure compensation: If the subject is *darker* than 18-percent gray, use *less* exposure than the meter suggests.

Here's a simple way to remember which way to adjust exposure for non-average scenes: If the scene is *lighter* than 18-percent gray, use *more* exposure; if it is *darker* than 18-percent gray, use *less* exposure.

**Adjusting Exposure**—Here is a scale of reflectances, in percentages, with 18 percent at the center. Assuming uniform lighting on the entire scale, the scale shows exposure steps because it is obtained by doubling values:

4.5 - 9 - 18 - 36 - 72.

Black velvet has a reflectance of about 3 percent. The 4.5 percent on the above scale is also black. As you can see, there are 2 steps between black and 18-percent gray. If you show the exposure meter a black card, and you want it to appear black in the photo, use 2 steps less exposure than the meter suggests.

At the other end of this scale, a reflectance of 72 percent is not really white. One more step would be 144 percent, which is not possible. A half-step would be 108 percent—also not possible. White is 90 percent or more, a little less than half a step greater than 72 percent.

If you show the meter a white card, and want it to appear white in the photo, increase the metered exposure by about 2.5 steps.

## EXPOSURE COMPENSATION

EOS 620/650 cameras have a push-button on top labeled EXP.COMP that

is used to give more or less exposure than the meter reading. With the Main Switch set to A, beeper on or off, press the EXP.COMP button and the LCD Display changes to show a number with a plus-minus symbol. If no compensation is being used, the number will be 0.0.

While depressing the EXP.COMP button, rotate the Input Dial so the desired amount of exposure compensation appears in the display. The range of exposure compensation is +5 to -5 exposure steps, in half steps.

When exposure compensation is not zero, a plus-minus symbol appears in the viewfinder exposure display as a reminder. To cancel exposure compensation, set it back to zero.

**How it Works**—If you set an amount of exposure compensation, such as −1, the effect inside the camera is exactly the same as if you had changed the film speed setting. An exposure compensation of −1 tells the camera

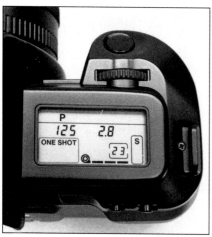

Pressing the EOS 620/650 Shutter Button halfway turns on the camera electronics and displays. If you release the Shutter Button, the displays remain on for eight seconds. This LCD Display Panel shows that the camera is set for Programmed automatic exposure with metered exposure settings of 1/125 second at *f*-2.8. The ONE SHOT **autofocus** mode is being used. Film is in the camera. Frame 23 will be exposed next, using Single-Frame film winding.

## CENTER-WEIGHTED METERING

This drawing shows a center-weighted metering pattern. Maximum meter sensitivity is at the center. Sensitivity decreases progressively in zones away from center. EOS cameras use center-weighted metering with flash only.

If the P symbol in the viewfinder glows steadily, exposure will be OK. If it blinks slowly (two times per second), exposure will be OK, but a slow shutter speed will be used and firm camera support is suggested. If the P symbol blinks rapidly (eight times per second), the scene is too bright or too dark for good exposure. If the scene is dark, use flash. If the scene is bright, use an ND filter on the lens.

## METERING METHODS

The light sensor in the viewfinder of EOS cameras is used in two ways, so there are two metering methods that will be discussed separately. They are called *evaluative* metering and *partial* metering.

The primary metering method is evaluative metering, which is designed to provide correct exposure for non-average scenes automatically. The exposure meter "evaluates" the scene and makes decisions for you.

It will be easier to understand if I begin by describing two earlier metering methods that led to evaluative metering.

**Full-Frame Metering**—Not used in EOS cameras, the exposure meter measures the entire scene impartially. The brightnesses in the frame are averaged and the result used to set exposure. A problem occurs if the subject is against an unusually bright or dark background.

For example, if you photograph a person against a snow bank, the meter reads light from both. If the person is small compared to the background, the exposure meter sees mainly background, which is white. If you use the metered exposure, the snow is underexposed by about 2 steps and appears gray in the photo. The subject is also underexposed about 2 steps and will appear as a silhouette against the gray background. Exposure compensation should be used.

**Center-Weighted Metering**—Not used by EOS cameras to measure ambient scene illumination, this method is an improvement over full-

that the film needs one step less exposure than the ISO number on the film carton suggests. If you have ISO 100 film in the camera and set exposure compensation to −1, the camera behaves as though ISO 200 film were loaded. It will provide correct exposure for ISO 200, which is one step *less* exposure.

You can use exposure compensation any time you wish, except with the Main Switch set to the green rectangle. I have suggested using exposure compensation to give subjects correct appearance, such as making black look black. You can use it to increase or decrease exposure for other reasons.

**High and Low Key**—Photos that often need deliberate overexposure from the metered exposure are *high key* images, such as a photo of a blond model in a white gown in a white room. You can add exposure by using exposure compensation.

Low-key photos are the opposite.

They are mainly dark, having only limited light tones. Reduce the metered exposure by using exposure compensation.

### TURNING THE METER ON

With the EOS 620/650 Main Switch turned on, the exposure meter and displays are turned on by depressing the Shutter Button halfway. The aperture and shutter-speed values to be used for the next exposure are displayed in the viewfinder, below the image area, and in the LCD Display on top of the camera. If you remove your finger from the button, the meter and the displays remain on for 8 seconds. The Shutter Button also controls the autofocus system, as discussed earlier.

**With EOS 750/850 Cameras**—Pressing the Shutter Button halfway turns on the autofocus and metering systems. The camera-selected shutter-speed and aperture settings are not displayed.

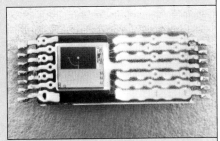
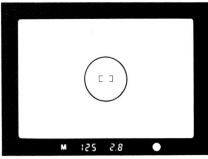
frame metering. The entire scene is measured, but more weight or significance is attached to brightness at the center—for example, 75 percent to the center and 25 percent to the outer area.

If the subject fills the center of the frame, then a background that is unusually light or dark doesn't have much effect on exposure. Exposure compensation is not needed.

If the subject is small compared to the central metering area, or the subject itself is unusually light or dark, then exposure compensation will be required. If the subject is not in the central metering area, exposure is determined mainly by whatever is in the central area. Exposure compensation may be necessary.

Although center-weighted metering is not used by the viewfinder sensor, it is used by the sensor in the mirror box that controls exposure due to flash, discussed later in this book.

## EVALUATIVE METERING

This is the usual way of metering with an EOS 620/650 and the only method with an EOS 750/850 camera. It automatically provides good exposure, even of non-average scenes, without any "help" from the photographer.

The accompanying drawing shows the light sensor in an EOS viewfinder. It is segmented so it measures light in three areas of the frame. The center circle occupies 6.5% of the frame. The surrounding ring is a separate measuring area. The four corners are measured separately, but averaged together.

A computer in the camera uses the three measured brightnesses to *evaluate* the scene and set exposure as needed. For example, the outer two zones may be brighter than the center. The computer concludes that the subject is in the center zone against a bright background. Or, the outer zone may be dark and the two inner zones bright. The computer concludes that the subject occupies the two inner zones against a dark background.

After evaluating the scene, exposure is set automatically for the subject, not the background.

**How Good Is It?**—Evaluative metering works very well for scenes and subjects of the type that most people shoot. It is not designed for unusual situations, with high contrast between subject and background.

**Interaction with Focus Mode**—The preferred way to use evaluative metering is with the one-shot autofocus mode. To focus, you must place the AF

Frame on the subject, which assures that the subject is near the center of the frame.

In the one-shot AF mode, focus locks as soon as it is found. Exposure locks when focus locks. Then you can recompose to place the subject off center if you wish. You can't shoot unless the In-Focus Indicator glows.

In the EOS 620/650 servo AF mode, both focus and exposure may change until the Shutter Button is depressed fully to make the shot. If the subject is centered and the In-Focus Indicator glows, the result should be the same as the one-shot mode. If the subject is not centered, the result is unpredictable.

**Exposure Compensation**—EOS 620/650 exposure compensation can be used with evaluative metering. It won't often be necessary because evaluative metering provides exposure compensation of most scenes automatically.

You can adjust for unusually bright or dark backgrounds, subjects that are much lighter or darker than average, or for high-key or low-key effects.

## PARTIAL METERING

This method is an option of EOS 620/650 cameras. It gives you complete control of exposure. It requires thought and decisions, but it is some-

Gray card

Black center, white background

White center, black background

**The three test targets shown above were photographed with slide film under uniform illumination using EOS evaluative metering. Above left is a gray card. It reproduced as a medium gray, as it should. The other two targets also reproduced correctly even though the center area and background have greatly different brightnesses.**

Chef against white

Model against black

**These photos are similar to the test targets shown above. Both photos were made using evaluative metering. The chef is backlit against a white background. The model is seated in front of a dark fireplace, illuminated by daylight from her left.**

times very useful. Scene brightness is measured only by the center circle in the segmented light sensor in the viewfinder, which is why this is called *partial* metering.

In the accompanying drawing of the standard focusing screen, the circle around the AF Frame designates the part of the scene that is metered: 6.5 percent of the picture area. Accessory focusing screens have the same circle.

You don't have to worry about anything outside that circle. You do have to worry about what's in the circle because the metered exposure will cause that area to record on film as though it had 18 percent reflectance—whether it does or not.

The part of the scene that is included in the metering circle depends on focal length. Longer focal lengths make the

image larger, so the fixed-diameter circle appears smaller. With a zoom lens, for example, you can zoom to a long focal length and place the metering circle on a subject's face or clothing. Lock exposure and then zoom back to include more of the scene.

An asterisk symbol appears in the viewfinder display to show that the partial meter reading is locked. If you hold the Shutter Button depressed halfway, you can release the Partial-Metering Button and the exposure reading will still be locked.

**Turning on the Meter**—The Partial-Metering Button is at top right on the back of the camera. Operate it with your right thumb.

To use partial metering, you must first press the Shutter Button halfway. That turns on the camera *evaluative*

metering system and it makes an exposure reading.

**Interaction with Focus Mode**—Using partial metering and the one-shot AF mode, you can set exposure on one object, set focus on a different object, and then compose the scene any way you wish.

Press the Shutter Button halfway. The camera will set focus if possible and set exposure using evaluative metering. These settings will not be used.

Release the Shutter Button. That turns off the autofocus system. The exposure system remains on for 8 seconds. It is not locked.

Place the partial metering circle in the viewfinder on the desired metering surface—in or out of the scene. Press the Partial-Metering Button. Keep

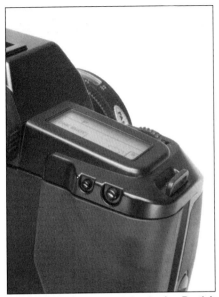

The larger button, at right, is the Partial-Metering Button. On the EOS 620, shown in this photo, the smaller button illuminates the LCD Display Panel in dim light. The EOS 650 has a Partial-Metering Button but does not have LCD Display Panel illumination.

The Partial-Metering Circle in the viewfinder was placed on the white statue and exposure locked, based on that measurement. The result is a gray-looking statue that should appear white.

The Partial-Metering Circle in the viewfinder was placed on the sunlit part of the painted background and exposure locked. The photo was recomposed to place the statue at the center of the frame. Pressing the Shutter Button halfway focused on the statue. Exposure was taken from one part of the scene, focus from another. The white statue appears white.

your thumb on the button to lock that reading.

Place the AF Frame in the viewfinder on the object to be focused—in or out of the scene. Depress the Shutter Button halfway to focus. Both focus and exposure are locked by holding the Shutter Button halfway down. You can release the Partial-Metering Button.

Recompose to place the focused object wherever you wish—in or out of the frame. Press the Shutter Button fully to make the shot.

With the servo AF mode, operation is similar except that focus cannot be locked and therefore you cannot compose with the focused object off center.

**Using the Partial Meter**—Because the partial meter measures only a small area of the scene, you can use it like a probe to select a small area of a single brightness. For example, if you place an 18-percent gray card in the scene, you can measure the card and lock that exposure.

If you shoot with the card in the scene, it will reproduce correctly in the resulting photo. Assuming uniform scene illumination, and not excessive subject contrast, everything else in the scene will be correct also.

If you lock exposure and then remove the gray card, the result will be the same except that the card won't be in the picture.

You don't have to use a gray card. Meter on any medium tone in the scene, lock exposure and shoot. You can meter on a group of different brightnesses, if they average to about 18 percent reflectance. For example, you can meter on a checkerboard. The white and black squares will average to a medium gray.

**Substitute Metering**—The metering surface doesn't have to be in the scene. Find any medium tone that is in the *same light* as the scene. Lock exposure. Recompose and shoot. You have *substituted* a metering surface outside the scene for one inside the scene.

The world is well supplied with medium tones to meter on, once you learn to recognize them: grass, dirt and weeds, asphalt streets, foliage, carpets, painted walls, upholstery, and many others.

**Light or Dark Backgrounds**—With partial metering, you can usually exclude the background from the reading. Use a long lens or move close enough so the subject fills the metering circle. Then, exposure is based only on sub-

## EV NUMBERS AND EQUIVALENT EXPOSURE SETTING

| Aperture | Shutter Speed (sec.) | | | | | | | | | |
|---|---|---|---|---|---|---|---|---|---|---|
| | 30 | 15 | 8 | 4 | 2 | 1 | 1/2 | 1/4 | 1/8 | 1/15 |
| f-1.0 | −5 | −4 | −3 | −2 | −1 | 0 | 1 | 2 | 3 | 4 |
| f-1.4 | −4 | −3 | −2 | −1 | 0 | 1 | 2 | 3 | 4 | 5 |
| f-2.0 | −3 | −2 | −1 | 0 | 1 | 2 | 3 | 4 | 5 | 6 |
| f-2.8 | −2 | −1 | 0 | 1 | 2 | 3 | 4 | 5 | 6 | 7 |
| f-4.0 | −1 | 0 | 1 | 2 | 3 | 4 | 5 | 6 | 7 | 8 |
| f-5.6 | 0 | 1 | 2 | 3 | 4 | 5 | 6 | 7 | 8 | 9 |
| f-8.0 | 1 | 2 | 3 | 4 | 5 | 6 | 7 | 8 | 9 | 10 |
| f-11 | 2 | 3 | 4 | 5 | 6 | 7 | 8 | 9 | 10 | 11 |
| f-16 | 3 | 4 | 5 | 6 | 7 | 8 | 9 | 10 | 11 | 12 |
| f-22 | 4 | 5 | 6 | 7 | 8 | 9 | 10 | 11 | 12 | 13 |
| f-32 | 5 | 6 | 7 | 8 | 9 | 10 | 11 | 12 | 13 | 14 |

EV numbers are in the body of these table. The *f*-number scale is at left, shutter speeds along the top. For example, the EV number representing *f*-4.0 at 1/1000 second is EV 14. All other *pairs* of shutter-speed and aperture values that give the same amount of exposure—for example *f*-5.6 at 1/500 second and *f*-8.0 at 1/250 second—are also EV 14.

ject reflectance. If the subject is a medium tone, lock exposure and shoot.

**Exposure Compensation**—If you don't measure on a medium tone with about 18 percent reflectance, you must use exposure compensation—if you want the metered tone to be correctly rendered.

The reflectance of light skin is about 36 percent, which is one step greater than 18 percent. If you meter on light skin and use the metered exposure, the skin tone will end up too dark—near 18 percent in the image. Correct exposure should require one more exposure step. however, if the meter reading includes skin and some darker background or clothing, the skin tone will probably be OK.

The back side of a commercially available 18-percent gray card is white, with a reflectance of 90 percent, which is 5 times as much as 18 percent. White paper has about the same reflectance. If you meter on white, give 5 times as much exposure, which is nearly 2.5 steps. If you meter on black, use 2 or 2.5 steps less exposure.

**Uneven Illumination**—If a scene is partly in bright light and partly in shadow, and it has a wide range of reflectances in both areas, the photo will usually lose some detail in the shadows or highlights.

To preserve shadow detail, use partial metering to measure a medium tone in the shaded part of the scene. Highlight detail will be lost into white. To preserve highlight detail, meter on a medium tone in the brightly lit area. Shadow detail will be lost into black.

**Main Switch at Green Rectangle**—At this EOS 620/650 setting, evaluative metering is automatically selected. Partial metering cannot be used.

### THE SUNNY-DAY f-16 RULE

A rule of thumb for setting outdoor

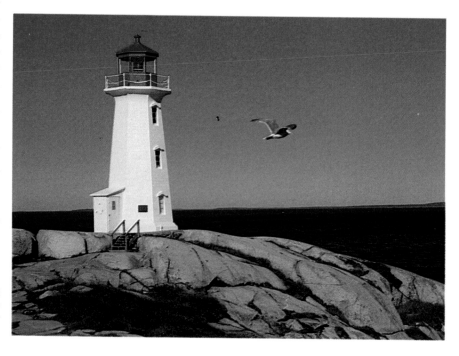

Because this scene is in direct sunlight on a clear day, it can be photographed with manual exposure control, using the "sunny-day-*f*-16" rule, discussed in the text.

## EV NUMBERS AND EQUIVALENT EXPOSURE SETTING

| Aperture | Shutter Speed (sec.) | | | | | | | |
|---|---|---|---|---|---|---|---|---|
| | 1/30 | 1/60 | 1/125 | 1/250 | 1/500 | 1/1000 | 1/2000 | 1/4000 |
| f-1.0 | 5 | 6 | 7 | 8 | 9 | 10 | 11 | 12 |
| f-1.4 | 6 | 7 | 8 | 9 | 10 | 11 | 12 | 13 |
| f-2.0 | 7 | 8 | 9 | 10 | 11 | 12 | 13 | 14 |
| f-2.8 | 8 | 9 | 10 | 11 | 12 | 13 | 14 | 15 |
| f-4.0 | 9 | 10 | 11 | 12 | 13 | **14** | 15 | 16 |
| f-5.6 | 10 | 11 | 12 | 13 | 14 | 15 | 16 | 17 |
| f-8.0 | 11 | 12 | 13 | 14 | 15 | 16 | 17 | 18 |
| f-11 | 12 | 13 | 14 | 15 | 16 | 17 | 18 | 19 |
| f-16 | 13 | 14 | 15 | 16 | 17 | 18 | 19 | 20 |
| f-22 | 14 | 15 | 16 | 17 | 18 | 19 | 20 | 21 |
| f-32 | 15 | 16 | 17 | 18 | 19 | 20 | 21 | 22 |

exposure "when all else fails" is: On a sunny day, exposure for an average scene is f-16 and the reciprocal of film speed. If film speed is 125, shutter speed is 1/125 second. Of course, any equivalent aperture and shutter-speed combination, as described below, can also be used.

## EV NUMBERS

Exposure Value (EV) numbers were originally used to designate pairs of f-numbers and shutter speeds that produce the *same* exposure. As you can see in the accompanying table, EV 0 is f-1 at 1 second or f-1.4 at 2 seconds, or f-2 at 4 seconds, and so forth.

EV units are similar to exposure steps. A change from EV 0 to EV 1 is one exposure step.

Another use of EV numbers is to state the scene-brightness range of an exposure meter or electronic focus detector. If the scene is too bright or too dark, these systems can't function properly.

When EV numbers are used to state scene brightness, a film-speed of ISO 100 is assumed and aperture size, usually f-1.4, is given or implied. For example, a *brightness* of EV 0 is the scene illumination that will correctly expose ISO 100 film using an aperture of f-1.4 and a shutter speed of 2

seconds—one of the pairs of exposure settings designated by EV 0.

Using the Sunny-Day f-16 rule and referring to the EV table, you can see that an outdoor scene in sunlight has a brightness of about EV 15.

**Exposure-Meter Range**—The exposure-meter of EOS 650 and EOS 620 cameras works over a brightness range of EV −1 to EV 20. Canon refers to this as the Meter-Coupling Range.

EV −1 is dim, such as at twilight. EV 20 is brighter than a sunlit scene on a clear day.

The exposure meter of EOS 750/850 cameras normally works over a range of EV 0 to EV 20.

**Focus-Detector Range**—The operating range of the electronic focus detector in all current EOS models is EV 1 to EV 18.

Bright light is rarely a problem unless there is a strong reflection. If the scene illumination is too dim, flash units for EOS cameras have built-in AF Auxiliary Light Emitters that allow autofocus on nearby subjects, even in the dark.

## EXPOSURE MODES

EOS cameras have several exposure-control modes that are used with ambient (continuous) scene

illumination. In addition, there are exposure modes with electronic flash, discussed in Chapter 8.

All ambient-light exposure modes discussed in this section are available with EOS 620/650 cameras. The selected mode is shown by a symbol in the LCD Display panel located on top of the camera.

Among these ambient-light modes, only one is available with EOS 750/850 cameras. It is the Program mode, which automatically sets both shutter speed and aperture.

Canon uses the abbreviation AE to mean automatic exposure.

## EOS 620/650 APERTURE-PRIORITY AE

When depth of field is important, use this mode. The aperture setting has priority because aperture controls depth of field. You set aperture to the desired value. The camera then sets shutter speed automatically for correct exposure.

Set the Main Switch at A, beeper on or off. Press the MODE button while turning the Input Dial until an AV symbol (Aperture Value) appears at the top of the LCD Display. This symbol means that the aperture value is fixed but shutter speed may change.

Release the MODE button. An f-

This shows all possible symbols in the LCD Display Panel of an EOS 650. The exposure modes are shown by the symbols across the top of the display, only one of which is used at one time. The M, for example, signifies manual exposure control.

Numerals are constructed using short segments that can be turned on individually. All segments are used to form the numeral 8. If some segments are turned off, 8 becomes 3 or 5, and so forth.

number appears in the LCD Display on top of the camera, just below the AV symbol. Turn the Input Dial to select the desired aperture size.

Compose the image. Press the Shutter Button halfway to turn on the camera electronics and displays. The user-selected aperture and camera-selected shutter speed are displayed in the viewfinder and LCD Display. You can use partial metering, if you wish. Press the shutter button fully to make the shot.

While metering the scene, you can select a different aperture if you wish. Release the shutter button. The exposure meter and display will remain on for 8 seconds. Set aperture by using your right forefinger to rotate the Input Dial. Depress the Shutter Button.

**Viewing Depth of Field**—Pressing the Depth-of-Field Check Button locks exposure and stops down aperture to the set value, so you can see depth of field in the viewfinder. If it is not what you want, turn the Input Dial to change aperture. Depth of field will increase with smaller aperture, decrease with larger aperture. Shutter speed will change automatically to maintain the same EV.

## EOS 620/650 SHUTTER-PRIORITY AE

When shutter-speed is important, use this mode. You choose shutter speed to control image blur due to sub-

ject motion or due to handholding the camera. The camera then sets aperture automatically for correct exposure.

Set the Main Switch at A, beeper on or off. Press the MODE button, while turning the Input Dial until a Tv symbol (Time Value) appears at the top of the LCD Display. This symbol means that the exposure time (shutter speed) is fixed but aperture may change.

Release the MODE button. A shutter speed appears in the LCD Display on top of the camera, just below the Tv symbol. Turn the Input Dial to select the desired shutter speed.

Compose the image. Press the Shutter Button halfway to turn on the camera electronics and displays. The user-selected shutter speed and camera-selected aperture are displayed in the viewfinder and LCD Display. You can use partial metering, if you wish. Press the shutter button fully to make the shot.

While metering, you can select a different shutter speed if you wish. Release the shutter button. The meter and display remain on for 8 seconds. Set shutter speed by using your right forefinger to rotate the Input Dial. Depress the Shutter Button.

**Viewing Depth of Field**—The Depth-of-Field Check Button works. If shutter speed has priority, aperture size and depth of field will be secondary but can be changed by selecting a different shutter speed.

## EOS PROGRAM AE

Use this mode for convenience, when you are not concerned about depth of field. Using a built-in program, the camera sets *both* aperture and shutter speed for correct exposure. Canon refers to this as an *intelligent* program.

With an EOS 750/850 camera, set the Main Switch to PROGRAM. With an EOS 620/650, set the Main Switch at A, beeper on or off. Press the MODE button while turning the Input Dial until a P symbol appears at the top of the LCD Display.

Release the MODE button. Press the Shutter Button halfway to turn on the camera electronics and displays. The camera-selected shutter speed and aperture are displayed in the viewfinder and LCD Display. You can use partial metering, if you wish.

**Intelligent Program**—The intent of the program is to provide correct exposure while minimizing image blur due to camera shake, which it does intelligently, just as you would.

In dim light, the program uses the maximum aperture of the lens, so the shutter speed can be as fast as possible. Aperture size does not change while shutter speed increases with more light. This is shown by the horizontal part of the accompanying program graphs.

If the light increases so shutter speed is approximately equal to the reciprocal

of the lens focal length, a transition occurs. The program stops "worrying" about camera shake—because shutter speed has become fast enough to prevent noticeable image blur. For example, with a 50mm lens, the transition occurs at a shutter speed of 1/50 second.

From that point, as the light becomes brighter, both shutter speed and aperture change gradually. For each step change in shutter speed, there is also a step change in aperture size. This is shown by the angled part of the program graphs.

Because of electronic communication between lens and camera, the camera "knows" the focal length and aperture range of the lens that is installed. If it is a zoom lens and you change focal length by zooming, the program changes accordingly, to use a different transition point. If zooming causes a change in maximum aperture, the program uses a different maximum aperture value.

The program cannot use slower or faster shutter speeds than the camera can provide. It cannot use larger or smaller apertures than those available on the lens.

Everything discussed in this section is illustrated by the accompanying program graphs.

**Multiple Programs**—The Intelligent Program is actually not just a single program but a sophisticated multiple program. It adapts to the focal length of every lens, and changes with zoom lenses. It adapts to the maximum and minimum aperture of every lens, and changes if maximum aperture varies when zooming.

## EOS 620/650 OVER- OR UNDEREXPOSURE

In all automatic exposure modes, aperture and shutter speed values are displayed. Exposure will be correct if no displayed value is blinking. Over- or underexposure is indicated by blinking aperture, shutter speed, or both.

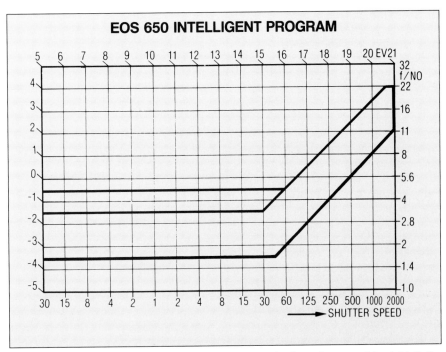

**EOS 650 INTELLIGENT PROGRAM**

The bottom graph is for an EF 50mm *f*-1.8 lens. The horizontal segment is at *f*-1.8, the maximum aperture of the lens. The transition between the horizontal segment and the inclined segment is at a shutter speed of 1/50 second, which agrees with the rule for handholding a 50mm lens. Above the transition, the program gradually selects smaller aperture and faster shutter speed impartially, in equal amounts, as the light becomes brighter.

The upper graph is for the EF 35—70mm *f*-3.5—4.5 lens. It has two horizontal segments because the lens has two maximum apertures—*f*-3.5 and *f*-4.5, depending on which focal length is being used. Intermediate aperture values are between those extremes. It has two transition points. At a focal length of 35mm, the transition is at a shutter speed of approximately 1/35 second, according to the rule for handholding a 35mm lens. At a focal length of 70mm, the transition point is approximately 1/70 second (actually 1/60 second).

The Intelligent Program adapts automatically to the aperture range and focal length of the lens being used. The transition point on the graph is the reciprocal of focal length, approximately, of the lens being used.

The Intelligent Program for other models is similar except for differences in the range of available shutter speeds.

The values that blink are the ones that are set automatically by the camera.

**Aperture-Priority AE**—The camera sets shutter speed and blinks shutter speed if there is a problem.

● Overexposure: In bright light, the camera exposure system will select faster shutter speed until the fastest speed is reached. If the light is still too bright, the fastest shutter speed blinks to indicate that overexposure will result *at the set aperture*. Try smaller aperture.

● Underexposure: In dim light, the camera will select slower shutter speeds until the slowest speed is reached. If the light is still too dim, the slowest shutter speed blinks to indicate that underexposure will result at the set aperture. Try larger aperture.

**Shutter-Priority AE**—The camera sets aperture and blinks the aperture value if there is a problem.

● Overexposure: The lens minimum aperture value blinks to warn of overexposure *at the set shutter speed*. Try faster shutter speeds.

81

## EOS 620/650 EXPOSURE WARNINGS

| MODE | OVEREXPOSURE | | UNDEREXPOSURE | |
| --- | --- | --- | --- | --- |
| | SHUTTER SPEED | APERTURE | SHUTTER SPEED | APERTURE |
| **Program AE** | Fastest shutter speed blinks | Smallest aperture blinks | Slowest shutter speed blinks | Largest aperture blinks |
| **Shutter-Priority AE** | Set value displayed | Smallest aperture blinks | Set value displayed | Largest aperture blinks |
| **Aperture-Priority AE** | Fastest shutter speed blinks | Set value displayed | Slowest shutter speed blinks | Set value displayed |
| **Depth-of-Field AE** | Fastest shutter speed blinks | Smallest aperture blinks | Slowest shutter speed blinks | Largest aperture blinks |
| **Manual** | Set value displayed | CL (close aperture) | Set value displayed | OP (open aperture) |

## EOS 750/850 EXPOSURE WARNINGS

| Symbol | Condition | Meaning |
| --- | --- | --- |
| P | Blinks rapidly (8 per second) | Light too bright or dark for good exposure. If too dark, use flash. If too bright, use ND filter. |
| P | Blinks slowly (2 per second) | Exposure is OK. Slow shutter speed being used. Suggest firm camera support or flash. |
| P | Glows steadily | Exposure is OK. |

● Underexposure: The lens maximum aperture blinks to warn of underexposure at the set shutter speed. Try slower shutter speeds.

**Program AE**—The camera sets both aperture and shutter speed. It blinks both if there is a problem.

● Overexposure: If the light is so bright that overexposure will result, the camera will already have tried the fastest shutter speed *and* the smallest aperture. Both values blink.

● Underexposure: If the light is so dim that underexposure will result, the slowest shutter speed and largest aperture values blink.

**What To Do**—In any AE mode, if overexposure is indicated with the fastest shutter speed and minimum aperture, there are remedies. Use a neutral-density filter over the lens to reduce the amount of light, as discussed in Chapter 6. Reduce the scene illumination, if possible. Change to film with a slower ISO speed rating.

If underexposure is indicated with the slowest shutter speed and maximum aperture, use electronic flash, increase scene illumination by some other method, or use faster film.

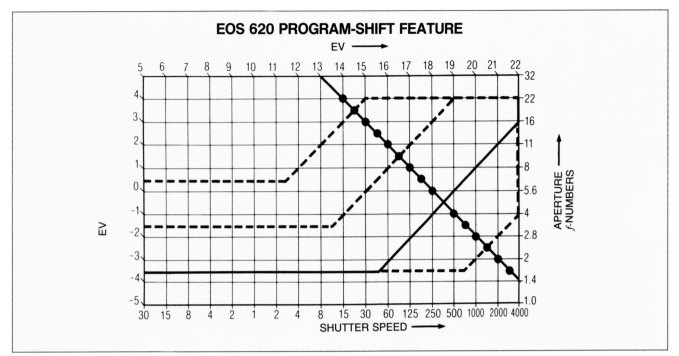

**EOS 620 PROGRAM-SHIFT FEATURE**

The EV line at EV 13 represents metered scene brightness. The program graph shown by the solid line is unshifted. It represents all pairs of shutter speed and aperture that can be selected by the program, whether or not they provide correct exposure. For example, *f*-8 and 1/1000 can be used by the program.

Correct exposure of this scene with a brightness of EV 13 is designated by the intersection of the program graph and the EV-13 line. At that intersection, the unshifted program graph selects *f*-4.5 and 1/350 second.

The program graph can be shifted up or down, as shown by the dashed lines that are parallel to the unshifted program line. Suppose the program is shifted to the first dashed line above and to the left. Correct exposure is at the intersection of the EV-13 line and the shifted program line. The shifted program will use *f*-9.5 at 1/90 second.

Both aperture and shutter speed were changed by shifting the program, but exposure did not change because both values remained on the EV-13 line, providing an exposure of EV 13.

By shifting the program graph to different locations, other pairs of shutter-speed and aperture values can be used, all providing the same exposure.

## PROGRAM SHIFT

This feature is available only with the EOS 620 camera. It allows you to use the program AE mode as though it were shutter-priority or aperture-priority auto. The Main Switch must be at A, beeper on or off, and the program AE mode selected.

**Shifting**—While metering the scene, you can release the Shutter Button and the meter will remain on for 8 seconds. During that time, you can turn the Input Dial to change shutter speed and aperture. Both will change simultaneously to maintain the metered EV.

Turning the Input Dial to the left selects slower shutter speeds and smaller apertures. Turning it to the right selects faster shutter speeds and larger apertures.

Pressing the Depth-of-Field Check Button to view depth of field locks exposure. You can rotate the Input Dial with the same result.

**Exposure**—If the camera did not indicate over- or underexposure before shifting, it will not do so after shifting because the same EV is maintained.

**Range of Shifted Values**—Not all values of shutter speed and aperture are

available. For example, suppose you are shifting to faster shutter speeds and reach 1/125 at *f*-3.5, which is the maximum aperture of the lens. You can't shift any further in that direction because there is no larger aperture to allow a faster shutter speed.

**Duration of Shift**—In the single-exposure film-winding mode, shifted values are used for only one frame. When film is advanced for the next frame, the camera reverts to the normal program, but you can shift again if you wish.

In the continuous film-winding

# EOS 650 DEPTH-OF-FIELD MODE

LCD Panel and viewfinder displays are shown in the drawings. A typical viewfinder image for each step is below. When the DEPTH mode has been selected, the word DEPTH appears at the top of the LCD Panel. You may use either autofocus mode and the single or continuous drive mode.

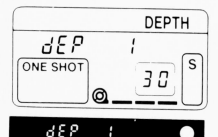

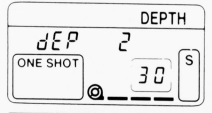

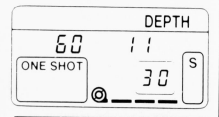

Place the AF Frame over an object at the near limit of the desired depth of field. In this example, I focused on the flowers. Press the Shutter Button halfway. The symbol dEP 1 appears in the displays. The nearby object is brought to focus and that subject distance is stored.

Place the AF Frame over an object at the far limit of the desired depth of field. In this example, I focused on the distant cliffs. Press the shutter button halfway again. The symbol dEP 2 appears in the displays. The far object is brought to focus and that subject distance is stored.

Recompose the scene as you want it, so that both the near and distant objects focused on are in the scene. Press the Shutter Button halfway again. The camera calculates the correct point of focus between the near and far limits and focuses the lens to that distance. It calculates and displays the aperture value for the desired depth of field and the shutter speed for correct exposure of the scene. Press the Shutter Button fully to make the exposure.

mode, shifted values are used for one sequence of exposures—until you lift your finger from the Shutter Button.

To cancel the shift without shooting, press the MODE button.

## DEPTH-OF-FIELD AE

This mode is available on the EOS 650, 750 and 850, but not on the EOS 620. It's a way of setting depth of field by "showing" the camera the nearest and farthest objects that you want to appear in good focus. That establishes the zone of good focus.

**With EOS 650**—The following paragraphs apply to the EOS 650. The procedure with EOS 750/850 cameras is discussed later.

To select this mode, turn the Main Switch to A, beeper on or off. Press the MODE button while turning the Input Dial to display the word DEPTH in the LCD Display.

The focus mode can be either one-shot or servo. In this mode, operation is the same at either setting. The winding mode can be single or continuous and film will be advanced accordingly. The lens Focus-Mode Switch must be at AF.

Looking into the viewfinder, compose the scene. If you are using a zoom lens, set focal length and don't change it during this procedure.

You are going to move the camera and then later return to the same composition. As a point of reference, notice where the AF Frame appears in the composition.

While viewing the scene that you intend to shoot, choose an object in the foreground to be the near limit of good focus. That distance is referred to as dEP 1. Choose an object at the far limit, dEP 2. In the following procedure, you will press the Shutter Button three times.

**Step 1**—Move the camera to place the AF Frame over the foreground object. Press the Shutter Button halfway. The lens should focus and the In-Focus Indicator should glow. If not, try another area on the target object or choose a

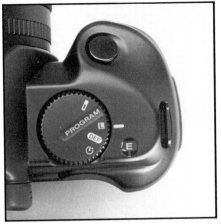

To select the automatic Depth-of-Field Mode on an EOS 750/850 model, turn the Main Switch to DEP.

different object at the appropriate distance.

When focus is successful, dEP 1 appears in the displays. That focused distance is memorized by the computer in the camera. Release the Shutter Button.

**Step 2**—Repeat step 1, using the distant object to establish dEP 2, which is also memorized. Release the Shutter Button.

The computer calculates the aperture size and focused distance to produce good focus from the near limit to the far limit, as determined by the two memorized distances.

**Step 3**—Recompose the original scene. Press the Shutter Button halfway. Aperture size and focused distance change immediately to the calculated values needed for the desired depth of field. Shutter speed is set by the camera to provide good exposure with that aperture size.

The focused-distance scale on the lens shows the final focused distance. The displays show shutter speed and aperture—for example, 500 and 16. Press the Shutter Button fully to make the exposure.

**Change Your Mind?**—If you release the shutter button without making the exposure, the displays may be confusing. The shutter speed is replaced by dEP. Using the preceding example, the displays show dEP 16. Press the shutter button again and shutter speed returns.

If you decide not to make the shot, the displays will turn off in 8 seconds and all data in memory will be cleared. You can do the same thing sooner by pressing the MODE button. Either way, the camera remains in the DEPTH mode, ready for another dEP 1.

**Minimum Depth**—If you focus on the *same* object for dEP 1 and dEP 2, depth of field will be minimum and focused distance will be the same as dEP 1 and dEP 2. The maximum aperture that provides correct exposure will be used.

**Exposure Warnings**—The camera sets both aperture and shutter speed. If there is a problem, it blinks both. The indications are the same as in program AE.

**With Lens on M**—With manual focus, the camera will not follow this procedure. It operates as though it were on Program AE.

**Doing it Backwards**—If you set dEP 1 on the distant object and dEP 2 on the nearby object, the camera forgives you. The result is the same as if you had not reversed the distances.

**Prefocusing**—To prefocus the lens and wait for a moving subject to arrive, define the focused zone using Steps 1 and 2. Press the Shutter Button halfway for Step 3, which will automatically set focused distance within the focused zone. Wait for the subject to arrive in the focused zone. Press the Shutter Button fully to make the shot.

**Zone Too Deep**—You may choose near and far limits that are impossibly far apart. If so, the camera will set minimum aperture and the appropriate shutter speed for good exposure.

The minimum aperture value will blink in the displays to indicate that depth of field will be less than you had "asked for." You can shoot, if you

This is a *single* exposure made in a darkened room using a zoom lens and an EOS camera. Exposure time was set at one second, using the shutter-priority automatic mode. The lens was zoomed *during* the exposure, pausing at each end of the zoom range to allow a sharp image to form. In between, the image is continuously blurred.

This is a *multiple* exposure made with a zoom lens and an EOS 620 set to make four exposures on the same frame. The film-speed setting was multiplied by four so the total exposure is correct for the scene brightness. The lens was zoomed *between* exposures to make four sharp images. The camera was on programmed automatic exposure.

wish. Exposure should be OK. Depth of field will be as deep as possible.

**How to Increase Depth Further**—To cancel without shooting, press the MODE button. There are three ways to increase depth of field: smaller aperture, greater distance to the scene, shorter focal length. The camera has already tried minimum aperture. Back up or change focal length and try it again.

### EOS 750/850 DEPTH MODE

Set the Main Switch to DEP. The signals for the three steps are different, but the end result is the same as already described.

Detailed instructions for this mode are in the discussion of EOS 750, 750 QD and 850 cameras in Chapter 10.

## MULTIPLE EXPOSURES

Multiple exposures on the same frame are not possible with the EOS 750/850 or 650 but can be done with the EOS 620. I will discuss theory first, then the method.

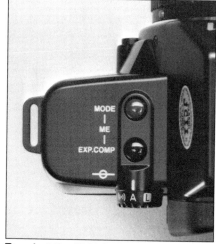

To select the Multiple Exposure ME mode with an EOS 620 camera, press the MODE and EXP.COMP buttons simultaneously.

**Background**—The background must be dark and poorly illuminated. If you were to make the first of several exposures against a light background, the area *not occupied* by the first subject would be exposed by the light background.

If you now were to place a second subject in the area occupied by the light background and make another exposure, the second subject would be overexposed and appear "washed out." The first subject would also become overexposed because the light background overlays the area originally occupied by the first subject.

Even a dark background becomes lighter with each multiple exposure, which puts a practical limit on the number of multiple exposures on the same frame.

**Non-Overlapping Subjects**—With a dark background, give each subject normal exposure. Because the subjects don't overlap, none gets additional exposure when other subjects are imaged in the frame.

**Overlapping Subjects**—Give re-

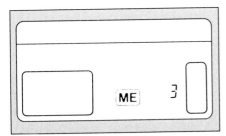

While pressing the EOS 620 MODE and EXP.COMP buttons, turn the Input Dial to set the number of multiple exposures to be made on the same frame, as shown in the LCD Panel display. In this example, the camera is set to make a triple exposure.

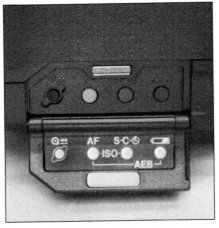

To set an EOS 620 for Automatic Exposure Bracketing, open the Switch Cover and simultaneously press the two pushbuttons that are linked by the AEB label.

When Automatic Exposure Bracketing has been selected, use the Input Dial to set the amount of exposure change between frames, as shown in the LCD Panel. In this example, the exposure increment to be used for bracketing is set at 1.0 step.

duced exposure to each subject, so the *total* exposure on film is normal. For 2 exposures of overlapping subjects, divide normal exposure for each subject by 2. For 3 exposures, divide normal exposure by 3, and so forth.

**Setting Exposure**—Technically, the best method of adjusting exposure for overlapping subjects is to change the film-speed setting.

Multiply the actual film speed by the number of overlapping exposures. For example, with ISO 400 film and 3 overlapping exposures, 400 x 3 = 1200. Manually set the camera to the nearest value, which is 1250.

Practically, changing film speed is risky because you may forget to change it back again when you have finished making the multiple exposure.

Another method is to use exposure compensation, which changes in half steps. This is less risky because a warning symbol appears in the viewfinder when exposure compensation is not zero. In exposure steps, the adjustment is calculated by finding the square root of the number of overlapping ex-

posures. Approximate settings are:

| OVERLAPPING EXPOSURES | EXPOSURE COMPENSATION |
|---|---|
| 2 | −1 |
| 3 | −1.5 |
| 4 | −2 |
| 5 | −2 |
| 6 | −2.5 |
| 7 | −2.5 |
| 8 | −3 |
| 9 | −3 |

**The Procedure**—You can preset an EOS 620 camera to make up to nine exposures on the same frame. Turn the Main Switch to A, beeper on or off. Press and hold down the MODE and EXP.COMP buttons simultaneously. On the camera, these buttons are connected by a line with the symbol ME.

The LCD Display changes to show an ME symbol and the value 1, which appears in the area normally used as the frame counter. Turn the Input Dial so the value changes to the desired number of multiple exposures, such as 3. Release both buttons.

The camera is now programmed to make that number of exposures on the same frame, and then advance film to the next frame. Adjust exposure as necessary before shooting. You can use either the single or continuous winding mode. Press the Shutter Button to make the exposures.

During the multiple-exposure sequence, the symbol ME blinks in the LCD Display as a reminder. The adjacent "number of exposures" value counts down toward zero as exposures are made. The film is automatically advanced at the end of the sequence and multiple-exposure operation ends. To make a multiple exposure on the next frame, repeat this procedure.

**To Change the Number of Exposures**—While making the sequence of multiple exposures, you can change the number of exposures. Press the MODE and EXP.COMP buttons simultaneously while turning the Input Dial to a higher or lower number of exposures. Release both buttons. The camera will make the new number of exposures, *in addition* to those already

The Manual Aperture-Set Button M on EOS cameras is near the bottom of the lens mount. Operate it with your left thumb. When the Manual Override exposure mode has been selected, you can change aperture size by pressing the M button while turning the Input Dial. If the M button is *not* pressed, turning the Input Dial changes shutter speed.

made. This allows you to make more than 9 multiple exposures.

**To Cancel**—If you decide not to make the multiple exposure *before* beginning to shoot, press the MODE and EXP.COMP buttons simultaneously while turning the Input Dial so the number of exposures is reduced to 1. Release both buttons. The camera and LCD Display return to normal settings, and the multiple exposure is canceled.

While shooting, if you set the counter to *zero* and release both buttons, the multiple-exposure sequence ends and the next frame is advanced immediately. Zero does not actually appear as a number in the display. The display becomes blank, which should be interpreted as zero.

## EXPOSURE BRACKETING

A good way to improve the odds of getting a good shot is to shoot the scene several times, each with a different exposure. That is called *bracketing*.

With negative film, bracketing is usually done in full steps. With slide film, which normally has less exposure latitude, half steps are usually used.

In any automatic-exposure mode, you can bracket using the exposure-compensation control. It isn't very convenient, for several reasons: It requires two fingers, one on each hand. The exposure display in the viewfinder is turned off. You will usually take the camera away from your eye and look at the LCD Display to see the amount of exposure-compensation being set—although you can count clicks of the Input Dial, if you wish.

It is often best to bracket quickly, before the subject moves or changes expression. It is difficult to change exposure quickly with the exposure-compensation control.

### AUTOMATIC BRACKETING WITH EOS 620

The EOS 620 provides automatic exposure bracketing (AEB) that works quickly. The camera exposes three frames of film in sequence when the Shutter Button is pressed, each with a different exposure. The EOS 650 does not have this feature.

**To Select**—The EOS 620 must be set at an AE mode and the Main Switch must be at A, beeper on or off. Open the Switch Cover on the back of the camera. Counting from the left, pushbuttons 2 and 4 are connected by a line with the label AEB. Press both pushbuttons simultaneously and release. You have 8 seconds to make the remaining setting.

**Bracket Increment**—The LCD Display shows the symbol AEB and the value 0.0. That value represents the bracket increment—the amount of change between frames. Turn the Input Dial to select the bracket increment that you want to use—such as 0.5 or 1.0 step. The range is 0.0 to 5.0, in half steps.

**To Bracket**—Compose the scene and depress the Shutter Button fully to make the exposures. The self-timer can be used to delay shutter operation.

Three frames will be exposed sequentially in the continuous winding mode, even if the single-exposure mode is set. If autofocus is being used, focus is locked at the beginning of the sequence.

**Exposure Sequence**—If not already locked, exposure is locked when you press the Shutter Button fully. The term *reference* exposure means the locked-in value.

Exposure of frame 1 will be reference exposure *minus* the bracket incre-

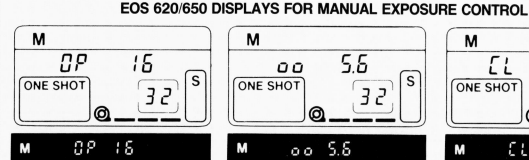

## EOS 620/650 DISPLAYS FOR MANUAL EXPOSURE CONTROL

On Manual, pressing the M button turns on the exposure meter and displays exposure-guide symbols in the LCD Panel and viewfinder. The OP symbol suggests opening the aperture by turning the Input Dial. In this example, the camera exposure meter is suggesting that *f*-16 is too small for the selected shutter speed.

Correct exposure of an average scene is indicated by the oo symbol. Here, the camera exposure meter "thinks" that the correct aperture value is *f*-5.6. You can use a larger or smaller aperture, if you wish.

The CL symbol suggests closing the aperture. Here, the camera exposure meter "thinks" that *f*-1.8 is too large for the selected shutter speed.

In the Manual mode, begin by selecting the shutter speed that you plan to use. Then, press the M button and set aperture. If the resulting aperture doesn't provide the desired depth of field, change shutter speed accordingly and repeat the procedure. For example, if you want smaller aperture for more depth of field, use a slower shutter speed.

---

ment. Frame 2 will use reference exposure. Frame 3 uses reference *plus* the bracket increment.

**Next Frame**—After the bracketed sequence of three frames, AEB is canceled. To use it again, you must set it again.

To expose the next frame after the sequence, you must lift your finger off the Shutter Button. If you hold the button halfway depressed, the camera remains in the bracket mode but has nothing left to do.

**Bracketing and Exposure Compensation**—Both functions work together. If exposure compensation is zero, reference exposure is the same as the metered exposure for the scene. If exposure compensation is used, reference exposure is the metered value plus the amount of compensation. Bracketing is centered on the reference exposure.

For example, if metered exposure is EV 11 and you use exposure compensation of +1 step, reference exposure becomes EV 10. The bracket sequence will be EV 11, EV 10, EV 9.

**Shifting the Bracket Range**—You

may want to bracket only in one direction from metered exposure. You can use exposure compensation to shift the bracket range up or down. In the preceding example, the first frame was at metered exposure and the next two received *more* exposure.

**How Exposure is Changed**—You may prefer to bracket by changing aperture, rather than shutter speed, or the reverse. With the camera set for shutter-priority AE, bracketing is done by changing aperture size. On aperture-priority AE, shutter speed is changed.

On program AE, exposure is changed by the program, following the program graph. If the light is bright, both shutter speed and aperture will change. In dim light, below the transition point of the graph, only shutter speed changes.

**Over- or Underexposure**—If the first frame will be over- or underexposed, the displays blink in the usual way for the AE mode being used. No warning is given for frames 2 and 3.

The bracketing sequence works even

if over- or underexposure results. Shutter speeds beyond the range of the camera and apertures beyond the range of the lens cannot be used, which may result in two or more frames receiving the same exposure.

**To Cancel**—To cancel before shooting, reset the exposure increment to zero or turn the Main Switch momentarily to the green rectangle.

After shooting starts, auto bracketing cannot be canceled—even by turning off the Main Switch or turning it to the green rectangle—unless the camera runs out of film.

**Bracketing and Multiple Exposures**—If you set both modes simultaneously, both will operate. The first 3 exposures of the multiple exposure will be bracketed. If it is a double exposure, 2 exposures will be bracketed.

**Precautions**—Automatic bracketing cannot be used with flash. Also, if end-of-roll occurs during a bracket sequence, the film will be rewound automatically and the remainder of the bracket sequence canceled.

# MANUAL OVERRIDE

EOS 620 and 650 cameras have this mode. Exposure is not set automatically. You set both aperture and shutter speed manually, using controls on the camera. The camera exposure meter serves as a guide and "recommends" an exposure based on metering the scene. You can use the metered exposure or any other amount.

**To Select**—Set the Main Switch to A, beeper on or off. Press the MODE button while turning the Input Dial to display an M symbol in the LCD Display on top of the camera.

**Displays**—When the manual mode has been selected, a shutter speed and aperture value appear immediately in the LCD Display. When this mode is being used, the LCD Display remains on continuously.

The viewfinder display is turned on by depressing the Shutter Button halfway. It remains on for 8 seconds after you release the button.

**Setting Exposure**—Begin by choosing a shutter speed. When *both* shutter speed and aperture are displayed, the metering system is not turned on and you can control only shutter speed. Turn the Input Dial to select and display the shutter speed that you plan to use.

Compose the scene. Use your left thumb to press the button labeled M (Manual Aperture-Set Button) at lower left, near the lens mount. Pressing this button does several things:
- The exposure meter is turned on.
- The Input Dial sets aperture instead of shutter speed.
- If the viewfinder display was off, it is turned on.
- In the displays, the shutter-speed value is replaced by an exposure-guide symbol.

The guide symbol tells you which way to change aperture so the camera is set for the amount of exposure that the meter "recommends".

OP suggests *opening the aperture.*
CL suggests *closing the aperture.*
oo means exposure is within a half step

of the meter recommendation.

These symbols are formed from "pieces" of the shutter-speed numbers that normally appear in this area. For example, oo is the lower portion of 88.

Normally, evaluative metering is used. To use partial metering, press the Partial-Metering button while also pressing the M button.

You don't have to obey the exposure-guide symbols. If you decide to change aperture, continue depressing the M button while turning the Input Dial. Aperture value is displayed and you can see it change. If you change exposure to agree with the camera meter recommendation, the guide symbol changes to oo.

While following an OP or CL suggestion, you may encounter the maximum or minimum aperture of the lens without reaching oo. Or, you may end up with an unsuitable aperture, for depth-of-field reasons. If so, release the M button and use the Input Dial to select a different shutter speed.

When you have set exposure, press the Shutter Button fully to make the shot.

**Exposure Compensation**—Using exposure compensation affects the meter reading and therefore the exposure-guide indication. If you set an exposure compensation of +1 and then set exposure controls so the viewfinder display is oo, exposure will be one step greater than if exposure compensation were zero.

**Advantages**—In my opinion, there are two advantages of manual exposure control. One is that the exposure setting is always locked until you change it. Another is simplicity of bracketing. You can bracket any time, without presetting anything, as much as you wish, for as many frames as you wish.

## BULB MODE

EOS 620 and 650 cameras have this mode. The bulb setting is a way of making exposures that are longer than 30 seconds—the slowest shutter speed. With early cameras, the shutter was held open by squeezing a rubber

bulb—hence the name.

This setting is made with the camera in the manual-exposure mode. Turn the Input Dial toward slower shutter speeds until buLb appears in the displays, instead of a shutter speed. Then press the M button while turning the Input Dial to set the desired aperture.

The meter does not operate. The shutter will remain open as long as you hold the Shutter Button depressed fully. The shutter can be opened, and locked open remotely, by using Remote Switch 60T3 and interchangeable handgrip GR20, which is standard with the EOS 620 and fits the EOS 650. For long exposures, a tripod or other firm camera support is recommended.

This mode is commonly used for long exposures at night. Although battery power is used to open the shutter, battery power is not used to hold the shutter open. The bulb mode uses significantly less power than other modes.

# EOS 620/650 STANDARD CONTROL SETTINGS

The standard control settings are made automatically when the Main Switch is set to the green rectangle. They make camera operation most convenient. The standard settings are:
- One-shot AF
- Program AE
- Beeper on
- Single-exposure film winding
- Zero exposure compensation
- Automatic multiple exposure off
- Automatic bracketing off

**Reset to Standard Settings**—While using the camera with the Main Switch on A, you may have changed the standard settings and perhaps dialed in some exposure compensation. You will occasionally want to cancel everything and return to the standard settings.

The simplest and fastest way is to turn the Main Switch to the green rectangle and then back to A. The settings at A will be the same as they were at the green rectangle.

## EOS 620/650 BULB MODE DISPLAY

The Bulb mode can be used only with the camera set for Manual exposure control. The symbol M appears in both displays along with the symbol bulb in the area normally used for shutter speed. Aperture value is shown in both displays at the usual location. The shutter remains open as long as the Shutter Button is depressed. The camera exposure meter does not operate.

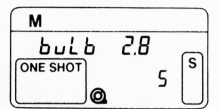

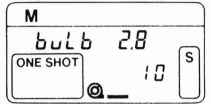

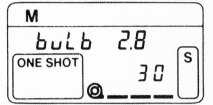

The area of the LCD Panel normally used as a frame counter becomes an exposure-time counter, displaying elapsed time in seconds. It counts to 30 seconds and repeats. In this example, the shutter has been open for 5 seconds.

The dashes normally representing film become time markers, each representing 30 seconds of elapsed time. Here, one dash plus 10 seconds on the counter mean that elapsed time is 40 seconds.

Three dashes plus 30 seconds on the counter mean that elapsed time is 120 seconds. If the shutter button is still pressed, the timing display is erased and the timer starts over at zero.

## CABLES FOR REMOTE CONTROL

**Grip GR20 has a Remote-Control Socket.** This grip fits any EOS camera and is standard on the EOS 620. Remote Switch 60T3 (60 centimeters long) plugs into the socket. Pressing the white button on the remote switch opens the shutter and holds it open. To lock the shutter open for long time exposures, press the white button and slide it forward. The shutter will remain open until you slide the button backward and release it.

**Remote Switch Adapter T3 is a short cable that fits between the Remote-Control Socket of Grip GR20 and a conventional mechanical cable release.** Depressing the plunger on the cable release opens the shutter and holds it open. If the cable release has a lock to hold the plunger depressed, you can use it to lock the shutter open for long time exposures.

# Light & Filters

**Illuminated fountains at Longwood Gardens in Pennsylvania, photographed on daylight color slide film.**

The word *photography* is derived from two Greek words meaning *drawing with light*. Light is variously characterized as consisting of rays, waves or particles of energy. Each concept is applicable in specific situations. To understand how a lens works, the concept of rays works best. Colors are most easily understood by considering light as waves with different wavelengths. The energy-particle concept is used in technical discussions of exposure.

## THE COLOR SPECTRUM

In the visible spectrum, different wavelengths of light produce different color sensations, as shown in the accompanying chart. Light wavelengths are measured in nanometers (nm)—each nm being one billionth of a meter.

Wavelengths longer than about 700nm are *infra-red (IR)* and not visible. Special IR films respond to these wavelengths.

Wavelengths shorter than about 400nm are *ultraviolet (UV)* and not visible. All commonly available films are sensitive to UV. Normally, it is best to prevent film from being affected by UV radiation. This is done with appropriate filtration.

**Sunlight**—Sunlight is white and is composed of all visible colors plus IR and UV. A rainbow separates and dis-

**Different colors of light have different wavelengths, measured in nanometers (nm). A nanometer is one-billionth of a meter. The visible spectrum extends from about 400nm (blue) to about 700nm (red). Wavelengths shorter than about 400nm are called ultraviolet (UV) and are invisible but will expose most films. Wavelengths longer than about 700nm are called infrared (IR). They are invisible and will only expose special IR films.**

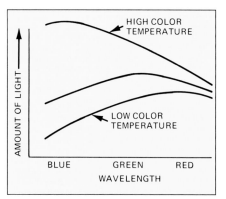

Figure 6-1/These curves show how the color of light radiated from a heated black material changes with temperature. At relatively low temperatures, the light is mainly red. An electric heating element is an example. At higher temperatures, the proportion of green and blue light increases and the overall result becomes more nearly white. A high-wattage incandescent light bulb is an example. At even higher temperatures, the radiant light is predominately blue. Even though the blue sky is not actually hot, we say it has a high color temperature because it is blue.

## APPROXIMATE COLOR TEMPERATURES

| Source | Color Temperature (K) |
| --- | --- |
| Setting Sun | 1500 to 2000 |
| Candle | 1800 |
| Household Tungsten | |
| Lamp:       40 Watt | 2600 |
| 75 Watt | 2800 |
| 100 Watt | 2900 |
| 200 Watt | 3000 |
| 3200K Photo Lamp | 3200 |
| 3400K Photo Lamp | 3400 |
| Blue Photoflood Lamp | 4800 |
| Theatrical Arc Lamp | 5000 |
| Standard Daylight | 5500 |
| Electronic Flash | 5500 to 6000 |
| Skylight:       Overcast | 6500 to 7500 |
| Hazy Blue | 9000 |
| Clear Blue | 12,000 to 20,000 |

plays the visible colors of the spectrum that compose sunlight.

## COLOR TEMPERATURE

When certain materials are heated to a high temperature, they become *incandescent*, which means that they radiate light. When such a body just begins to glow, the light emitted is red. The heating elements of an electric stove are an example. If the temperature of the object is increased, additional shorter wavelengths of light are emitted, as shown in Figure 6-1. When heated even more, the object will eventually become *white hot*, emitting white light. The sun is an example.

The *color temperature* of a radiant object specifies the color of light that it radiates. Color temperature is measured in the absolute temperature scale—in degrees Kelvin (K).

The color temperature of sunlight is about 5000K. Candlelight is about 1800K. Light from a clear blue sky is the equivalent of about 12,000K or higher. Of course, that doesn't mean that the sky is actually hot. It means that the skylight has the same color as a material that has been heated to a temperature of 12,000K or higher.

**Photographic Daylight**—On a clear day, objects receive both white sunlight and blue light from the sky. The combined illumination is more blue than sunlight alone. Standard photographic daylight has a color temperature of about 5500K.

**Tungsten Lights**—Light from any lamp with a glowing tungsten filament, such as an ordinary household light bulb, is called *tungsten* light. The color temperature of household tungsten lamps ranges from about 2500K to 3000K, depending on the wattage rating of the lamp.

There are two standard tungsten color temperatures for photographic lamps: 3200K and 3400K.

**Continuous Spectrum**—All incandescent light sources radiate a *continuous* spectrum. The curves in Figure 6-1 are examples. They are continuous across the spectrum, with some light at all wavelengths. All general-purpose color films are designed to work best with light that has a continuous spectrum.

**Discontinuous Spectrum**—Light from most non-incandescent sources doesn't have a continuous spectrum. Fluorescent lamps, for example, emit light strongly at several color temperatures but produce little or no light at other wavelengths.

Some fluorescent lamps are labeled "daylight." Although they simulate daylight to human vision, they do not necessarily do so to color film. Therefore, the color quality of non-incandescent light sources is often a problem in color photography.

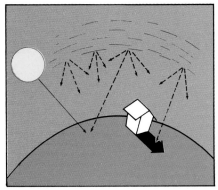

Light from the sun is scattered throughout the atmosphere. Short-wavelength blue light is scattered more than longer wavelengths. That's why skylight is blue.

## COLOR BALANCE OF FILMS

Films are manufactured to be exposed by light with one of the standard color temperatures, and so labeled.

**Daylight Film**—Films in this category are intended for photographing scenes in standard photographic daylight, with a color temperature of 5500K. If so used, it will record colors realistically. The film is "balanced" for daylight.

**Tungsten Film**—Films in this category are balanced for use with tungsten sources. Type A tungsten film is for use with 3400K light. Type B is for 3200K, and is also suitable for use with household tungsten lamps. Usually, the film carton or a leaflet inside will say what color temperature the film is balanced for. If the carton just says Tungsten, it's probably Type B.

**Matching Light to Film**—Normally, you should use daylight film in daylight, and tungsten film in tungsten light.

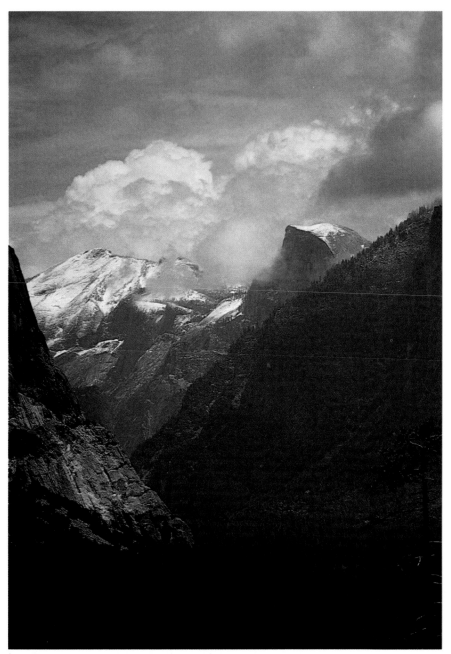

In a distant scene, there's a relatively great expanse of atmosphere between camera and scene and, therefore, more scattered blue light.

If you use daylight film in tungsten light, objects in the photo will be too red because the scene illumination was more red than the film "expected." Sometimes, and to a limited extent, that effect can be pleasing. If you use tungsten film in daylight, the photo will be too bluish. This effect is rarely pleasing, especially in photos of people.

You can use color filters on the camera lens in order to balance tungsten light for daylight film and the reverse. However, it's generally best to use the appropriate film for the light source.

To capture the red and orange colors of a brilliant sunset, use daylight color film. Set exposure on a medium tone in the sky, such as at the top of this photo. Foreground objects will appear in silhouette.

The reddish color of the light from the setting sun is apparent on this white mission tower, photographed using daylight color slide film.

The sky is generally a darker blue high up than down near the horizon. That's largely because dust and moisture particles near the earth's surface scatter light of all colors more uniformly.

## ATMOSPHERIC EFFECTS

Light from the sun passes through atmosphere to reach the earth. That causes some changes in the light.

**Atmospheric Scattering**—Sunlight is *scattered* by molecules of air and by particles such as smoke and dust. Clean air in the upper atmosphere scatters short, blue wavelengths more than longer wavelengths. Blue light is *extracted* from sunlight and scattered throughout the atmosphere. That's why the sky looks blue.

If an object is in the shade of a tree or building, it is not illuminated directly by the sun. It receives only light from the sky, which we call skylight. Skylight is much more blue than sunlight. For that reason, people photographed in the shade may have bluish skin tones. This can be corrected by a *skylight* filter, described later.

When the sun is near the horizon,

sunlight passes through more of the atmosphere to reach the place where you are than it does at noon. Therefore, more of the blue light is extracted by scattering. At sunrise and sunset, light from the sun is more red than at midday.

**Light from Distant Scenes**—Even in clear air, distant objects look bluish. Blue haze in a photograph suggests great distances.

If there is dust or other pollution in the air, all wavelengths are scattered and distant objects disappear in a white haze.

With a clear sky, nearby shadows are dark and distinct. Shadows of distant objects appear less dark and distinct because of scattering by the intervening air.

On an overcast day, clouds in the sky intercept and diffuse all of the light from the sun. The entire sky becomes a relatively uniform source of light. Shadows are weak and subtle.

**Heat Turbulence**—When the air is hot it becomes turbulent. This turbulence tends to distort a distant view. The greater the distance, the more marked the distortion. This is often evident in photos of distant scenes, taken with long telephoto lenses.

# CONTROLLING THE LIGHT

To make a good picture, sometimes you must control the light on the subject—its direction and distribution—and the color of the light reaching the film. Using filters to control color is discussed later.

### SHADOWS

When light illuminates a subject, the brightest source is called the *main light*. In daylight, the main light is usually the sun. In a studio, the main light is usually a lamp.

The main light casts shadows. The angle of the main light in a portrait controls facial shadows and subject *modeling*. Shadows disclose the loca-

Photographers spend a lot of time "waiting for the right light." This is the village of Tadoussac on the Bay of St. Lawrence. The camera was handheld for both shots. At twilight, the longer exposure time caused the lights to appear elongated due to camera movement.

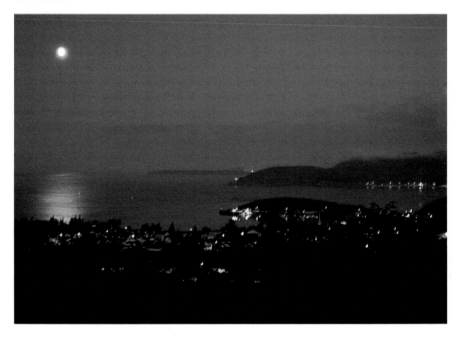

tion of the main light. We are accustomed to light from above or to the side. Shadows from a light source below the subject look unnatural.

Dark shadows obscure details that we may prefer to see. Distinct shadows with well-defined edges give the appearance of harsh and unpleasant lighting.

**Point Source**—A single, small source of light is a point source. A bare light bulb in a room is an example. Even though the sun is very large, it is at a very great distance and acts as a point

The subjects are backlit by warm-colored sunlight and frontlit from below by even warmer light that is reflected from a brick terrace and wall. Front lighting from below is usually not desirable for people pictures. However, in this example, the effect is moderated by pleasant facial expressions.

source on a clear day. Point sources cast shadows that are dark and distinct.

Light from a point source decreases in brightness at greater distances from the source, following the inverse-square law. This is illustrated in Figure 6-2. In practice, the inverse-square law does not apply to sunlight because the sun is so far away.

**Large Source**—A source that is physically large, compared to the subject, produces diffused shadows that are less dark and less distinct. Light from a large source, close to the subject, does not follow the inverse-square law.

On an overcast day, the entire sky is a large source of light. Light comes to the subject from many directions. Shadows are faint and not well defined.

If the sky is clear, but the subject is in the shade, only light from the sky illuminates the subject. Shadows are dim and indistinct.

Usually, portraits look better without harsh shadows on faces. Portraits made outdoors on an overcast day, or in the shade on a clear day, look better than portraits in direct sunlight.

## FILL LIGHTING

In situations where shadows cast by the main light are too dark, they can be lightened by directing another source of light into the shaded areas. That is called "filling" the shadows with light, or *fill* lighting.

In sunlight, shadows can be filled by a reflector panel or by electronic flash.

## STUDIO LIGHTING

Lighting problems in a studio are the same as outdoors, but easier to control. Studio lighting may be several individual lamps or a single large source.

Most of the b&w photos in this book, of cameras and other equipment, were made with a single large source, to minimize shadows. The source is a bank of fluorescent lights.

For artistic photography, *controlled* shadows are usually preferred. That is done with a main light, fill light, and sometimes lights for other purposes

An overcast day is good for outdoor portraits because the light is uniform and there are no strong shadows.

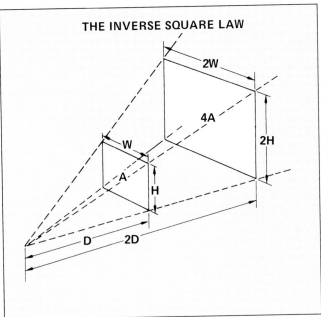

**THE INVERSE SQUARE LAW**

Figure 6-2/A small source produces an expanding beam of light. When the light travels twice as far, it illuminates an area that is twice as tall and twice as wide, which is four times as much area. Because the light covers four times as much area, brightness is reduced to one fourth. When the light travels three times as far, the illuminated area is nine times as large and brightness is reduced to one ninth. With an expanding beam of light, brightness is always reduced in proportion to the distance squared.

## ILLUMINATION AND DISTANCE

| To Decrease Illumination by: | Multiply Light-Source Distance by: |
|---|---|
| 1 exposure step | 1.4 |
| 2 exposure steps | 2 |
| 3 exposure steps | 2.8 |
| 4 exposure steps | 4 |
| **To Increase Illumination by:** | **Divide Light-Source Distance by:** |
| 1 exposure step | 1.4 |
| 2 exposure steps | 2 |
| 3 exposure steps | 2.8 |
| 4 exposure steps | 4 |

## LIGHTING AND BRIGHTNESS RATIOS

| For Lighting Ratio of: | Fill-Light Distance equals Main-Light Distance Times: | Brightness Ratio is: |
|---|---|---|
| 1:1 | 1 | 2:1 |
| 2:1 | 1.4 | 3:1 |
| 3:1 | 1.7 | 4:1 |
| 4:1 | 2 | 5:1 |

This table shows how to position lights of *equal brightness* to produce various lighting ratios.

such as to lighten the background.

The main light is positioned to establish the basic lighting pattern and direction of the shadows. Its brightness has the most effect on exposure. Shadows will usually be too dark.

When a main-light position has been established, you can place the fill light to control the shadows. The fill light must not be strong enough to produce its own shadows.

There are two ways to control the amount of light reaching the subject from a studio lamp. One is to control the brightness by using bulbs of different wattage ratings. The brightness of most studio-type flash units can be adjusted by a power control.

The other way to control brightness is to change the distance between lamp and subject. Studio lamps can be treated as point sources that follow the inverse-square law. If the distance is doubled, brightness at the subject be-comes 1/4 as much. If distance is tripled, brightness becomes 1/9, and so forth.

## LIGHTING RATIO AND BRIGHTNESS RATIO

When a subject is illuminated by two light sources at different locations, there are three values of light on the subject. One is the area illuminated only by the main light. Another is the area illuminated only by the fill light— in the shadows cast by the main light. The third is the area illuminated by both lights, where they overlap.

Suppose the main light casts 2 units of light on the subject and the fill light casts 1 unit of light. The brightest area receives 3 units of light. The darkest area receives only 1 unit.

**Lighting Ratio**—This is the ratio of brightnesses caused by main light only and fill light only. In this example, the lighting ratio is 2:1 (two to one) be-cause the main light is twice as bright aa the fill light.

**Brightness Ratio**—This is the ratio of actual brightnesses of the light on the subject, as seen by the camera. In this example, the brightness ratio is 3:1 be-cause the brightest area receives 3 times as much light as the darkest area. The brightness ratio is recorded on the film.

**Establishing the Ratios**—The easiest way to establish the lighting ratio is to use lights of the same wattage at different distances from the subject. See the accompanying table.

You can measure lighting ratio with the exposure meter in your camera. With main light only, measure on a gray card at the subject location. With fill light only, measure again. Find the difference, in exposure steps. The lighting ratio is that number of exposure steps squared.

For example, if the readings are *f*-11

Tungsten film used with daylight illumination results in a bluish color imbalance that is usually unattractive and unnatural looking. Good subject areas for evaluating color rendition are skin tones and white objects such as this bicyclist's helmet. Using an amber 85B color-coversion filter on the lens removes the bluish cast and makes a better photo.

at 1/60 and f-5.6 at 1/60, the difference is 2 steps. The lighting ratio is 4:1. To find brightness ratio, add 1 to the numerator of the lighting ratio. The brightness ratio is 5:1.

## SETTING EXPOSURE

Usually, you will want correct exposure of the part of the subject that is lit by the main light. Meter on a gray card that is lit by the main light—with or without the other lights turned on. Fill lighting usually doesn't contribute much to the total exposure.

## TYPES OF PHOTO LAMPS

Tungsten photo lamps are available with color-temperature ratings of 3200K or 3400K. Because 3200K lamps operate at a lower filament temperature, their life expectancy is longer.

**Tungsten Lamps**—As tungsten lamps age, tungsten evaporates from the heated filament and forms a gray coating on the inside of the glass envelope. This gradually lowers both light output and color temperature.

**Tungsten-Halide Lamps**—A major improvement is the tungsten-halide type, also called tungsten-halogen. The tungsten that evaporates from the filament is continuously removed from the glass envelope and replaced on the filament. This gives uniformity of light output and color temperature, and longer life.

## FILTERS

There are four basic categories of filters:
- *Color filters* change the color of light that passes through the filter.
- *Polarizing filters* are used to control reflections, record colors more vividly, darken a blue sky, and reduce glare without changing the color of the light.
- *Neutral-density filters* reduce the amount of light without changing its color.
- *Special-effect filters* do a variety of things, usually optical "tricks."

Filters are available in a variety of

materials and with several methods of attachment to the lens. Filters and their applications are discussed here without attention to how they are attached. Later in this chapter, filter materials and mounting methods are discussed.

## COLOR FILTERS FOR COLOR FILM

Eastman Kodak uses a set of numbers, called Wratten numbers, to identify standard color filters. These numbers are used by most filter manufacturers and also in this book, where applicable.

### COLOR CONVERSION FILTERS

These filters *convert* the color temperature of light from the scene to match the type of color film in the camera. For example, if you are using tungsten film but need to take a photo in daylight, you can place a color conversion filter in front of the lens.

These filters make relatively *large*

## COLOR-CONVERSION FILTERS

| Color-Film Type | Light Source | Conversion Filter |
|---|---|---|
| Daylight (5500K) | Tungsten, 3400K | 80B |
| Daylight (5500K) | Tungsten 3200K or household | 80A |
| Tungsten Type A (3400K) | Daylight, 5500K or Electronic Flash | 85 |
| Tungsten Type B (3200K) | Daylight, 5500K or Electronic Flash | 85B |

Figure 6-3/Color-conversion filters change the color balance of the illumination to suit the type of film being used. This is a relatively large change.

## LIGHT-BALANCING FILTERS

| Filter Color | Effect on Photo | Wratten Number |
|---|---|---|
| DARKER YELLOW | | 81D |
| | | 81C |
| | REMOVE BLUE | 81B |
| | | 81A |
| LIGHTER YELLOW | | 81 |
| LIGHTER BLUE | | 82 |
| | REMOVE RED | 82A |
| | | 82B |
| DARKER BLUE | | 82C |

Figure 6-4/Light-balancing filters make smaller color changes than color-conversion filters.

changes in the color of the light. Common conversion filters are shown in Figure 6-3.

### LIGHT BALANCING FILTERS

These filters make *smaller* changes in color than conversion filters. Light-balancing filters are used to "fine-tune" the colors on color film.

For example, the light on an overcast day or in the shade is bluish. If you shoot without correction, colors in the photo have a blue cast, which is especially noticeable in skin tones. The correction is a filter that removes some of the blue. The filter will look amber or yellow.

At sunrise or sunset, the light is reddish. To correct, use a filter that removes red. The filter will look blue.

Figure 6-4 shows common light-balancing filters.

### FILTER FACTOR

Color-conversion and light-balancing filters control light across the entire spectrum and are called *broad-band*.

They reduce the amount of light—typically by one to four exposure steps.

Filter manufacturers publish a *filter factor* for each filter. The factor states light loss caused by the filter. The value is written with an X to show that it is a factor. It gives the exposure increase that will compensate for the light absorbed by the filter. A filter factor of 2X means that exposure should be doubled—one exposure step. A factor of 4X means two steps.

If you are using the camera exposure meter with the filter in place on the lens, the effect of the filter is *included* in the measurement. No correction for filter factor is necessary. Use the metered exposure.

### COLOR-COMPENSATING FILTERS

Color-Compensating (CC) filters control principally one color in the spectrum while also transmitting the other colors partially. Their purpose is to control the three primary colors and the three complementary colors—red,

green, blue, yellow, magenta and cyan. The filters come in a series of different strengths. They make relatively small changes in color.

CC filters have a special nomenclature that tells you the type of filter, its color and how "strong" that color is.

For a filter labeled CC20R, the letters CC mean that it's a Color-Compensating filter. The last letter is the initial letter of its color. R means that it looks red when viewed against white light. The number 20 indicates the darkness or density of the filter. Higher numbers mean stronger colors.

**General Use**—You can use CC filters to make small changes in color, just as any other color filter. A CC30Y gives a pleasant sunny look to a scene photographed on a gray day.

**With Fluorescent Light**—Daylight color film exposed under fluorescent light usually has a yellow-green cast. Skin tones look unhealthy. For best color reproduction with fluorescent light, a combination of CC filters can be used, tailored to the type of fluores-

cent lighting. Figure 6-5 gives some suggested *starting* filter sets. By testing, you can probably improve the color.

## SKYLIGHT, UV AND HAZE FILTERS

If a subject is in the shade, illuminated by skylight only, an uncorrected color photo will look blue. Distant scenes often have a blue haze. Films respond both to visible blue light and invisible ultraviolet which also gives color images a bluish cast. Three types of filters are available to reduce excessive blue:

● *UV filters* reduce ultraviolet light without much effect on visible light.

● *Skylight filters* reduce UV and the shortest blue wavelengths. They reduce haze and slightly warm the colors in a photo.

● *Haze filters* are a little warmer than skylight filters.

There is little difference between these types. Some photographers use a skylight filter permanently on the lens, simply for lens protection. It resembles a transparent lens cap.

## FLUORESCENT-LIGHT FILTERS

Combining CC filters to correct fluorescent light takes time and testing. There are one-piece filters that do a reasonable job. Nomenclature is not standard but usually obvious. For example, FLA, FLB and FLD are for tungsten type A film, tungsten type B and Daylight film respectively.

# COLOR FILTERS FOR B&W FILM

On b&w film, different colors of equal brightness record at about the same shade of gray.

**Contrast Filtering**—With b&w film, the only way to differentiate between two colors of equal brightness is to make one a darker shade of gray. This increases the *contrast* between the two shades. A color filter lightens its own

| SOME COMMONLY USED COLOR FILTERS | | | | | |
|---|---|---|---|---|---|
| Nomen-clature | Film Type | Light | Filter Effect | Visual Color | Filter Factor |
| UV or Haze | Any | Day | Reduce UV exposure | Clear | IX |
| ND 4X or ND 0.6 | | Any | Reduce light 2 steps | Gray | 4X |
| ND 8X or ND 0.9 | | Any | Reduce light 3 steps | Gray | 8X |
| 8 or K2 | B&W | Day | Normal sky | Yellow | 1.5X |
| 15 or G | Pan | Day | Darker sky | Yellow | 2X |
| 25 or A | | Day | Very dark sky | Red | 8X |
| 8 or K2 | | Day | Normal tones | Yellow | 1.5X |
| 11 or XI | | Tung | Normal tones | Yel-Grn | 4X |
| IA or Skylight | Color Day-light | Day | Reduce blue skylight | Lt. Pink | IX |
| 81C | light | Day | Warmer image | Orange | 1.5X |
| 82C | | Day | Less red with low sun | Lt. Blue | 1.5X |
| 80B | | 3400K | Normal colors | Blue | 3X |
| 80A | | 3200K | Normal colors | Drk. Blue | 4X |
| FLD | | Fluor | Normal colors | Purple | IX |
| 85C | Color Tung-sten | Day | Normal colors, morning or late afternoon | Amber | 1.5X |
| 82C | | Tung | Normal colors with household lamps | Lt. Blue | 1.5X |
| FLB | | Fluor | Normal colors | Orange | IX |
| 85 | 3400K | Day | Normal colors | Amber | 2X |
| 85B | 3200K | Day | Normal colors | Amber | 2X |

Mixed lighting, with two or more color temperatures, is often a problem. Here, the subject is illuminated by tungsten light from her left and daylight from her right. The photo was made with daylight film, which is the best compromise in this situation. With skin tones, a slightly "warm" color imbalance is always more acceptable than a "cool," bluish imbalance.

Fluorescent and tungsten light are both evident in this photo. Photographed with daylight film, the fluorescent overhead light caused a green cast on the white counter and the skin tones. The tungsten table lamp in the background appears excessively yellow to the daylight film.

With mixed lighting, it is usually best to correct skin tone and accept the resulting effect on other colors. This photo was made using an "all purpose" filter for fluorescent lighting and daylight film. The green cast is gone. However, the tungsten lamp is even more reddish.

color and darkens all other colors. The accompanying photos of a rose are examples of contrast filtering.

## DARKENING BLUE SKY ON B&W

In most b&w outdoor photos, the sky looks whiter than the actual scene. If there are clouds, they are about the same shade as the sky and barely noticeable. A more dramatic photo usually results if the sky is darkened.

To make the sky darker, use a filter that absorbs blue light from the sky. The result is to darken the sky without much effect on the clouds. A yellow filter has a mild effect. A red filter has a strong effect. An orange filter has a moderate effect. Select the filter by looking through it at the sky.

## CUTTING HAZE WITH B&W

B&W film is very susceptible to haze in outdoor scenes because of scattered blue light and UV. With color film, blue haze appears blue and usually does not obscure distant objects. With b&w, haze appears white or light gray and does obscure distant objects.

If you photograph a distant scene without haze correction, the photo will *always* show more haze than you saw because the film "sees" the UV that your eyes don't see. The accompanying table lists filter colors to increase or decrease haze with b&w film.

# POLARIZATION OF LIGHT

Light travels along ray paths with a wave motion similar to waves on water. Water waves can move only up and down. Light waves can move or vibrate in all directions perpendicular to their path of travel.

## RECOMMENDED FILTRATION FOR FLUORESCENT LIGHTING

| Film Type | Fluorescent Lamp Type | | | | | |
|---|---|---|---|---|---|---|
| | Daylight | White | Warm White Deluxe | Warm White | Cool White Deluxe | Cool White |
| Daylight | 40M+30Y | 20C+30M | 40C+40M | 60C+30M | 30M | 30C+20M |
| Tungsten (3200K) | 85B+30M +10Y | 40M+40Y | 30M+20Y | 10Y | 50M+60Y | 10M+30Y |
| Tungsten (3400K) | 85+30M +10Y | 40M+30Y | 30M+10Y | NONE | 50M+50Y | 10M+20Y |

Figure 6-5/These recommendations are approximate. For best results, make test exposures.

Because b&w film doesn't show colors, objects that we expect to look different may appear about the same tone in a photo. For example, this red rose is about the same shade of gray as the surrounding green leaves.

A green filter lightens the leaves and darkens the red rose.

A red filter lightens the rose and darkens the green leaves.

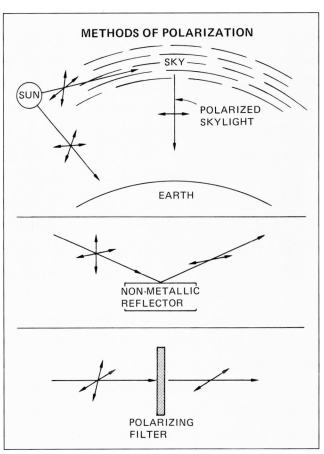

In this drawing, two crossed arrows perpendicular to the light path indicate unpolarized light. A single arrow indicates polarized light.

The part of a blue sky that forms a right angle between the sun and your location is polarized to the greatest extent. For example, at noon, when the sun is high, the most polarized skylight is near the horizon.

Light reflected from a non-metallic surface is polarized to a greater or lesser extent, depending on the angle of the reflection.

When unpolarized light passes through a polarizing filter it becomes polarized. The angle of polarization depends on the orientation of the polarizing filter.

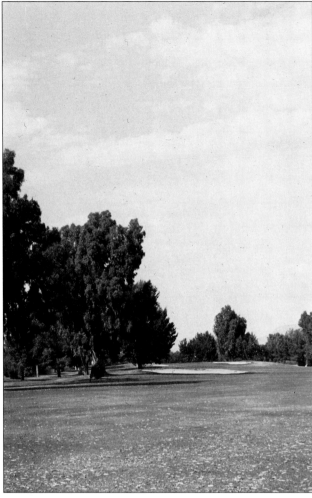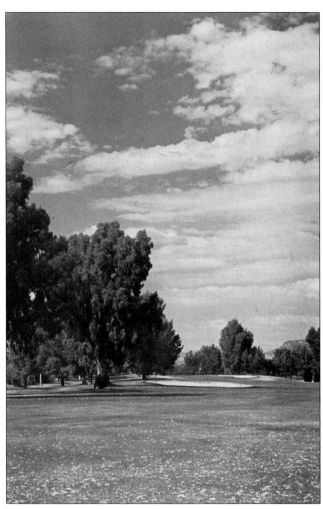

In b&w photographs, clouds and sky often reproduce at about the same tone. A filter that holds back blue light will darken blue sky, making white clouds more clearly visible. Yellow, orange and red filters—in that order—provide increasing contrast between sky and clouds.

Unpolarized light vibrates in all directions. Polarized light vibrates in only one direction. Much of the light that we see every day is polarized.

**Polarization by Reflection**—Light becomes polarized when it is reflected, at specific angles, by most surfaces except unpainted metal. The direction of polarization is determined by the orientation of the reflecting surface.

Unpolarized light that reflects off a horizontal surface becomes horizontally polarized. After reflection, the light vibrates only horizontally as it travels along the ray path. Reflection by a vertical surface polarizes light vertically.

**Polarization of Skylight**—Light from a clear blue sky is polarized in a band across the sky. That band is at a right angle to the direction of the sunlight reaching you. If the sun is low on the horizon, the polarized band is overhead and runs from north to south. If the sun is overhead, the polarized band is near the horizon.

## POLARIZING FILTERS

Polarizing materials are made into polarizing filters. If unpolarized light enters the filter, polarized light emerges from the other side. The direction of polarization is determined by rotating the filter.

If the light entering the filter is already polarized, it will be transmitted, blocked, or partially transmitted, depending on the orientation of the filter.

Polarizing filters that mount on camera lenses are made so they can be rotated. The filters are gray, so they don't change the color of light and, therefore, can be used with color film.

## CIRCULAR POLARIZING FILTERS

Ordinary polarizing filters—called linear polarizers—should not be used

The Canon PL-C Circular Polarizing Filter has a threaded mount that screws into the filter threads of a lens. The filter can be rotated in its mount by turning the narrow serrated ring at the front.

on EOS cameras. These cameras have a semi-transparent main mirror which allows some of the light to pass through to the autofocus system. It is possible for an *ordinary,* linear polarizing filter to transmit polarized light that cannot pass through the mirror. If that happens, the autofocus system cannot operate.

**Canon Circular Polarizer**—Canon offers a special *circular* polarizing filter for EOS cameras. It transmits light of one polarization and blocks other light, the same as ordinary polarizers, but does not interfere with autofocus operation.

These filters are labeled Canon CIRCULAR PL-C. The word *circular* doesn't signify that the filters are round, even though they are. It means that light passing through the filter is polarized *circularly* rather than *linearly.* Canon uses PL to mean polarizer. The C means circular.

The Canon circular polarizing filter can be used as discussed in the following paragraphs.

## REDUCING REFLECTIONS

Because reflected light is frequently polarized, it can be reduced by a polarizing filter. Reducing or removing a reflection can enable you to see and photograph what is behind the reflecting surface. Here are some examples.

Use a polarizing filter to block reflections on a window that prevent you

To the eye, and the camera without polarizing filter, merchandise in this shop window was obscured by reflections. A polarizing filter blocked the polarized reflected light rays so the interior became visible. Polarization is maximum when the angle between the reflected rays and the reflecting surface is about 35 degrees and diminishes at other angles. Only one pane in this window reflected strongly polarized light toward the camera.

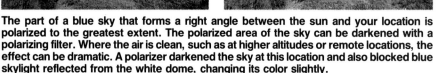

The part of a blue sky that forms a right angle between the sun and your location is polarized to the greatest extent. The polarized area of the sky can be darkened with a polarizing filter. Where the air is clean, such as at higher altitudes or remote locations, the effect can be dramatic. A polarizer darkened the sky at this location and also blocked blue skylight reflected from the white dome, changing its color slightly.

A conventional linear polarizer prevents autofocus operation with EOS cameras but can be used with manual focus. A Canon Circular Polarizer does not prevent autofocus. Camera-metered exposure should be correct with either type.

A polarizer can have more than one effect on a photo. Here, it was intended to darken the sky. It did that, but also removed the reflection of the blue sky from the water surface in the foreground.

from seeing inside. Use a polarizer to remove surface reflections on wooden furniture that prevent you from seeing the wood grain.

With a polarizing filter on the lens, look through the camera and rotate the filter for best effect.

## IMPROVING COLOR SATURATION

Direct sunlight is unpolarized. Some of this light reflects off the surfaces of buildings, cars, foliage on trees, flower petals and other objects. The reflected white light dilutes and obscures the colors. If you use a polarizing filter to block the reflected light, you see the color that's underneath the surface. The color improvement this causes is sometimes amazing. Rotate the filter for best effect.

## DARKENING SKY

If you compose an outdoor scene so the polarized part of the sky is in view,

you can darken the sky dramatically with a polarizing filter. That doesn't work on overcast days because an overcast sky is not polarized.

This is commonly done with color film because the polarizer doesn't change colors of the scene. Sometimes you must compromise between the rotation of the polarizer that gives the best sky and a different setting that gives the most color improvement of objects in the scene.

## NEUTRAL-DENSITY FILTERS

With color or b&w film, you may want to reduce the amount of light coming through the lens without changing its color. That allows using slower shutter speed or larger aperture.

Light is absorbed by Neutral-Density (ND) filters, which are gray or neutral in color. They have optical den-

The photographic effect of a Neutral Density filter is merely to reduce the amount of light. The filter is gray, so the color balance of the light is not changed. The light band across the top of this filter is a reflection.

## NEUTRAL-DENSITY FILTERS TO INCREASE EXPOSURE TIME OR APERTURE SIZE

| ND Filter Type | Multiply Exposure Time by: | Or, Open Aperture by: (Steps) |
|---|---|---|
| ND .1 | 1.25 | 1/3 |
| ND .2 | 1.6 | 2/3 |
| ND .3 or 2X | 2 | 1 |
| ND .4 | 2.5 | 1-1/3 |
| ND .5 | 3.1 | 1-2/3 |
| ND .6 or 4X | 4 | 2 |
| ND .8 | 6.3 | 2-2/3 |
| ND .9 or 8X | 8 | 3 |
| ND 1.0 | 10 | 3-1/3 |
| ND 2.0 | 100 | 6-2/3 |
| ND 3.0 | 1000 | 10 |

ND filters reduce the amount of light entering the camera and thereby cause a change in shutter speed or aperture or both.

sity, so they absorb light. The reduction of light is stated in the nomenclature by a filter factor or a density value.

ND 2X and ND 0.3 are examples. A filter factor of 2X or a density of 0.3 represents one exposure step. A density of 0.6 is two steps, a density of 0.9 is three steps, and so forth.

**Stacking ND Filters**—Using one filter on top of another, usually screwed together, is called *stacking* filters. You may stack ND filters to get more density.

If the "strength" is specified by filter factors, the result is the *product* of the factors. For example, ND 2X stacked with ND 4X is the same as ND 8X.

With densities, add the numbers. For example, ND 0.3 with ND 0.6 is equivalent to an ND 0.9 filter.

## SPECIAL-EFFECT FILTERS

There are lots of special-effect filters. Many special effects are influenced by aperture and focal length. Viewing the scene with different apertures and focal lengths will usually show the effect. This section lists popular types, with brief descriptions.

### COLOR FILTERS

Ordinary color filters can be used for special effects with color film. For example, you can make people green or a sky red.

**Color Filters with Flash**—Using a color filter over the flash window causes the flash to emit colored light. Nearby objects are illuminated mainly by the flash and will reflect that color. Distant objects, lit by daylight, receive very little light from the flash and will have normal colors.

You can reverse the effect by using a CC filter over the flash and the complement of that color over the lens. Nearby objects will appear with normal color because the two filters cancel each other's effect. Distant objects, which receive little or no light from the flash, are colored by the filter over the lens.

**Variable-Color Filters**—Special filters with polarizers inside provide variable color when rotated. Because of the polarizer, these filters may prevent

autofocus with EOS cameras, as discussed earlier.

**Two-Color Filters**—These filters have two colors. Half of the filter is one color, half the other. If the colors change gradually from one to the other, it is called a *graduated* filter. Sometimes one half of the filter is clear instead of being colored.

A version that is useful for exposure control has a neutral-density filter on one half, which blends into a clear area. The neutral-density portion is used to darken the sky with any film.

**Spot or Clear Center**—These devices have a circular spot in the center that may be colored or clear. The surrounding area is another color or "frosted" to make a diffused image. Some types are dark outside of the center spot to *vignette* the image.

### MASKS

Masks are not really special effect filters; they are special effect "devices."

Masks are black panels in a holder that fits in front of the lens. They are available with openings in the mask—such as circles, hearts, and diamonds—along with negative or reversed patterns—such as an opaque circle in a clear frame. They also are available as solid panels that cover half of the film frame.

Masks are used for double exposures. Place the first mask in position and make an exposure. The film receives an image through the opening in the mask. The rest of the frame is unexposed.

Then, place the reversed mask in position and make another exposure in the unused area. Meter each shot without the mask and shoot at the metered exposure. Bracket toward increased exposure.

Common tricks with masks are to place a face in an unusual location, such as in a wine glass, or make two images of the same person.

## CAUTION

The filter types described in the remainder of this section may prevent autofocus operation. If they do, focus manually.

## MULTIPLE-IMAGE PRISMS

These are clear, with molded prisms on the front surface. Each prism produces a separate image of a single subject. If the prisms are in a circular pattern, the images form a circle around a central image. If the prisms are in a row, the images are also in a row.

## STAR FILTER

A filter with a grid of narrow, opaque lines in clear glass or plastic causes star patterns around bright points of light. Some star filters have one set of lines that can be rotated in respect to the other, causing asymmetrical star patterns.

## DIFFRACTION FILTER

Diffraction special-effect filters have many closely spaced opaque lines in clear glass or plastic. If the lines are parallel, linear rainbow patterns are formed in the image. If the lines are concentric circles, radial rainbow patterns are formed. The effect is noticeable mainly around bright points in the image.

## SOFT-IMAGE FILTER

Clear filters with a rippled surface diffuse the image, creating a soft-focus effect. In portraiture, this obscures small details, such as facial wrinkles. Some makers offer soft-focus filters in several "strengths," identified by numbers. When the effect is sufficiently strong, the result can be a "dreamlike" photo.

## FOG FILTER

These have a frosted surface that gives the effect of fog in the image. They are available in different "strengths" to produce more or less fog effect.

Filter threads on the EF 28mm f-2.8 lens are 52mm in diameter. A 52mm to 55mm step-up ring allows mounting a 55mm filter on this lens.

## FILTER MATERIALS

Filters are made of a variety of materials, as described next.

## GELATIN FILM

Eastman Kodak manufactures a large variety of inexpensive, high-quality gelatin filters. They are square, thin and flexible. They are also delicate and difficult to clean. Handle them only by the edges, preferably with soft, cotton gloves. They can be cut with scissors. They are used only as color filters, not special-effect devices that alter ray paths.

## ACETATE FILM

Acetate-film filters are similar to gelatin filters but have inferior optical quality. They are used to color light sources, such as flash or studio lights. They are not intended for use over a camera lens unless image distortion is acceptable.

## GLASS

Glass filters are durable, easy to clean and usually more convenient than gelatin film. They are also more expensive. Good quality glass filters have anti-reflection coatings on both surfaces. That increases light transmission and reduces surface reflections. Glass filters are made both for color changes and optical special-effects.

## PLASTIC

Plastic filters are more durable than gelatin but scratch more easily than glass. They cost more than gelatin but less than glass filters. They usually don't have anti-reflection coatings.

## EFFECT OF AGE

All filters may change color slowly due to age, exposure to light or heat. Store in a cool, dry, dark place in containers that protect the surfaces.

## FILTER MOUNTING METHODS

Most lenses have a threaded ring inside the front of the lens barrel to mount filters. The diameter of the filter ring in millimeters is shown in the lens table of Chapter 2. Attachments that screw into the filter ring must have external threads with the same diameter.

**Step-Up and Step-Down Rings—** Threaded adapter rings are available to change the filter-thread diameter of a lens. The adapter screws into the lens. On the front of the adapter are threads with larger or smaller diameter than the lens.

Step-Up Rings provide a larger thread diameter than the lens. Step-Down Rings provide a smaller diameter.

Step-Down Rings should be used with caution. The ring itself or the attachment screwed into the ring may block light around the edges and vignette the image.

## SCREW-IN FILTERS

A screw-in filter is mounted in a threaded frame. It is installed by screwing it into the filter threads on the lens, or into a step-up or step-down ring.

**Stacking Screw-In Filters**—These filters have internal threads on the front of the frame that are the same diameter as those on the back. That allows stacking filters with the same thread diameter. However, under certain circumstances stacking filters may cause vignetting.

**Choosing Filter Size**—Canon EF lenses use front-mounted screw-in filters with several different thread diameters.

To avoid purchasing the same filters in different sizes, consider buying filters to fit the largest filter-thread diameter that you own or plan to own. These can be mounted on lenses with smaller filter-thread diameters by using step-up rings.

**Use with Lens Hood**—Lens hoods for EF lenses clip over the outside of the lens. There is normally room for a filter to fit inside the hood. Screw in the filter first, then attach the hood.

**Precautions**—Using step-up rings to mount filters with diameters that are larger than the filter size of the lens may prevent use of a hood. You can usually shade the lens some other way, such as with your hand.

The front element of some zoom lenses is mounted in a carrier that is drawn into the lens body when zooming. The filter threads are on the carrier and are withdrawn also. Any screw-in lens attachment that is larger in diameter than the carrier will prevent zooming.

The EF 35—70mm $f$-3.5—4.5 is an example. The front lens cover clips into the filter threads and is larger in diameter than the front-element carrier. It can be attached only when the lens is set at 35mm focal length.

## SERIES FILTERS

Series filters are no longer common. They are round and without threads.

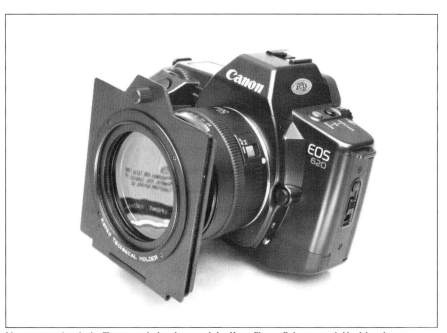

Unmounted gelatin filters and plastic special-effect filters fit in a special holder that mounts in the filter threads on a lens. Holders of this type are usually called gel holders. The reflection in this photo is from a gelatin filter in the holder.

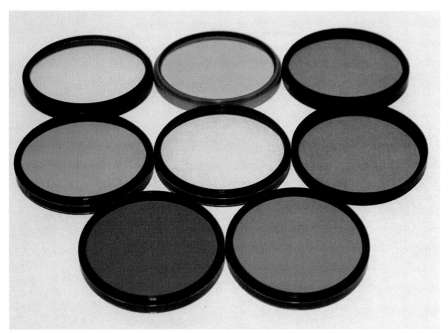

One method of mounting filters is to place them in circular threaded frames.

The EF 35—70mm $f$-3.5—4.5 lens is unusual in that the filter threads are on a carrier ring (arrow) that moves backward into the lens body when the zoom control is rotated away from the 35mm setting. To attach a lens cap, the lens must be set at the focal length of 35mm. Step-up rings with diameters larger than the carrier ring cannot be used, except at a focal length setting of 35mm.

Filters for use with a magnetic filter holder are mounted in magnetic frames.

They fit into a series adapter, which screws into the lens. A retaining ring screws into the front of the adapter to hold the filter in place.

Today, some lens accessories are attached using a series adapter.

## GELATIN FILTER HOLDERS

Gelatin filters are usually placed in a thin metal frame. They can be stacked in the frame because they are very thin. The frame is held in a slotted holder. The holder screws into the filter threads on the lens. Some "gel" holders have threads on the front to attach a threaded lens hood.

The Fisheye EF 15mm $f$-2.8 lens has a slotted holder on the back for use with gelatin filters.

## FILTER SYSTEMS

Several manufacturers offer filter-mounting systems with a variety of filters that are usually flat, plastic squares. They may be color or special-effect types. Masks are also available.

One system uses a plastic holder with several slots for filters, so they can be stacked. The holder attaches to the filter threads of the lens using threaded adapters that are available for various filter-thread sizes.

For filters that require rotation, such as a polarizer, the filter may be round and rotate in the holder. The holder itself can also be rotated.

A lens hood fits on the front of the filter holder. The hood is in sections, so you can make it longer or shorter, depending on the angle of view of the lens. Add sections until the image in the viewfinder begins to show vignetting. Then remove the last section you added. Remove one additional section, to be quite sure there's no vignetting.

**Advantages**—Filter systems fit a wide range of lens diameters, requiring only a threaded adapter for each diameter. They offer a large variety of filters and special-effect gadgets, all similar in shape and size.

# Close-Up & Macro

Making large images of small objects is an interesting and useful part of photography. This chapter discusses several methods.

## MAGNIFICATION

Magnification is defined as the height or width of the image on film divided by the height or width of the subject. For example, if the image fills the narrow dimension of the frame, the image is about 24mm tall. Suppose the subject is 30mm tall. Magnification is 24/30, which is 0.8. The image in the camera is 80% as tall as the subject. If the image on film is the same size as the subject, magnification is 1, which is called *life-size,* sometimes stated as 1:1 (one to one).

Photographing objects at life size or larger is called *photomacrography,* commonly referred to as *macro photography.*

In Figure 7-1, the subject is a tree and the image is an upside-down tree. The outside rays from the subject are shown along with the outside rays that form the image. The *angle* between the outside rays is the *same* on both sides of the lens. Both subject and image extend across the same angle of view. Therefore, the sizes of image and subject are proportional to their distances from the lens. If image and subject were the same distance from the lens, they would be the same size.

Thus, there are two ways to calculate magnification. You can compare image size to subject size or you can compare image distance to subject distance. The formula for magnification is:

$$M = \frac{I}{S}$$

where M is magnification, I is image size or distance, and S is subject size or

Photographs made at high magnification often show us detail of which we might otherwise not be aware.

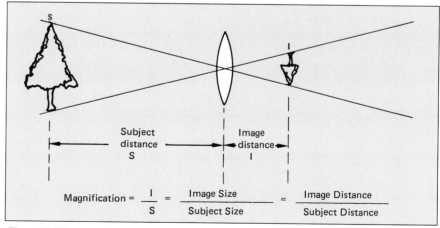

**Figure 7-1/**Because the lens angle of view is the same on both sides of the lens, the ratio of image size to subject size is the same as the ratio of their distances from the lens.

distance. Of course you must divide size by size or distance by distance.

**Magnification at Infinity**—If a subject moves into the distance, the size of its image diminishes until it is merely a point. Mathematically, as subject distance approaches infinity magnification approaches zero.

**Increasing Image Distance**—Lens-to-film distance is increased by moving the lens farther from the film to focus on closer subjects. That increases image distance, image size and magnification.

**Relationship Between Subject and Image Distances**—Neither distance can change independently of the other. As one becomes larger, the other *must* become smaller.

### RELATIVE MAGNIFICATION

Lenses with longer focal lengths produce a larger image of an object in the scene, assuming lens-to-subject distance does not change. If a 50mm lens makes an image of a subject at a certain distance, the image made by a 100mm lens will be twice as tall and the image made by a 200mm lens will be four times as tall.

This is called *relative* magnification because the magnification is compared to that of a 50mm lens. The relative magnification of a 200mm lens is 200mm divided by 50mm, which is usually stated as 4X.

The minimum focusing distance usually increases with focal length, so the benefit of increased relative magnification may not apply at close distances. For example, a 50mm lens may focus as close as 18 inches. A 200mm lens won't focus that close, so it cannot produce an image four times as tall because it cannot get close enough to the subject.

### INCREASING MAGNIFICATION BY TELE-EXTENDER

A special advantage of a tele-extender is that it multiplies both focal length and aperture by a factor, such as 2X, but does not change the minimum focusing distance of the lens. This in-

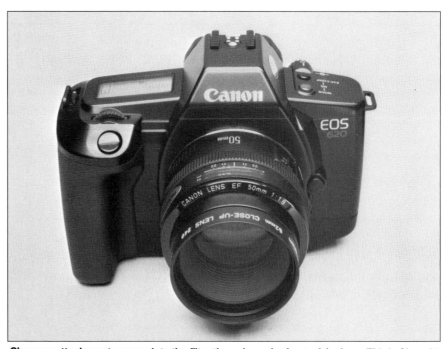

Close-up attachments screw into the filter threads on the front of the lens. This is Close-Up Lens 240, which has a 52mm thread diameter, attached to an EF 50mm *f*-1.8 camera lens. This combination provides a magnification range of 0.21 to 0.36, the exact magnification depending on the setting of the Manual Focusing Ring on the lens.

creases magnification by the same factor, such as 2X, even at the closest focusing distance.

The closest focusing distance of the EF 300mm *f*-2.8L lens is 3 meters—about 10 feet. Magnification is 0.11 at that distance. By attaching Extender EF 2X, the lens becomes a 600mm *f*-5.6 lens with the same closest focusing distance but a magnification of 0.22 at that distance.

**Focusing Range**—When focal length is increased by attaching a tele-extender, the minimum lens-to-film distance must increase by the same factor, otherwise the lens will no longer focus to infinity. For example, a 300mm lens requires 300mm between the lens rear node and the film when focused at infinity. With a 2X extender, the lens-to-film distance must be 600mm to focus at infinity. The extender provides the increased lens-to-film distance because it fits between the lens and the camera.

## CLOSE-UP ATTACHMENTS

Close-up attachments, usually called close-up lenses, are available from Canon and other manufacturers. They are simple lenses mounted in circular threaded frames, like filters. They screw into the filter ring on the front of a camera lens to provide an inexpensive and simple way to increase magnification. The amount of light reaching the film is not affected significantly.

Image quality is always reduced by a close-up lens, but the effect may be acceptable or even unnoticed, depending on the subject. Flatness of field is reduced, straight lines or edges may curve a little and the image will be somewhat less sharp. All of these effects are worse at higher magnifications.

A rule of thumb is that satisfactory image quality is provided by close-up

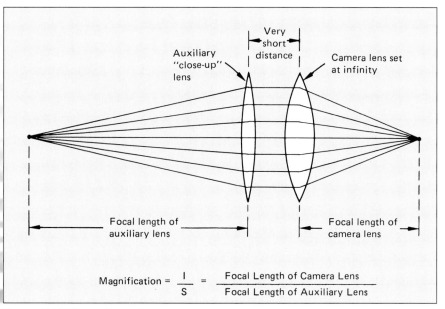

$$\text{Magnification} = \frac{I}{S} = \frac{\text{Focal Length of Camera Lens}}{\text{Focal Length of Auxiliary Lens}}$$

**Figure 7-2/With auxiliary close-up lenses, and the camera lens focused at infinity, magnification is easy to calculate. With the camera lens focused closer than infinity, magnification increases and is not as easy to calculate.**

It will bring parallel rays to focus at a distance equal to its own focal length.

With a close-up lens attached, the distance from close-up lens to subject is the focal length of the *close-up lens*. Light rays from each point on the subject enter the close-up lens and emerge as parallel rays. The parallel rays enter the camera lens and are brought to focus at the film plane.

**How to Calculate Magnification—** With the camera lens focused at infinity, image distance is the focal length of the camera lens. Subject distance is the focal length of the close-up lens. Magnification (M) is easy to calculate:

$$M = \frac{\text{Camera Lens Focal Length}}{\text{Close-Up Lens Focal Length}}$$

Both focal lengths must be in millimeters (mm). Assume you are using a 200mm camera lens with a 4 diopter close-up lens. The close-up lens has a focal length of 250mm.

$$\text{Magnification} = \frac{200\text{mm}}{250\text{mm}}$$
$$= 0.8$$

Image magnification is 0.8 with the camera lens focused at infinity. If the camera lens is focused closer than infinity, subject distance decreases and magnification increases. Image magnification is then less simple to calculate.

**Finding the Needed Diopter Value—** Usually, you decide how much magnification you want and wish to know how many diopters to use. The accompanying table shows the range of magnifications and subject distances with various combinations of accessory close-up lenses installed on a 50mm camera lens.

For example, the table shows that a 3 diopter close-up lens has a range of magnifications from 0.15 to 0.28 when used on a 50mm camera lens, depending on the setting of the focus control.

For a camera lens with a different focal length, or magnifications not on

---

lenses at magnifications up to about 0.5. If you use close-up lenses to photograph non-flat objects in nature, such as flowers, the results may be satisfactory at higher magnifications.

**Nomenclature—** Canon close-up lenses are discussed later in this chapter. This section describes accessory close-up lenses that are available from a variety of other manufacturers.

These lenses are usually sold in sets of three or four, with labels such as 1, 2, 3, 4, and 10. The labels usually express the power of the lenses in *diopters*.

$$\text{Diopters} = \frac{1}{\text{Focal Length (meters)}}$$
$$= \frac{1,000}{\text{Focal Length (mm)}}$$

A lens with a focal length of 1,000mm has a power of 1 diopter. If the focal length is 2,000mm, the power is 1/2 diopter; a focal length of 200mm signifies a power of 5 diopters.

**Stacking Close-Up Lenses—** For higher magnification, close-up lenses may be stacked by screwing them together. The reason diopters are used as labels is that the diopter power of stacked lenses is the sum of the individual diopters. A 3 close-up lens stacked with a 1 is equivalent to a 4 close-up lens.

**Focal Length—** Diopters are helpful as labels, but to use close-up lenses you need to know focal length *in millimeters,* which can be calculated from the diopter value.

$$\text{Focal Length (mm)} = \frac{1000}{\text{Diopters}}$$

A 4 diopter close-up lens has a focal length of 1000/4, which is 250mm. The accompanying table shows diopters and the equivalent focal lengths in both millimeters and inches.

**Image Formation—** As shown in Figure 7-2, close-up lenses play an optical trick on the camera lens. If the camera lens is focused at infinity, it is "expecting" parallel rays from a distant scene.

113

## MAGNIFICATION WITH ACCESSORY CLOSE-UP LENSES

| Camera Lens (mm) | Close-Up Lens | Maximum Subj. Dist. (mm) | (in) | Minimum Subj. Dist. (mm) | (in) | Magnification (min.) | (max.) |
|---|---|---|---|---|---|---|---|
| 50 | 1 | 1000 | 39 | 310 | 12 | 0.05 | 0.18 |
| 50 | 2 | 500 | 20 | 237 | 9 | 0.10 | 0.24 |
| 50 | 3 | 333 | 13 | 191 | 8 | 0.15 | 0.29 |
| 50 | 4 | 250 | 10 | 161 | 6 | 0.20 | 0.35 |
| 50 | 5 | 200 | 8 | 138 | 5 | 0.25 | 0.41 |
| 50 | 6 | 167 | 7 | 122 | 5 | 0.30 | 0.46 |
| 50 | 10 | 100 | 4 | 82 | 3 | 0.50 | 0.69 |

**The inscription on an accessory close-up lens usually indicates its power in diopters. Accessory close-up lenses are usually packaged in sets with diopter ratings of 1, 2 and 3 or 1, 2 and 4. They can be stacked for higher power, such as 6. Some makers offer a 10-diopter close-up lens and some offer variable-power adjustable close-up lenses.**

## MAGNIFICATION WITH CANON CLOSE-UP LENSES

| Camera Lens (mm) | Close-Up Lens | Maximum Subj. Dist. (mm) | (in) | Minimum Subj. Dist. (mm) | (in) | Magnification (min.) | (max.) |
|---|---|---|---|---|---|---|---|
| 50 | 240 | 240 | 9 | 157 | 6 | 0.21 | 0.36 |
| 50 | 450 | 450 | 18 | 225 | 9 | 0.11 | 0.25 |
| 50 | 500 | 500 | 20 | 237 | 9 | 0.10 | 0.24 |

**The labels on Canon close-up lenses indicate focal length in millimeters. This table shows magnification with a 50mm lens set at infinity.**

the table, you can calculate the strength of the close-up lens for the desired amount of magnification, *assuming* that the camera lens is focused at infinity. The formula is:

$$\text{Diopters} = \frac{1000 \times \text{Magnification}}{\text{Camera Lens Focal Length}}$$

The camera lens focal length is in millimeters (mm).

Suppose the formula yields a diopter value of 0.33, which is not a standard value. Use the next smaller standard value, 3 diopters, and focus the camera lens closer than infinity.

**Canon Close-Up Lenses**—Canon close-up lenses are labeled 240, 450 or 500. The labels are focal length in *millimeters,* not diopters. Except for

### CLOSE-UP LENSES WITH OTHER FOCAL LENGTHS

**The accompanying tables show magnification with camera lenses of 50mm focal length. *Maximum* magnification with other focal lengths is proportional to focal length, if the camera lens is focused at infinity. For example, magnification with a 200mm lens is 4 times as great as with a 50mm lens. If the lens is not focused at infinity, longer focal lengths give increased magnification, but not in the proportions suggested above.**

the difference in labeling, they work as already discussed.

**Singlet or Doublet**—Ordinary close-up lenses are *singlets,* which means they are made of a single piece of glass. Most of the lens-design techniques

### CANON DOUBLET CLOSE-UP LENSES

| Label | Focal Length | Thread Diameter |
|---|---|---|
| 240 | 240mm | 52mm |
| 450 | 450mm | 52mm & 58mm |
| 500T | 500mm | 58mm |

used to correct aberrations cannot be used with only a single piece of glass, which is the reason for compound lenses that use more than one piece of glass.

Canon close-up lenses are *doublets,* made of two pieces of glass of different types and shapes. This allows correction of aberrations. The image made

with a doublet is usually better than that made with a singlet.

The literature packaged with Canon close-up lenses makes recommendations intended to maintain image quality above a certain standard. For example, Canon suggests using close-up lenses only with camera lenses in the focal-length range of 35mm to 135mm.

Some combinations of close-up and camera lenses are not recommended. However, you are the judge of image quality for your purpose and there is no harm in trying other combinations.

**Using Close-Up Lenses**—Install the close-up lens or lenses on the camera lens. If you stack close-up lenses, place the higher diopter rating—shorter focal length—nearer the front surface of the camera lens.

Support the camera firmly to avoid image blur. Depth of field is reduced by higher magnifications. It will be improved by using smaller aperture. Use the metered exposure. Light is not significantly reduced by the close-up lens.

The focusing ring on the camera lens affects both focused distance and magnification. With a close-up lens attached, the focused-distance scale on the camera lens will not show subject distance correctly.

As stated earlier, with the camera lens focused at infinity, the distance to a focused subject is the focal length of the close-up lens or combination of close-up lenses. A subject at a greater distance *cannot* be focused. There is also a minimum distance, below which the subject cannot be focused.

**Manual Focus**—With the camera Focus-Mode Switch set to Manual, set the camera lens at infinity. Find focus by moving the camera. If magnification is not enough with the camera lens focused at infinity, set it to a shorter distance. Find focus again by moving the camera closer to the subject.

**Autofocus**—On autofocus, the camera will focus the combination of close-up and camera lens, if the image is not greatly out of focus. After focusing, if image size is not correct, move closer or farther away and focus again.

A split-field lens is a close-up lens that's half lens and half air space.

## SPLIT-FIELD LENSES

An accessory split-field lens is a close-up attachment that is half lens and half air space. It is used to focus two objects—one near and one far—so far apart that both cannot be included in the depth of field of the camera lens alone.

Half of the image is formed by the combination of camera lens and the close-up part of the split-field lens. For that part of the image, the near subject—perhaps 20 or 30 inches from the camera—will be in focus. The other half of the image is formed by the camera lens alone. That part of the subject may be as far as 100 feet away.

There will be a blurred zone of bad focus between the near focus of the split-field lens and the far focus of the camera lens. This can be visually minimized by careful subject composition.

Split-field lenses are labeled with a diopter value in the same manner as close-up lenses. Of course, that applies only to the lens part of the attachment.

**Focusing**—Manually set focus at the distant object. Move the camera to bring the nearby object in focus through the split-field lens.

## MACRO-ZOOM LENSES

Most EF zoom lenses, discussed in Chapter 2, allow close focusing with a maximum magnification of about 0.2. They are mentioned here because they offer another method of achieving higher than usual magnification.

The "macro" range of a zoom lens produces images comparable in quality to those produced by close-up lenses—at the same magnification. If that magnification is enough, a macro-zoom lens is more convenient to use.

This EF 35—105mm *f*-3.5—4.5 Zoom lens has a close-focusing macro range. Magnification is greater at longer focal-length settings, with maximum magnification of about 0.2. The smallest marked distance on the focused-distance scale is 1.2 meters. Closer distances are in the zone labeled MACRO. **The autofocus system works very well in the macro range.**

The macro range of a zoom lens provides a handy way to photograph objects in nature, such as this cactus flower.

# MAGNIFICATION BY EXTENSION

With a lens focused at infinity, the image distance is the same as the focal length of the lens—the *minimum* distance ever used between lens and film. To focus on a subject nearer than infinity, the lens elements are moved forward from the minimum distance. The amount that the lens is moved forward is called lens *extension*. More extension produces a larger image of a closer subject.

There are two ways to use the lens extension provided by the focus control. One is to focus on a subject at a certain distance and accept the magnification that results. The other is to set the lens extension for a desired amount of magnification and then change subject distance to find focus— by moving camera or subject.

## MAGNIFICATION OF ORDINARY LENSES

The maximum magnification provided by ordinary lenses is relatively small. For example, with the lens fully extended, the closest focusing distance of an *ordinary* 50mm lens, such as the EF 50mm *f*-1.8 is 0.45 meters, about 18 inches. At that distance, magnification is 0.15. The image is 15% as tall as the subject.

**Why Lens Won't Focus Closer**—As an ordinary lens is focused on closer subjects, image quality deteriorates. The lens designer sets a limit to the closest focusing distance at a value that still produces excellent image quality. Mechanically, you can't focus the lens closer than that limit.

## CALCULATING MAGNIFICATION

When using lens extension to control magnification, it is often useful to know how much extension is needed.

The formula is simple:

$$X = M \times F$$

where S is lens extension in millimeters, M is magnification and F is focal length of the lens in millimeters.

Suppose you want a magnification of 0.5 with a 50mm lens:

$$X = 0.5 \times 50mm$$
$$= 25mm$$

Extension is 25mm. Starting with the lens focused at infinity, move the lens forward 25mm and magnification of a focused subject will be 0.5.

For the rest of this discussion, please refer again to Figure 7-1.

**Image Distance**—In that example, the lens was 50mm from the film when focused at infinity—because it's a 50mm lens. For a magnification of 0.5, lens extension is 25mm. The *total* distance from lens to film becomes

116

This is the EF Macro 50mm $f$-2.5 lens. Magnification and focused distance are read through the window on the lens body. This lens is set for a magnification of 0.1, which is shown as 1:10 on the scale. At that magnification, focused distance is 2 feet or 0.6 meter. As shown in the accompanying table, maximum magnification is 0.5. The lens focuses to infinity, where magnification is theoretically zero.

This is a TV screen photographed at a magnification of 1.0 using the EF Macro 50mm $f$-2.5 lens and accessory Life-Size Converter EF. You can see the red, green and blue elements used to make the TV image. The ghost images of the numerals were part of the original TV image.

75mm, about 3 inches, which is image distance.

**Subject Distance**—For sharp focus *and* the desired magnification, it is necessary to place the subject at the correct distance—by moving either the subject or the camera.

Magnification is always the ratio of image distance to subject distance:

$$M = \frac{I}{S}$$

That expression can be rearranged to calculate subject distance:

$$S = \frac{I}{M}$$

Using the same example:

$$S = \frac{75mm}{0.5}$$
$$= 150mm$$

Subject distance is 150mm, about 6 inches.

**Focused Distance**—The focused-distance scale of a lens shows the distance from the film plane in the camera to the subject plane in front of the lens. Theoretically, this is the sum of image distance and subject distance, which we have just calculated *exactly*. It's 150 mm. That would be true with a thin, single-element lens.

Practical, real-world lenses have several elements and some distance from the front element to the back element. The lens designer designates two optical locations from which subject distance and image distance are measured—the front and rear nodes.

In the real world, the focused distance is the sum of three distances: film to rear node, rear node to front node, front node to subject. Usually, we don't know the distance between the nodes, so we can't calculate focused distance exactly. It is accurate if you read it from the lens focused-distance scale.

**Life-Size Images**—As calculated earlier in this section, a lens extension of 25mm is required for a magnification of 0.5 with a 50mm lens. By the same method, we can calculate that an extension of 50mm is required for a magnification of 1.

With different focal lengths, the results are similar: For a magnification of 0.5, extension is always half of the focal length; for a magnification of 1, extension is always equal to the focal length.

## ADDITIONAL LENS EXTENSION

Some lens extension is provided by the focusing mechanism of a lens. An ordinary 50mm lens has a focus travel of about 10mm, with a resulting magnification of about 0.15. To get more magnification, you must provide more extension than the amount built into the lens focusing mechanism.

There are several ways to provide the extension needed for a certain magnification. At press time, no equipment for the methods discussed in this section had been announced by Canon for use with EOS cameras. It is possible that they may be available before the next edition of this book.

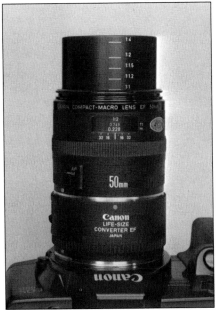

To use the accessory Life-Size Converter EF, install the Converter on the camera body. Then mount the EF Macro 50mm *f*-2.5 lens on the forward end of the Converter. This changes the focused-distance range and the magnification range, as shown in the accompanying table. Magnification is read on the telescoping forward part of the lens body. The lens is set for a magnification of 1.0, shown as 1:1 on the lens scale. When the Converter is used, the scales in the window on the lens body are not correct and the lens cannot focus to infinity.

### EF MACRO 50mm *f*-2.5 LENS WITHOUT LIFE-SIZE CONVERTER EF

| Focused-Distance Scale Reading | | Magnification Scale Reading | Magnification Factor |
|---|---|---|---|
| Meters | Feet | | |
| 0.228 | 0.749 | 1:2 | 0.500 |
| 0.249 | 0.815 | 1:2.5 | 0.400 |
| 0.270 | 0.887 | 1:3 | 0.333 |
| 0.316 | 1.038 | 1:4 | 0.250 |
| 0.363 | 1.19 | 1:5 | 0.200 |
| 0.411 | 1.35 | 1:6 | 0.167 |
| 0.509 | 1.67 | 1:8 | 0.125 |
| 0.6 | 2 | 1:10 | 0.100 |
| 0.8 | 2.6 | | |
| 0.9 | 3 | | |
| 1 | 3.28 | | |
| 1.5 | 5 | | |
| 3 | 10 | | |

### EF MACRO 50mm *f*-2.5 LENS WITH LIFE-SIZE CONVERTER EF

| Magnification Factor | Magnification Scale Reading | Focused Distance | |
|---|---|---|---|
| | | Meters | Feet |
| 0.25 | 1:4 | 0.423 | 1.39 |
| 0.5 | 1:2 | 0.294 | 0.97 |
| 0.67 | 1:1.5 | 0.263 | 0.86 |
| 0.83 | 1:1.2 | 0.246 | 0.81 |
| 1.0 | 1:1 | 0.237 | 0.78 |

**Extension Tubes**—An extension tube is a hollow, empty cylinder. It fits between lens and camera.

Sets of extension tubes of various lengths can be used to change the magnification range of a lens. With a 50mm lens, an extension tube that is 25mm long will provide magnification of 0.5 with the lens focused at infinity. A 50mm extension tube provides magnification of 1 with the lens focused at infinity.

The tubes can be stacked as desired, to change extension in fixed increments. The amount of magnification is "fine-tuned" by the focus control of the lens, which increases magnification as it moves the lens farther from the film. Any lens can be used on the forward end of an extension tube but image quality is best if a macro lens is used.

**Bellows**—A bellows fits between lens and camera to provide a continuously variable amount of extension. The maximum extension and maximum magnification is typically greater than that provided by extension tubes.

**Focusing Range**—With an extension device between lens and camera, the lens can no longer focus to infinity because lens-to-film distance cannot be made small enough. This is not a problem because the extension device is intended specifically to magnify the image of subjects that are close to the lens.

## MACRO LENS

The EF 50mm *f*-2.5 Compact-Macro lens is specially designed to focus closer than ordinary lenses, with good image quality throughout the focusing range.

Macro lenses have better flatness of field than ordinary lenses, so you can photograph flat objects, such as postage stamps, and get excellent overall sharpness, as well as a lack of distortion. Optically, macro lenses are designed to produce images of good quality at a magnification of 1. Macro lenses focus to infinity, and can therefore also be used for ordinary photography.

**Focus Travel**—The EF 50mm *f*-2.5 Macro lens focuses to about 9 inches with a magnification of 0.5 at that distance. As you have seen, that requires a lens extension of 25mm, which is pro-

vided by the focusing mechanism of the lens. The focus "travel" is longer than on ordinary 50mm lenses.

**Depth of Field**—Increasing magnification greatly reduces depth of field. You can get some of it back by using a smaller lens aperture. For that reason, the minimum aperture of this lens is $f$-32, which is smaller than usual for 50 mm lenses.

**Magnification Scale**—The focused-distance scale shows magnification at each focused distance, as a fraction with a numerator of 1. See the accompanying table.

**Setting Magnification**—To set up for a desired magnification, set the lens Focus-Mode Switch to M for manual focusing. Turn the Manual Focusing Ring on the lens to the desired amount of magnification. Notice the focused distance for that magnification. Place the subject at the indicated distance from the film-plane mark engraved on top of the camera. Move the camera slightly to bring the image into best focus.

**Focusing**—If the exact magnification is not important, but you want to fill the frame with the image of a small object, it is convenient to use autofocus. Move the camera closer or farther away, autofocusing at each distance, until you see the desired image size in the viewfinder.

**Life-Size Converter EF**—Developed for the EF 50mm $f$-2.5 Macro lens, this converter is a combination of tele-extender and extension tube. It has glass lens elements that increase the focal length of the lens from 50mm to about 70mm, with a proportional increase in magnification. Additional magnification is provided by making the device longer than needed for a conventional tele-extender.

Because of the added extension with the converter installed, the lens will not focus to infinity. Without the converter, the magnification range is "zero" with the subject at infinity up to 0.5 with the subject 9 inches from the film plane. With the converter, the magnification range is 0.25 to 1.

### EXPOSURE FACTOR WITH EF MACRO 50mm $f$-2.5 LENS

| Magnification | Exposure Factor with Lens alone | Exposure Factor with Converter | Approx. Manual Correction in Exposure Steps |
|---|---|---|---|
| 0.1 | 1.21 | | 0 |
| 0.125 | 1.27 | | 0 |
| 0.167 | 1.36 | | 0.5 |
| 0.2 | 1.44 | | 0.5 |
| 0.25 | 1.56 | 1.58 | 0.5 |
| 0.33 | 1.78 | | 1.0 |
| 0.4 | 1.96 | | 1.0 |
| 0.5 | 2.25 | 2.07 | 1.0 |
| 0.67 | | 2.44 | 1.0 |
| 0.83 | | 2.83 | 1.5 |
| 1.0 | | 3.25 | 1.5 |

With any lens, increased magnification causes reduced image brightness. At magnifications of 0.1 or more, the light loss is significant. If you use the light meter built into the camera, disregard this table. The camera measures the actual amount of light that comes through the lens and calculates exposure accordingly.

If you are using an *external light meter,* the indicated exposure must be *multiplied* by the exposure factor shown here. For example, if magnification is 0.2, multiply the accessory exposure-meter recommendation by a factor of 1.44 and set exposure manually on the camera. In the manual mode, exposure can be set in half-step increments.

These photos were made at magnifications of 0.1, 0.25, 0.5 and 1.0 using the EF Macro 50mm $f$-2.5 lens and Life-Size Converter EF. With the Focus-Mode Switch on Manual, the lens focus control was set for the desired magnification. Focus was achieved by moving the camera. Exposure was set automatically by the camera, using the Aperture-Priority AE mode.

The pin in the fabric is about 32mm long and therefore nearly fills the frame at a "life-size" magnification of 1. Increased magnification decreases depth of field, as you can see. The camera was angled slightly and aperture set at $f$-11 to make the depth-of-field limitations more evident. Smaller aperture will increase depth of field, but not much.

# Electronic Flash

If the subject is close to a wall, direct flash causes a distinct shadow. This woman is in costume for a Dixieland jazz festival.

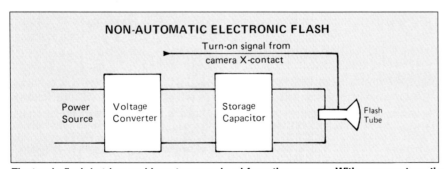

Electronic flash is triggered by a turn-on signal from the camera. With a non-automatic flash, there is no way to turn it off. It emits light until the storage capacitor becomes discharged. If fully charged before firing, it makes the same amount of light each time it is triggered.

Canon refers to its electronic flash units as *Speedlites,* such as Speedlite 420EZ. Flash units with EZ or E in the nomenclature are said to be *dedicated* to EOS cameras because they have special capabilities when used together.

## BASIC PRINCIPLES

The components of a simple non-automatic electronic flash are shown in the accompanying diagram. The Power Source is usually batteries, which supply a low voltage, such as 6 volts. The flash tube requires a much higher voltage, such as 400 volts. The Voltage Converter changes the voltage from the battery to the needed higher value.

The Storage Capacitor stores electrical energy in a way similar to a battery. It is charged slowly, by electrical energy from the voltage converter. To fire the flash, it is discharged very rapidly, supplying a brief burst of energy.

The Flash Tube is a glass envelope filled with xenon gas. It is turned on by a signal from the camera. The electrical energy from the storage capacitor causes the flash to emit a pulse of very bright light.

**Color Quality**—Light from an electronic flash simulates daylight. When used with daylight film, colors are usually realistic. With tungsten film, a conversion filter is required, as discussed in Chapter 6.

**Non-Automatic Flash**—In the system depicted in the accompanying diagram, there is no way to turn the flash tube off. The burst of light continues until the storage capacitor is discharged. A non-automatic flash is similar to a flashbulb in that it makes the same amount of light each time it is fired.

**TTL Auto Flash**—An automatic flash

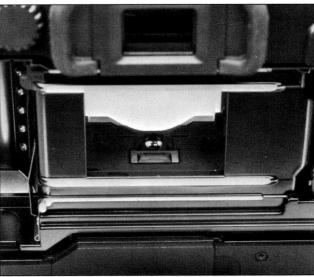

This is an EOS camera with the back cover open, focal-plane shutter open, mirror up, and lens removed. There are two sensors in the bottom of the mirror box. The round lens is the TTL light sensor. It looks "backward" to measure light reaching the film during exposure by electronic flash. The rectangular sensor is the BASIS electronic focus detector.

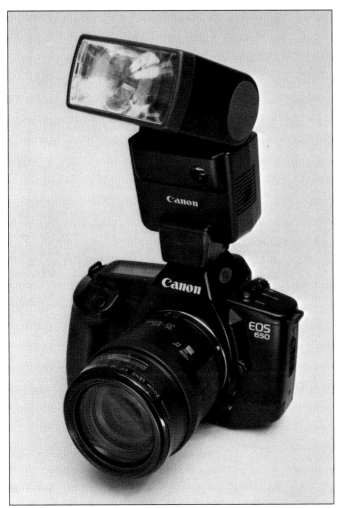

This is Speedlite 420EZ. The EZ flash units are designed to work with EOS cameras and provide completely automatic flash. The flash head of the 420EZ can be tilted and rotated to provide more natural lighting by bouncing the flash off a wall or ceiling.

does not make the same amount of light each time it fires. In EOS cameras, light from the flash is measured on the surface of the film, during the actual exposure. When sufficient light has been measured—flash plus ambient (continuous) light on the scene—the camera produces a turn-off signal that extinguishes the flash. Because the light being measured has come *through the lens,* this is called TTL automatic flash.

**Energy-Saving Design**—The duration of the flash determines the amount of charge withdrawn from the storage capacitor. For a short pulse of light, the charge level is reduced only a small amount and the remaining energy in the storage capacitor is saved for the next flash. This is not the "Save Energy" function of EZ flashes, which is automatic turnoff.

**Recycle Time**—Whether the flash is manual or automatic, the storage capacitor in the flash supplies electrical power for each burst of light. The capacitor is usually recharged before the flash is fired again. Recharging time, called *recycle time,* is affected by battery type. It is longer with nearly discharged batteries and if more charge has been withdrawn from the storage capacitor.

**Audible Charging**—The charging circuit in most flash units makes a faint hum that rises in pitch as the storage capacitor nears full charge.

**Ready Lamp**—When an EZ flash is charged and ready to fire, a Ready Lamp glows on the back of the flash unit. Simultaneously, a "lightning" symbol appears in the viewfinder as a

Light from a flash falls off rapidly with increasing distance, following the inverse-square law. If a flash is the only or main light source, the effect can be pronounced.

When direct flash is the main light source, a distant background receives very little illumination and is dark in the photo.

flash-ready indicator.

**Testing**—To test an EZ flash when the Ready Lamp is glowing, press the Ready Lamp as though it were a pushbutton. If the flash and batteries are OK, the flash will fire and then recharge.

**Maintenance Tips**—For long storage, remove the batteries from the flash. Otherwise, they may leak or corrode and damage the flash.

The storage capacitor may deteriorate if not charged occasionally. If the flash has not been used for two or three months, it's a good idea to insert batteries and fire the flash using the test procedure. Then, turn off the flash with the Ready Lamp glowing and store it in that condition.

Keep the flash away from heat, moisture, dirt and vibration. Don't use a Canon flash on a camera of another brand.

## EFFECTS OF FLASH-TO-SUBJECT DISTANCE

Subjects at different distances from the flash receive noticeably different amounts of illumination. Light from a flash is an expanding beam that decreases in brightness according to the inverse-square law, illustrated in Chapter 6. If distance from the flash is doubled, brightness decreases to 1/4, which is 2 exposure steps.

Suppose flash is the principal source of light for subjects at 5, 10 and 20 feet. If the subject at 10 feet is correctly exposed, the nearer subject will be *overexposed* by 2 steps and the distant subject will be *underexposed* by 2 steps. The result will be evident in the photograph.

To avoid that problem, place subjects at approximately the same distance from the flash. Compose so there are no other large objects, such as furn-

iture, at closer distances.

Another consequence of light falloff from a flash is that a distant background receives very little illumination. Suppose light from a flash is sufficient to provide correct exposure at 10 feet. At 20 feet, the light is reduced by 2 steps. At 40 feet, light falloff is 4 steps. Objects at that distance and beyond are severely underexposed by the flash. Exposure of distant objects in the background is determined by the ambient light on the scene.

## FLASH DURATION AND SHUTTER SPEED

Electronic flash produces a pulse of light with extremely short duration, such as 1/20,000 second. Because SLR cameras use focal-plane shutters, there is a range of shutter speeds in which flash cannot be used. Operation of a focal-plane shutter is described more

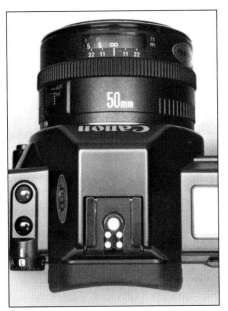

The hot shoe on an EOS camera has five electrical contacts. The large X-sync contact delivers the turn-on signal to the flash. The four smaller contacts provide automatic features, such as turning off the flash when exposure is correct and operating a viewfinder display to show when the flash is ready to fire.

## EOS DISPLAYS WITH FLASH

P

60    5.6

ONE SHOT

14    S

FOCUS INDICATOR

60    5.6    ⚡    ●

SHUTTER SPEED
APERTURE    FLASH-CHARGE INDICATOR

When an EZ flash is turned on, charged, and ready to fire, the Flash-Charge Indicator appears in the viewfinder display. Shutter-speed and aperture values may change so they are suitable for the flash mode being used. The values are shown in the LCD Panel and viewfinder display. The Focus Indicator glows steadily when the image is in focus. In dim light, the EZ flash unit will emit a pulse of dark-red light to assist the camera in automatically focusing on the subject.

fully in Chapter 1.

The flash must be fired *after* the first curtain has fully opened, but *before* the second curtain starts to close. Otherwise, part of the frame would be covered by one of the curtains during the brief burst of light from the flash.

**Shutter-Curtain Travel Time—** Each shutter curtain takes a certain amount of time to move across the frame, called *travel time*.

**Exposure Interval—** The exposure time begins when the first shutter curtain *starts* to open the frame and ends when the second curtain *starts* to close the frame.

**With Slow Shutter Speeds—** Suppose the shutter-curtain travel time is 1/100 second and the exposure time is 1/30 second. At the beginning of the exposure interval, the first curtain *starts* to move. After 1/100 second, the first curtain is fully open and the entire

frame is exposed to light.

The focal-plane shutter remains fully open until the end of the exposure interval of 1/30 second. Then, the second curtain *starts* to close the frame.

There is a period of time, between 1/100 and 1/30 second from the beginning of the exposure, when the frame is completely uncovered. Electronic flash can be used during that period.

**With Fast Shutter Speeds—** Suppose the travel time is 1/100 and the exposure interval is 1/500 second. The first curtain begins the exposure by starting to open the frame. After 1/500 second, the second curtain *must* start closing, to end the exposure.

The second curtain starts closing the frame *before* the first curtain has fully opened it. Flash cannot be used because there is never an opportunity for it to illuminate the entire frame.

As shown in Chapter 1, exposure by *continuous* light is made through a narrow traveling slit between the two curtains.

### FREEZING MOTION

Another consequence of short-duration flash is that it can "freeze" or stop motion. Because the exposure time due to flash is very short, subject movement during that interval may be imperceptible in the photo.

### CONNECTING A FLASH

Flash units mount in a holder on top of the camera that is commonly called a "hot shoe" because it has electrical contacts. Flash units have a mounting foot that fits in the hot shoe. Electrical contacts on the flash foot mate with those in the hot shoe.

**Hot-Shoe Contacts—** A hot shoe has a central contact that fires the flash. EOS

Flash at the X-sync shutter speed "stopped" the movement of this automobile photographed at night.

This photo was made using flash at a shutter speed of 1 second with first-curtain sync. Because of the longer exposure time, the moving lights of the autombile left a trail. Because the flash fired near the beginning of the exposure interval, the trail seems to extend forward from the vehicle.

Changing to second-curtain sync caused the light trail to extend behind the car, to produce a more normal-looking photo.

cameras and flash units have special "dedicated" features that require additional connections between flash and camera, which are provided by auxiliary contacts in the hot shoe.

## FLASH SYNCHRONIZATION

An electronic flash is fired by a signal from the camera. Timing that signal so the flash is fired when the shutter is fully open is called synchronization, abbreviated *sync*.

**First-Curtain Sync**—The usual way to fire a flash is to give the sync signal at the instant the first shutter curtain becomes fully open. That's the first opportunity to fire the flash and get a fully exposed frame.

**X-Sync Shutter Speed**—As discussed earlier, electronic flash can be used at slow shutter speeds, but not at speeds that are too fast. The *fastest* shutter speed at which electronic flash can be used is called the X-sync speed. The focal-plane shutters in EOS cameras have short travel times and therefore fast X-sync shutter speeds—1/250 second for the EOS 620 and 1/125 second for the EOS 650, 750 and 850.

**Protection Against Incorrect Settings**—With Canon dedicated electronic flash, EOS cameras will not allow shutter speeds faster than X-sync to be used.

**Advantage of Fast X-Sync Speed**— When flash is used, there may also be some continuous light on the scene, such as room lighting or street lamps. There is exposure due to the flash and also a chance of some exposure due to the ambient light. Exposure due to ambient light is affected by shutter speed—slower speeds give more exposure.

If the subject is moving, you may get a sharp image due to the short-duration flash, and a blurred image of the same subject due to ambient light. The second image is called a ghost. It is usually not desired. A fast X-sync shutter speed reduces exposure due to ambient light and therefore reduces the possibility of undesired ghost images.

Using the manual flash-head zoom capability of a 420EZ flash, I deliberately set the flash-coverage angle to match the angle of view of an 80mm lens while using a 28mm lens to make this photo. The flash beam did not cover the angle of view of the lens.

Notice that the flash pattern has approximately the same shape as the film frame—a width-to-height ratio of 3:2. When the flash beam angle matches the angle of view of the lens, most of the light from the flash falls inside the image frame and very little is wasted.

Notice also that the flash pattern is displaced upward in this photo. That happened because the flash head is about six inches above the center of the lens and the subject was close to the camera. This is called parallax error. With the correct flash beam angle, it is not visible.

## FLASH AND AMBIENT-LIGHT EXPOSURE

With electronic flash, you can use the X-sync shutter speed, or any *slower* speed. No matter what shutter speed is used, the entire flash occurs while the shutter is open. Therefore, exposure due to the flash alone is the same at any allowable shutter speed. Exposure due to ambient light varies with shutter speed, just as if flash were not used.

## SLOW-SYNC FLASH

Using flash with a shutter speed slower than the X-sync speed is sometimes called *slow-sync* flash.

**In Dim Light**—Because light from a flash diminishes with increased distance, photos exposed mainly by flash often have correctly exposed subjects against very dark backgrounds. If the ambient light on the scene is not too bright, you can make the background lighter by using a slower shutter speed. Exposure of the subject due to ambient light also increases, but not to the same degree.

Let's use some numbers to illustrate that. Suppose you are using flash in dim light to photograph a subject against a distant background. Suppose you are using the X-sync shutter speed of 1/250 second and the flash puts 48 "units" of light on the subject.

The dim ambient light puts 2 units of light on the subject in addition to light from the flash, for a total of 50 units, which produces correct exposure. The distant background also receives 2 units of ambient light during the exposure time but no significant light from the flash.

Suppose shutter speed is changed to 1/60, approximately 4 times as long.

Background and subject will each receive 4 times as much ambient light, which is 8 units.

As you know, doubling the amount of light increases exposure by one step. Background illumination increased from 2 to 8 units, which is 2 exposure steps.

The total amount of light *on the subject* increased from 50 to 56 units, which is a small fraction of an exposure step—not enough to notice. The result is a lighter background with essentially the same exposure of the subject.

**In Bright Light**—If the ambient illumination is bright, using a slower shutter speed increases the ambient-light exposure of both background and subject. To prevent overexposure of the subject, the amount of flash exposure must be reduced in proportion to the increase in ambient-light exposure.

## SECOND-CURTAIN SYNC

When using electronic flash, there are occasions when a ghost image of a moving subject is desired, or cannot be prevented. With first-curtain sync, the ghost image is formed by ambient-light exposure that occurs *after* the flash has fired.

With a moving subject, this makes a photo in which the motion seems backwards. There is a sharp image of the subject due to the flash and a blurred image that extends in front of the subject, because the subject continued to move. We expect the blurred image to trail behind a moving subject, not precede it.

A dedicated feature of EOS 620/650 cameras and EZ flash units is second-curtain sync. Instead of firing the flash at the instant the first curtain is fully open, it fires just before the second curtain begins to close.

With second-curtain sync, the blurred image is formed *before* the sharp image caused by the flash. This causes the ghost image to trail behind the subject. This effect requires a shutter speed slower than 1/60 second—such as 1/2 or 1 second—to allow a suitably long trail to form.

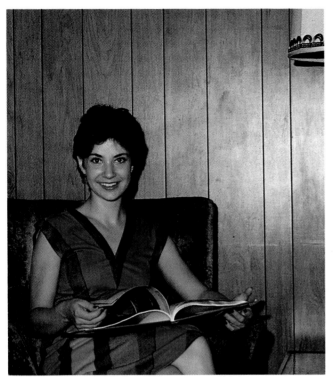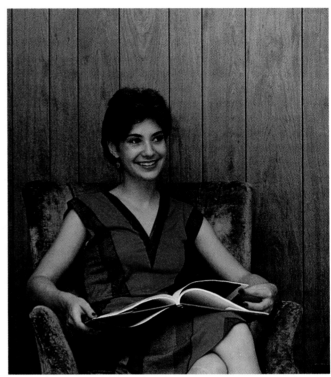

Direct flash (left photo) produces flat lighting, with a shadow if the subject is near a wall. Flash light bounced off the ceiling (right photo) produces softer light, better modeling of facial features, and soft realistic shadows.

## FLASH COVERAGE ANGLE

Flash units produce a rectangular beam of light having approximately the same shape as the 35mm film frame. The coverage of the beam is stated by its similarity to the angle of view of a lens. For example, if the flash coverage angle is 50mm, the flash will illuminate everything in the scene that is within the angle of view of a 50mm lens.

**Zoom Head**—EZ flash units have an internal zoom mechanism that changes the coverage angle according to the lens in use. If the lens is zoomed, the coverage angle changes automatically to agree with the new focal length.

**Brightness**—Changing coverage angle affects illumination of the scene. A narrow angle, such as 80mm "concentrates" light from the flash into a smaller portion of the scene. Therefore, the light is brighter. A wide angle, such as 28mm, covers more of the scene but with less illumination.

## FILL FLASH

Fill lighting from one source is used to lighten shadows caused by another light source. A common use of electronic flash is to provide fill lighting outdoors, where the main light is the sun. EOS cameras and dedicated flash units can automatically control flash fill with sunlight. This is discussed later in this chapter.

## BOUNCE FLASH

A pleasing photo can be made by bouncing light from the flash off the ceiling or a wall. The resulting light on the subject is diffused by the bounce and arrives at an angle that gives some modeling to facial features.

To allow bouncing with the flash in a hot shoe, the flash head of the Speedlite 420EZ can be tilted from horizontal to vertical and swiveled 180 degrees to the left or 90 degrees to the right.

The surface used to bounce the light should be white or near-white because the bounced light will assume the color of the bounce surface. The surface should be reasonably reflective and nearby. Less light reaches the subject than with direct flash because the path is longer and because some light is absorbed and scattered by the bounce surface.

With EZ flash and EOS cameras, exposure with bounced flash can be controlled automatically.

## GUIDE NUMBER

Exposure by electronic flash depends on the light output of the flash, flash-to-subject distance, film speed and lens aperture. Shutter speed is not a factor because all allowable speeds hold the shutter open longer than the duration of the flash.

The light output of a flash is expressed by a *guide number*, which is

part of the flash specifications. A higher guide number represents a more powerful flash.

When flash was first developed, guide numbers were used to calculate exposure settings for the camera, with pencil and paper or by a calculator dial on the back of the flash.

EOS cameras usually control flash exposure automatically, so such calculations are normally not necessary. However, there are some applications of flash that require use of guide numbers. They are used in flash specifications tables and it is helpful to understand what they mean.

Guide numbers assume that you will photograph an average subject indoors, where the subject is illuminated both by direct light from the flash and reflected light from the flash that bounces off walls and ceiling. Guide numbers do not take into account additional exposure due to ambient light.

## CALCULATING APERTURE SIZE

To set exposure by guide-number (GN) calculation, choose a shutter speed that can be used with electronic flash. Then figure aperture with this formula:

$$f\text{-number} = \frac{GN}{\text{Subject Distance}}$$

**Units**—Guide numbers are specified in feet or meters and subject distance must be expressed in the same unit. After focusing, you can read subject distance on the lens Focused-Distance Scale.

For example, if the flash guide number is 60 (feet) and subject distance is 15 feet:

$$f\text{-number} = \frac{60}{15}$$
$$= f\text{-4}$$

## CALCULATING DISTANCE

You may occasionally want to calculate the operating distance of a flash:

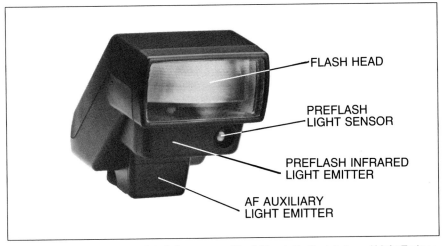

EZ flash units have three built-in light sources: Flash Head, Preflash Infrared Light Emitter, and AF Auxiliary Light Emitter.

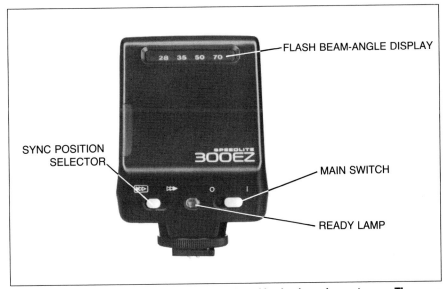

Speedlite 300EZ provides fully automatic flash and is simple and easy to use. There are only two controls: the Main Switch, and the Sync Position Selector, which selects first-curtain or second-curtain sync.

$$\text{Subject Distance} = \frac{GN}{f\text{-number}}$$

The units for GN and distance are the same: meters or feet. To find maximum distance, use the maximum aperture of the lens.

## VARIABLE GUIDE NUMBER

Some flash units have variable power levels, variable angles of coverage, and other settings that affect guide number, so the specifications show more than one guide number. Pick the number that applies to the settings you will use. Be sure you understand the conditions for which that number is valid.

## GUIDE NUMBER VERSUS FILM SPEED

A guide number is published for a specified film speed—usually ISO 100—which must be stated as part of the guide number.

**Converting to Different Film Speed**—If you are using a different

film speed, you must convert the GN so it applies to the new film speed:

$$\text{New GN} = \text{Publ. GN} \times \sqrt{\frac{\text{New FS}}{\text{Publ. FS}}}$$

where FS signifies the Film Speed. Suppose the published GN is 20 feet with a film speed of 25. You are using film with a speed of 400. To convert the guide number:

$$\begin{aligned}
\text{New GN} &= 20 \times \sqrt{400/25} \\
&= 20 \times \sqrt{16} \\
&= 20 \times 4 \\
&= 80 \text{ (feet)}
\end{aligned}$$

With the same flash, but faster film, shooting distance increases because faster film needs less light for exposure.

## SAVE-ENERGY FUNCTION

To conserve battery power, an EZ flash turns itself off automatically after five minutes if it has not been fired. To turn it back on again, press the Ready Lamp on the flash, or depress the Shutter Button halfway, or press any camera control button.

## AF AUXILIARY LIGHT EMITTER

If you use flash because the scene is dark, it may also be too dark for the camera's autofocus system. Flash units for EOS cameras have a built-in AF Auxiliary Light Emitter on the front of the flash body. When fired, it produces a dark-red pattern of vertical stripes. This pattern falls on the subject to assist the camera autofocus system, when needed.

This works when a flash is installed and turned on. If the EOS camera senses that the scene is too dark, it will automatically trigger the light emitter to assist autofocus. Then, it fires the flash to expose the film.

You can take focused, correctly exposed photos in total darkness! However, you may need a pocket flashlight to aim the camera at the subject.

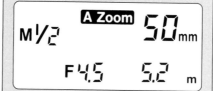

### 420EZ DISPLAY ON MANUAL

### VIEWFINDER DISPLAY

This shows the display on the back panel of a 420EZ flash, set to M for manual, and the corresponding viewfinder display in an EOS camera set to manual. The flash light output is set to 1/2 power. A ZOOM means that the flash-head zooms automatically to match lens focal length. The flash beam angle is set to cover the angle of view of a 50mm lens. Aperture is F 4.5 (*f*-4.5) and the shooting distance is 5.2 meters. Flash units sold in the United States may show distance in feet rather than meters.

The viewfinder display shows the manually set shutter-speed and aperture values, a flash-ready indication, and the In-Focus Indicator.

## FLASH NOMENCLATURE

The nomenclature incorporates the maximum guide number that is produced by the most favorable settings of the flash—such as the narrowest coverage angle.

Speedlite 420EZ has a maximum guide number of 42 (meters). Speedlite 300 EZ has a maximum guide number of 30 (meters). The 160E has a maximum guide number of 16 (meters).

# FLASH MODES

Not all flash units have all the modes discussed in this section. At the end of this chapter is a description of each current flash model, plus the built-in flash of the EOS 750 and 750 QD.

**Ready Lamp**—This discussion assumes that the flash Ready Lamp is glowing. When the lamp is not glow-ing, the camera operates as though the flash were not installed.

**Shutter Button**—Most of the displays and operations discussed in this section occur only when the Shutter Button is depressed partway to turn on the camera electronics.

## MANUAL FLASH

In this mode, nothing is automatic. No light sensor is used to measure the light. The flash makes the same amount of light each time it fires.

Set the flash to its manual mode. Set the EOS camera to its manual mode. Set shutter speed at X-sync or slower. Set any aperture available on the lens.

The distance to the subject that produces correct exposure can be found by a guide-number calculation. The 420EZ makes the calculation for you. Press the Shutter Button halfway and a display on the flash shows the set aperture and the resulting shooting distance. Change aperture if necessary so the displayed distance is the same as the flash-to-subject distance—or change flash-to-subject distance to match the value displayed.

If you change shutter speed, shooting distance does not change. If you change aperture, distance changes accordingly.

If you zoom the lens, the flash head zooms automatically to the appropriate coverage angle and the distance changes—because flash brightness varies with coverage angle. If zooming causes aperture to change, distance changes accordingly.

**In Bright Light**—The procedure just described uses flash to give full exposure of the subject, on the assumption that the ambient light is dim and contributes little to exposure. If the ambient light is bright, it adds to the total exposure and overexposure may result.

The usual reason to use flash in bright ambient light is to fill the shadows, which requires a different procedure.

**Manual Flash Fill**—The continuous

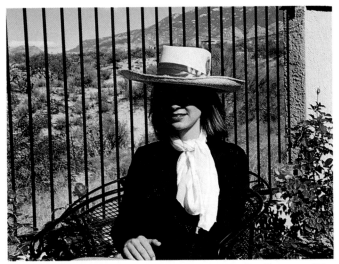

An EOS camera, using evaluative metering in the Program AE mode, gave balanced exposure for this outdoor portrait. There are facial shadows, but detail is visible. Sunlight passing through the woven hat brim can be seen in the shaded area. The sunlit area of the face is well exposed. The white scarf is not over-exposed.

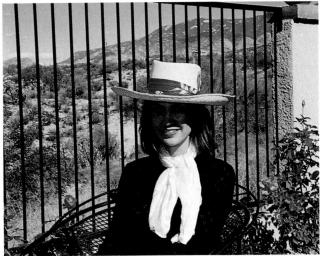

Shadows can be lightened in the manual flash mode, or automatically—in the easy way. Here, the shadows were filled automatically using an EZ-type flash in the ATTL mode with the camera on Program AE. Light from the flash blended with ambient light and exposure was automatically adjusted for the combination. The facial shadow is "opened up" but still there to retain the outdoor sunlit effect. Sunlight passing through the hat brim is still visible. The white scarf is not overexposed.

light source, such as the sun, dominates exposure. Position the flash so it puts light into the shadows.

Set shutter speed at X-sync. Meter and set aperture for *full* exposure by ambient light, for example f-8 at 1/125.

Use a shooting distance that gives one or two steps less than full exposure by the flash—with the aperture already selected. Suppose the guide number is 40 feet. Using the formula given earlier, shooting distance for *full exposure* by flash would be is 40/8, which is 5 feet. That would be too much exposure.

Doubling shooting distance reduces flash exposure by 2 steps with no effect on ambient-light exposure. Place camera and flash 10 feet from the subject. To provide the image size you want, change focal length. Make the shot.

There is some uncertainty about exposure because the flash adds to the ambient light. You may prefer to place the flash a little closer to the subject for more fill. If you move the flash closer, try closing aperture a half step.

The ATTL automatic flash mode, described later, provides flash fill automatically.

**Exposure Compensation**—With flash and camera on manual, there is no reason to use the camera exposure-compensation control. If you do, it has the effect of changing film speed. With Speedlite 420EZ, which displays shooting distance, displayed distance will change and will not be correct for whatever aperture is set. You can adjust exposure manually by choosing shutter speed and aperture for the desired effect.

## AUTOMATIC FLASH

There are several automatic flash modes. Each will be described individually.

**Light Sensor**—In any automatic mode, EOS cameras control flash exposure using a silicon light sensor in the bottom of the mirror box. It measures light on the film due to the flash *plus* ambient light. When the sensor has measured sufficient exposure, the camera turns off the flash. The focal-

plane shutter remains open until the set exposure time has elapsed, then closes.

## TTL AUTO

TTL auto means that flash duration is controlled by the light sensor in the camera body, measuring light that has come through the lens. Except for that, this mode is similar to the manual mode. See the paragraph entitled *TTL Program,* later in this chapter.

Set the flash for automatic exposure control. Set the camera on manual. You set aperture and shutter speed manually. This mode is also called Manual Mode (TTL) in instruction booklets.

**Shutter Speed**—If you select a shutter speed that is faster than X-sync, the camera changes it to X-sync.

**Operating Range**—The operating range is from the minimum distance to the maximum distance at which a subject can be correctly exposed by the flash.

At the maximum shooting distance, the flash duration is as long as possible. If the subject is farther than the max-

# ATTL PROGRAM GRAPHS

## ATTL APERTURE GRAPH FOR EOS 620

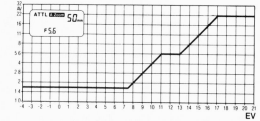

This graph shows how aperture is set automatically according to ambient-light scene brightness with an EF 50mm *f*-1.8 lens and ISO 100 film. The scale at left is *f*-numbers. The scale along the bottom is scene brightness expressed in EV numbers. For reference, EV 15 is the brightness of an outdoor scene in sunlight.

In dim light, from EV −4 to EV 7, the program selects maximum aperture. At a scene brightness between EV 7 and EV 8 the program begins to reduce aperture size gradually as brightness increases. The reason that aperture does not change between EV 11 and EV 13 is discussed below.

## ATTL SHUTTER-SPEED GRAPH FOR EOS 620

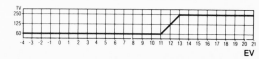

X-sync shutter speed for the EOS 620 is 1/250 second. In dim light, the ATTL program uses a shutter speed of 1/60 second for increased ambient-light exposure of the background. In bright light, it uses the X-sync speed. The transition occurs between EV 11 and EV 13. Because shutter speed increases with scene brightness through this EV range, aperture size does not change. Graphs for the EOS 650 are similar, except that X-sync speed is 1/125 second.

## ATTL FLASH EXPOSURE LEVEL

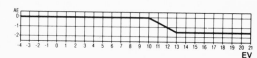

Using the TTL flash sensor in the camera mirror box, the ATTL program turns off the flash when sufficient exposure has been measured. The "definition" of sufficient exposure depends on the ambient scene brightness. If the scene is dim, the flash provides full exposure, which is shown as a Flash Exposure level of 0. If the scene brightness is EV 10 or greater, the ambient light provides normal exposure and the flash is used only to fill shadows. To accomplish that, the Flash Exposure level is reduced by 1.5 steps.

imum distance, it will be underexposed by the flash. If the subject is closer, the automatic-exposure system turns off the flash sooner and correct exposure results.

At the minimum shooting distance, the flash is turned on and turned off again as quickly as possible. If the subject is closer than the minimum shoot-ing distance, it will be overexposed.

The maximum distance can be *increased* by: larger aperture, faster film, or narrower flash coverage angle. Minimum distance may increase when maximum distance increases.

**Aperture**—Choose an aperture such that the subject distance is within the shooting range. Usually you have a choice of several apertures.

With the 420EZ, the maximum and minimum distances are shown in a display on the back of the flash. The 300EZ has no display. The range is shown by a table in the 300EZ specs in this chapter and in the flash instruction booklet. Canon refers to the shooting-distance range as the Automatic Flash Coupling Range.

**Exposure Warning**—With slow film, such as ISO 25, it is possible to select an aperture such that the maximum shooting distance is less than the minimum shooting distance. Correct exposure is impossible. The distance display on the 420EZ flash blinks as a warning. There is no warning in the camera display.

**Exposure Compensation**—If a small subject is against a background that is unusually light or dark the background may influence the center-weighted reading of the flash sensor. Exposure compensation can be used to give the same amount of exposure to a non-average subject as it would an average subject at the same distance.

With Speedlite 420, exposure compensation has the effect of changing film speed and will therefore change the displayed operating range. The actual shooting range will not change.

## ATTL MODES

ATTL means Advanced TTL. Flash illumination and ambient light are balanced automatically to provide correct exposure of both subject and background in ambient light from total darkness to sunlit scenes. In bright light, fill flash is automatic.

In the ATTL modes, exposure is controlled by a flash-exposure program built into the camera. The camera-shake warning does not function.

**Light Emissions**—In any ATTL mode, an EZ flash unit may produce four different light emissions. One is from the AF Auxiliary Light Emitter to assist the camera autofocus system in dim light. This emitter has no effect on flash operation.

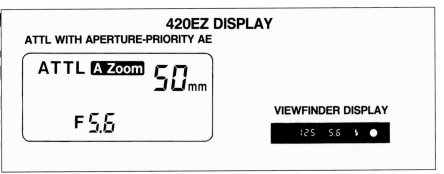

## 420EZ DISPLAY
### ATTL WITH APERTURE-PRIORITY AE

ATTL A Zoom 50mm

F 5.6

**VIEWFINDER DISPLAY**

125  5.6  ⚡ ●

With the flash set for ATTL and the camera on aperture-priority AE, the 420EZ display shows the manually set aperture value. The viewfinder display shows manually set aperture and automatically set shutter speed—30 seconds to X-sync depending on scene brightness.

Another is the normal burst of light from the flash tube that illuminates the scene during an exposure.

Another is a pulse of dark-red light, called a *preflash,* which comes from an emitter in the flash body. A round preflash light sensor is adjacent to the preflash emitter. In most ATTL modes, the dark-red preflash, described shortly, is a test that is performed before making the actual exposure.

The fourth possible emission is a white-light preflash, also described shortly. It is produced by the flash tube as a test when bouncing the light.

**Background Illumination**—Ambient light is measured by the segmented light sensor in the viewfinder, before the exposure. Only the four corners of the sensor are used, with the result averaged. This tends to emphasize background brightness.

**Subject Illumination**—When the shutter opens and the flash fires, light on the film is measured by the flash sensor in the camera. Because the sensor has a center-weighted metering pattern, this measurement is primarily exposure of a centered subject.

**Subject Distance and Reflectance**—Except when using bounce flash, pressing the Shutter Button halfway triggers the dark-red preflash emitter in the flash body. Light reflected from the subject is measured by the preflash sensor.

Assuming an average subject, the amount of reflected preflash indicates subject distance. If the subject is too far away for correct exposure, a warning signal appears in the viewfinder. There is no warning if the flash is too close to the subject.

**When Bouncing**—If the flash head is tilted or rotated to bounce the flash, a white-light pulse from the main flash tube is emitted instead of the dark-red preflash, but for the same purpose. The dark-red preflash cannot follow the bounce path, and therefore would not produce a valid result.

## THE ATTL PROGRAM

The program always uses both ambient light and flash to expose the scene, but in varying proportions. When the ambient light is dim, the ATTL program uses mainly flash to provide correct exposure. If you have the flash turned on in bright ambient light, the program assumes that you want to use fill flash. It uses mainly ambient light for correct exposure and flash to fill shadows.

The first program decision is shutter speed, based on the ambient-light measurement. As you can see in the accompanying ATTL Shutter-Speed

Program graph, shutter speed is slower in dim ambient light. This gives more ambient-light exposure to the background, so it is less dark. Shutter speed is faster in bright light to avoid overexposing the background.

Then next decision is the flash exposure level. This is a form of exposure compensation for the flash, also based on the ambient-light measurement. See the accompanying graph entitled ATTL Flash Exposure Level. In dim ambient light, the flash sensor in the camera turns off the flash when full exposure of the subject has been measured. That is represented by the 0 value on the graph.

In bright light, the flash exposure level is reduced to −1.5, which means 1.5 steps *less* exposure is needed to turn off the flash. That sets the flash to fill shadows, rather than provide full exposure.

With those decisions made, the ATTL program calculates two aperture sizes. One is the aperture that would provide full exposure with ambient light. The other is a guide-number calculation to find the aperture for full exposure by the flash at the subject distance determined by the preflash.

The program uses the *smaller* of those two aperture sizes—the "ambient" aperture or the "flash" aperture.

If the scene illumination is dim, the "ambient" aperture will be the larger. The program uses the smaller "flash" aperture. The scene is exposed mainly by flash. The aperture used is smaller than the aperture needed for full exposure by ambient light, therefore the dim ambient light contributes little to the total exposure.

If the scene illumination is bright, the "ambient" aperture will be smaller and will be used. That gives correct exposure to the scene using ambient light. The effect of the flash is reduced for two reasons: The aperture used is smaller than the aperture that would give full exposure with flash. Also, the flash exposure level is reduced by 1.5

steps as shown in the accompanying graph. The effect of the flash is merely to fill the shadows.

This program, with variations, is used with all ATTL automatic-exposure modes—described in following sections.

**Operating Range**—When exposure is controlled by the ATTL program, Speedlite 420EZ does not display shooting distance. The program uses both flash and ambient light to make each exposure. In daylight, shooting distance is unlimited—the same as without the flash.

In dim light, there is an underexposure warning if the combination of flash and ambient light is insufficient. This can happen only with a subject beyond the range of the flash, otherwise the exposure will be made by flash.

There is a minimum shooting distance, just as in the TTL mode. Subjects closer than the minimum distance will be overexposed by the flash.

**Exposure Compensation**—Unusually light or dark backgrounds can cause the subject to be under- or overexposed. Exposure compensation can be used to assure correct exposure of the subject.

## ATTL WITH PROGRAM AE

Set the flash for ATTL and the camera for programmed automatic exposure—the P symbol in the camera LCD Display. With the flash Ready Lamp glowing and the Shutter Button pressed halfway, both shutter speed and aperture are set by the ATTL program, as just described.

**Shutter-Speed Range**—The range of shutter speeds used by the ATTL program in this mode is from 1/60 second to X-sync speed. With an EOS 620, X-sync speed is 1/250 second, therefore the usable range is 1/60 to 1/250 second.

**Aperture Range**—Any aperture on the lens can be used by the program. Because the camera "knows" which lens is installed, it will not attempt to

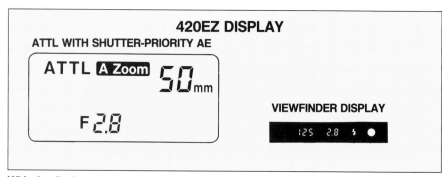

With the flash set for ATTL and the camera on shutter-priority AE, the 420EZ display shows the automatically selected aperture value. The viewfinder display shows the manually set shutter speed and automatically set aperture.

use aperture sizes that are not available.

**Exposure Warnings**—If the subject is too far away for flash exposure and the ambient light is too dim for ambient-light exposure, underexposure will result. The camera warns you by blinking values in the viewfinder—the largest aperture and the slowest shutter speed that can be used by the ATTL program, which is 1/60 second.

If ambient light is so bright that overexposure will result, the camera warns you. If the subject is in the same ambient light as the background, it will be overexposed.

The subject may be dimly lit against a bright background—for example a person silhouetted against the sky—in which case flash exposure of the subject will be OK but the background will be overexposed. Either way, the camera blinks the smallest aperture value and the fastest shutter speed that can be used—1/125 second with the EOS 650 and 1/250 second with the EOS 620.

**Green Rectangle**—With the flash on ATTL and the camera Main Switch at the green rectangle, operation is the same as ATTL with program AE.

**Depth-of-Field AE**—With the flash on ATTL and the camera set for Depth-of-Field AE, operation is the same as ATTL with program AE.

## ATTL WITH SHUTTER-PRIORITY AE

Set the flash for ATTL and the camera for shutter-priority AE—the TV symbol in the LCD Display. Manually set any shutter speed from 30 seconds to X-sync. If you set a higher value, the camera will change it to X-sync before shooting.

Flash exposure level is varied by the program in accordance with ambient light, as shown earlier. Shutter speed is not varied by the program.

With the flash Ready Lamp glowing and the Shutter Button pressed halfway, aperture is set by the ATTL program as described earlier. Any aperture on the lens can be used.

This mode allows slower shutter speeds than the program mode, which gives greater control of background exposure in dim light. Slow shutter speeds can also be used for special effects such as deliberate ghost images of a moving subject.

**Exposure Warnings**—If the subject is too far away for flash exposure and the ambient light is too dim for ambient-light exposure, underexposure will result. The camera warns you by blinking the aperture and shutter-speed values in the viewfinder.

If the maximum aperture value blinks, the light is too dim for good background exposure at the set shutter

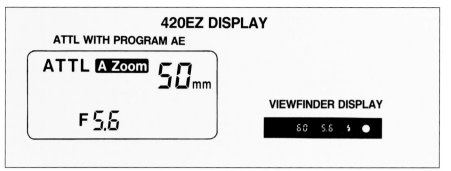

## 420EZ DISPLAY

**ATTL WITH PROGRAM AE**

ATTL **A Zoom** 50mm

F 5.6

**VIEWFINDER DISPLAY**

60   5.6   ⚡   ●

With the flash set for ATTL operation and the camera on Program Automatic Exposure (AE), the display on the 420EZ flash shows the aperture set by the ATTL program. The viewfinder display shows both aperture and shutter-speed values selected by the program—in this example, 1/60 second and *f*-5.6. Refer to the ATTL program graphs earlier in this chapter and you will see that the program chooses 1/60 second and *f*-5.6 at an ambient-light scene brightness of EV 11. At this brightness, the flash-exposure level has been reduced 1/2 step, allowing ambient light to provide more of the total exposure.

speed. Use a slower shutter speed, if you wish. Flash exposure of the subject should be OK either way.

If the minimum aperture value blinks, the light is too bright for good background exposure at the set shutter speed. Use a faster shutter speed, if you wish. Unless the ambient light is also too bright on the subject, flash exposure of the subject should be OK.

### ATTL WITH APERTURE-PRIORITY AE

Set the flash for ATTL and the camera for aperture-priority AE—the AV symbol in the LCD Display. Manually set any aperture size.

With the flash Ready Lamp glowing and the Shutter Button pressed halfway, shutter speed is set by the ATTL program. Speeds from 30 seconds to X-sync can be used.

Flash exposure level is varied by the program in accordance with ambient light changes, as shown earlier. In bright light, shutter speed is set for full exposure by ambient light. Flash exposure level is reduced by 1.5 steps. Flash fill is the result.

In dim ambient light, most of the subject exposure is by flash. Shutter speed is slower than the metered value by one or two steps, depending on camera model, to lighten background.

In this mode, you can set aperture to control depth of field. You can have a background with good exposure, and good or bad focus, as you wish. After setting aperture, you can view depth of field by pressing the Depth-of-Field Check button on the camera, if the scene is not too dim.

**Exposure Warnings**—If the aperture is too small for flash exposure of the subject, both values blink. Move closer or use larger aperture.

If the slowest shutter speed blinks, the light is too dim for good background exposure at the set aperture. Use a larger aperture, if you wish. Flash exposure of the subject should be OK either way.

If the X-sync shutter speed blinks, the light is too bright for good background exposure at the set aperture. Use a smaller aperture, if you wish. Unless the ambient light is also too bright on the subject, flash exposure of the subject should be OK.

### TTL PROGRAM

The TTL automatic flash mode uses the flash set for automatic exposure control by the light sensor in the camera. The camera is set for manual control of shutter speed and aperture. You can use any aperture, any shutter speed of X-sync or slower. Shooting range depends on the manual settings and is shown by a data table for the

300EZ or on the flash display for the 420EZ.

Exposure depends on the amount of light measured by the sensor in the camera mirror box and is controlled by a built-in program. The TTL program varies flash exposure level according to scene brightness in the same way as the ATTL program. If the ambient light is dim, full exposure is given by the flash. If the light is bright, exposure by the flash is reduced up to 1.5 exposure steps.

The TTL program does not vary the manually set shutter speed according to scene brightness.

### VARIABLE FLASH OUTPUT

The 420EZ, in its manual mode, can be set to produce full light output or reduced output. The setting is indicated by fractions on the flash display panel: 1/1 for full output, 1/2, 1/4, 1/8, 1/16, and 1/32. At any manual-mode output level, the flash makes the same amount of light each time it fires.

The guide number changes with output level, as shown in the 420EZ specs in this chapter. The shooting distance in the flash display changes with output level. With reduced light output, less electrical energy is removed from the storage capacitor and recycle time is shorter.

### RAPID-FIRE CAPABILITY

When a flash has been fired, the storage capacitor is usually recharged before the next flash. If you must wait for full recharge before you can use the flash again, you may miss a shot while waiting.

EZ flash units offer a novel capability called *rapid fire* that reduces the waiting time. You can fire the flash *while it is charging,* before it is fully charged. If fired before full recharge, maximum light output is not possible, but may not be needed.

When rapid-fire flash can be used, the Ready Lamp on the flash glows with a green color to indicate partial charge. Red indicates full charge. The flash-ready indicator in the camera

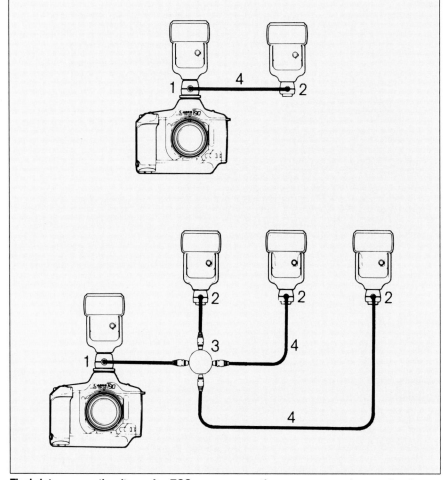

Flash interconnection items for EOS cameras are the same as used on earlier Canon T-series models, except for the Hot-Shoe Adapter. This drawing shows a Canon T90 camera but illustrates interconnection methods for EOS cameras. Refer to the numbered items on the drawing:
1. Hot-Shoe Adapter 2 is used with EOS cameras. It fits between a flash unit and the hot shoe to provide a socket for an electrical Connecting Cord.
2. Off-Camera Shoe Adapter fits on the end of a Connecting Cord and provides a hot shoe to attach a flash unit.
3. TTL Distributor allows up to three remote flash units to be interconnected and controlled by the camera.
4. Connecting Cord 60 (60cm, 2 feet long) or Connecting Cord 300 (300cm, 10 feet long) can be used. They can be joined together to make lengths not exceeding 9 meters, or 30 feet.

Any automatic or manual flash mode can be used. Compatible flash units are EZ types, Macrolite ML-2 and ML-3. Second-curtain flash sync cannot be used. The AF Illuminator of EZ-type flashes will not operate. The automatic flash-head zoom feature of EZ-type flashes will not operate, but the angle can be set manually. The EOS 650 Depth mode cannot be used. With the EOS 620, program shift and automatic bracketing will not operate.

turns on with the Ready Lamp either green or red.

With the 420EZ flash, the rapid-fire capability can be used with the flash on ATTL automatic, or on manual, but not on TTL auto.

In the ATTL mode, shooting distance is not displayed. Rapid-fire can be used. An underexposure warning appears in the viewfinder if there is insufficient charge for the subject distance.

In the manual mode, rapid-fire can be used when there is sufficient charge for the output level. For example, if the flash is set for 1/16, the Ready Lamp glows green as soon as there is enough charge for that output. The flash will be 1/16 of full output, not less.

With manual-mode settings of 1/1 or 1/2, there is no opportunity for rapid-fire because a charge level of 1/2 or more is considered full charge and the Ready Lamp glows red.

In the TTL mode, the maximum shooting distance is based on full charge, therefore the Ready Lamp never glows green to suggest shooting before full charge.

REPEATING FLASH
There are two types of repeating flash. One provides multiple flashes during the exposure of a single frame—called stroboscopic flash. The other uses the continuous-exposure film-winding mode of the camera and provides one flash for each frame.

Either way, the storage capacitor recharges as much as possible between flashes. Flashing will stop when the capacitor becomes discharged.

Stroboscopic Flash—Several flashes in sequence can show stages of an action or motion. On film, this is similar to a multiple exposure, except that it is all done during one exposure. The 420EZ flash has this capability, discussed later in this chapter.

Continuous Mode—The best method is to use flash and camera on manual, because the flash output level can be adjusted. With reduced flash output, more flashes can be made before the storage capacitor becomes discharged, recycle time is shorter and flashes can occur at a faster rate.

Ambient light should be dim, so exposure is mainly by flash. Set shutter speed to X-sync or slower. Set aperture by a guide-number calculation based on subject distance. With the 420EZ, the shooting distance is displayed for each aperture.

## EZ FLASH EXPOSURE WARNINGS IN ATTL MODE WITH EOS 620/650 CAMERAS

| CAMERA MODE | BACKGROUND OVEREXPOSED | | BACKGROUND UNDEREXPOSED | | SUBJECT UNDEREXPOSED BY FLASH | |
|---|---|---|---|---|---|---|
| | Shutter | Aperture | Shutter | Aperture | Shutter | Aperture |
| Program AE | Fastest ATTL* speed blinks | Smallest aperture blinks | | | Slowest ATTL* speed blinks | Largest aperture blinks |
| Shutter-Priority AE | Set value shown | Smallest aperture blinks | Set value shown | Largest aperture blinks | Set speed blinks | Ambient-metered aperture blinks |
| Aperture-Priority AE | Fastest ATTL* speed blinks | Set value shown | Slowest speed blinks | Set value shown | Ambient-metered speed blinks | Set aperture blinks |

*EOS 650 shutter-speed range in ATTL mode is 1/60 to 1/125 second.
EOS 620 shutter-speed range in ATTL mode is 1/60 to 1/250 second.

The number of flashes is uncertain but can be found approximately by testing. It depends on flash battery condition, flash output setting and firing rate. A table in the stroboscopic flash discussion later in this chapter shows the approximate number of flashes for that mode and for this one also. When flashing stops, the camera will continue to expose frames, as long as the Shutter Button is held down.

## BATTERIES

The number of flashes from a set of batteries, and the recycle time, is determined by the type of batteries used. Ordinary carbon-zinc batteries provide the least number of flashes. Alkaline batteries provide the greatest number of flashes.

Rechargeable Ni-Cd (NiCad) batteries provide more flashes than carbon zinc, but less than alkaline. They provide shorter recycle times because they can supply more current.

When recycle time becomes excessively long, the batteries should be replaced. All batteries should be the same brand and type. All should be replaced at the same time.

In cold weather, batteries lose power but recover when warmed up again. It's a good idea to keep a spare set warm in your pocket. Ni-Cd batteries are best for cold-weather use.

## USING MORE THAN ONE FLASH

Indoor photography is sometimes improved by using more than one flash—such as one flash for the main light and another for fill.

**Optical Slave Unit**—The second flash can be fired by an accessory optical *slave* unit that is triggered by light from the main flash on the camera.

No wires are used to interconnect the flash units. Before purchasing slave units for this purpose, check with the dealer to be sure they are suitable for use with the flash brand and model to be triggered.

All flash units should be on manual, with distances adjusted to provide the desired lighting ratio—as discussed in Chapter 6.

**TTL Hot-Shoe Adapter 2**—Up to four Canon Speedlites can be interconnected and exposure controlled automatically using accessory items shown in the accompanying diagram.

# EZ FLASH UNITS

Current EZ flash units and specifications are discussed here. When a flash has a feature or control that has been described previously, it will be mentioned but not discussed again in detail. Additional information or features not described earlier are included here.

## SPEEDLITE 420EZ

This is a hot-shoe flash with bounce capability. It has a manual mode with adjustable light output, plus automatic

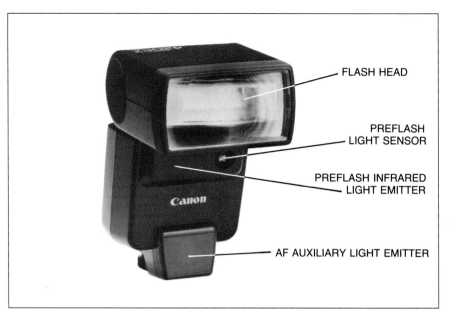

The flash head of Speedlite 420EZ tilts and swivels for bounce flash.

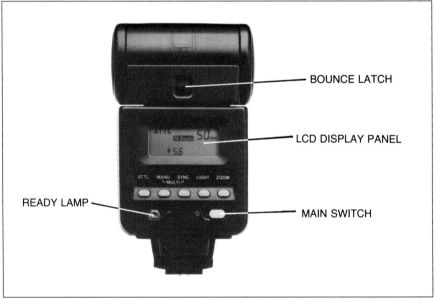

To tilt or swivel the 420EZ flash head, depress the Bounce Latch.

**Flash Coverage Angle**—A built-in zoom mechanism in the flash head sets flash coverage angle to: 24mm, 28mm, 35mm, 50mm, 70mm, or 80mm for focal lengths of 80mm or longer.

There are two modes: A Zoom (automatic) and M Zoom (manual). The selected mode and the coverage angle are shown in the flash display.

At A Zoom, the flash head automatically zooms to a coverage angle appropriate for the focal length of the lens being used. With zoom lenses, the flash changes coverage angle when the lens is zoomed.

For bounce flash, you may prefer manual control of the coverage angle. To select M Zoom, press the ZOOM button on the back of the flash. Pressing this button repeatedly cycles the flash through all possible coverage angles and then back to A Zoom.

**Operating Modes**—Manual, TTL with camera on manual, ATTL with camera on Program AE, Aperture-Priority AE or Shutter-Priority AE, and repeating flash.

**Rapid-Fire Flash**—In the ATTL modes, the flash can be fired when partially or fully charged. Rapid-fire flash can be used in the manual mode with flash output levels of 1/4 or less.

**Ready Lamp**—Glows red when flash is fully charged, green to indicate partial charge for rapid-fire capability.

**Test**—Press the Ready Lamp to fire the flash independently of the camera.

**Bounce Flash**—The flash head tilts upward 90 degrees from horizontal, with marked click stops at 60, 75 and 90 degrees. It rotates horizontally 180 degrees to the left and 90 degrees to the right, with marked click stops at 60, 75 and 90 degrees. Horizontal rotation requires moving the Bounce Latch control upward.

When the flash head is tilted or rotated, a bounce symbol appears in the flash display. When the flash is in the A Zoom mode, coverage angle is automatically changed to 50mm but the value disappears from the display. It is replaced by dashes, to suggest that you may wish to set coverage angle man-

modes and a repeating flash "strobe" capability. It can use first-curtain or second-curtain sync. Maximum guide number is 42 (meters) or 140 (feet) at ISO 100.

**Main Switch**—The Main Switch is labeled 0 and 1. Moving it to 1 turns on the flash and sets it to the ATTL mode.

**Energy-Saving Function**—If not used, power is automatically switched off after five minutes. During the last 30 seconds, the flash display blinks as a warning. Power is restored by pressing any control button on the camera or the Ready Lamp on the flash.

**Display**—On the back of the flash body is an LCD display that shows control settings and operating status.

ually. If you set the angle manually, its value appears in the flash display.

**Preflash**—A dark-red preflash is emitted from the flash body to set exposure in all ATTL modes, except with bounce flash. With bounce, a white-light preflash at 1/20 power is emitted by the main flash tube.

**ATTL Button**—Restores ATTL setting if flash is on manual.

**MANU Button**—When pressed, it sets the flash for manual operation at full power.

**Manual Power Levels**—Pressing the MANU button repeatedly cycles the flash through all possible power levels and shows power setting in flash display. Power levels are: 1/1, 1/2, 1/4, 1/8, 1/16 and 1/32.

**SYNC Button**—When pressed, alternately selects first-curtain or second-curtain sync. Second-curtain sync is shown by a symbol in the flash display.

**LIGHT Button**—When pressed, illuminates the flash display for 8 seconds.

**Stroboscopic Flash**—The 420EZ can be set for repeating flashes during a single exposure by pressing the MANU and SYNC buttons simultaneously. This places the flash in the manual mode. Flash output levels can be selected by pressing the MANU button repeatedly.

### 420EZ MAXIMUM NUMBER OF FLASHES IN STROBOSCOPIC MODE

| Flash Output Level | Strobe Rate | | | | |
|---|---|---|---|---|---|
| | 1 HZ | 2 HZ | 3 HZ | 4 HZ | 5 HZ |
| 1/1 | 1 | 1 | 1 | 1 | 1 |
| 1/2 | 2 | 2 | 2 | 2 | 2 |
| 1/4 | 5 | 5 | 4 | 4 | 4 |
| 1/8 | 12 | 9 | 9 | 8 | 8 |
| 1/16 | 173 | 25 | 20 | 18 | 17 |
| 1/32 | 244 | 88 | 39 | 30 | 29 |

Second-curtain sync cannot be used. Pressing the SYNC button repeatedly selects flash rates of 1, 2, 3, 4, or 5 flashes per second (HZ). The word MULTI and the set flash rate, such as 3 HZ, appear in the flash display.

Set the camera to its manual mode. Shooting distance appears in the flash display. Set aperture and flash output level for the subject distance. The multiple-exposure discussion in Chapter 5 will be helpful.

The slowest flash rate is 1 per second. Use a shutter speed of 1 second or longer, depending on the desired number of flashes. For example, if you select 3 seconds and 4 flashes per second, there will be 12 flashes.

When the Shutter Button is pressed, flash operation begins. It continues until the shutter closes or the flash storage capacitor becomes discharged.

More flashes are available at reduced flash output level, such as 1/32, because each flash takes less charge from the storage capacitor. More flashes are available at a repetition rate of 1 HZ because there is more time between flashes to recharge the storage capacitor.

**Guide Number**—The guide number varies according to flash coverage angle and the power level. On manual, the power level is adjustable. For all other modes, full flash power is available when needed for correct exposure.

### 420EZ GUIDE NUMBER IN METERS (FEET) WITH ISO 100

| Power Level | Flash Coverage Angle | | | | | |
|---|---|---|---|---|---|---|
| | 24mm | 28mm | 35mm | 50mm | 70mm | 80mm |
| 1/1 | 25 (83) | 27 (90) | 30 (100) | 35 (116) | 4 (133) | 42 (140) |
| 1/2 | 17.7 (59) | 19.1 (63) | 21.2 (70) | 24.7 (82) | 28.3 (94) | 29.7 (99) |
| 1/4 | 12.5 (41) | 13.5 (45) | 15 (50) | 17.5 (58) | 20 (66) | 21 (70) |
| 1/8 | 8.8 (29) | 9.5 (31) | 10. (35) | 12.4 (41) | 14.1 (47) | 14.8 (49) |
| 1/16 | 6.3 (21) | 6.8 (22) | 7.5 (25 | 8.8 (29) | 10 (33) | 10.5 (35) |
| 1/32 | 4.4 (14) | 4.8 (16) | 5.3 (17) | 6.2 (20) | 7.1 (23) | 7.4 (24) |

**To find the guide number at a different film speed, use the formula shown earlier in this chapter.**

Speedlite 300EZ has a fixed flash head that cannot be tilted for bounce flash.

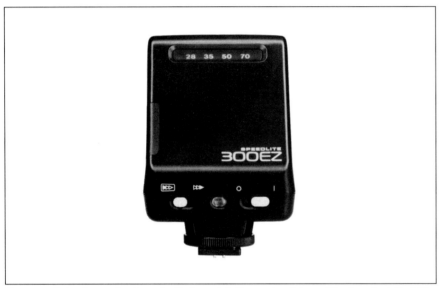

Beam angle is changed automatically, to match the angle of view of the lens installed. The set value is illuminated in the Flash Beam-Angle Display.

**AF Auxiliary Light**—In dim light, a dark-red pattern of vertical bars is automatically projected onto the subject to aid autofocus. With no other subject illumination, the autofocus range is 0.9 to 8 meters (3 to 26.2 feet).

**Power Source**—Four AA-size 1.5 volt batteries, carbon-zinc, alkaline or Ni-Cad.

**Dimensions**—75x122x106mm (2.95x4.8x4.17 in.).

**Weight**—350g (12.4 oz.) without batteries.

### SPEEDLITE 300EZ

This is a hot-shoe flash without bounce capability. It has ATTL and TTL automatic modes and can use first-curtain or second-curtain sync. Maximum guide number is 30 meters (100 feet) at ISO 100.

**Main Switch**—The Main Switch is labeled 0 and 1. Moving it to 1 turns on the flash.

**Mode Selection**—With the camera in any automatic-exposure mode, the 300EZ is automatically in the ATTL automatic mode. With the camera on manual, the 300EZ is in the TTL auto mode.

**Energy-Saving Function**—When the flash is not used, power is automatically switched off after five minutes. Power is restored by pressing any control button on the camera or the Ready Lamp on the flash.

**Flash Coverage Angle**—A built-in zoom mechanism in the flash head automatically sets a flash coverage angle suitable for the focal length of the lens being used. The setting is shown by an illuminated figure in a display on the back of the flash. Angles are: 24mm, 35mm, 50mm or 70mm. The 24mm setting is used for focal lengths from 24mm to 35mm, and so forth. The 70mm setting is used for focal lengths of 70mm and longer. With zoom lenses, the flash automatically changes coverage angle when the lens is zoomed.

**Guide Number**—The guide number varies according to flash coverage angle.

**Shooting Distance Range**—In the ATTL modes, shutter-speed and aperture values blink in the viewfinder if the subject is too far away. There is no warning if the subject is too close.

In the TTL modes, maximum and minimum shooting distances vary with flash coverage angle, aperture and film speed, as shown in the accompanying table.

For example, with *f*-8 and a flash coverage angle of 35mm, operating range is 0.7 to 3.2 meters, or 2.3 to 10.5 feet.

To convert values on this table to a different film speed (FS), multiply value by the $\sqrt{FS/100}$. For example, to convert to ISO 200, multiply by $\sqrt{200/100}$, which is 1.4 approximately.

**Rapid-Fire Flash**—In the ATTL mode, the flash can be fired when partially or fully charged. This feature does not function in the TTL mode.

**Ready Lamp**—Glows red when flash is fully charged, green to indicate par-

## 300EZ OPERATING RANGE IN METERS (FEET) USING TTL AUTO MODE WITH ISO 100

| Aperture | Flash Coverage Angle | | | |
| --- | --- | --- | --- | --- |
| | 28mm | 35mm | 50mm | 70mm |
| f-1.0 | 2.8—22 (9.2—72.2) | 3.2—25 (10.5—82) | 3.5—28 (11.5—91.9) | 3.8—30 (12.5—98.4) |
| f-1.4 | 2.0—16 (6.6—52.5) | 2.2—18 (7.2—59) | 2.5—20 (8.2—65.6) | 2.7—22 (8.9—72.2) |
| f-1.8 | 1.7—13 (5.6—42.7) | 1.9—15 (6.2—49.2) | 2.1—17 (6.9—55.8) | 2.3—18 (7.5—59) |
| f-2.0 | 1.4—11 (4.6—36.1) | 1.6—13 (5.2—42.7) | 1.8—14 (5.9—45.9) | 1.9—15 (6.2—49.2) |
| f-2.8 | 1.0—7.8 (3.3—25.6) | 1.1—8.9 (3.6—29.2) | 1.3—9.9 (4.3—32.5) | 1.4—11 (4.6—36.1) |
| f-3.5 | 0.9—6.6 (3—21.7) | 1.0—7.5 (3.3—24.6) | 1.1—8.4 (3.6—27.6) | 1.2—9.0 (3.9—29.5) |
| f-4.0 | 0.7—5.5 (2.3—18) | 0.8—6.3 (2.6—20.7) | 0.9—7.0 (3.0—23) | 1.0—7.5 (3.3—24.6) |
| f-4.5 | 0.7—4.7 (2.3—15.4) | 0.7—5.3 (2.3—17.4) | 0.8—5.9 (2.6—19.4) | 0.8—6.3 (2.6—20.7) |
| f-5.6 | 0.7—3.9 (2.3—12.8) | 0.7—4.5 (2.3—14.8) | 0.7—5.0 (2.3—16.4) | 0.7—5.3 (2.3—17.4) |
| f-8.0 | 0.7—2.8 (2.3—9.2) | 0.7—3.2 (2.3—10.5) | 0.7—3.5 (2.3—11.5) | 0.7—3.8 (2.3—12.5) |
| f-11 | 0.7—2.0 (2.3—6.6) | 0.7—2.2 (2.3—7.2) | 0.7—2.5 (2.3—8.2) | 0.7—2.7 (2.3—8.9) |
| f-16 | 0.7—1.4 (2.3—4.6) | 0.7—1.6 (2.3—5.2) | 0.7—1.8 (2.3—5.9) | 0.7—1.9 (2.3—6.2) |
| f-22 | 0.7—1.0 (2.3—3.3) | 0.7—1.1 (2.3—3.6) | 0.7—1.3 (2.3—4.3) | 0.7—1.4 (2.3—4.6) |
| f-32 | | 0.7—0.8 (2.3—2.6) | 0.7—0.9 (2.3—3.0) | 0.7—1.0 (2.3—3.3) |

## 300EZ GUIDE NUMBER WITH ISO 100

| Flash Coverage Angle | 28mm | 35mm | 50mm | 70mm |
| --- | --- | --- | --- | --- |
| Guide Number in Meters | 22 | 25 | 28 | 30 |
| Guide Number in Feet | 73 | 83 | 93 | 100 |

To find the guide number at a different film speed, use the formula shown earlier in this chapter.

tial charge for rapid-fire capability.

**Test**—Press the Ready Lamp to fire the flash independently of the camera.

**Preflash**—A dark-red preflash is emitted from the flash body to set exposure in all ATTL modes.

**Sync Selector**—Move to left to select first-curtain sync and to right for second-curtain sync.

**AF Auxiliary Light**—In dim light, a dark-red pattern of vertical bars is automatically projected onto the subject to aid autofocus. With no other subject illumination, the autofocus range is 0.9 to 6 meters (3 to 19.7 feet).

**Power Source**—Four AA-size 1.5 volt batteries, carbon-zinc, alkaline or Ni-Cad.

**Dimensions**—66x89x101mm (2.6x3.5x4 in.).

**Weight**—215g (7.6 oz.) without batteries.

### MACRO RING LITE ML-3

With a macro lens used at high magnification, the subject is very close to the front of the lens. Light from a

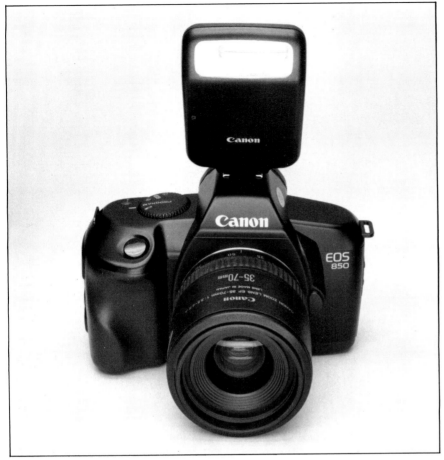

**Speedlite 160E is intended for use on EOS 750, 750 QD and 850 cameras. It is small, lightweight and completely automatic, with a built-in AF Auxiliary Light Emitter for auto-focus in the dark. It has no controls—not even an On-Off switch—and is controlled completely by the camera.**

## SPEEDLITE 160E SPECIFICATIONS

**Guide Number:** With Ready-Light red, 16 meters (52 feet); with Ready-Light green, 8 meters (26 feet).
**Coverage Angle:** 35mm or longer lens.
**Number of Flashes:** Between 400 and 4000 with new battery.
**Recycle Time:** 0.3 to 0.7 seconds to green; 0.3 to 1.7 seconds to red.
**AF Auxiliary Light Range:** 1.0 to 5 meters (3.3 to 16.4 feet).
**Shooting Distance:** With Ready-Light red, 0.7 to 5.6 meters (2.2 to 18.3 feet) with ISO 100; with Ready-Light green, 0.7 to 2.8 meters (2.2 to 9.1 feet) with ISO 100.

flash unit mounted in the hot shoe may be blocked by the lens.

Macro Ring Lite ML-3 has a control unit that mounts in the camera hot shoe and a flash unit that mounts on the front of the lens. The flash unit has two small rectangular flash heads mounted on a ring that screws into the filter threads on the lens. If both flash heads are used, shadowless illumination of the subject results. Either one may be used alone to bring out subject detail by sidelighting.

Built-in incandescent lamps in each flash head can be turned on to assist viewing or manual focusing. If turned on, these lamps turn off automatically when the flash ready-lamp lights or when the Shutter Button is pressed.

Operation is the same as the EZ flash units, including automatic or manual control of exposure. Guide number is 11 (meters) or 36 (feet) at ISO 100. However, with a subject that is very close to the flash, guide-number calculations are not reliable. Therefore, automatic exposure is recommended.

### SPEEDLITE 160E

This is a lightweight, compact flash, designed for EOS 750/850 cameras. The flash is powered by a lithium 2CR5 battery in the flash battery chamber, which is the same battery type used by the camera.

**With EOS 850**—Mount the flash in the hot shoe.

**With EOS 750 and 750 QD**—If the built-in flash is popped up, close it by pressing it down before installing Speedlite 160E in the hot shoe. With the 160E installed, the built-in flash will not fire, even if it is popped up. However, if it is popped up, it will block light from the AF Auxiliary Light Emitter on the 160E and prevent autofocus in dim light.

These cameras have an On-Off switch for the built-in flash. It has no effect on Speedlite 160E.

**On-Off**—There is no On-Off switch on the 160E. The flash is controlled by the camera. When the flash is installed

and the camera Main Switch is not at L, pressing the Shutter Button halfway causes the flash to charge and the Ready-Light on the back of the flash to glow. If you remove your finger from the Shutter Button, the Ready-Light turns off in about five seconds.

**Firing the Flash**—The camera will fire the flash automatically if the scene is in dim light or if the subject is backlit enough to benefit from frontal fill flash. The flash will fire with the camera Main Switch at PROGRAM or Self-Timer, but not at DEP.

**Exposure Control**—The camera sets aperture automatically for good exposure of the subject. It sets shutter speed in the range of 1/60 to 1/125 second to improve ambient-light exposure of a typical background. Exposure is controlled by the TTL flash sensor in the mirror box.

**Flash Ready-Light**—While the flash is charging, the Ready-Light on the flash and the P symbol in the viewfinder do not glow. The shutter will not operate while the 160E is charging.

When the Ready-Light is green, the flash is partially charged but charge is sufficient to fire the flash. When the Ready-Light glows red, the flash is fully charged.

**Guide Number**—When the Ready-Light is red, the ISO 100 guide number is 16 (meters) or 52 (feet). When it is green, the guide number is 8 (meters) or 26 (feet).

**Recycle Time**—The flash recharges to the green condition in 0.3 to 0.7 seconds, depending on the amount of charge used in the preceding flash. Full recharge takes 0.3 to 1.7 seconds.

**Continuous Firing**—When you hold the Shutter Button depressed to shoot a continuous sequence of frames, the flash will fire with each exposure if the battery has sufficient power. The camera will pause between frames for the flash to recharge. To minimize delay between frames, the flash will fire at reduced charge, with the Ready-Light green, and at reduced range. See the flash specs.

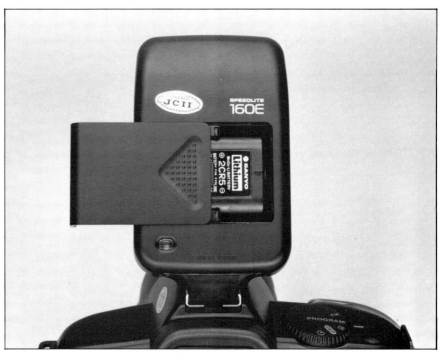

**Speedlite 160E uses the same type of battery as EOS cameras—a lithium 2CR5. The flash Ready-Light is in the lower left corner.**

**EOS 750 AND
750 QD BUILT-IN
FLASH SPECIFICATIONS**

**Guide Number:** 12 (meters), 39 (feet), with ISO 100.
**Coverage Angle:** 35mm or longer lens.
**Recycle Time:** About 2 seconds.
**AF Auxiliary Light Range:** 1.0 to 4 meters (3.3 to 13.1 feet).
**Shooting Distance:** 1.0 to 4.3 meters (3.3 to 14.1 feet) with ISO 100.

EOS 750 and 750 QD cameras have a built-in flash and AF Auxiliary Light Emitter that are controlled entirely by the camera. With the Flash Switch on the camera set to AUTO, the flash pops up when needed, fires, and then pops down again.

**Viewfinder Indications**—When the flash is charged, the P symbol glows steadily. There is no indication that the camera will or won't fire the flash.

**AF Auxiliary Light Emitter**—Fired automatically by the camera when needed, its range is 1 to 5 meters (3.3 to 16.4 feet).

**With EOS 620/650**—The 160E can be used, but will fire for every exposure because the flash cannot be turned off. Exposure control is automatic, by the TTL sensor in the camera.

### EOS 750 AND EOS 750 QD BUILT-IN FLASH

This built-in flash is similar in operation to Speedlite 160E except that it has less light output and can be turned off using the Flash Switch on the camera body. The flash draws power from the battery in the camera.

**On-Off**—These cameras have a Flash Switch on the top panel, identified by a "lightning" symbol. When set to AUTO, the flash is under automatic control by the camera. When set to OFF, the flash will not operate.

**Flash Charge**—When the Flash Switch is set to AUTO, pressing the Shutter Button halfway causes the flash to charge. There is no Ready-Light on the flash.

**Firing the Flash**—The camera will pop up the flash and fire it automatically if the scene is in dim light or if the subject is backlit enough to benefit from frontal fill flash. After firing, the flash automatically retracts. The flash will fire with the camera Main Switch at PROGRAM or Self-Timer, but not at DEP.

**Remove Lens Hood**—Because the built-in flash is close to the lens, use of a lens hood may block some of the light. When the flash head pops up, remove the lens hood, if one is on the lens, before shooting.

**Exposure Control**—The camera sets aperture automatically for good exposure of the subject. It sets shutter speed in the range of 1/60 to 1/125 second to improve ambient-light exposure of a typical background. Exposure is controlled by the TTL flash sensor in the mirror box.

**Guide Number**—The ISO 100 guide number is 12 (meters) or 39 (feet).

**Recycle Time**—Approximately 2 seconds.

**Continuous Firing**—When you hold the Shutter Button depressed to shoot a continuous sequence of frames, the flash will fire with each exposure, if the battery has sufficient power. The camera will pause between exposures for the flash to recharge.

**Viewfinder Indications**—When the flash is charged, the P symbol glows steadily. If the camera "intends" to use flash, the flash will pop up automatically.

**AF Auxiliary Light Emitter**—Fired automatically by the camera when needed, its range is 1 to 4 meters (3.3 to 13 feet).

# Interchangeable Backs

The back cover of EOS 620/650 cameras is removable so you can install an accessory back that provides various functions, such as imprinting the date on the film when you take a picture. Different accessory backs offer different functions.

An accessory back has a built-in clock and electronic calendar, similar to a digital wrist watch, so it "knows" the year, month, date and time-of-day. The back also contains a battery in a battery compartment.

Electrical contacts on the back mate with a row of contacts on the camera body, near the back-cover hinge. These contacts provide data communications between the accessory back and the camera. They should be kept clean by wiping occasionally with a clean, lintless, dry cloth. When you do that, be very careful not to touch the focal-plane-shutter in the camera body.

Imprinting data on the film is done by a light source in the accessory back that projects alphanumeric symbols (letters and numbers) onto the back side of the film. The light travels through the film base to expose the emulsion on the front of the film. The intensity of the printing light is controlled automatically, depending on the speed of the film being used.

The accessory backs discussed in this chapter fit both EOS 620 and EOS 650 cameras.

**To Install**—Begin by removing the standard back cover. BE CERTAIN THERE IS NO FILM IN THE CAMERA BEFORE OPENING THE BACK COVER.

Check the film-cartridge symbol in the LCD Display Panel. If there is film in the camera, but it has been rewound, you can open the back cover. If it has not been rewound, opening the camera will allow light to reach the film that

Quartz Date Back E can be used to imprint the date or other information on the lower right corner of the frame.

extends out of the cartridge. This will damage or destroy the images on that part of the film.

Remove the standard back cover as shown in the accompanying photo. Install the accessory back by reversing that procedure.

## QUARTZ DATE BACK E

This back imprints data on the film and remembers the date that the film in the camera was loaded. It has pushbutton controls and an LCD display. It is called *Quartz* because it uses a quartz crystal to maintain accurate time.

**Clock/Calendar**—Specified accuracy is plus or minus 30 seconds per month at room temperature (20°C or 68°F). The calendar is programmed to be correct from year 1986 to 2029 with automatic adjustment for leap years.

**Imprinting Modes**—There are four modes that display data on the Date

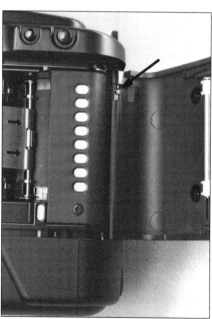

To remove the camera back cover, press downward on the pin (arrow) that extends from the hinge. Tip the back downward slightly and remove.

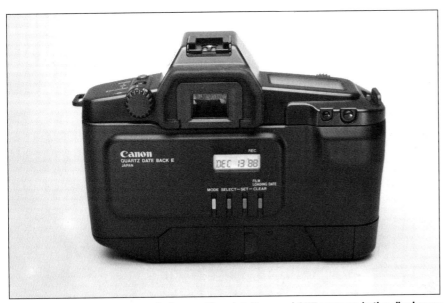

If Quartz Date Back E is set so it does not imprint, the word OFF appears in the display on the Date Back. If data appears in the display, as shown here, the displayed data will be imprinted.

Back LCD display and imprint the displayed data on the film. Only one mode can be used at a time.

- Year/Month/Date, such as '88 9 23, which is September 23, 1988. The order can be changed to Date/Month/Year, such as 23 9 '88. Notice that the year digits are preceded by an apostrophe. The order can also be changed to Month/Date/Year, with the month identified by three letters, such as SEP 9 '88.
- Date/Time, such as 23 4:51, which is 4:51 in the morning on the 23rd day of the month. This order cannot be changed. The time function uses a 24-hour clock. Noon is 12:00, one o'clock in the afternoon is 13:00, and so forth. Thirty minutes past midnight is 0:30.
- An arbitrary six-digit number of your choice, such as 12 34 56. These digits are displayed and imprinted in pairs. Each pair can be changed from 00 to 99. You can make any pair blank to provide, for example, 12   56.
- A frame counter that begins with Fc 00 00 and counts up to Fc 99 99. The

frame count increases automatically when film is advanced in the camera, whether the frame number is being imprinted on the film or not. When film is loaded, the frames that are automatically advanced to reach frame 1 are not counted.

The counter does not reset to zero when a fresh cartridge of film is placed in the camera. You can reset it manually.

**Non-Imprinting Modes**—There are two modes that don't imprint anything but display data in the LCD display on the Quartz Date Back E:

- The word OFF appears when the back is turned off. The internal clock/calendar continues to run.
- The film-loading date is stored in the back each time a fresh cartridge of film is loaded into the camera. The date is obtained from the built-in clock/calendar. The film-loading date is displayed on command—even with the back turned off.

**Controls**—The pushbutton controls are recessed to reduce the chance of

pressing them inadvertently.

**MODE Button**—When pressed, the MODE button cycles through the imprinting modes and OFF. For example, to turn the back off, press the MODE button repeatedly until the word OFF appears in the LCD display on the Date Back.

**SELECT Button**—The SELECT button is the first step in changing displayed data. It selects the value to be changed and the selected value blinks in the display. For example, if the arbitrary number 12 34 56 is being displayed, pressing the SELECT button will cause 56 to blink, so it can be changed.

Pressing SELECT again will cause 34 to blink so it can be changed, and so forth. When all three pairs have been selected, pressing the SELECT button again stops all blinking and the Date Back resumes normal operation.

**SET Button**—When a value has been selected, pressing the SET button causes it to change. Suppose the frame counter is being displayed and shows Fc 00 07. If you press SELECT, the value 07 will blink. If you press SET it changes to 08 and continues blinking.

Each time you press SET, the value being changed increases by one unit. If you hold down the SET button, the value will increase continuously and rapidly until you release the button. When you have finished changing values, press SELECT until nothing blinks.

Because the SELECT button cycles through the displayed values in order, you may select values that you don't want to change. If so, press SELECT again, to select the next value in the display.

**CLEAR Button**—Pressing the CLEAR button sets the selected value to its minimum value or starting point. For example, if 99 is blinking, pressing CLEAR sets it immediately to 00. If OCT is blinking, pressing CLEAR sets it to JAN.

FILM LOADING DATE is a second function of the CLEAR button and a

second label for that button on the Date Back. If nothing is blinking, pressing and holding this button displays the loading date for the film in the camera. This can be done in any mode, including OFF. When you release the button, the Date Back reverts to normal operation.

**Changing Year/Month/Date Order** Press the MODE button to display this mode. Release the button. While pressing the SET button, pressing the MODE button repeatedly cycles through the three formats discussed earlier.

**Setting Year/Month/Date**—Use the SELECT and SET buttons to change the year, month or date if any value is incorrect. Regardless of the order in the display, year will be selected first for change, then month, then date.

**Setting the Time**—In the Date/Time display, a colon appears between hours and minutes, such as 6:45, which is 6:45 AM. Seconds are not displayed but are counted in the internal clock.

If this mode is displayed, pressing SELECT causes the colon to blink. Pressing SET will zero the seconds counter in the clock and it will immediately begin counting upward from zero. This allows you to set time to agree precisely with another clock or a radio time signal.

After zeroing the seconds counter, use SELECT and SET to change minutes and hours as needed. The colon will stop blinking when you select minutes to be changed.

**Imprinting Data**—With three exceptions, whatever appears in the Date Back display will be imprinted on the film. The four imprinting modes described earlier will imprint.

Nothing will be imprinted if the Date Back display shows the word OFF.

Data cannot be imprinted when a value is blinking, but the camera can be used. If the frame counter appears in the Date Back display, and the value is blinking, it will not imprint on the film if you expose a frame. However, the frame count will increase and remain correct.

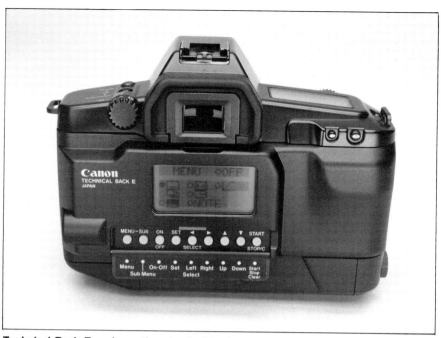

Technical Back E replaces the standard back cover of EOS 620 and 650 cameras. It imprints data on the film, stores information about each exposure as you make the shot, and has many other functions. Control buttons are under a folding cover, shown open here.

The third exception is the film-loading date.

**Imprint Confirmation**—When the displayed data has been imprinted, a black rectangle appears in the upper right corner of the Date Back display, just below the word REC, which means *recorded*. The confirmation rectangle appears for about two seconds.

**Imprint Location**—Data appears in the lower right corner of the photo. The data will be easier to read if you compose so this area in the frame is dark. Against a very light background, the data may not be visible.

**LCD Display**—The display will fade and become difficult to read in about five years. It can be replaced at a Canon service center.

**Battery**—A fresh battery lasts about three years. When the battery is discharged, the word BATTERY appears in the Date Back display. Remove the cover of the battery chamber. Use a screwdriver to tip up the old battery and remove it. Wait 15 seconds. Replace with a lithium 3-volt CR2025 battery

with the + mark up. If the display does not return to normal, remove the battery, wait at least 15 seconds and replace.

All data will be lost and all modes must be reset to current date, time, and so forth.

**Dimensions**—148 x 58.4 x 24.7mm (5.8 x 2.3 x 0.9 in.).
**Weight**—75g (2.6 oz.).

## TECHNICAL BACK E

This is an interchangeable back cover for the EOS 620 and EOS 650. There are two accessories for Technical Back E. Keyboard Unit E works like a typewriter and makes it easier to enter data into the technical back. Interface Unit TB (IBM-PC) allows data interchange between the technical back and an IBM PC, XT or portable computer.

Technical Back E can imprint data, such as exposure settings, on the film. It can store camera-control settings for up to 361 frames. It can control camera

145

# TECHNICAL BACK E TYPICAL DISPLAYS

Technical Back E uses four types of displays.

## MENU screen

The Menu uses symbols for the seven functions of the technical back, plus OFF. This screen is used to turn functions on or off and to turn the technical back on or off.

## SUB MENU screen (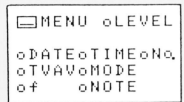)

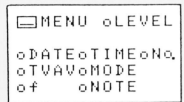

A Sub-Menu offers choices relating to one function. This is the Sub-Menu for the Imprint function. Choose up to three items to be imprinted, such as DATE, TIME and NOTE. The LEVEL symbol adjusts intensity of the imprinting lamp, when this is necessary.

## SET screen (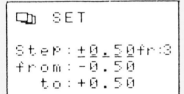)

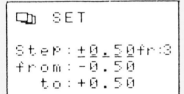

The Set Screen is used to enter data or instructions. This is the Set Screen for Automatic Exposure Bracketing. The exposure change shown is +0.50 step for each of 3 frames. Bracketing starts at -0.50 step below metered exposure and ends at +0.50 step. All of these values can be changed on the Set Screen.

## EXECUTION screen (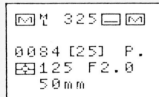)

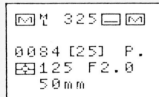

The Execution Screen shows what a function is doing. This is for the Data Storage function. There is room to store data for 325 more frames. Symbols to the right of 325 show that both Data Imprint and Data Storage are turned on. Displayed data is for roll 0084, frame (25), which used P (programmed) exposure and Evaluative metering. Shutter speed was 1/125 second (125) and aperture was F 2.0. Lens focal length was 50mm.

# TECHNICAL BACK E FUNCTION SYMBOLS

In the LCD display of Technical Back E, these symbols represent the indicated functions:

 DATA IMPRINT

 DATA STORAGE

 PROGRAM SETTING

 AUTO EXPOSURE BRACKETING

 TIMER

 CORRECT DATA BEFORE IMPRINTING

NOTE NOTE SETTING

OFF MAIN SWITCH

functions, such as time exposures.

I will list the capabilities of the unit, then show examples of its use. Space does not permit giving detailed procedures for every operation. The instruction booklet for Technical Back E has useful set-up charts.

## FUNCTIONS

The technical back offers seven functions, represented by symbols in the LCD display.

**Notes**—You can enter up to four notes with up to 30 characters each and save them in the technical back.

**Imprint**—Choose up to three of the following items to imprint: date, time, shutter-speed and aperture, exposure mode, film counter, or a note.

Data is imprinted in a single horizontal line across the bottom of the frame during automatic rewind at the end of the roll. Data will not imprint on the correct frames if you rewind before the last frame. If necessary, shoot blank frames to reach end-of-roll and trigger automatic rewind.

**Data Storage**—Stores data about each frame in the technical back, including a note, if desired. Later, you can use the technical back LCD Panel to display the data or send it to a computer.

**Design Your Own Program**—Two program graphs, A and B, are stored in the technical back. Either can be selected for use instead of the camera's built-in Intelligent Program.

You can replace program A or B with a program that you draw on the LCD Panel by pressing buttons on the technical back. Then, you can use the program that you drew.

**Automatic Exposure Bracketing**—This gives the EOS 650 auto bracketing and the EOS 620 more capability than built into the camera. Brackets up to 9 frames with a preset exposure change of up to 2 steps in increments of 0.25 step.

**Exposure Timer**—You can select one of two timers, A or B. Timer A makes groups of exposures, with a specified time interval between each group and a specified time delay before the first

group. For example, wait 4 hours, then expose 7 groups of 3 frames, with an interval of 18 minutes between groups. The delay and interval can be from 1 second to 99 hours, 59 minutes and 59 seconds.

Timer B switches the camera to the bulb setting and makes a single long exposure, using a specified aperture, after a specified delay. The delay and the exposure duration can be from 1 second to 99 hours, 59 minutes and 59 seconds.

**Imprint Data Correction**—Data to be imprinted is held in the technical back until end of roll. Imprinting occurs during rewind. This allows correcting or changing data before imprinting.

## INSTALLATION

Be sure there is no film in the camera. Remove the standard back cover as shown earlier. Replace with Technical Back E.

## POWER SOURCE

Uses one CR2025 lithium battery. It lasts about one year.

**Battery Check**—When the battery nears discharge, a battery symbol appears in the LCD display on the technical back.

## CONTROLS

Under a fold-out cover on the technical back are nine pushbuttons, shown in the accompanying illustration.

## LCD PANEL

An LCD Panel on the technical back provides display *screens* for each function. To turn on the LCD Panel, press any of the nine buttons. It will turn itself off after about 30 seconds.

## MENUS

Some screens are *menus,* offering several items to choose from. There is a circle to the left of each item that can be chosen.

## TURNING ON FUNCTIONS

If a circle on the menu is open, not

filled in, the adjacent function is not turned on. If the circle is solid, the function is turned on.

## CURSOR

Four controls are Cursor Buttons with arrow symbols: up, down, left, right. When a menu is displayed, one of the circles on the menu will blink. That is the location of the cursor. Pressing Cursor Buttons moves the cursor, causing a different circle to blink.

## DISPLAYS

Depending on the function being used, up to four screens may appear. Examples are shown in the accompanying illustration.

● Menu shows symbols for each of the seven functions, and which are turned on. It also has an OFF symbol. When the technical back is turned off, only the OFF symbol appears.

● Sub Menu is used by two functions—Data Imprint and Data Storage—to choose data to be imprinted or stored.

● Set Screen is used to enter or correct data, such as date or time.

● Execution Screen shows which functions are being used and what they are doing.

## SET-UP PROCEDURES

Using Technical Back E is straightforward, once you understand its functions and control procedures. The main problem is knowing which buttons to press and in which order.

Following paragraphs present a few "button-pushing" sequences as examples. If you have Technical Back E, it may be helpful to install it on an empty EOS 620 or 650, then load a practice roll of film and perform these procedures. It will also be helpful to refer to the instruction booklet for the technical back.

## TURNING THE
## TECHNICAL BACK ON

Turn on the LCD Panel by pressing any control button. If the technical

back is turned off, the screen will be blank except for the OFF symbol and adjacent circle. Press the On-Off button. The Menu Screen will appear.

## DATA IMPRINT FUNCTION

1. On the Menu Screen, move cursor to Imprint symbol.
2. Press Sub Menu Button to display items to be imprinted.
3. Move cursor to a Data Item symbol. Circle blinks. Turn on Data Item by pressing On-Off Button so blinking circle is solid. Turn off by making circle open. Repeat, to turn on up to three items.
4. If you selected the date, time, film counter, or a note, you may wish to enter or verify the data using the Set Screen.
5. Press Menu Button to return to Menu. Move cursor to the Imprint symbol. Press On-Off Button to turn on Imprint function.
6. Press Menu Button again to display the Execution Screen. The function symbol that was last designated by the cursor appears at the top left corner of the screen. Data on the screen relates to that function.

If Imprint was the last function designated by the cursor, the screen shows what is to be imprinted. Press the Shutter Button to make the next exposure and imprint the displayed data.

## ENTERING NOTES

You can enter up to four notes into the memory of the technical back, each with up to 30 characters. Select any of the stored notes to be imprinted. Select the same or a different note to be stored in the technical back with other data for each frame.

There are two ways to enter notes: by using control buttons on Technical Back E or Keyboard Unit E. The Technical Back E method is discussed next; the Keyboard Unit E method, a little later.

**Using Technical Back E**—This is the more complex way. Follow these steps:

1. On the Menu, move the cursor to NOTE.
2. Press the Menu Button. A note number, 1 to 4, will be displayed. If a note is stored, it will be displayed.
3. Press the Select Button to change note numbers.
4. When the desired number is displayed, press the Set Button. If note 1 was selected, the top of the screen reads NOTE 1 SET. A blinking underscore appears at the space for the first character of the note.
5. Press the up or down Cursor Button. A sequence of available characters appears above the underline. Stop at the desired character. To enter a blank, press the Start Stop Clear Button.
6. Press the right Cursor Button to move to space 2. Repeat step 5. Pressing the left Cursor Button causes a move to the left.
7. Repeat steps 5 and 6 until the note is complete.
8. Press Set to enter the note.
9. Press Select to enter or change another note.
10. When you have finished, press Menu to return to the Menu.

## IMPRINTING A NOTE

Imprinted data is in a single line with up to 30 characters. The LCD display uses three lines with 10 characters each to show what is to be imprinted. If only a note is to be imprinted, all 30 characters of the note will appear. If one additional item is to be imprinted, the note moves down to make room and 10 characters disappear from the end of the note. If two other items are imprinted, the note is shortened by 20 characters.

The note to be imprinted is selected in the Imprint function.

1. On the Menu, move the cursor to the Imprint symbol.
2. Press the Sub Menu Button.
3. Move the cursor to NOTE.
4. Press the On-Off Button to turn NOTE on.
5. Press the Sub Menu Button. The Execution Screen appears, to show what will be imprinted, including a note. The note number appears at the top of the screen, such as $I^1$, where I means Imprint. If a note is being stored in memory, its number will also appear, such as $M^3$, where M means Memory. The two notes don't have to be the same.
6. To select a different note to be imprinted, press Select.
7. Press Menu to end the procedure. The screen shows what is to be imprinted at the next exposure.

## DATA STORAGE FUNCTION

This function stores data for each frame in the technical back. The data can later be recalled. There are two capacity settings.

With Normal capacity, you can store 13 data items for each of 361 exposures. The items are: Serial number or cartridge number, frame number, exposure mode, metering mode, flash used or not, shutter speed, aperture, focal length, exposure compensation, film speed, date, time and note.

With Reduced capacity, you can store 7 items of data for 824 frames. The items are: Serial number or cartridge number, frame number, exposure mode, flash used or not, shutter speed, aperture and focal length.

On screens associated with data storage, a number appears at top center to show the remaining number of frames about which data can be stored.

## KEYBOARD UNIT E

The keyboard connects to Technical Back E with a cable. It makes it easier to enter notes, correct or change data before imprinting. Four additional notes can be stored in Keyboard Unit E and exchanged as a group with the four notes in the technical back. Thus, with the keyboard connected, you can choose from eight notes. If the data storage capacity of the technical back becomes full, you can move, or *dump*, the data into the keyboard unit. Later, you can move it back into the technical back.

## INTERFACE UNIT TB (IBM-PC)

This fits between the technical back and an IBM PC, XT or Portable Personal Computer. An MSX model is for computers using the MSX operating system.

A 5-inch diskette with programs is supplied. Turn on the computer and bring up DOS. The ready symbol A will appear on the computer screen. Place the diskette in drive A, type ifu and press the Enter key.

A menu will appear. Press function keys on the computer to make menu selections. Capabilities include:

● You can transfer stored data from the technical back to the computer, display it, print it out or save it to disk.

● You can enter up to four notes using the computer keyboard and transfer them to the technical back. You can correct, add to or delete notes.

● You can design special characters or symbols and transfer them to the technical back, to imprint them on film.

● You can preset imprint data for up to 36 frames and transfer data to the technical back to imprint it.

● You can use timer functions.

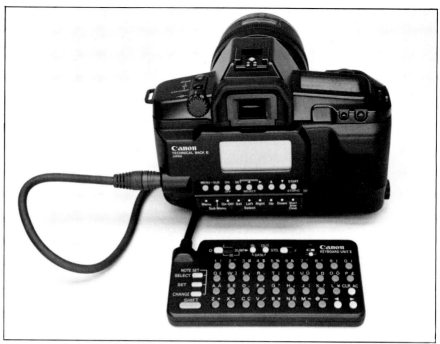

Keyboard Unit E plugs into Technical Back E and works like a typewriter. It makes data entry and correction easier and expands the storage capacity of the technical back.

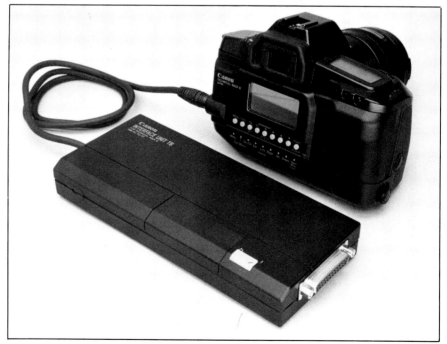

Interface Unit TB (IBM-PC) fits between Technical Back E and an IBM personal computer. It allows data interchange between the technical back and the computer. You can store exposure data for many frames on a diskette or print it out on paper.

# EOS SLR Cameras

By using a relatively wide-angle lens at a small lens aperture, you can ensure sharp images from close-up all the way to the most distant part of a scene, as in this photo. Alternatively, you can use limited depth of field selectively, to deliberately record the main image sharply against an unsharp background or foreground.

This chapter begins with a description of EOS 620 and 650 cameras. Later, the EOS 750/850 models are discussed.

Topics that have been discussed in earlier chapters may be mentioned here, but will not be explained again in detail. Reference to earlier chapters is made, when appropriate. For example, One-Shot AF and Servo AF modes are listed as camera capabilities, without lengthy discussion. In Chapter 3, these features are described in detail.

EOS cameras are a new series of Canon autofocus SLR cameras, with companion EF lenses and flash units.

For maximum user convenience, they can be used as fully automatic "point and shoot" cameras. For maximum creativity or to suit user preference, most automatic features can be overruled, providing manual control when desired.

Automatic features include: film loading, film advance, film rewind, setting film speed, focusing the lens, setting exposure, and adjusting exposure for non-average scenes.

With an EZ or E flash unit, an EOS camera can take correctly exposed and correctly focused pictures, automatically, even in total darkness. At

the other extreme, a flash can be used in daylight to provide automatic flash fill.

The EOS 620/650 back cover is removable to allow use of accessory backs, such as Quartz Date Back E.

EOS 620/650 control settings are made by rotating the Input Dial with your right forefinger. The function being set or selected, such as exposure mode, is established by pressing a separate pushbutton while rotating the Input Dial.

Special features of the EOS 620 and 650, not common to both models, include setting depth of field auto-

| DIFFERENCES BETWEEN EOS 620 AND EOS 650 | | |
|---|---|---|
| FEATURE | EOS 620 | EOS 650 |
| Shutter Speed Range | 30 to 1/4000 sec. | 30 to 1/2000 sec. |
| X-Sync Shutter Speed | 1/250 sec. | 1/125 sec. |
| Depth of Field AE | No | Yes |
| Auto Exposure Bracketing | Yes | No |
| Multiple Exposures | Yes | No |
| Program Shift | Yes | No |
| LCD Display Illumination | Yes | No |

matically, automatic bracketing, multiple exposures, program shift, and the fastest shutter speed. The differences, which have been pointed out in earlier chapters, are shown in the accompanying table.

## LENSES

EOS cameras use interchangeable Canon EF (Electro Focus) lenses which have small built-in motors for autofocus and to set aperture size. Both functions are controlled by electrical signals from the camera.

The lens uses a small built-in computer (microprocessor) to efficiently execute commands from the camera. A built-in ROM (Read-Only Memory) chip stores data about the lens, such as aperture range and focal length. This data is transmitted automatically to the electronic systems in the camera body.

With EF zoom lenses, a mechanism in the lens monitors the focal-length setting and transmits that information to the camera.

**Lens Mount**—EOS cameras use a new bayonet-type EF lens mount that is not the same as the mount on earlier Canon SLR cameras. The mount diameter has been increased from 48mm to 58mm.

The distance from the front surface of the mount to the film plane has been increased from 42mm to 44mm to allow using a larger mirror, which reduces image cutoff with long-focal-length lenses. The entire image is visible in the viewfinder with focal lengths of 800mm or shorter.

**Camera-Lens Interface**—The EF lens mount is fully electronic, with no mechanical linkages or couplings between camera and lens. Data is exchanged by electrical contacts on the camera that mate with contacts on the back of the lens.

The EOS camera sets focused distance and aperture size by electrical commands that are transmitted through the contacts in the lens mount.

Data that flows from lens to camera includes focal length, maximum and minimum aperture, and other lens characteristics. This data is used by the automatic-exposure and automatic-focus systems in the camera body.

**Focus-Mode Switch**—Each EF lens, except A-type, has a Focus-Mode Switch with an M (Manual) setting and one or more AF (Auto Focus) settings. At the M setting, focusing is done manually. However, the autofocus system in the camera continues to operate the focus indicator in the viewfinder.

EF lenses with more than one AF setting have restricted focusing zones, such as from 1.5 meters to infinity, that are selected by choosing the desired AF setting.

When a focus zone has been selected, its limits are transmitted automatically to the autofocus system in the camera through the contacts in the lens mount.

**Earlier Lens Types**—Earlier lens types, such as Canon FD and FL lenses, cannot be used on EOS cameras. EF lenses cannot be used on earlier non-EOS cameras.

**EOS 620/650 Descriptions**—Although there are differences in the operating features of the EOS 650 and EOS 620, they are basically similar. The following section is a discussion of the EOS 650, including all of its operating features.

After that, a section is devoted to the EOS 620, but only features that are not available in the EOS 650 are discussed.

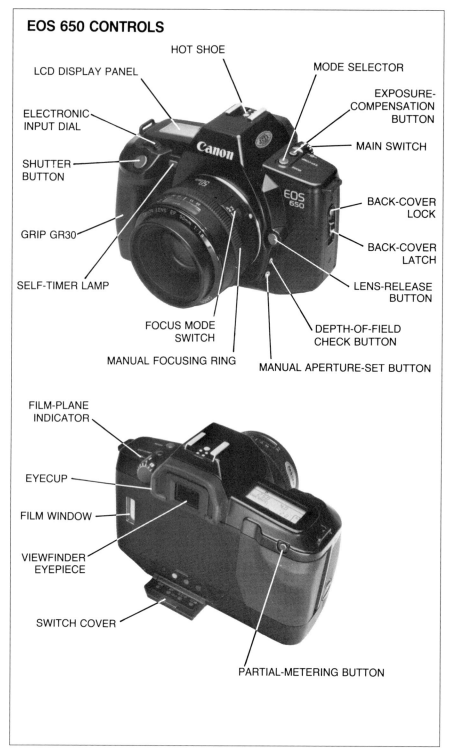

## EOS 650 CONTROLS

LCD DISPLAY PANEL

HOT SHOE

MODE SELECTOR

EXPOSURE-COMPENSATION BUTTON

ELECTRONIC INPUT DIAL

MAIN SWITCH

SHUTTER BUTTON

BACK-COVER LOCK

GRIP GR30

BACK-COVER LATCH

SELF-TIMER LAMP

LENS-RELEASE BUTTON

FOCUS MODE SWITCH

DEPTH-OF-FIELD CHECK BUTTON

MANUAL FOCUSING RING

MANUAL APERTURE-SET BUTTON

FILM-PLANE INDICATOR

EYECUP

FILM WINDOW

VIEWFINDER EYEPIECE

SWITCH COVER

PARTIAL-METERING BUTTON

# EOS 650 CAMERA

The EOS cameras depend on battery power to operate and will not function if the battery is discharged or absent. If you are traveling with an EOS camera, carry a spare battery or be sure replacement batteries are available at your destination. These batteries have a long storage life.

## BATTERY

A single 6-volt lithium battery, type 2CR5, supplies power both to the camera and the lens. Install by removing the handgrip, as shown in the accompanying photo.

**Battery Check**—With the Main Switch on, open the Switch Cover on the back of the camera and press the Battery-Check Button at the extreme right. This button is identified by a battery symbol that looks like a *conventional* battery, such as an AA type. The LCD panel shows a bc (battery check) symbol. Battery condition is indicated using the three bars that normally represent film, as shown in the accompanying illustration.

**Battery Capacity**—In cold weather, battery power is reduced, as you can see in the accompanying table. Keep the camera away from the cold if possible, such as inside your jacket, until you are ready to shoot. For extended shooting, keep a second battery in your pocket—warm and ready to use.

**With low Battery**—If the shutter operates, exposure will be correct. However, an almost discharged battery may not have enough power to advance the next frame. If that happens, film advance will resume when a fresh battery is installed.

**With Dead Battery**—The camera will not operate if the battery is dead or removed.

battery may cause the bc symbol and the battery-check bars to flash. See the section entitled *Malfunction Warning,* later in this chapter.

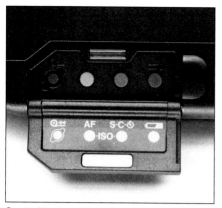

Control buttons that are not often used are behind the Switch Cover on the back of the camera. From left-to right, they are: Midroll Rewind button, AF Mode select button, Film-Winding Mode select button, Battery-Check button. Pressing the two center buttons simultaneously displays the set film speed and allows you to change it, if desired.

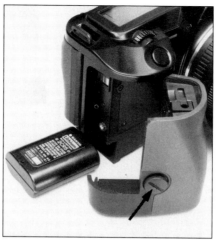

Removing the grip exposes the battery chamber. The grip is held in place by a screw (arrow) that can be loosened with a coin.

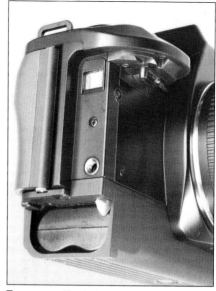

To remove the battery, use your finger to move the plastic tab at the upper right corner. When installing a fresh battery, the battery itself forces the tab out of the way. You must press the battery in far enough to allow the tab to drop down into the position shown here.

## 2CR5 LITHIUM BATTERY CAPACITY

| TEMPERATURE | 24-EXPOSURE ROLLS | 36-EXPOSURE ROLLS |
|---|---|---|
| Normal (20C or 68F) | 150 | 100 |
| Cold (−20C or −4F) | 15 | 10 |

## INTERCHANGEABLE GRIPS

There are three interchangeable grips that can be used on EOS cameras: **Grip GR20**—Standard with the EOS 620, this grip has a built-in Remote-Control Terminal for use with remote-control equipment.

**Grip GR30**—Standard with the EOS 650, this grip is the same size as GR20 but has no Remote-Control Terminal.

**Grip GR10**—This is a larger grip, convenient for people with large hands. There is no Remote-Control Terminal.

## MEMORY FOR CONTROL SETTINGS

When the battery is dead or being replaced and the camera is turned off, camera status and control settings are held in a special EEPROM (Electrically Erasable Programmable Read-Only Memory), which requires no battery power. It stores film speed, frame count and all camera settings.

When a fresh battery is installed, or the camera is turned on again, the camera resumes operation as though there had been no power interruption.

## LCD DISPLAY PANEL

An LCD (Liquid-Crystal Diode) Display Panel on top of the camera shows camera-status information. It has displays to guide you when loading film and making control settings. What is displayed depends on the camera condition and the operation being performed.

**With Camera Off**—With the camera turned off, the LCD Display Panel shows whether or not film is in the camera. If film is loaded, it shows the frame count.

**Camera On**—With the Main Switch turned on, the LCD display shows three additional items: focus mode, film-winding mode and exposure mode. If special camera settings have been made, such as exposure compensation, symbols appear in the display to show the special settings.

**Meter On**—With the camera electronic systems turned on by depressing the Shutter Button halfway, the LCD display shows two additional items: the shutter-speed and aperture values.

If you remove your finger from the Shutter Button without making an exposure, these items remain in the display for eight seconds. If you shoot and *immediately* release the Shutter Button, these items disappear immediately from the display. Pressing the Shutter Button halfway causes them to reappear.

**Depth-of-Field AE Mode**—When the Depth-of-Field AE mode has been selected, the EOS 650 LCD display

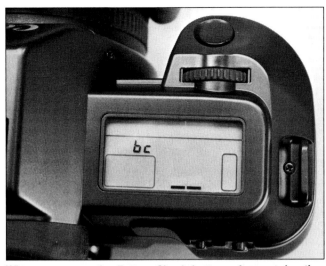

When you press the Battery-Check button, after opening the Switch Cover, the symbol bc appears in the LCD Display Panel. Three bars indicate sufficient charge. Two bars, as shown here, mean that the battery is nearing discharge. One blinking bar, or no bar at all, means replace the battery.

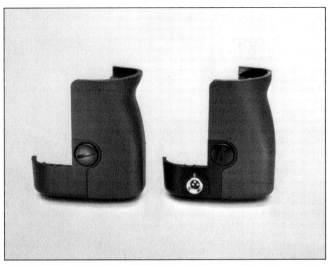

Grip GR30 is at left, Grip GR20 at right. They are interchangeable and the only difference is that Grip 20 has a Remote Control Socket, shown here with the cover removed. Grip 30 is standard on the EOS 650. Grip 20 is standard on the EOS 620. A larger interchangeable grip, Grip GR10, does not have a Remote Control Socket.

shows which of the three steps is to be performed next. The same information appears in the viewfinder display, which is normally used for this purpose.

**Illumination**—The EOS 650 does not have built-in illumination for the LCD panel. If the ambient light is dim, an external light source, such as a flashlight, will be helpful.

**Effect of Temperature**—At freezing temperatures or colder, LCD displays become sluggish and change slowly. At high temperatures of 60°C or 140°F, LCD displays become dark and unreadable. Normal operation is restored at normal temperatures.

**Operating Life**—After about five years, LCD displays fade permanently and become hard to read. The LCD Display Panel can be replaced at a Canon service facility.

## LOADING FILM

Open the camera back and insert a film cartridge as shown in Chapter 4. A film-cartridge symbol will appear in the LCD Display Panel. Close the camera back.

With the Main Switch turned on, the film end is grasped automatically by the takeup mechanism and film is automatically advanced to frame 1. In the LCD display, three dashes representing film extend from the film-cartridge symbol and blink in sequence to suggest film motion from left to right inside the camera—from the cartridge to the take-up spool.

When film loading is completed, the film symbol stops blinking. The frame-counter area in the LCD display shows frame 1 and the camera is ready to use.

**Warning**—If the automatic film-loading procedure doesn't work correctly, the dashes representing film will continue to blink, the frame-counter area in the LCD display remains blank, and the camera will not operate if you press the Shutter Button. Open the camera back and start over.

It may be necessary to pull more film from the cartridge, or push some back in. Film can be wound back into the cartridge by inserting a suitable "tool"—such as a key or paperclip—into the hole at either end of the cartridge and rotating the tool.

**Film-Load Check Window**—The standard back cover has a window that allows you to see if a film cartridge is in the camera and to read data imprinted on the cartridge—usually film speed and a code to identify the film type.

## REWINDING FILM

The end of the roll is sensed automatically by the camera. When the last frame has been exposed, a motor in the camera immediately rewinds the film. The film end is drawn all the way into the cartridge.

**LCD Display**—During rewind, the dashes representing film in the display panel blink sequentially to suggest film motion from right to left—from takeup mechanism into cartridge.

When rewind is completed, the film symbol disappears. The cartridge symbol blinks to indicate that it is safe to open the camera and remove the cartridge.

**Mid-Roll Rewind**—To rewind before the last frame is exposed, open the

Switch Cover on the back of the camera and press the button farthest to the left with your fingernail. This Film Rewind button is recessed to reduce the chance of pressing it inadvertently. The adjacent symbol shows a film cartridge with arrows indicating film motion into the cartridge.

**Low Battery**—If the battery is nearing discharge, rewind may stop before completion. If so, replace the battery and press the Film Rewind Button. Rewinding will resume.

**Modifications**—At a Canon service center, the EOS 650 can be modified to prevent automatic rewind at the end of the roll. The camera will then not rewind until you press the Rewind Button.

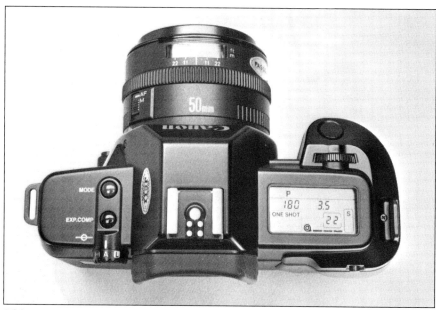

EOS 650 controls that are most often used are on top of the camera.

## EXPOSURE MODES

An exposure mode is selected by pressing the MODE button while turning the Input Dial until the desired mode symbol appears at the top of the LCD display. Exposure modes are discussed in Chapter 5.

**Intelligent Program Automatic**—Designated by a P symbol, both shutter speed and aperture are set automatically by the camera for correct exposure. The program changes automatically according to lens focal length.

**Aperture-Priority Automatic**—Designated by an AV symbol, you set aperture using the Input Dial. The camera sets shutter speed automatically for correct exposure.

**Shutter-Priority Automatic**—Designated by a TV symbol, you set shutter speed using the Input Dial. The camera sets aperture automatically for correct exposure.

**Depth-of-Field AE**—Available on the EOS 650, this mode allows you to specify depth of field by "showing" the camera the near limit and the far limit. The camera then chooses an aperture size for the desired depth of field and a shutter speed for correct exposure with that aperture value. This procedure is described in Chapter 5 and summarized

later in this chapter.

**Manual Exposure Control**—Designated by an M symbol, you set both aperture and shutter speed manually. Aperture is set by turning the Input Dial while pressing the Manual Aperture-Set Button on the lens mount, labeled M. Shutter speed is set by turning the Input Dial without pressing the M button.

While you are setting aperture, the camera exposure meter serves as a guide but does not control exposure, as discussed in Chapter 5.

## FOCUS INDICATION

Focus can always be judged by observing the image on the focusing screen. In addition, the electronic focus detector in the camera examines the image inside the AF Frame at the center of the image.

**In-Focus Indicator**—A green circle in the viewfinder, below the image area, glows steadily when the image is in good focus.

**Beeper**—When turned on, a beeper in

the camera makes a "beep-beep" sound when the image is in good focus.

**Autofocus Impossible**—If the Focus-Mode Switch on the lens is set to AF and electronic focus detection is impossible for any reason, the In-Focus Indicator blinks. You should then focus manually.

## FOCUS MODE

Focus mode is determined both by the Focus-Mode Switch on an EF lens and a setting made on the camera.

**Lens on AF**—With the lens set to AF, the lens will be focused automatically by the camera, if possible.

Two AF mode settings can be made. Open the camera Switch Cover and press the AF button. After releasing the button, you have eight seconds to make the mode selection. Turn the Input Dial to choose ONE SHOT or SERVO, as shown in the LCD panel.

## ONE-SHOT MODE

Depressing the Shutter Button halfway causes the camera and lens to

search for focus in the AF Frame.

Usually, the lens can move directly to focus on the subject. If it cannot, a "search" is conducted. The lens is focused at progressively shorter distances until the shortest distance is reached. Then it is focused at greater distance until infinity is reached. If focus is not found, the search stops and the In-Focus Indicator blinks until you release the Shutter Button.

**Focus Priority in One-Shot Mode—** If the image is not in focus, an exposure cannot be made, even when you depress the Shutter Button fully.

**Focus Lock in One-Shot Mode—** When found, focus is locked at that distance and will not change until you release the Shutter Button.

**Exposure Lock in One-Shot Mode—** The autofocus system and the evaluative metering system both require the main subject to be in the center of the frame while the camera sets focus and exposure. With One-Shot AF, both focus and exposure are locked when focus is found. This allows you to recompose and place the subject off center, if you wish, before making the shot.

## SERVO MODE

Pressing the Shutter Button halfway causes the camera to seek good focus *continuously* until the Shutter Button is pressed fully to make an exposure. An exposure can be made whether or not the image is in focus.

When the Servo AF mode is used to make a continuous sequence of frames by holding the Shutter Button down, the camera will attempt to refocus between frames. Thus, it can maintain focus on a moving subject, if the subject is not moving too fast. Exposures will be made whether or not the image is in focus.

## MANUAL FOCUS MODE

With the Focus-Mode Switch on the lens set to M for manual focus, the LCD panel displays the symbol M.FOCUS. Focus the lens manually.

**Focus Confirmation—**When focusing manually, the electronic focus detector in the camera continues to operate the In-Focus Indicator in the viewfinder. But the lens is not focused automatically.

When you have focused the lens manually, so the area inside the AF Frame is sharp, the In-Focus Indicator glows to *confirm* your setting.

When you are focusing manually, the In-Focus Indicator will never blink to suggest that focus is impossible.

## LIGHT RANGE FOR AF

The electronic focus detector operates with scene illuminations in the range of EV 1 to EV 18 at ISO 100. In either autofocus mode, it focuses the lens and operates the viewfinder In-Focus Indicator. On manual focus, it operates the In-Focus Indicator to confirm the manual focus setting.

**AF Auxiliary Light Emitter—**In light that is too dim for unaided electronic focus detection, if an EZ flash unit is attached and turned on, the camera will automatically trigger the AF Auxiliary Light Emitter on the flash. This briefly illuminates the subject with a dark-red pattern of vertical bars to assist the autofocus system. This works even in total darkness, when the subject is centered and within the range of the AF Auxiliary Light Emitter.

## FILM-WINDING MODE

After each exposure, film is automatically advanced to the next frame by a motor in the camera body. When the last frame has been exposed, film is automatically rewound.

**Frame Counter—**A frame-counter area in the LCD Display Panel is used to display the number of the *next* frame to be exposed.

**Winding-Mode Selection—**There are two film-advance (film-winding) modes. To select a mode, open the Switch Cover and press the blue button, which is labeled with an S, a C, and a clock-face symbol that represents the self-timer. After releasing the button, you have eight seconds to make the mode selection. Turn the Input Dial until the desired symbol appears in the LCD panel.

**Single-Exposure Mode—**Designated by S, the camera exposes a single frame each time you depress the Shutter Button fully. It will not expose the next frame until you release the Shutter Button more than halfway and then press it again.

**Continuous-Exposure Mode—**Designated by C, the camera exposes frames continuously as long as the Shutter Button is held down or until the last frame on the roll is exposed.

The camera always waits for the shutter to close before advancing film. Therefore, the continuous-exposure frame rate is reduced at slow shutter speeds. For example, if shutter speed is 1 second, exposures cannot be made at rates faster than 1 per second.

**Frame Rate with One-Shot AF—**In the continuous film-winding mode with One-Shot AF, the frame rate is about 3 per second unless reduced by long exposure time.

**Frame Rate with Servo AF—**In the continuous film-winding mode with Servo AF, the maximum frame rate is reduced to about 2 per second to allow a small amount of time for autofocus between frames. This provides the capability of maintaining focus on a moving subject. Even so, focus is not assured and exposures will be made whether or not the image is in focus.

## SELF-TIMER MODE

Designated by the clock-face symbol, this is the single-exposure film-winding mode with a 10 second delay after the Shutter Button has been fully depressed and before the shutter opens. During the countdown, a red Self-Timer Lamp flashes on the front of the camera—more rapidly during the last 2 seconds. The frame-counter area in the LCD Display Panel changes its function and displays time remaining, counting down from 10 seconds.

When the Shutter Button is fully depressed to *begin* the countdown, focus is locked even in the Servo mode, and

exposure is set and locked. If your eye will not be at the viewfinder when you press the Shutter Button, cover the eyepiece with the Eyepiece Cover that is snapped into the pad on the shoulder strap. Otherwise, incorrect exposure is likely because of stray light entering the eyepiece.

If you stand in front of the camera when pressing the Shutter Button, the camera will lock focus on you. This will almost certainly not be the correct distance for what you intend to photograph.

To cancel self-timer operation during countdown, turn the Main Switch off or press the Battery-Check Button.

## INTERACTION AMONG MODES

| | ONE-SHOT AF MODE | SERVO AF MODE |
|---|---|---|
| **SINGLE-EXPOSURE WINDING MODE** | AF and AE lock when image is focused. | AF changes continuously. AE locks just before shutter opens. |
| **CONTINUOUS-EXPOSURE WINDING MODE** | AF and AE lock when image is focused. Continuous exposures made at locked focused distance and locked exposure value. Max. frame rate approx. 3 per second. | AF changes between exposures. Will follow moving subject if possible. AE set before each exposure. Max. frame rate approx. 2 per second. |

## INTERACTION AMONG MODES

Focus mode, film-winding mode, exposure and frame rate interact as shown in the accompanying table.

## MAIN SWITCH

The Main Switch has an *off* setting, labeled L (Lock) and three *on* settings.
**Green Rectangle**—Canon refers to this setting of the Main Switch as "full auto." It uses standard settings for all camera modes, as shown below, and disables all camera controls except the Shutter Button and two buttons inside the Switch Cover: the Film-Rewind Button and the Battery-Check Button.
**Standard Settings**—The standard settings are selected by turning the Main Switch to the Green Rectangle. They are:
● Programmed automatic exposure
● One-shot autofocus
● Single-exposure film winding
● Beeper on
● Zero exposure compensation
● Multiple exposure function inoperative (on EOS 620)
● Automatic bracketing function inoperative (on EOS 620)
**Main Switch at A**—To use modes and settings other than standard, turn the Main Switch to A. All modes and functions can be used, except that the beeper is turned off.
**Beeper**—To turn on the beeper, rotate the Main Switch past A to the "sound wave" symbol. This is the A setting with the beeper turned on.
**Mode Reset**—In the A mode, a convenient way to return the camera to standard settings is to turn the Main Switch to the green rectangle and then back to A.

## FILM SPEED

Film speed can be set automatically or manually.
**With DX Film**—A row of electrical contacts in the camera film chamber reads the DX code on the cartridge. The encoded film speed is set automatically. While the film is being advanced to frame 1, the set film-speed value is displayed in the LCD panel. The film-speed setting can be changed, if you wish, by a manual procedure.
**Manual Procedure**—Set the Main Switch at A. Open the Switch Cover on the back of the camera. Press the yellow and blue buttons simultaneously and release. In the diagram on the back of the switch cover, these buttons are connected by an ISO symbol.

The LCD panel will show the set film speed for about eight seconds. During that time, rotate the Input Dial to change film speed to the desired value.

You can restore the normal display in the LCD panel by waiting for the eight seconds to expire, or by pressing the Shutter Button halfway, or by pressing the MODE button.
**With Non-DX Film**—If the film cartridge does not have a DX code, the camera retains the film-speed setting used with the preceding roll of film. That value blinks in the LCD Display Panel until you use the manual procedure—that is, press the yellow and blue buttons simultaneously. If the set film speed is incorrect, change it. If it is correct, don't change it.

If you don't use the manual procedure, the film-speed value will continue to blink in the LCD panel between exposures. The camera will operate.
**Film-Speed Range**—With DX-coded film, the range of film speeds that can be set is ISO 25 to 5000. With the manual procedure, film speeds from ISO 6 to 6400 can be used.

## SHUTTER SPEED

The EOS 650 shutter-speed range is 30 seconds to 1/2000 second. X-sync speed is 1/125 second.

## BULB SETTING

In this mode, the shutter remains open as long as you hold down the Shutter Button. The shutter can also be held open with remote control equipment, such as Remote Cord 60T3 plug-

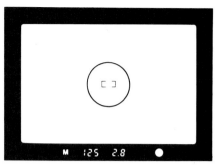

The EOS 620 and EOS 650 have the same viewfinder display.

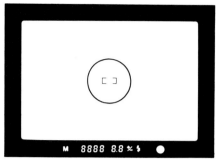

This shows the EOS viewfinder display with all components "turned on." Other numbers and characters are formed using sections of the figure 8.

ged into the Remote Control Terminal of Grip GR20. The autofocus system operates normally. The exposure meter does not operate.

**To Select**—In the Manual exposure mode, turn the Input Dial toward slower shutter speeds until the symbol buLb appears in the LCD panel and viewfinder display—in the area normally used to show shutter speed. The set aperture value is displayed to the right of the buLb symbol.

**Exposure Timer**—When the Shutter Button is pressed to begin the exposure, the three bars that normally represent film in the LCD panel disappear temporarily. In this mode, they are used as exposure-time markers, each representing 30 seconds.

The frame-counter area changes function and becomes an exposure timer, counting from 1 to 30 seconds. When the first 30 seconds have been counted, a single bar appears. The counter starts over at 1 second, which is actually 31 seconds.

When 60 seconds have elapsed, a second bar appears and the counter starts over. At 90 seconds, a third bar appears and the counter starts over. After 120 seconds, all bars disappear and the entire timing procedure repeats.

## CAMERA-SHAKE WARNING

As discussed in Chapter 2, the slowest shutter speed recommended for hand-holding is the reciprocal of the focal length being used. When the camera sets shutter speed automatically—except with flash—the turned-on beeper will warn you if the shutter speed is slower than the reciprocal of focal length.

If shutter speed is too slow, the beeper produces single beeps continuously until you turn off the beeper, change to a suitable shorter focal length, or adjust the camera to use an acceptable shutter speed. These beeps may intermingle with the *beep-beep* used to signal good focus, but it is easy to distinguish between them.

## VIEWFINDER

The viewfinder shows 94 percent of the actual image area, both horizontally and vertically. Viewfinder-image magnification is 0.8 with a 50mm lens focused at infinity. Objects in the scene appear 80 percent as tall as if you were viewing them directly.

**Apparent Image Distance**—The viewfinder optics have a power of −1 diopter, which causes the focusing-screen image to appear as though it were one meter distant.

**Eyepoint**—You can see the entire viewfinder image with your eye 19.3mm (3/4 inch) away from the eyepiece.

**Dioptric Adjustment Lens**—To adapt the viewfinder optics to match your eyesight or your eyeglass prescription, Dioptric Adjustment Lenses discussed in Chapter 3, are available.

**Interchangeable Focusing Screens**—Accessory focusing screens are available, as shown in the accompanying illustration. The interchanging procedure in shown in Chapter 3.

**Information Displays**—Information related to camera status, exposure and focus is shown below the image area in the viewfinder. See the accompanying illustration.

## VIEWING DEPTH OF FIELD

With the Main Switch at A, compose the scene, focus and prepare the camera to shoot. Press and hold the Depth-of-Field Check Button. Aperture will stop down to the value that will be used to make the exposure. Depth of field at that aperture can be observed in the viewfinder image.

If depth of field is not satisfactory, adjust the camera to select a different aperture size and check again. Releasing the Depth-of-Field Check Button before shooting is optional.

## METERING

EOS cameras have separate light sensors for ambient-light and flash exposure.

**Ambient-Light Sensor**—A segmented silicon photocell (SPC) in the viewfinder housing measures brightness of the focusing-screen image before the shutter opens to make an exposure. Turn on the meter by depressing the Shutter Button halfway.

**Metering Range**—The meter-coupling range is EV −1 to EV 20 with $f$-1.4 and ISO 100.

**Evaluative Metering**—The viewfinder SPC has six segments that obtain three measurements, as discussed in Chapter 5. These measurements are evaluated by a computer program stored in the camera. The resulting exposure setting includes exposure compensation, if needed.

**Partial Metering**—The center part of the segmented SPC in the viewfinder is

used alone to measure the center of the image, approximately 6.5 percent of the total area. The metered area is indicated by a circle on the focusing screen, surrounding the AF Frame. The meter reading receives no special processing or evaluation.

Partial metering is useful for substitute metering and for situations beyond the capability of the evaluative metering system. It cannot be used with the Main Switch set to the green rectangle.

To use partial metering, first turn on the metering system by pressing the Shutter Button halfway. It will meter immediately using the evaluative method. Then press the Partial Metering Button with your right thumb. The metering pattern changes and a partial reading is taken.

**Exposure Lock**—A partial reading is locked when made—indicated by an asterisk in the viewfinder display. It will remain locked as long as you depress the Partial Metering Button. If you hold the Shutter Button depressed halfway, you can release the Partial Metering Button and exposure will remain locked until you release the Shutter Button.

**TTL Flash Metering**—When a Canon EZ flash is used, an SPC in the bottom of the mirror box measures both ambient and flash light at the surface of the film, during the exposure. The metering pattern is center-weighted. When sufficient light for correct exposure has been measured, the camera turns off the flash, as discussed in Chapter 8.

## EXPOSURE COMPENSATION

Exposure compensation can be set from −5 to +5 steps, in half-step increments. In the camera, the effect of exposure compensation is the same as changing film speed.

**All EOS models use the same interchangeable focusing screens.**

## EOS INTERCHANGEABLE FOCUSING SCREENS TYPE E

**Type E-A, Microprism.** Matte (frosted) surface with microprism optical focusing aid at center. Circle is partial-metering zone, discussed in Chapter 5. This screen is suitable for general photography. Microprism focusing aid may black out at apertures smaller than *f*-5.6.

**Type E-B, New Split.** Matte surface with new type biprism (split-image) optical focusing aid at center, surrounded by partial-metering circle. Suitable for all lenses. Optical focusing aid not useful at apertures smaller than *f*-5.6 but does not black out.

**Type E-C, Overall New Laser Matte/AF Frame.** Standard factory-installed screen for EOS cameras. Matte surface with AF frame and partial-metering circle at center. Useful with all lenses.

**Type E-D, Laser/Matte Section.** Matte surface with grid lines. Useful for architectural photography and to assist image placement within frame.

**Type E-H, Laser Matte/Scale.** Matte surface with vertical and horizontal scales marked in millimeters, plus partial-metering circle. Useful in high-magnification photography.

**Type E-I, Laser Matte/Double-Cross-Hair Reticle.** Matte Surface except clear within partial-metering circle. Reticle (cross) in center formed by double lines. Precise focus can be checked by moving your eye slightly while observing position of reticle on subject. If cross-hairs don't move in relation to subject, image is in focus. Useful in high-magnification and astrophotography.

**Type E-L, Cross Split-Image.** Matte surface with combined horizontal and vertical biprism inside partial-metering circle. Biprisms split image both vertically and horizontally when image is out of focus. Optical focusing aid not useful at apertures smaller than *f*-5.6.

In any automatic-exposure mode, exposure will increase or decrease by the amount of exposure compensation being used. On manual exposure, the meter reading will increase or decrease, but actual exposure is controlled manually.

To use exposure compensation, press the EXP.COMP button. The LCD display shows the amount of compensation with a plus/minus symbol. Turn the Input Dial to change the displayed compensation to the desired value. Release the EXP.COMP button.

**Exposure-Compensation Warning Symbol**—When exposure compensation is not zero, a plus/minus symbol appears as a reminder in the viewfinder display and the LCD Display Panel.

### EOS 650 DEPTH-OF-FIELD AE MODE

This mode allows you to set depth of field by "showing" the camera the desired near and far limits of good focus. This mode is not available with an EOS 620 camera.

**Procedure**—Press the MODE button while turning the Input Dial to display the symbol DEPTH in the LCD panel. Compose the scene, setting focal length if you're using a zoom lens.

Place the AF frame over an object at the near limit. Press the Shutter Button halfway. The symbol dEP 1 appears in the viewfinder and LCD panel. When the In-Focus Indicator glows, that distance has been memorized by the camera.

Place the AF frame over an object at the far limit. Press the Shutter Button halfway. The symbol dEP 2 appears in the viewfinder and LCD panel. When the In-Focus Indicator glows, that distance has been memorized by the camera.

The camera calculates an aperture and focused distance that will provide the desired depth of field, if possible.

Recompose the scene as you planned to shoot it. Press the Shutter Button halfway. The camera measures exposure and chooses a shutter speed to provide correct exposure with the calculated aperture. Both shutter speed and aperture are displayed. The camera changes focus to the calculated distance and turns on the In-Focus Indicator to assure you that everything is OK. Press the Shutter Button fully to make the shot.

**Warnings**—Because the camera sets both shutter speed and aperture, both blink simultaneously as exposure warnings, the same as in the Program mode.

If the desired depth of field cannot be provided, even at the smallest aperture, the smallest aperture value on the lens will blink. If you shoot anyway, exposure will be OK and depth of field will be as extensive as possible.

**To Reset**—If you are partway into the procedure and wish to start over, press the MODE button.

### FLASH

Canon EZ flash units, such as Speedlite 300EZ, are preferred and have more automatic features with EOS cameras than earlier models of Canon flash. EZ flash units have a built-in AF Auxiliary Light Emitter that is triggered automatically in dim light to assist autofocus.

EZ flash units balance the ambient light with light from the flash to provide automatic flash fill in daylight. Operating modes are: ATTL autoflash, TTL autoflash and Manual flash, as discussed in Chapter 8.

**Other Flash Units**—Earlier Canon A-series, G-series and T-series flash units can be used with the EOS camera on Manual. The flash may be on automatic or manual. Set shutter speed to X-sync or slower. If a faster speed is set, the camera will change it to X-sync. Set aperture by reference to the flash control panel or the flash manual.

Speedlite 300TL can be used in the TTL automatic mode with exposure control by the TTL light sensor in the EOS camera. The 300TL mode selection may be either ATTL or FEL.

Canon 277T and 299T Speedlites

After preparing the camera to shoot, pressing the Depth-of-Field Check Button (arrow) stops down the lens to shooting aperture so you can see depth of field in the viewfinder. The lower button, labeled M, is the Manual Aperture-Set Button.

can be used on "light sensing" automatic with exposure controlled by a light sensor on the flash body. The mode selector should be at F.NO.SET. These flash units can also be used on manual with guide-number exposure control.

The 244T was designed only for the T50 camera and cannot be used with EOS cameras.

G-series and A-series Speedlites can be used on automatic with exposure controlled by a light sensor on the flash body or manual with guide-number exposure control.

### MALFUNCTION WARNING

If a blinking bc symbol appears in the LCD panel and the battery-check bars blink, the battery may be discharged, the battery contacts may be dirty, or the camera may have malfunctioned.

To test for dirty contacts, remove the battery and wipe the contacts with a

# EOS 650 SPECIFICATIONS

**Type:** 35mm SLR with automatic focus, automatic exposure, and built-in motor drive.

**Lenses:** Canon EF lenses.

**Lens Mount:** Canon EF mount.

**Viewfinder:** Fixed eye-level pentaprism. Shows 94 percent of image, vertically and horizontally. Magnification is 0.8 with 50mm lens focused at infinity. Dioptric power is 1. Eyepoint (viewing distance) is 19.3mm, approx. 3/4 inch.

**Focusing Screen:** Interchangeable. Standard screen is New Laser-Matte type with AF frame at center.

**Viewfinder Displays:** Shutter speed, aperture, in-focus indicator, metered-manual exposure indication, AE lock symbol, flash-charge symbol, exposure-compensation symbol, depth-of-field AE indicators.

**LCD Display Panel:** Shows camera status and exposure data.

**Depth-of-Field Check Button:** Stops down lens to allow viewing depth of field at shooting aperture.

**Ambient-Light Exposure Metering:** TTL full-aperture metering using segmented silicon photocell (SPC) in viewfinder housing. Evaluative metering provides automatic compensation for centered subject in non-average scene. Partial metering measures central 6.5 percent of image area without automatic compensation. Stopped-down metering not possible.

**Flash Metering:** SPC in mirror box measures light on film during flash exposure. In ATTL flash mode, light from flash balanced with ambient light using both sensors.

**Metering Range:** EV 1 to EV 20 with 50mm $f$-1.4 and ISO 100.

**Exposure Modes:** Shutter-priority AE, aperture-priority AE, intelligent program AE, flash AE, depth-of-field AE, manual.

**Beeper:** Can be switched on or off. Used to signal good focus or provide camera-shake warning.

**Camera-Shake Warning:** If camera sets shutter speed automatically, except in flash mode, beeper warns if shutter speed is slower than reciprocal of focal length.

**Film-Speed:** With DX film cartridge, film speed is set automatically over range of ISO 25 to 5000. Manual procedure can be used to set ISO 6 to 6400.

**Exposure Compensation:** Plus or minus 5 steps in half-step increments.

**Multiple Exposures:** Not possible.

**Autofocus System:** Turned on by depressing Shutter Button halfway. Uses Canon BASIS sensor. Beeper, if turned on, indicates good focus. AF In-Focus Indicator glows steadily to indicate good focus; blinks in either AF mode if autofocus not possible.

**Focus Modes:** In One-Shot AF mode, focus locks when found. In any AE mode, exposure locks when focus locks. Exposure cannot be made unless image is in focus.

In Servo AF mode, focus is continuously adjusted. An exposure can be made at any time, whether or not the image is in focus. In any AE mode, exposure locks when Shutter Button is fully depressed.

In Manual focus mode, lens must be focused manually. Electronic focus detector continues to operate AF In-Focus Indicator in viewfinder to provide focus confirmation. Beeper operates, if turned on.

**AF Operating Range:** EV 1 to EV 18 at ISO 100.

**AF Auxiliary Light:** Built into EZ-type flash units, triggered automatically when needed by AF system in camera.

**Shutter:** Vertical-travel focal-plane shutter, electronically controlled.

**Shutter-Speed Range:** 30 to 1/2000 second. Stepless on automatic exposure. Manually set in half-step increments. X-sync speed is 1/125 second.

**Self-Timer:** 10 second delay accompanied by blinking red Self-Timer Lamp on front of camera.

**Film-Loading:** Automatic, using built-in motor.

**Film-Winding:** Two selectable modes. Single-exposure or continuous at maximum rate of 3 frames per second.

**Film-Rewind:** Automatic at end of roll, using built-in motor. Mid-roll rewind provided by pushbutton.

**Grip:** Interchangeable.

**Back Cover:** Interchangeable.

**Battery:** One 6V lithium, 2CR5 or equivalent.

**Battery-Check Button:** Indicates battery condition by display in LCD Panel.

**Dimensions:** 148 x 108 x 67.5 mm (5.8 x 4.25 x 2.6 in.)

**Weight:** 660g (23.3 oz.), body only.

---

clean, dry cloth. Replace the battery and operate the shutter. If the blinking bc remains, try a new battery or one that is in good condition. Remove and replace the battery several times. Operate the shutter one time. If the blinking bc remains, have the camera checked at a Canon service facility.

## MAJOR ACCESSORIES

EOS 650 cameras use EF lenses, EZ and earlier Canon flash units, interchangeable E-type focusing screens, interchangeable E-type camera backs, S-type or E-type Dioptric Adjustment Lenses, Angle Finder A2 or B, Magnifier S, Canon PL-C Circular Polarizing Filters and other general-purpose filters, interchangeable hand grips GR10, GR20 and GR30, and remote-control equipment if Grip GR20 is installed.

## EOS 620 CONTROLS

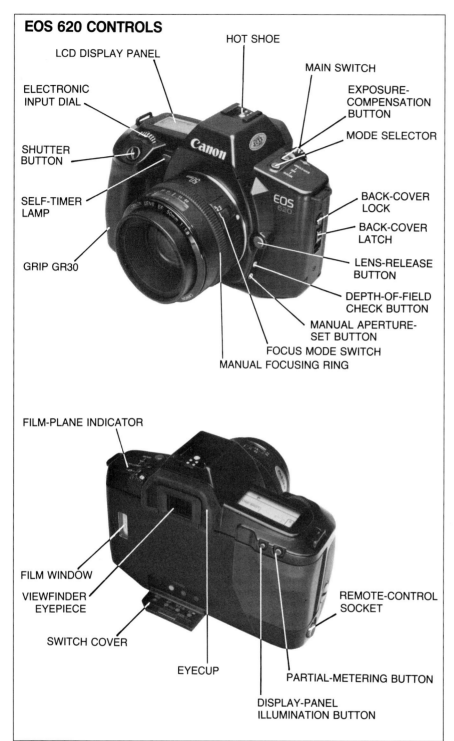

LCD DISPLAY PANEL

HOT SHOE

MAIN SWITCH

ELECTRONIC INPUT DIAL

EXPOSURE-COMPENSATION BUTTON

MODE SELECTOR

SHUTTER BUTTON

SELF-TIMER LAMP

BACK-COVER LOCK

BACK-COVER LATCH

LENS-RELEASE BUTTON

GRIP GR30

DEPTH-OF-FIELD CHECK BUTTON

MANUAL APERTURE-SET BUTTON

FOCUS MODE SWITCH

MANUAL FOCUSING RING

FILM-PLANE INDICATOR

FILM WINDOW

VIEWFINDER EYEPIECE

REMOTE-CONTROL SOCKET

SWITCH COVER

EYECUP

PARTIAL-METERING BUTTON

DISPLAY-PANEL ILLUMINATION BUTTON

## EOS 620 CAMERA

The preceding section is a complete discussion of the EOS 650. This section includes only features of the EOS 620 that are not available on the 650.

For full details on the EOS 620, I suggest that you read the EOS 650 discussion first, then this section. For reference, a table at the beginning of this chapter lists the differences between the EOS 620 and 650.

### EOS 620 SHUTTER SPEEDS

The fastest EOS 620 shutter speed is 1/4000 second.

X-sync speed for the EOS 620 is 1/250 second.

In the ATTL flash mode, with the camera on Program automatic, shutter speed is set automatically for EZ flash units. The *slowest* speed used by the ATTL program with the camera on P is 1/60 second. Therefore, the range of shutter speeds that can be used with the EOS 620 on ATTL Program flash is 1/60 to 1/250 second.

### EOS 620 PROGRAM SHIFT

With an EOS 620 in the Program automatic-exposure mode, you can change shutter speed and aperture value simultaneously by rotating the Input Dial. The purpose is to use a shutter speed or aperture that is different from the one selected by the program.

The exposure value is maintained. If you turn the Input Dial to select a faster shutter speed, aperture size is automatically increased. If you select smaller aperture, a slower shutter speed is used.

### EOS 620 AUTO-EXPOSURE BRACKETING

You can set an EOS 620 to make a sequence of three bracketed exposures with a single operation of the Shutter Button, using a preset exposure difference between frames. Automatic Exposure Bracketing (AEB) can be used in any automatic-exposure mode, or on manual exposure—but not at the buLb

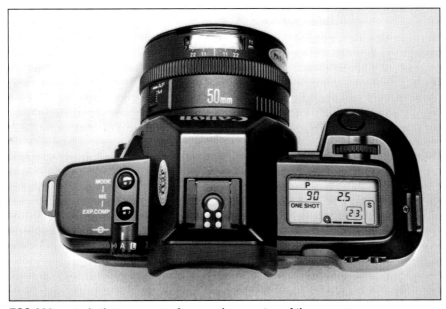

EOS 620 controls that are most often used are on top of the camera.

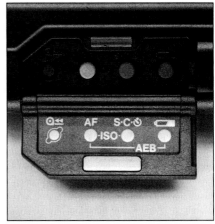

Control buttons that are not often used are behind the Switch Cover on the back of the camera. From left-to right, they are: Midroll Rewind button, AF Mode select button, Film-Winding Mode select button, Battery-Check button. Counting from the left, pressing buttons 2 and 3 simultaneously displays the set film speed and allows you to change it if desired. Pressing buttons 2 and 4 simultaneously selects Automatic Exposure Bracketing.

setting and not with electronic flash.

**To Select AEB**—Set the Main Switch to A. Open the Switch Cover and simultaneously press the AF button and the Battery-Check Button. These buttons are connected by a line and the symbol AEB.

**To Set Up**—The LCD display will show the value 0.0 and an AEB symbol. You have eight seconds to select the exposure change between frames (bracket value, in exposure steps) that will be used. Turn the Input Dial to change the displayed 0.0 to the desired bracket value, such as 0.5.

**Operation**—Press the Shutter Button halfway. A meter reading is taken that becomes the *reference exposure*. When you press the Shutter Button fully, focus is locked, reference exposure is locked, and a sequence of three exposures is made—even in the single-exposure film-winding mode. They will be bracketed with increasing exposure, in this manner:

Frame 1 is reference exposure minus bracket value.

Frame 2 is reference exposure.

Frame 3 is reference exposure plus bracket value.

Notice that this bracket pattern is centered on metered exposure.

**With Exposure Compensation**—If exposure compensation is used, it changes the reference exposure by the amount of compensation.

**To Cancel**—Before pressing the Shutter Button, you can cancel automatic bracketing by setting the bracket value to 0.0 again. Bracketing cannot be canceled once the sequence begins—unless the camera runs out of film. If that happens, the remainder of the sequence is canceled.

**To Repeat**—After each bracketed sequence, the camera returns to normal operation. To bracket again, you must perform the setup procedure again.

## EOS 620 MULTIPLE EXPOSURES

Up to nine multiple exposures on the same frame can be preset with the EOS 620. Either the single-exposure or continuous-exposure winding mode

can be used. Focus and exposure are set in the usual way, depending on the modes selected. The exposure-compensation control can be used as discussed in Chapter 5.

**To Select**—Press and hold down the MODE and EXP.COMP buttons simultaneously. On the EOS 620, these buttons are connected by a line with the symbol ME (Multiple Exposures).

**To Set Up**—The LCD panel will show an ME symbol and the value 1 in the area normally used as a frame counter. Rotate the Input Dial so the value changes to the desired number of multiple exposures, such as 3. Release the MODE and EXP.COMP buttons. The ME symbol remains in the LCD panel.

**Operation**—Press the Shutter Button fully to make the exposures. After the first exposure, the ME symbol blinks as a reminder that multiple exposures are preset and still to be made.

When the last exposure has been made, film is advanced to the next frame, the ME symbol disappears, and the camera reverts to normal operation.

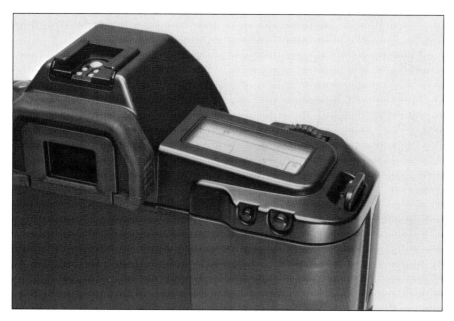

These two buttons, on the back of the EOS 620, are convenient to press with your right thumb. The left, smaller button illuminates the LCD Display Panel in dim light. The right, larger button selects partial-area metering.

**Exposure Counter**—The preset number of exposures in the LCD panel counts down to show the remaining number of exposures to be made. When the value is 1, there is one more exposure to make.

**Cancel or Change**—To cancel before the first exposure, reset the number of exposures to 1. To terminate after making some of the planned exposures, reset the number of exposures to 0, which is a blank display.

To change the number of exposures after beginning the sequence, reset the number. The total will be the exposures already made plus the new value in the display. For example, if you start at 7 and count down to 5, two exposures have been made. If you then reset to 9, a total of 11 exposures will result. If you reset to 1, a total of three exposures will result.

## INTERCHANGEABLE GRIPS

There are three interchangeable grips that can be used on EOS cameras.
**Grip GR20**—Standard with the EOS 620, this grip has a built-in Remote Control Terminal for use with remote-control equipment.
**Grip GR30**—Standard with the EOS 650, this grip is the same size as GR20 but has no Remote Control Terminal.
**Grip GR10**—This is a larger grip, convenient for people with large hands. There is no Remote Control Terminal.

## EOS 620 LCD PANEL ILLUMINATOR

An LCD display does not glow. In dim light, illumination is necessary to read the display. The EOS 620 has built-in illumination. With the Main Switch turned on, pressing the Display Panel Illumination Button on the back of the camera causes the entire panel to glow so it can be read in the dark. It will continue to glow for eight seconds after you release the button.

The light is produced by *electroluminescence* (EL), similar to the light from a glowworm or firefly. The light is called an EL Illuminator.

## MODIFICATIONS

At a Canon service center, the EOS 620 can be modified to prevent automatic rewind at the end of the roll. The camera will then not rewind unless you press the Rewind Button. The EOS 620 can also be modified so it leaves the film end extending from the cartridge when rewind has been completed, rather than drawing it inside.

## MAJOR ACCESSORIES

EOS 620 cameras use EF lenses, EZ and earlier Canon flash units, interchangeable E-type focusing screens, interchangeable E-type camera backs, S-type or E-type Dioptric Adjustment Lenses, Angle Finder A2 or B, Magnifier S, Canon PL-C Circular Polarizing Filters and other general-purpose filters, interchangeable hand grips GR10, GR20 and GR30, and remote-control equipment, if Grip GR20 is installed.

# EOS 620 SPECIFICATIONS

**Type:** 35mm SLR with automatic focus, automatic exposure, and built-in motor drive.

**Lenses:** Canon EF lenses.

**Lens Mount:** Canon EF mount.

**Viewfinder:** Fixed eye-level pentaprism. Shows 94 percent of image, vertically and horizontally. Magnification is 0.8 with 50mm lens focused at infinity. Dioptric power is 1. Eyepoint (viewing distance) is 19.3mm, approx. 3/4 inch.

**Focusing Screen:** Interchangeable. Standard screen is New Laser-Matte type with AF Frame at center.

**Viewfinder Displays:** Shutter speed, aperture, in-focus indicator, metered-manual exposure indication, AE lock symbol, flash-charge symbol, exposure-compensation symbol.

**LCD Display Panel:** Shows camera status and exposure data.

**LCD Panel Illuminator:** Turned on for 8 seconds by pressing Illuminator Button.

**Depth-of-Field Check Button:** Stops down lens to allow viewing depth of field at shooting aperture.

**Ambient-Light Exposure Metering:** TTL full-aperture metering, using segmented silicon photocell (SPC) in viewfinder housing. Evaluative metering provides automatic compensation for centered subject in non-average scene. Partial metering measures central 6.5 percent of image area without automatic compensation. Stopped-down metering not possible.

**Flash Metering:** SPC in mirror box measures light on film during flash exposure. In ATTL flash mode, light from flash balanced with ambient light using both sensors.

**Metering Range:** EV 1 to EV 20 with 50mm $f$-1.4 and ISO 100.

**Exposure Modes:** Shutter-priority AE, aperture-priority AE, intelligent program AE, program shift, flash AE, manual.

**Beeper:** Can be switched on or off. Used to signal good focus or provide camera-shake warning.

**Camera-Shake Warning:** If camera sets shutter speed automatically, except in flash mode, beeper warns if shutter speed is slower than reciprocal of focal length.

**Film-Speed:** With DX film cartridge, film speed is set automatically over range of ISO 25 to 5000. Manual procedure can be used to set ISO 6 to 6400.

**Exposure Compensation:** Plus or minus 5 steps in half-step increments.

**Automatic Exposure Bracketing:** Three frames exposed in sequence with bracket interval of plus or minus 5 steps, selectable in half-step increments.

**Multiple Exposures:** Up to 9 exposures can be preset.

**Autofocus System:** Turned on by depressing Shutter Button halfway. Uses Canon BASIS sensor. Beeper, if turned on, indicates good focus. AF In-Focus Indicator glows steadily to indicate good focus. Blinks in either AF mode if autofocus not possible.

**Focus Modes:** In One-Shot AF mode, focus locks when found. In any AE mode, exposure locks when focus locks. Exposure cannot be made unless image is in focus.

In Servo AF mode, focus is continuously adjusted. An exposure can be made at any time, whether or not the image is in focus. In any AE mode, exposure locks when Shutter Button is fully depressed.

In Manual focus mode, lens is focused manually. Electronic focus detector continues to operate AF In-Focus Indicator in viewfinder to provide focus confirmation. Beeper operates, if turned on.

**AF Operating Range:** EV 1 to EV 18 at ISO 100.

**AF Auxiliary Light:** Built into EZ-type flashes, triggered automatically when needed by AF system in camera.

**Shutter:** Vertical-travel focal-plane shutter, electronically controlled.

**Shutter-Speed Range:** 30 to 1/4000 second. Stepless on automatic exposure. Manually set in half-step increments. X-sync speed is 1/250 second.

**Self-Timer:** 10 second delay accompanied by blinking red Self-Timer Lamp on front of camera.

**Film-Loading:** Automatic, using built-in motor.

**Film-Winding:** Two selectable modes. Single-exposure or continuous at maximum rate of 3 frames per second.

**Film-Rewind:** Automatic at end of roll, using built-in motor. Mid-roll rewind provided by pushbutton.

**Grip:** Interchangeable.

**Back Cover:** Interchangeable.

**Battery:** One 6V lithium, 2CR5 or equivalent.

**Battery-Check Button:** Indicates battery condition by display in LCD Panel.

**Dimensions:** 148 x 108 x 67.5 mm
(5.8 x 4.25 x 2.6 in.)

**Weight:** 700g (24.7 oz.), body only.

## EOS 750, 750 QD AND 850 CAMERAS

These three cameras are the same except for two features. EOS 850 is the basic model. EOS 750 is an 850 with a built-in flash and Flash Switch added. EOS 750 QD is an EOS 750 with a Quartz Date Back added. The camera shown here is an EOS 750 QD.

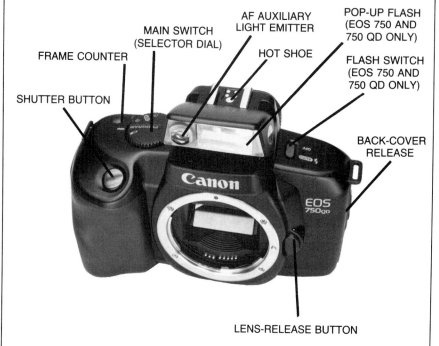

FRAME COUNTER

SHUTTER BUTTON

MAIN SWITCH (SELECTOR DIAL)

AF AUXILIARY LIGHT EMITTER

HOT SHOE

POP-UP FLASH (EOS 750 AND 750 QD ONLY)

FLASH SWITCH (EOS 750 AND 750 QD ONLY)

BACK-COVER RELEASE

LENS-RELEASE BUTTON

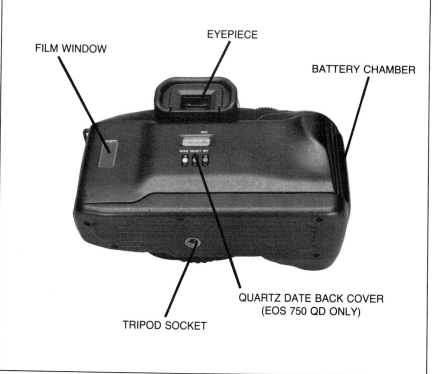

FILM WINDOW

EYEPIECE

BATTERY CHAMBER

TRIPOD SOCKET

QUARTZ DATE BACK COVER (EOS 750 QD ONLY)

# EOS 750, 750 QD AND 850

These cameras are basically the same. The EOS 750 is an 850 with a built-in pop-up flash added. The EOS 750 QD is a 750 with a permanently installed date back added. The following discussion applies to all three camera models. When a feature is discussed that is not common to all three models, it will be clear which model has the feature.

These easy-to-use cameras, with simplified controls, share the electronic systems, accessories, and many features of the more sophisticated EOS 620/650 models.

### LENSES

All EF lenses can be used. For users who desire maximum simplicity of operation, A-type lenses are suggested—such as the EF Zoom 35—70mm *f*-3.5—4.5A. These lenses don't have a Manual Focusing Ring, Focused-Distance Scale or Focus-Mode Switch. They are always set for autofocus operation.

### POWER

A 6-volt lithium 2CR5 battery is used.

### MAIN SWITCH

Also referred to as the Selector Dial, this control has five positions:
- At the Battery Symbol, battery power is checked, as described later.
- At PROGRAM, the camera is turned on and will set exposure using the built-in Intelligent Program.
- At L, the camera is turned off.
- At DEP, the camera is turned on and the automatic Depth-of-Field mode selected.
- At the Clock-Face symbol, the camera is turned on and the Self-Timer is set.

### SHUTTER BUTTON

When the camera is turned on, pressing the Shutter Button halfway turns on the camera electronics and viewfinder

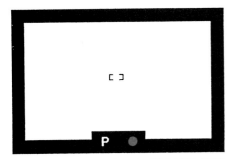

The viewfinder displays in EOS 750, EOS 750 QD and EOS 850 cameras are simple and easy to understand. The exposure symbol P glows steadily when exposure is OK. It blinks slowly if exposure is OK but shutter speed will be slow enough to require firm camera support. It blinks rapidly if exposure will not be OK. The green-dot In-Focus Indicator glows steadily when the image is in focus. If focus cannot be confirmed electronically, the dot blinks rapidly. It also blinks to guide you through the automatic depth-of-field procedure.

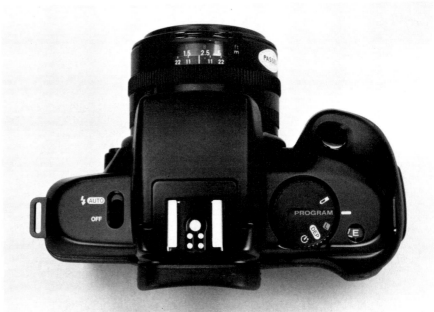

Most EOS 750/850 controls are on the camera top panel. All models have a Main Switch, Frame Counter and Shutter Button. The EOS 750 has a built-in pop-up flash and Flash Switch, shown here. The EOS 750 QD has three pushbutton controls and an LCD Display on the Quartz Date Back cover.

display. The autofocus and programmed automatic-exposure system both function. Press the Shutter Button fully to make an exposure.

## LOADING FILM

Film loading is automatic, as described in Chapter 4. The entire roll is immediately wound onto the takeup spool. As exposures are made, film is drawn back into the cartridge, which protects exposures if the camera back is accidentally opened.

## FILM-LOAD WARNING

If film is incorrectly loaded, the camera will not operate, the beeper sounds for four seconds, and the Frame Counter shows an E symbol.

## FRAME COUNTER

The frame counter starts at the highest frame number on the roll and counts down, always showing the number of frames *remaining to be exposed*.

## FILM WINDOW

A window in the camera back allows you to read the small label on a film cartridge that states film type, film speed and number of exposures on the roll.

## FILM SPEED

With DX-coded film cartridges, film speed in the range of ISO 25 to 3200 is set automatically to the nearest full step. Most films are rated at a full step, such as ISO 100, 200 or 400. If not, the camera setting may be 1/3 step greater or less than the encoded value on the film cartridge.

This small difference in film speed is not significant when using negative film. With color slide film, a small amount of underexposure is usually better than overexposure.

With non-DX film, the automatic setting is ISO 25. There is no manual procedure to set film speed and no electronic display of the set value.

## FILM-ADVANCE MODES

When the camera is set to PROGRAM or Self-Timer, a continuous sequence of exposures will be made as long as you depress the Shutter Button. In the DEP mode, only a single exposure is made.

## FOCUS MODES

Manual focus or autofocus is selected by a Focus-Mode Switch on EF lenses, except those of the A type.

## FOCUS AND EXPOSURE LOCK

When autofocus is being used, focus is locked when found. Exposure is set and locked when focus is locked. Both remain locked until you make the exposure or release the Shutter Button. You can recompose before shooting, if you wish.

If you hold down the shutter button to make a continuous sequence of exposures, the camera refocuses between frames and resets exposure for each

# EOS 750, 750 QD AND 850 SPECIFICATIONS

**Type:** 35mm autofocus SLR with programmed automatic exposure, automatic depth-of-field control and built-in motor drive. EOS 750 also has built-in flash with AF Auxiliary Light. EOS 750 QD has built-in flash and also Quartz Date Back.

**Lenses:** Canon EF lenses only.

**Viewfinder:** Fixed eyelevel pentaprism. 92 percent vertical and horizontal coverage of image. Magnification is 0.8 with 50mm lens at infinity. Eyepoint is 16mm (0.62 inch).

**Focusing Screen:** Fixed, New Laser-Matte, with AF Frame.

**Viewfinder Displays:** Focus indicator. Exposure indicator, which also provides flash-charge indication and slow-shutter-speed warning.

**Metering:** With ambient light, SPC in viewfinder housing provides Evaluative Metering. With flash, SPC in mirror box measures light at film surface, using center-weighted pattern.

**Metering Range:** Ambient-light EV 0 to EV 20 with $f$-1.4 and ISO 100. At high temperature and humidity, EV 3 to EV 20.

**Film Loading:** Automatic. Entire roll is pre-wound onto takeup spool and then drawn back into cartridge as exposures are made.

**Frame Counter:** Starts at highest frame number, such as 36, and counts down to show remaining frames to be exposed.

**Film Speed:** Set automatically with DX cartridges to nearest full step in the range of ISO 25 to ISO 3200. With non-DX film, set to ISO 25. No manual film-speed control.

**Film Drive:** Continuous by built-in motor as long as Shutter Button is depressed.

**Autofocus Sensor:** BASIS phase-detection type.

**AF Range:** EV 1 to EV 18.

**Focus Modes:** One-Shot automatic or Manual with EF lens, except A-type lens.

**Focus and AE Lock:** For single shot, focus locked when found, exposure locked when focus locked. For continuous exposures, focus and exposure reset for each frame.

**AF Auxiliary Light:** Built into EOS 750 and EOS 750 QD. Range 1 to 4 meters (3.3 to 13 feet).

**Shutter:** Focal plane. Range is 1/2000 to 2 seconds, set automatically. X-sync speed is 1/125 second.

**Self-Timer:** Ten-second delay with audible beeper. Can be canceled.

**Power Source:** One 6-volt lithium 2CR5 in camera battery chamber. Also supplies power to built-in flash of EOS 750 and EOS 750 QD.

**Battery Check:** Setting of Main Switch; condition indicated by beeper rate.

**Quartz Date Back:** Built into EOS 750 QD.

**Dimensions:**
  EOS 750: 149x102x70mm (5.9x4.1x2.8 in.).
  EOS 750 QD: 149x102x71mm (5.9x4.1x2.8 in.).
  EOS 850: 149x97x70mm (5.9x3.8x2.8 in.).

**Weight without battery:**
  EOS 750: 620g (21.8 oz).
  EOS 750 QD: 635g (22.2 oz).
  EOS 850: 560g (19.8 oz).

consecutive frame.

With Manual focus, exposure is locked when the Shutter Button is depressed halfway. If you hold down the shutter button to make a continuous sequence of exposures, the camera resets exposure for each frame.

## EXPOSURE METERING

Evaluative metering is always used, as described in Chapter 5. This provides automatic exposure compensation for non-average scenes.

## EXPOSURE MODES

The following four exposure modes are available:
● PROGRAM, using the Intelligent Program AE (Automatic Exposure) shown in Chapter 5, is normally used.
● The DEP mode uses a special Depth-of-Field AE program that sets aperture for the desired depth of field and then sets shutter speed for correct exposure at that aperture.
● With the built-in flash of the EOS 750 and 750 QD, or with Speedlite 160E on any of these models, exposure is controlled by TTL Program Flash AE which provides automatic fill flash of backlit subjects and automatic flash with dim scene illumination.
● With an EZ flash unit such as the 300EZ, ATTL (Advanced TTL) Program Flash AE is provided, as described in Chapter 8.

## SHUTTER SPEEDS

The range of shutter speeds is 1/2000 to 2 seconds. Shutter speed is set automatically in increments of 1/8 step. X-sync speed is 1/125 second. There is no manual control of shutter speed.

## SLOW SHUTTER-SPEED WARNING

If the automatically set shutter speed is too slow for handholding the camera, the viewfinder P symbol blinks slowly to suggest firm camera support.

## EXPOSURE WARNINGS

If the scene is too dark or bright for good exposure, the P symbol in the viewfinder blinks rapidly. If the scene is too dark, use flash. If it is too bright, use a Neutral-Density filter on the lens.

## DISPLAYS

There are only two symbols in the viewfinder. See the accompanying illustration.

## SELF-TIMER

To set, turn the Main Switch to the Clock-Face symbol. Put the camera on a tripod or other firm support and prepare it to shoot. Press the Shutter Button fully. The exposure will be made after 10 seconds. If the lens is being focused automatically, the timer will not start unless the image is in focus.

If your eye will not be at the viewfinder eyepiece when you press the Shutter Button, cover the eyepiece with the Eyepiece Cover that is stored on the shoulder pad of the camera strap.

The beeper will beep slowly for the first eight seconds and rapidly during the last two seconds of the countdown.

To cancel the Self-Timer before an exposure is made, turn the Main Switch to any other setting.

## BEEPER

The built-in beeper cannot be turned off. Its functions are:
● To signal good focus.
● To signal Self-Timer countdown.
● To indicate steps in the Depth-of-Field procedure.
● To check the battery.
● To signal incorrect film loading.

## DEPTH OF FIELD MODE

Set the Main Switch to DEP. The camera will expose only a single frame when you press the Shutter Button. Flash cannot be used.

**Step 1**—Place the AF Frame over the nearest object to be in sharp focus. Press the Shutter Button halfway. The P symbol will not appear in the viewfinder. When focus is found, the beeper makes one quick "beep-beep" and the green In-Focus Indicator blinks slowly.

Release the Shutter Button. If you don't press the Shutter Button again within 10 seconds, the viewfinder display turns off and you must start again.

**Step 2**—Place the AF Frame over the farthest object to be in sharp focus. Press the Shutter Button halfway. The P symbol will not appear. When focus is found, the beeper makes two quick "beep-beeps" and the green In-Focus Indicator blinks rapidly.

Release the Shutter Button. If you don't press the Shutter Button again within 10 seconds, the viewfinder display turns off and you must start again at Step 1.

**Step 3**—Compose the scene as you intend to shoot it and press the Shutter Button halfway. To provide the desired depth of field, the camera focuses the lens at a calculated distance between the two objects, whether or not there is an important subject at that location.

The camera sets aperture at a calculated value that will provide the desired depth of field, if possible. It sets shutter speed according to the metered scene brightness, to give correct exposure at the set aperture.

If exposure is OK, the P symbol glows steadily. If exposure is OK but shutter speed is too slow for handholding the camera, the P symbol blinks to suggest using a camera support.

If the desired depth of field can be provided, the green In-Focus Indicator glows steadily. If the desired depth of field *cannot* be provided, the In-Focus Indicator blinks. Depth of field will be as great as possible. Exposure will be OK. Press the Shutter Button fully to make the exposure.

**To Cancel**—During the set-up procedure, you can cancel by releasing the Shutter Button for 10 seconds or by moving the Main Switch to any other setting, such as L.

**Doing It Backwards**—You can designate the distant object first, if you have a reason to do so.

**Lens on "M"**—The Depth mode will

not function. The camera sets exposure automatically and will make continuous exposures. Focus is manual.

**Minimum Depth**—To obtain *minimum* depth of field, focus on the *same* object at both Step 1 and Step 2.

## EOS 750 AND 750 QD FLASH

The EOS 750 and 750 QD have a built-in flash and a Flash Switch labeled AUTO-OFF. When set to AUTO, the camera will fire the flash when needed, as discussed in Chapter 8. The flash pops up and retracts automatically. Speedlite 160E can be used instead and operates in essentially the same way. EZ flash units can be used with ATTL operation, as described in Chapter 8.

## EOS 850 FLASH

The EOS 850 does not have a built-in flash or Flash Switch. It can use Speedlite 160E. The camera will fire the flash when it is needed. EZ flash units can be used with ATTL operation. See Chapter 8.

## AF AUXILIARY LIGHT EMITTER

The built-in flash of the EOS 750 and 750 QD has an AF Auxiliary Light that is triggered automatically by the camera when needed—when the flash is popped up. The camera pops up the flash when the scene is in dim light or the subject is backlit. Operating range is 1.0 to 4.0 meters (3.3 to 13.1 feet).

EZ flash units can be used on the EOS 750, 750 QD and 850 and will provide an AF Auxiliary Light when it is needed.

## BATTERY CHECK

Turn the Main Switch to the Battery Symbol. If the beeper sounds rapidly (eight beeps per second) the battery is OK. If it beeps two times per second, the battery is nearing discharge. If it doesn't beep at all, the battery is dead. Replace it.

**If the Battery Fails**—All camera functions depend on battery charge. If the battery fails during some operation,

The built-in Quartz Date Back of the EOS 750 QD has three pushbutton controls. When set to imprint data, it displays what will be imprinted on the film.

such as pre-winding the film during the film-load procedure, just replace the battery. The camera will resume whatever it was doing.

## HANDGRIP

The handgrip is removable, for battery replacement. It is not interchangeable with handgrips for EOS 620/650 cameras.

## END OF ROLL

When the last frame has been exposed, the camera rewinds the remaining film into the cartridge and draws the film leader into the cartridge also. The Frame Counter shows E.

## MAJOR ACCESSORIES

Canon EF lenses, EZ and E-type flash units, Dioptric Adjustment Lenses and other eyepiece accessories, Circular Polarizing Filters and most other general-purpose filter types.

## EOS 750 QD BUILT-IN QUARTZ DATE BACK

This permanently attached back cover can be set to imprint date or time in the lower right corner of the picture. The date back has a built-in electronic calendar that is programmed to keep the correct date and time of day through the year 2019.

**Modes**—There are four modes that imprint and one that doesn't. Pressing the MODE button on the date back selects modes in the order shown in the accompanying table.

**Display**—The LCD display on the date back shows what will be imprinted, or a row of dashes when nothing will imprint. The year digits are preceded by a ' symbol. A small M symbol appears above the month digits. In the time display, hour and minutes are separated by a colon.

**Imprint Confirmation**—In any im-

print mode, a bar appears in the upper right corner of the display. After each imprint, the bar blinks briefly as confirmation.

**Controls**—The MODE button sets the imprint mode. The SELECT button selects digits on the display that are to be changed. The selected digits blink. The SET button changes the blinking digits.

**Setting the Date**—Press the MODE button to display Year, Month, Date (Y M D), in any order.

Press the SELECT button. The Exposure Confirmation bar will disappear. The Y digits blink. Press the SET button repeatedly until the desired year is displayed.

Press the SELECT button. The M digits blink. Press the SET button repeatedly until the desired month is displayed.

Press the SELECT button. The D digits blink. Press the SET button repeatedly until the desired day of the month—such as 18—is displayed.

Press the SELECT button. The D digits stop blinking and the Exposure Confirmation bar reappears. The date back is set to imprint the date.

**Setting the Time**—Press the MODE button to display Date, Hour, Minute. The date will be the same as shown in the Y M D displays and is not changed in this procedure.

Press the SELECT button. The Exposure Confirmation bar will disappear. The Hour digits blink. Press the SET button repeatedly until the desired hour is displayed, using the 24-hour clock. For example, 1:44 p.m. is 13:44.

Press the SELECT button. The Minute digits blink. Press the SET button repeatedly until the desired minute is displayed.

Press the SELECT button. The colon between hours and minutes blinks. Press the SELECT button again. The colon stops blinking and the Exposure Confirmation bar reappears. The date back is set to imprint the time.

**The Imprint**—Whatever is dis-

To replace the battery, remove the handgrip. The handgrip for EOS 750/850 models is not interchangeable with handgrips for EOS 620/650 models.

### IMPRINT MODES OF EOS 750 QD BUILT-IN QUARTZ DATE BACK

| QD Display | Imprint |
| --- | --- |
| — — — | Imprints nothing |
| M D 'Y | Imprints Month, Date, Year |
| D M 'Y | Imprints Date, Month, Year |
| 'Y M D | Imprints Year, Month, Date |
| D H: M | Imprints Date, Hour, Minute |

played, except the row of dashes, will imprint in the lower right corner of the frame. The imprinted characters are orange with color film, white with b&w film. The imprint is easier to read if you compose so the lower right corner of the image is dark.

**Power Source**—The QD back uses one 3-volt lithium CR2025 battery.

Battery life is about three years. When the battery nears discharge, imprinted digits will be dim.

**Battery Replacement**—Use a small Phillips-head screwdriver to remove the battery-chamber cover, which is marked CR2025 3V and +. Remove the old battery and install a new battery, with the + side out.

# Index